Marie Read

Mastering Bird Photography

The Art, Craft, and Technique of Photographing Birds and Their Behavior

Mastering Bird Photography
The Art, Craft, and Technique of Photographing Birds and Their Behavior

Marie Read
www.marieread.com

Editor: Joan Dixon
Project manager: Lisa Brazieal
Design and type: Petra Strauch
Cover design: Rebecca Cowlin
Cover production: Kim Scott, Bumpy Design
Marketing coordinator: Mercedes Murray

ISBN: 978-1-68198-362-2
1st Edition (2nd printing, December 2020)
© 2019 Marie Read
All images © Marie Read unless otherwise noted
Feather graphic used by permission from iStock.com/mashakotcur

Rocky Nook, Inc.
1010 B Street, Suite 350
San Rafael, CA 94901
USA
www.rockynook.com

Distributed in the UK and Europe by Publishers Group UK
Distributed in the U.S. and all other territories by Ingram Publisher Services

Library of Congress Control Number: 2018952210

This book is printed on acid-free paper.
Printed in China

There's a high flyin' bird, flying way up in the sky
And I wonder if she looks down, as she goes on by
Well, she's flying so freely in the sky

Lord, look at me...
I'm rooted like a tree...

~ Richie Havens, singer-songwriter, 1941–2013

TABLE OF CONTENTS

FOREWORD

One of the first people I met when I took the helm of *Living Bird* magazine in 1990 was Marie Read, an avid bird photographer who lived nearby. She came to my office one day to show me a portfolio of her work, and I was stunned. Even then—nearly three decades ago—she had already amassed an amazing collection of bird images. And they were more than just excellent wildlife shots: Each image seemed to capture the very essence of the individual bird.

Before she left that day, I'd already chosen one of her pictures—a Black-capped Chickadee hovering under a dripping icicle to get a drink—for the back cover of the first issue of *Living Bird*, which I had edited. It would not be the last image of Marie's I would publish. Over the years, her pictures were often featured on the front and back covers—sometimes of the same issue—as well as in articles, portfolios, and spreads inside the magazine.

Looking through *Mastering Bird Photography*, you'll quickly see what attracted me to Marie's work. The breadth and variety of her images—the species, the habitats, the behaviors depicted—is remarkable. And each picture shows the mark of an artist in the composition, lighting, color, and attention to detail. It's not surprising. Marie has been at this for a very long time—more than thirty years—photographing in exotic locales such as Africa, Australia, Iceland, the Pribilof Islands, as well as in her own backyard, where many of my favorite photos of hers were taken.

Marie Read is a great teacher. Based on her long years in the field, her book is a virtual master class in bird photography, written in a friendly, engaging tone., The book covers a wide range of topics—equipment, lighting, composition, color, camouflage, flight photography, how to capture behavior, and more—and she provides sage advice on how the reader can achieve his or her own artistic vision. I'm sure wildlife photographers of all levels will find this book interesting and useful—and, above all, inspirational.

Tim Gallagher
Editor-in-Chief Emeritus, *Living Bird*

INTRODUCTION

Birds! The freest of Nature's free spirits! Colorful, musical, and full of life, they have captivated and inspired us since the dawn of human history. Their fascinating lives unfold in just about every habitat on Earth: In frigid polar regions, sweltering rainforests, stark deserts, and, increasingly, in our cities and gardens. Some live life high in the sky, others dive deep underwater. Most share the human love of daylight but a few emerge only under cover of darkness. But the true embodiment of birds' spirit is that most enviable of powers: flight.

Bird photography has become immensely popular, in no small part because it offers us humans—ever yearning for freedom—a way to capture some of that boundless avian spirit. It's as if we subconsciously hope that the essence of bird-ness holds the secret to lifting our spirits and liberating us, too.

Bird photography follows closely behind bird watching as one of North America's most popular pastimes. I'm delighted that you're joining the ranks!

I originally came to bird photography from a background in biology, with a deep interest in animal behavior. My work has reflected those roots: I enjoy showing people glimpses of birds going about their lives while interacting with each other and their habitats—brief moments in time that people ordinarily miss on casual observation. But I also love to portray these marvelous creatures in purely artistic ways.

What kind of bird photographs do *you* want to create: Closeup portraits with every feather tack sharp; brilliant flight and action shots; images that reveal birds' life history and behavior; or abstract or impressionistic images? If you're like me, your answer is, "All of the above!" In the following pages, I'll describe how I have explored each of these genres and I'll share a wealth of technical and creative tips to help you do the same.

There's no denying that the pursuit we have chosen is challenging, but it also should be a fun and creative adventure.

There are as many opinions as to the "correct" way to photograph birds, as there are photographers—and there certainly are many brilliant ones out there! I will share my way. I hope you find it helpful on your journey toward mastering bird photography.

Marie Read, December 2018

Figure 1.1: Wood Duck male preening, with colors of fall foliage reflected in the water.
Canon EOS 1D Mark III with 500mm f/4L IS USM lens, 1.4× teleconverter, Gitzo tripod, 1/800 sec., f/5.6, ISO 500. Cleveland, Ohio.

Chapter 1

GETTING STARTED IN BIRD PHOTOGRAPHY

After its companion flies off, there is just one Horned Puffin remaining on the rock ledge just ahead of me. I take the chance to relax my shoulders and rest my eyes after a long stretch of staring through the viewfinder. Not for long though! Before I know it, another puffin is landing in a flurry of wings as it scrambles to gain a foothold. Reflexively, I aim the camera and press the shutter button with no time to frame carefully. Often, that might be a recipe for failure, but not this time: One perfect frame has both a dynamic wing position and the two puffins' bills aligned as though they are about to kiss. Many factors contribute to a great bird image. Sometimes Nature adds the magic ingredient: Luck!

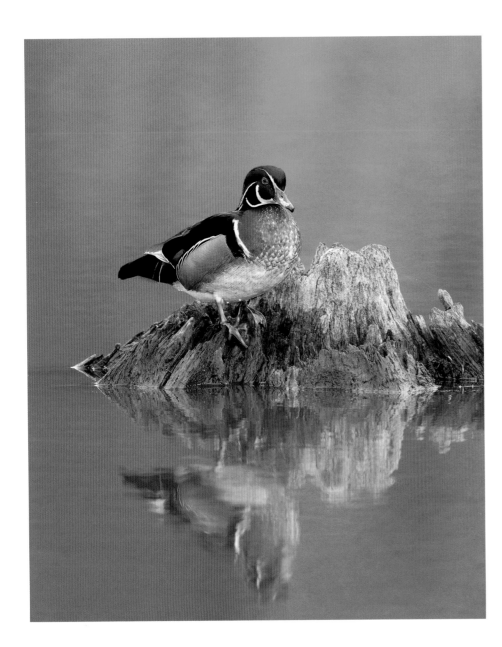

Figure 1.1:
Wood Duck male.
Canon EOS 1D Mark III
with 500mm f/4L IS
USM lens, Gitzo tripod,
Canon Speedlight 580
EXII, Better Beamer
flash extender,
1/400 sec., f/5.6,
ISO 1000. Cleveland,
Ohio.

As a young photographer back in the distant past, when dinosaurs and film cameras ruled the earth, I attended a talk about what it takes to make great nature photographs. The speaker's advice was deceptively simple and as relevant to bird photography as it was to nature photography in general. His four tips were: Be *there*, be *prepared*, be *aware*, and be *lucky*.

"Is that all? What about cameras and lenses and f-stops?" I hear you ask. Certainly, it's important to have good equipment and a firm grasp of photographic techniques to get started in bird photography. That's why every photo caption in this book includes the equipment and camera settings used.

But technical information alone gives you only a small fraction of the story. It doesn't reveal, for example, the importance of *timing* in obtaining the image of the Wood Duck and its reflection in figure 1.1; how vital it was to be there during the one week in October when reflections of fall foliage would color the water so beautifully in this particular pond; how essential were the calm conditions of early morning to produce the bird's reflection; and how important it was for me to wait until the bird's head was turned slightly toward me before pressing the shutter button.

Behind every shot in this book is a whole suite of factors beyond the technical, which fall under the umbrella of field craft: the knowledge, skills, and

preparedness that will empower you to create bird images that stand out from the crowd.

The four "Be's" of bird photography cover all the elements of field craft and then some! That's why it's so important to explore these before anything else.

Be There

Remember that college course in which you earned a point toward your grade by simply showing up for class? The same applies to bird photography. Just being there—in the right place at the right time—goes a long way toward achieving success.

In the Right Place

Where can you find subjects? If you're a birder, you likely already know some bird-rich spots in your local area. If not, join a bird club or an Audubon chapter, and attend field trips to learn where birds can be found in your region. Subscribe to local or regional online listservs for up-to-the-minute bird sightings. I find a lot of my local subjects through a local birding listserv. For instance, a report of Eastern Bluebirds feeding on juniper berries offered a fantastic opportunity that was only a twenty-minute drive from my home (figure 1.2). For bird sightings from

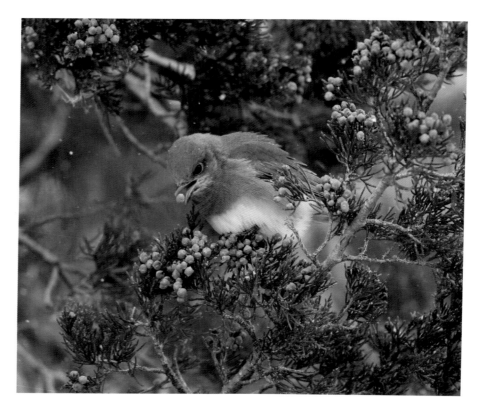

Figure 1.2:
Eastern Bluebird male feeding on juniper berries in winter.
Canon EOS 7D Mark II with 500mm f/4L IS lens, 1.4X teleconverter, beanbag over vehicle window, 1/640 sec., f/5.6, ISO 1600. Aurora, New York.

farther afield as well as close to home, explore *eBird*, the real-time, online database of bird observations from North America and worldwide.

Consider attending one of the numerous birding festivals held throughout North America. Festival field trips are a great way to learn where to find birds if you're traveling to an unfamiliar region. Bird photography is now so popular that photography workshops are often on the schedule, too. The bimonthly

magazine *Bird Watching* announces upcoming festivals in each issue, and the Cornell Lab of Ornithology's *All About Birds* website maintains a list of birding festivals that is searchable by date and location.

Numerous professional bird photographers lead workshops or tours to bird-rich locations throughout North America and across the globe. Before choosing one, know what you're getting. A photo workshop implies a certain

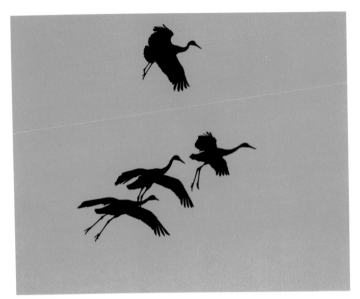

Figure 1.3: Greater Sandhill Cranes silhouetted against a sunset sky. Canon EOS 7D Mark II with EF 500mm f/4/L IS II lens, Gitzo tripod, 1/2500 sec., f/5.6, ISO 640. Bosque Del Apache National Wildlife Refuge, New Mexico.

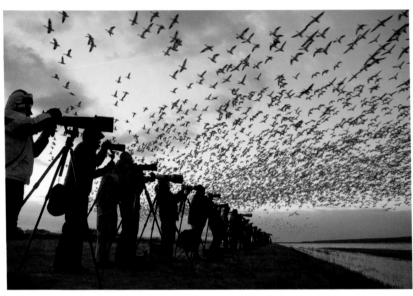

Figure 1.4: Bird photographers line up at sunrise to photograph the famous mass takeoffs of flocks of overwintering Snow Geese. Bosque Del Apache National Wildlife Refuge, New Mexico.

amount of structured teaching, either in the classroom or the field; while a photo tour may include little or no formal teaching, with the leader acting more as a guide and shooting alongside clients.

Peruse the image galleries of online forums such as NatureScapes.net or birdphotographers.net to discover where others go to shoot. Join in the discussions, and you'll find that most other photographers are happy to share location information.

Visit one of the renowned bird photography hotspots mentioned in chapter 15, where you'll find abundant and, often, quite approachable birds. At these tried-and-true spots, such as New Mexico's famous Bosque Del Apache National Wildlife Refuge, you'll have boundless opportunities to practice your skills (figure 1.3).

Hotspots, workshops, and tours often mean you are shooting alongside others... sometimes *many* others (figure 1.4)! You may come away with similar-looking shots to everyone else's. Still, you can experiment with creative techniques, and you have the chance to network with other photographers, learn about other good locations, and pick up useful tips.

For truly unique images, you might do better to find your own special hotspots close to home. (You'll save money, too!) Explore local parks, beaches, lakes, ponds, nature sanctuaries, and wildlife refuges. Visit them regularly and be observant. Over time, you'll discover where birds nest, feed, or gather to rest. The Red-tailed Hawks in figure 1.5, for instance, return each year to nest on the steep wall of a local gorge

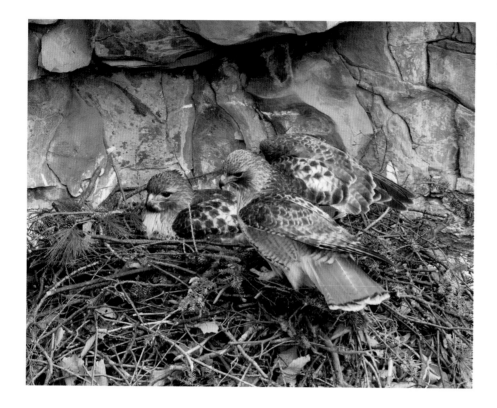

Figure 1.5: Red-tailed Hawk pair nesting on a rock ledge in a deep gorge.
Canon EOS 7D with 500mm f/4L IS USM lens, Gitzo tripod, 1/640 sec., f/5.6, ISO 640. Ithaca, New York.

near my home. A much-traveled bridge over the gorge offers photographers and the general public a rare window into the hawks' family life.

At the Right Time

Being there at the right time—whether time of day or time of year—can mean the difference between success and failure.

Time of Day

The early bird catches the worm, and if your goal is to capture it doing so, be out with your camera early in the day. You'll have the best light then, too. In general, diurnal birds tend to be most active and visible in the morning, even more so in spring when hormone levels are high. The dawn chorus of territorial songbirds, such as warblers (figure 1.6), thrushes, and tanagers, begins with the first glow of light in the sky.

Prairie-Chickens (figure 1.7) and grouse start displaying on their leks (display grounds) at dawn, too. To avoid flushing your subjects and ruining the photo opportunity, set your alarm to rise early and be well hidden in place before they arrive.

Especially in hot weather, birds often rest in the middle of the day, but activity picks up again in late afternoon and evening. When they are feeding their young, birds are active all day long.

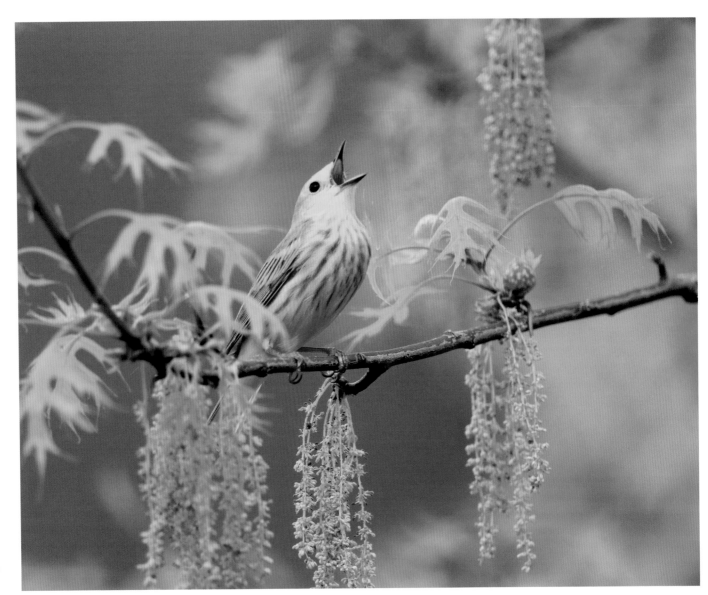

Figure 1.6:
Yellow Warbler
male singing.
Canon EOS 7D with
500mm f/4L IS USM lens,
1.4× converter, Gitzo tripod,
1/500 sec., f/5.6, ISO 500.
Ithaca, New York.

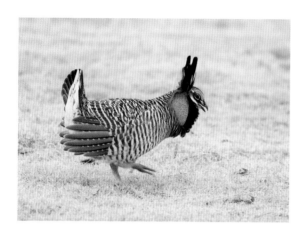

Figure 1.7: Greater Prairie-Chicken male. I needed to be in a blind at the lek well before dawn to capture the birds displaying.
Canon EOS 7D Mark II with EF 100–400 mm IS II lens (at 400mm), bean-bag support, 1/125 sec., f/5.6, ISO 3200. McCook, Nebraska.

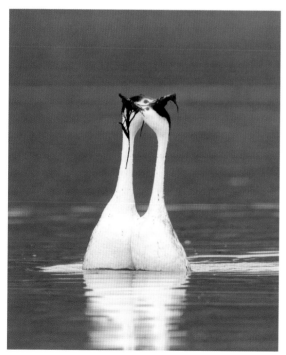

Figure 1.8: A pair of Clark's Grebes performs the Weed Ceremony, in which they slowly circle, breast-to-breast, holding nesting material.
Canon EOS 7D Mark II with Tamron SP 150–600mm F/5–6.3 Di VC USD G2 lens, handheld from a boat, 1/1250 sec., f/6.3, ISO 1250. Escondido, California.

Diurnal patterns can vary widely for activities other than territoriality and nesting. The best strategy is to time your presence based on your own scouting observations or information from other people familiar with the location.

Time of Year

Much of North America is strongly seasonal, and the changing seasons usher in various stages of a bird's annual life cycle. You can find birds at any time of year, of course, but if your goal is to photograph particular species in peak breeding plumage, or performing activities such as courtship or migration, knowing the right time of year is vital.

April in California finds pairs of Clark's Grebes (figure 1.8) and Western Grebes performing their graceful Weed Ceremonies as they gear up for nesting. The month of March is peak time for hundreds of thousands of Lesser Sandhill Cranes to be passing through central Nebraska during spring migration (figure 1.9).

Latitude affects the timing of annual stages of the life cycle, particularly breeding, although weather has an important influence too. Black Skimmers nesting on the beaches of southwest Florida have newly hatched chicks in early June, but on New York's Long Island, considerably farther north, skimmer chicks don't emerge until early August.

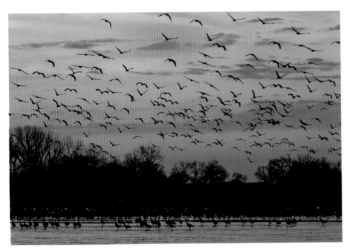

Figure 1.9: Lesser Sandhill Cranes take flight at sunrise from their roost on the Platte River during spring migration.
Canon EOS 7D Mark II with EF 100–400 mm IS II lens (at 142mm), handheld, 1/640 sec., f/5.6, ISO 1250. The Crane Trust, Grand Island, Nebraska.

Figure 1.10: A Blue Jay carries off an acorn in October.
Canon EOS 7D Mark II with EF 100–400 mm IS II lens (at 400mm), handheld, 1/2000 sec., f/5.6, ISO 640. Ithaca, New York. (Right)

If you're arranging travel to coincide with certain activities, it pays to research your subject and obtain current conditions at your destination before you leave home.

Being there at the right time is much easier if you shoot locally. Scouting out your local hotspots regularly throughout the year lets you plan ahead in anticipation of birds' seasonal activities. For example, where I live in central New York, autumn sends certain year-round resident species, such as Blue Jays, into a frenzy of food hoarding for the coming winter (figure 1.10). In years with good acorn crops I can guarantee that, in October, jays will be flying to and from huge oak trees in a particular local park, carrying off acorns to stash on their territories.

Timing is essential for short-lived opportunities. Seize the moment! In spring, I monitor the condition of the buds on crabapple trees in that same park. The beautiful blossoms attract throngs of songbirds such as Baltimore Orioles, Yellow Warblers, and Indigo Buntings (figure 1.11), as they feed on nectar or glean insect larvae. Once the trees burst into flower, I make sure to be there because peak bloom lasts just a few days—a rain shower or a windy day can knock all the petals down and then it's all over until next year.

Figure 1.11: Indigo Bunting male amid crabapple blossoms.
Canon EOS 7D Mark II with EF 500mm f/4/L IS II lens, 1.4X III teleconverter, Gitzo tripod.
1/800 sec., f/9.0, ISO 640. Ithaca, New York.

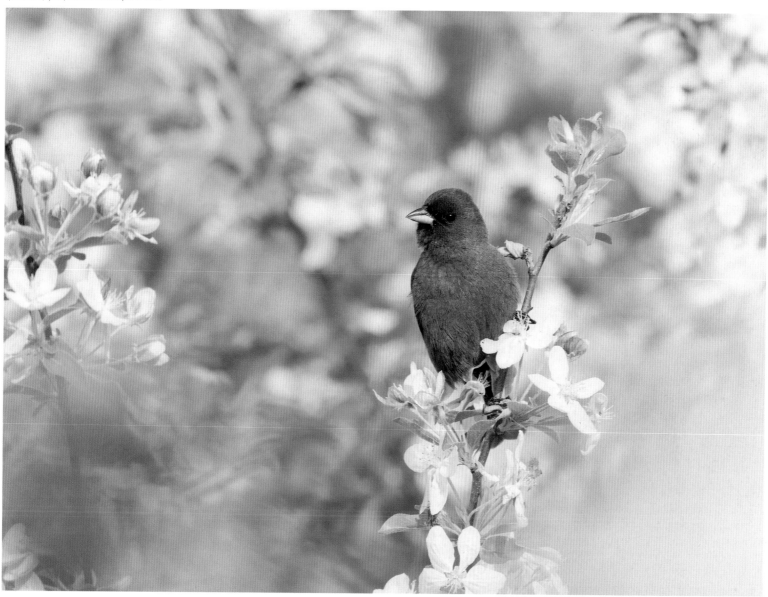

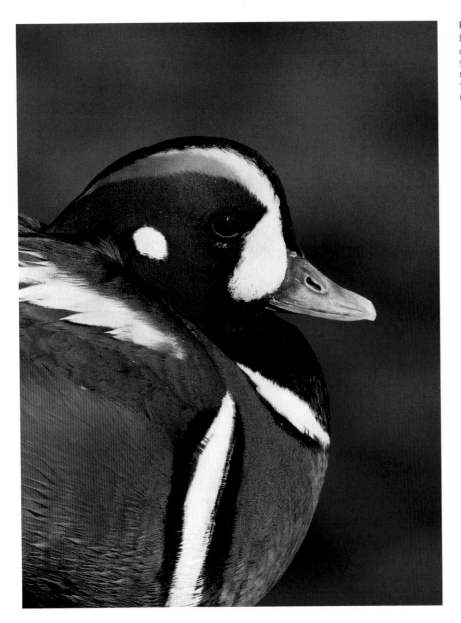

Figure 1.12: Harlequin Duck male.

Canon EOS 1Ds Mark II with 500mm f/4L IS USM lens, 2X teleconverter, Gitzo tripod, 1/320 sec., f/16.0, ISO 320. Barnegat Inlet, New Jersey.

Give It Time

Bird photography is time consuming. Be ready to work at length to get that special shot. Call it patience or call it persistence, having the determination to put in the necessary field time is one of my greatest strengths. In a productive situation, I may spend several hours at a time working a subject, often returning day after day to the same area to try again until I am satisfied with my images.

My husband tells the story of once leaving me on a rocky jetty to photograph Harlequin Ducks (figure 1.12) on a bitterly cold afternoon. Two and a half hours later he returned to pick me up only to find I was in exactly the same position as when he left. He jokes that he thought I had frozen in place. It felt that way to me, too! The moral of this story is to be sure to move around once in a while and don't forget to go home at the end of the day. Let figure 1.13 be a warning of the tragic fate that can befall a photographer who ignores this advice!

Figure 1.13: Spotted along a Montana roadside, a bird photographer who unfortunately sat still too long!

Be Prepared

Increase your chances of success by being well prepared before heading out into the field. Being prepared includes the following:

- Know your camera's physical layout and functions
- Understand the fundamental concepts of photography
- Know bird biology and understand birds' body language
- Have a plan or strategy
- Wear appropriate clothing and protective gear for weather and terrain
- Have strength, stamina, good concentration, and fast reflexes

First, Know Your Camera

Your first priority should be to familiarize yourself completely with your camera and lens. Study the user guide with the camera in your hand. Learn the functions of all the buttons and dials, and scroll through the various menus and displays. Modern cameras have a daunting array of adjustable functions, and it is good to know all the options, even if you eventually use only a subset of them.

Birds' activity levels, weather, and light conditions can quickly change, requiring you to efficiently adjust settings to match the situation. Know your

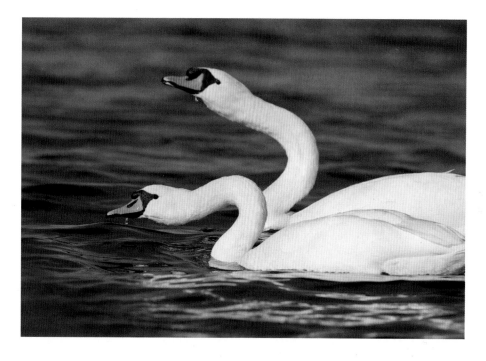

Figure 1.14: Mute Swan pair.
Canon EOS 1Ds Mark II with 500mm f/4L IS USM lens, 1.4X teleconverter, beanbag over car window, 1/2500 sec., f/7.1, ISO 400. Montezuma National Wildlife Refuge, New York.

camera's physical layout so you can change settings simply by touch. Don't forget the controls on the lens, too.

In particular, learn how to perform the following functions—we'll be revisiting them throughout the rest of the book:

- Adjust shutter speed, aperture, and ISO
- Use the autofocus system
- Select exposure and drive modes
- Use the light metering system
- Adjust the lens's image stabilization mode and focus range (if present)

Less vital, but still good to know, is how to access the camera's Live View function, which displays the scene on the camera's rear LCD screen. In certain circumstances, it can be easier to frame and set exposure using Live View than through the viewfinder.

Finally, for the highest quality images your camera is capable of producing, always shoot in RAW format rather than JPEG. (Note that many cameras have the option to shoot both formats at once.) RAW capture provides the maximum amount of digital information and gives you the most control over

how your images will ultimately appear. Furthermore RAW enables you to correct certain exposure errors such as occurred in figure 1.14. The original capture was overexposed, but since it was in RAW format, I was able to recover some detail in the blown-out white areas and salvage the image. (I'll share my workflow for this example in chapter 14.) If it had been shot as a JPEG, the result would have been far less satisfactory. To learn more about the benefits of RAW capture, see the special section at the end of this chapter.

Photography Fundamentals

You probably already know the basic concepts of photography, but if you are new to photography, now is the time to make sure you fully understand these fundamentals before you head out in search of birds. Find a basic photography book or online course. For a quick overview, see the special section at the end of this chapter.

Natural History Knowledge

One characteristic that top bird photographers share, which is reflected in the quality of their work, is a deep knowledge of birds and their lives. I can't stress too much that an understanding of birds will improve the quality of your images.

Figure 1.15: White-tailed Kite hovers watching for prey. Noticing that the kite consistently hunted over a particular field allowed me to be in place to capture it in action.
Canon EOS 7D Mark II with EF 100–400 mm IS II lens (at 400mm), 1.4X III teleconverter, handheld, 1/2000 sec., f/8.0, ISO 640. Costa Mesa, California.

I've had a lifelong fascination with bird behavior, and I enjoy discovering what birds do by watching them myself, as well as by reading about them. I encourage you to do the same. If you will be photographing an unfamiliar species, researching it ahead of time will give you an edge, for instance by alerting you to any unique attributes that might be meaningful to try to photograph. By capturing the uniqueness of a species, you are portraying its very essence.

Learn about bird biology in general and your goal species in particular—life history, habitat, preferred foods, behavior, and anything that makes the species special. For North American birds, a wealth of information is available online from such websites as Cornell Lab of Ornithology's *All About Birds* (free) or *Birds of North America* (subscription based), as well as from books and from talking to biologists, birders, and other photographers. Perhaps the best way

to get to know birds, though, is through observation: Be a bird *watcher* as much as you are a photographer.

In addition to species-specific information, it helps to know your individual subjects. Monitor the day-to-day routines of the very individuals you're hoping to photograph. Like humans, birds are creatures of habit—a Pileated Woodpecker visits a particularly resonant tree snag to perform territorial drumming, a Great Blue Heron can be found basking in the sun on the same log each morning, or a White-tailed Kite frequents a particular field to search for prey (figure 1.15). Based on predictable activities such as these, you can devise a photographic plan.

Develop a Plan

Sometimes I enjoy the freedom of wandering around with a lightweight camera combo and photographing whatever birds cross my path. I often do this when I'm scouting an area. But usually, my photo projects involve a certain amount of planning. That may be as simple as setting up a blind (see chapter 4) near a spot where I've noticed birds gathering regularly, and then being in place before they arrive. Or it may be complex and require critical timing, as did building a scaffolding tower to reach a Baltimore Oriole nest high in a tree (figure 1.16).

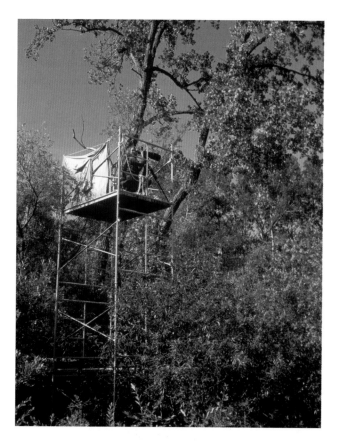

Figure 1.16: The author on a scaffold tower ready to photograph a Baltimore Oriole nest. Ithaca, New York.

The first step was to evaluate the site, then rent and transport scaffolding. Next, I had to resort to bribery: securing my husband's help by promising to buy him a shiny, new extension ladder. We delayed building the tower until late in incubation to minimize the risk of nest abandonment. We prepared a stable base by laying down planks on the muddy ground, and then we put up one tier of scaffolding at a time over a period of a week. The parent orioles became completely used to our presence. Once they began feeding their young (figure 1.17), I climbed up onto the tower platform each morning for two weeks to photograph at nest level, until the young orioles fledged.

When developing a plan for your own projects, make plenty of observations,

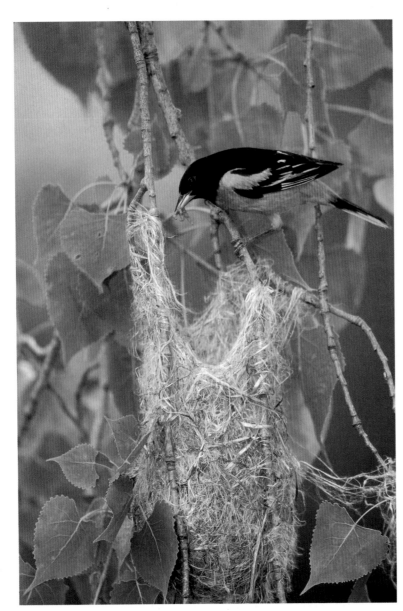

Figure 1.17: Baltimore Oriole male brings a caterpillar to feed young in the nest. Nikon F5, Nikkor 500mm f/4 AF lens, fill-flash, Fuji Provia film. Camera settings not recorded. Ithaca, New York.

get advice from other photographers or biologists if needed, and then consider the site characteristics and any previous experience you may have had with the goal species. Be prepared to adapt the plan as necessary.

Be Prepared for Weather and Terrain

Being uncomfortable may distract you into missing an opportunity, so dress appropriately. For cold or wet conditions, it's worth investing in high-quality winter wear, raingear, and waterproof footwear. Wear moisture-wicking clothing and a brimmed hat during hot weather. Consider protective gear too. Knee pads and long sleeves help prevent skin abrasion, if you expect to get down and dirty to shoot. Wear hip boots or chest waders for sloshing around a marsh or wading through water.

Keep in mind that weather affects birds' activities too. In windy weather, flocks of shorebirds and terns hunker down on the beach or shelter behind landforms. A warm autumn day may change fruit-eating waxwings into flycatchers, swooping high into the sky in pursuit of aerial insects. A cool, drizzly summer day forces high-flying swallows down out of the sky to swoop low over fields and lakes in search of aerial insect prey grounded by the weather. The better you know the behavior of your species

under various weather conditions, the better you can predict what types of images might be possible.

Be Prepared Mentally and Physically

Be prepared both mentally and physically. Being observant, having good powers of concentration, and being able to react quickly are learned skills that you should cultivate through practice.

Try this exercise: Find a bird that is keeping fairly still, for instance loafing or preening, and observe it closely through your telephoto lens for two minutes without letting your attention wander. (Tip: You'll find this easier and less tiring if your gear is on a tripod.) Train your reflexes by taking a shot each time the bird strikes a particularly elegant pose or does something dramatic or quirky (figure 1.18). Notice how the lighting changes on the bird's face with each tilt of its head and how compelling it is to have eye contact. Watch the changing juxtaposition of bill and feathers while it preens. Notice how changes in its posture and plumage (crest raised or lowered, for instance) signal whether it is relaxed or alert.

Next time, practice this for five minutes, then ten, and keep increasing the time until good concentration and quick reactions become second nature. Soon you'll be capturing some eye-catching shots. Observing birds closely is great

fun plus it will improve your photography in numerous ways, including helping you anticipate action, something we'll learn more about in chapter 8.

Finally, let's consider strength. Camera gear can be heavy, especially to handhold. Serious bird photographers need to be physically strong and have stamina. It's never too late to improve fitness and strength. To keep in shape, I regularly attend a fitness class that includes weight training.

Be Aware

Engage all your senses and get tuned in to what's going on around you. Pay attention to wind and light direction, notice the condition of the sky, and then use that information to determine where to position yourself for the best opportunities.

Be aware of what the birds are doing too, of course. Watch carefully and notice repeated, predictable behaviors. Capturing birds in action relies in large part on being able to anticipate behavior. Open your ears to birds' vocalizations, and try to determine the context in which they occur. Pay attention to alarm calls that may alert you that you're too close to the subject.

Allow yourself time to explore your subject in depth and consider your options for capturing it. Open your eyes to habitat elements or natural patterns

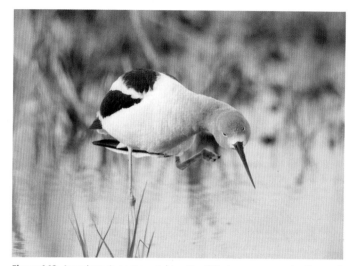

Figure 1.18: American Avocet scratching itself. Train your concentration and reflexes by closely watching the subject through your viewfinder and making an exposure each time the bird strikes a compelling pose.
Canon EOS 7D Mark II with EF 500mm f/4/L IS II lens, 1.4X III teleconverter, Gitzo tripod, 1/1000 sec., f/5.6, ISO 800. Bear River Migratory Bird Refuge, Utah.

that could form appealing compositions. Being open to possibilities is essential for developing that all-important "artist's eye."

While photographing Eared Grebes in Montana, I noticed they regularly swam through patches of pretty white flowers that were floating on the water's surface. I moved to where I had a good view of the flowers and then spent several hours waiting for a grebe to arrive and form the perfect composition (figure 1.19).

Be aware for your own safety, too. Watch for slippery rocks, unstable cliff

Figure 1.19: Eared Grebe swimming amidst white water-buttercup flowers.
Canon EOS 7D Mark II with EF 500mm f/4/L IS II lens, 2X III teleconverter, Gitzo tripod,
1/1000 sec., f/11, ISO 500. Benton Lake National Wildlife Refuge, Montana.

edges, hidden debris ready to trip you along an overgrown trail, or incoming tides that may flood your camera bag on the beach or, worse, cut off your return route to safety. Don't get so engrossed in photography that you ignore danger signs. Once, while some companions and I were intent on photographing Atlantic Puffins from a high cliff top in Iceland, we suddenly heard heavy breathing behind us to find that we were about to be crowded off the cliffs by a herd of over-friendly Icelandic ponies!

Be Lucky

Be lucky? Easier said than done! But in fact, the more you shoot the luckier you'll get. Time spent in the field—practicing photographic techniques, honing reflexes, and being persistent, observant, and open to opportunity—pays off, eventually. Armed with these skills, you'll be primed to take advantage of the lucky opportunities Nature offers, and the result will be not simply a good shot but a great one.

I was once blessed with a fantastic opportunity while photographing Common Loons from a pontoon boat. The loons were so used to watercraft that they often swam under the boat in pursuit of fish. As luck would have it, a loon surfaced at very close range with an impressive fish and in perfect light (figure 1.20). Being aware and prepared

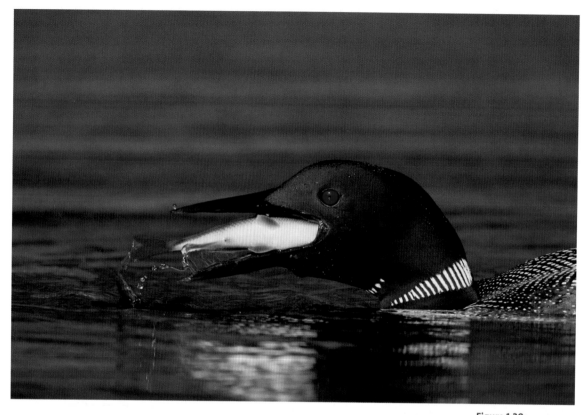

factored into the picture as well. I'd noticed a telltale trail of bubbles appearing on the water's surface indicating the loon's approximate location underwater. By concentrating on them I was able to focus on the loon's face the instant it broke the water's surface and capture several images. Two gulps later the fish was gone!

Luck favors the prepared!

Now that we've explored the various elements of field craft, you have a choice: Read the next sections to learn why to shoot in RAW and give yourself a refresher of basic photography concepts. Or, skip right to chapter 2 where we

delve into the nitty-gritty of choosing camera gear.

RAW Power!

The term "RAW" refers to the camera's native file format. Manufacturers signify their RAW formats with various filename extensions: Canon's is .CR2, Nikon's is .NEF, Sony's is .ARW, and so on.

Serious photographers shoot in RAW mode rather than JPEG because RAW files contain the maximum amount of digital information obtained by the camera's image sensor at the time of

Figure 1.20: Common Loon about to swallow a fish.
Canon EOS 1Ds Mark II with 500mm f/4L IS USM lens, 2× teleconverter, Gitzo tripod, 1/800 sec., f/8, ISO 250. Northern Michigan.

capture. RAW capture gives you the power to optimize, or develop, the image to your liking by modifying that data during image editing on the computer. With a RAW file, this process is non-destructive—none of the information is lost from the original file. You can re-edit the original RAW file as many times as you wish.

JPEG, on the other hand, is a compressed file format in which some information is immediately lost when the image is saved to the camera's memory card. Any parameters that you have preset, for instance Picture Style, white balance, and, most important, exposure settings, are irreversibly applied when the photo is taken. Trying to correct exposure mistakes in a JPEG file during postprocessing invariably degrades the image. Using RAW, you can correct overexposure (within limits) and tweak other parameters without losing quality.

The downside is that RAW files are large and consume more memory space than JPEGs. Furthermore, RAW files must be converted to another file format (such as TIF or PSD) for use, whereas JPEGs are usable immediately. Many cameras offer the option of shooting both formats at once: a JPEG version for immediate use and a RAW version to optimize at your leisure.

The benefits of RAW capture will become clear when we cover basic image editing in chapter 14.

Basic Photography Concepts

If you're new to photography, below is a brief review of the basic concepts and how they relate to camera functions and settings.

At its very essence, photography is all about light. By controlling the amount of light that reaches the camera's sensor, you determine the correct exposure—the basis of a successful image. We'll cover exposure in detail in chapter 6, but at this point, understand that three camera settings—shutter speed, aperture, and ISO—are used in combination to arrive at the correct exposure. This trio is sometimes referred to as the "exposure triangle." The effect of these settings is reciprocal: Changing one of them requires an equal but opposite change in one or both of the others to achieve the same exposure.

Shutter speed is the amount of time in seconds or fractions thereof that the shutter remains open allowing light to reach the image sensor. 1/15 second is considered a "slow" shutter speed, while 1/1600 second is a "fast" shutter speed.

Aperture is the adjustable, circular opening in the lens through which light passes to reach the sensor. Aperture size is referred to by the terms f-stop or f-number. A smaller f-number signifies a larger diameter aperture (e.g. f/2.8), whereas a larger number signifies a smaller diameter aperture (e.g. f/16).

ISO value indicates the camera sensor's sensitivity to light. Increasing the numerical value boosts the sensitivity, which is useful when shooting in low-light conditions.

In addition to their roles in exposure, shutter speed and aperture are viewed as creative settings because each can be changed to have important effects on how the subject appears in the final image. We'll revisit them in various later chapters, but for now consider the following:

- **Shutter Speed and Sharpness:** Shutter speed's main impact is on image sharpness (although other factors can affect sharpness as well). A fast shutter speed stops movement and the subject appears crisply focused. A slow shutter speed renders the subject blurred or "soft," something that most bird photographers want to avoid (although blurring can be used for creative effect as you'll discover).
- **Aperture and Depth of Field:** Aperture controls the image's depth of field: The zone between the nearest and farthest areas of the subject that appears sharply focused. Shooting "wide open" refers to selecting the lens's largest aperture (smallest f-stop), which results in a shallow depth of field. "Stopping down" the aperture refers to selecting a smaller diameter (larger f-stop), which increases the depth of field. By

controlling the depth of field, your choice of f-stop influences how much of the main subject appears sharp. Depth of field can be used creatively: A shallow depth of field isolates the main subject from the background whereas a larger depth of field can bring attention to the surroundings or background elements as well, although lens focal length and subject distance are important factors, too.

Chapter 2

EQUIPMENT ESSENTIALS

With acrobatic movements and a voice like a squeaky gate, the courting male Yellow-headed Blackbird is so preoccupied with enticing females to his territory that he ignores me standing barely thirty feet away, equally engrossed with capturing his every move. My professional digital camera focuses fast and accurately, firing off 10 frames per second. Viewed through my top-notch 500mm lens, the bird fills the frame. While I'm glad to have professional gear, I know that far more than equipment goes into obtaining stellar images. The camera and lens are simply my basic tools.

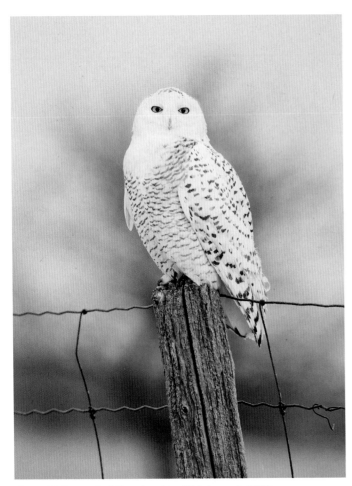

Figure 2.1: Snowy Owl. Since I captured this image in 2009, camera manufacturers have released scores of new camera models.
Canon EOS 1D Mark III with 500mm f/4L IS USM lens, beanbag over open car window. 1/250 sec., f/5.6, ISO 640. Amherst Island, Ontario, Canada.

I confess I'm surprised to find myself writing about the topic of camera equipment. I'm the opposite of a gear geek! I consider field craft, creative vision, and determination as contributing far more to great bird images than having the newest camera or the biggest lens. Yet, gear is what most bird photographers talk about when they meet.

People often ask me to recommend equipment for bird photography. It's always a difficult question to answer. Much depends on the photographer's budget, their aspirations, and how they plan to use their images. The photo captions throughout this book will reveal that you can capture professional quality shots without top-of-the-line gear. The basic requirements are a good camera body and telephoto lens, memory cards, a computer, and photo-editing software. More serious photographers should add a tripod. Beyond that, the sky's the limit on accessories to buy to fill your camera bag. Get ready to max out your credit card!

To click the Order button though, you have to make sense of the deluge of information about the latest photo gear and digital-imaging products. Explore equipment reviews on websites such as The Digital Picture, DPReview, and FredMiranda. Join online discussion forums such as NatureScapes.net to learn what gear other bird photographers use and to get their opinions of new products. Online camera stores often have educational sections (B&H's Explora or Adorama's Learning Center, for instance) to inform buyers about products. It's easy to succumb to information overload, but I hope the following guidelines will help you choose the equipment that's right for you. (Note that all camera and lens models mentioned are current as of October 2018.)

Cameras for Bird Photography

Bird photographers primarily use 35mm digital single lens reflex (DSLR) cameras—the classic camera design in which a viewfinder and a system of mirrors and prisms lets the photographer see through the lens the exact scene that the camera's sensor will capture. Presenting some serious competition to classic DSLRs are mirrorless cameras—lightweight bodies featuring electronic rather than optical viewfinders, which are expected to dominate the field very soon. Stay tuned!

Technology changes so fast and manufacturers release new camera models so often that any mentioned below may be obsolete by the time this book is published (figure 2.1). Nevertheless, consider the following important features before you purchase a camera.

Brand, Model, and Price

Regarding brands, Canon and Nikon lead the DSLR field. Although you're free to consider other manufacturers, it's a good idea to stick with these top brands because the vast body of information available from their users can advise you and help troubleshoot any problems you may have. Sony seems to have taken the lead in mirrorless models. Camera performance, image quality, and price vary depending on the target audience, corresponding to the following categories:

- **Entry level:** Targeted at general consumers and beginning photographers. Price: several hundred to one thousand dollars.
- **Intermediate level:** Targeted at serious amateurs and semi-professionals. Price: one thousand to several thousand dollars.
- **Professional level:** Targeted at professionals and serious amateurs with large bank accounts! Price: several thousand dollars.

Photographic Goals

What are your aspirations for your images? Are you part of the new "birding with a camera" crowd, looking to document birds seen on field trips and share images with friends or on social media? Are you more serious and competitive, active in a camera club, or planning to enter photo contests? Are you an aspiring professional, hoping to sell images for publication? Your answers to these questions will help you determine which category of camera fits your needs and your budget (figure 2.2).

Megapixel Rating

The amount of digital information a camera can record, measured in megapixels, spirals ever upward with each new camera model. Manufacturers would have us believe that more pixels automatically translate into improved image quality. The reality is more nuanced—sensor size and pixel size affect image quality, too.

Sensor Size: Full Frame vs. Crop Frame

DSLRs have either a full-frame sensor (24mm × 36mm, based on the size of the original 35mm film frame) or a smaller crop-frame sensor (sometimes called simply "crop sensor"), whose size, compared to a full-frame sensor, determines the camera's crop factor. Sensor size has important implications for bird photographers, who always crave more reach.

Consider an image taken with a full-frame camera. Given the same focal length lens, a crop-sensor camera

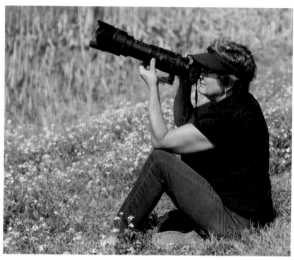

Figure 2.2: Consider your aspirations and your budget when deciding what gear to purchase.

captures only the central part of the scene, so the subject appears larger in the final image. The crop sensor's narrower field of view gives the impression of increasing the lens's focal length, a big advantage when approaching a skittish bird. The apparent magnification boost depends on the camera's crop factor, which can be anywhere from 1.3× to 2.0×, depending on the brand and model.

The crop sensor's advantage often comes at a cost, though: reduced image quality. Compared to those from a full-frame model with the same megapixel rating, images from a crop-sensor camera will likely be of lesser quality due

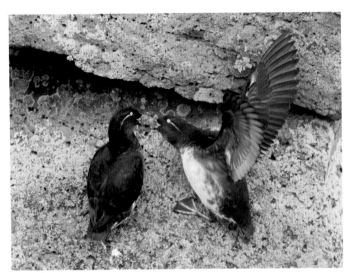

Figure 2.3: Parakeet Auklets.
Canon EOS 7D Mark II with EF 100–400mm IS II lens (at 400mm), handheld, 1/400 sec., f/8, ISO 2000. St. Paul, Pribilof Islands, Alaska.

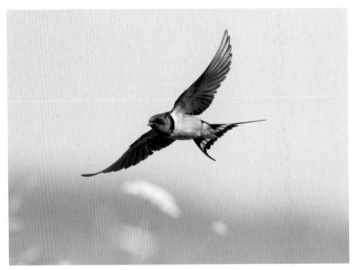

Figure: 2.4: A fast and accurate autofocus system is essential for capturing fast-moving birds, such as this Barn Swallow in flight.
Canon EOS 1D Mark III with 400mm f/5.6L USM lens, handheld, 1/2500 sec., f/5.6, ISO 800. Montezuma National Wildlife Refuge, New York.

to increased noise (described below). The pixels (technically, light-gathering photosites) of a crop sensor would be smaller and more likely to produce noisy images at high ISOs.

High ISO Performance

How well the camera handles noise is important under low-light conditions when high ISO values are needed. While photographing Parakeet Auklets on Alaska's famously foggy Pribilof Islands, I often used ISOs of 2000 or higher to give an adequate shutter speed for sharp shots (figure 2.3). Especially when using a high-megapixel, crop-sensor camera such as the Canon EOS 7D Mark II, image quality at high ISOs can suffer due to noise, in the form of a grainy appearance and random bright or incorrectly colored pixels that did not exist in the natural scene. Noise obscures subject sharpness and fine detail. Dark areas of the image will display the most noise and it will be most noticeable in smooth, less detailed areas. Don't presume that applying noise-reduction software during postprocessing will improve the outcome—it's far better to obtain low noise images in the first place.

Full-frame sensor and professional camera bodies are much better at producing low-noise images at high ISOs. The same is true of new versus older camera models, because manufacturers constantly improve both sensor design and in-camera image processing.

Autofocus Performance

Whoever first coined the term "moving target" surely must have been a bird photographer! A fast and accurate autofocus (AF) system is vital for bird photography (figure 2.4). Unsurprisingly,

you get what you pay for. High-end cameras are superior at acquiring and maintaining focus on moving subjects. This is mainly because, compared to entry-level models, pro and intermediate cameras generally have more AF sensors spread over a larger percentage of the picture area, as well as more high-precision cross-type sensors.

Frame Rate and Buffer Capacity

To capture action shots and birds in flight, the camera should have a high frame rate so you can shoot continuous high-speed bursts. Top-of-the-line cameras can shoot 10–14 frames per second (fps), less expensive models may reach 7 fps, and lower-end bodies come in at 5 fps or less. Equally important is the capacity of the buffer—a section of memory for temporary file storage that lets you continue shooting instead of having to wait until data is transferred, or written, to the memory card. High frame rates generate a lot of images, so the larger the buffer, the better. The 7 fps Nikon D850's buffer holds up to 51 RAW files before needing to clear, whereas the 6 fps entry-level Canon EOS Rebel T7i holds only 21 RAW files. For maximum efficiency, use high-capacity memory cards with a fast write speed (see *Memory Cards* below).

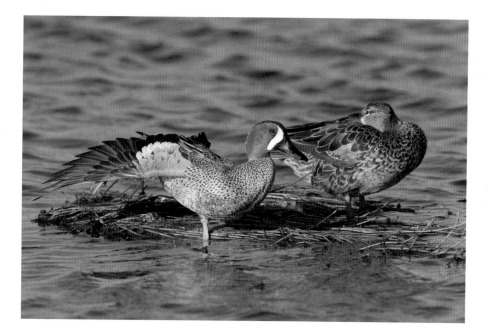

Figure 2.5:
Blue-winged Teal pair photographed with a Canon 7D series camera, which is more comfortable for me to handle than the 1D pro series.
Canon EOS 7D with 500mm f/4L IS USM lens, 1.4× converter, beanbag over car window, 1/1000 sec., f/8, ISO 400. Merritt Island National Wildlife Refuge, Florida.

Construction

Compared to entry-level or intermediate-level cameras, professional bodies are more rugged, made of sturdier materials, and are better sealed to protect against the elements. Pro bodies are heavy and bulky, so consider how much weight you are willing to lug around! After many years relying on Canon's 1D series of professional bodies, I switched to Canon's 7D series, which fit my small (and now arthritic!) hands much more comfortably (figure 2.5).

Decisions, Decisions...

As with any major purchase, choosing a camera involves a compromise between many factors. I suggest choosing a manufacturer and then—based on your budget, skill level, and photographic goals—decide which category of camera fits your needs. Purchase the manufacturer's most recent model in that category.

> **SUGGESTED CAMERAS FOR BIRD PHOTOGRAPHY**
>
> - **Entry level:** Nikon D5600 (CR), Canon EOS 80D (CR), Canon EOS Rebel T7i (CR)
> - **Intermediate level:** Canon EOS 7D Mark II (CR), Canon EOS 5D Mark IV (FF), Nikon D850 (FF), Nikon D500 (CR), Sony Alpha a9 mirrorless (FF)
> - **Professional level:** Nikon D5 (FF), Canon EOS 1DX Mark II (FF)
>
> *(Note: FF=full frame sensor, CR=crop sensor.)*

Try before You Buy

Consider renting the camera model you're considering buying and test it out to help you decide if it's right for you. Reputable photo gear rental companies include LensRentals.com and Lens-ProToGo.com (both of which offer far more than just lenses). Consider renting lenses or other gear for special trips, too, if your current budget can't justify a purchase.

Buy Used Gear

If your budget is limited, another option is to purchase used gear, although this should be done with caution. Probably, the safest way is through one of the major camera retailers with websites that have a used gear section. The advantage is that the equipment will have been examined by the store and rated for condition, and will come with a (limited) warranty. Alternatively, many online photography sites (such as Fred-Miranda.com) and discussion forums have classified sections where you might find a bargain. Most have buyer/seller ratings for trustworthiness. Look for a seller who states the camera's total number of shutter clicks and provides close-up images of the camera so you can evaluate its condition. Use sites such as eBay only if you're an experienced user already.

Lenses for Bird Photography

Unlike camera bodies, which manufacturers replace with dizzying frequency as technology improves, lenses hold their value far longer. It's better to invest in a high-quality lens than compromise on the lens in order to afford a top-of-the-line camera body. Key features to consider are focal length, lens speed, and image stabilization.

Lens Focal Length

Measured in millimeters (mm), the longer a lens's focal length, the higher the magnification and the narrower the angle of view. Narrowing the angle of view takes in less of the surroundings and helps separate the subject from the background. Bird photographers typically use lenses in the 300–600mm range to obtain a satisfactory image size of their often small and flighty subjects. For large, trusting birds or species photographed from a backyard photo blind, 300mm may be adequate. In field situations where subjects may be more wary, a minimum length of 400mm is preferable. A lens may be either fixed focal length (often called a prime lens) or a variable focal length zoom.

Pros and serious amateurs typically use "big glass"—500mm or 600mm super-telephotos. My subjects are often songbirds such as the Pine Grosbeak in figure 2.6, one of a flock that was easily spooked and which forced me to keep my distance. In such circumstances, I rely on my workhorse Canon EF 500mm f/4L IS II lens, almost always with a 1.4× teleconverter attached, to provide a satisfactory subject size (figure 2.7).

Lens Speed

Lens speed is determined by the lens's maximum aperture. A lens with a large maximum aperture—for instance f/2.8 or f/4—is termed a "fast" lens. Fast lenses have a large diameter front lens element, which translates into allowing in a lot of light. Autofocus needs light to function optimally, so a fast lens will always acquire focus faster than a slower lens of the same focal length. Be aware

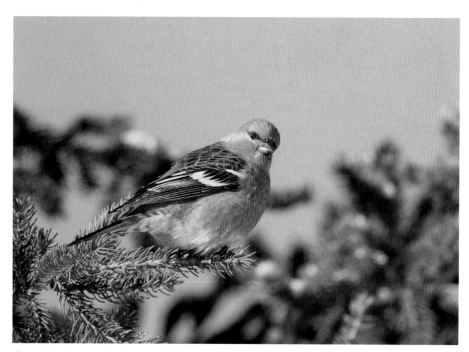

Figure 2.6: Pine Grosbeak near a popular bird feeding station.
Canon EOS 7D Mark II with EF 500mm f/4/L IS II lens, 1.4× III teleconverter, Gitzo tripod
1/1600 sec., f/5.6, ISO 400. Sax-Zim Bog, Meadowlands, Minnesota.

Figure 2.7: The author at work. A 500mm lens plus 1.4× teleconverter (total effective focal length 700mm) allowed me to stay well away from the Pine Grosbeak in figure 2.6 yet still obtain an adequate subject size.

that the maximum aperture of many zoom lenses varies as you change focal length, becoming smaller at longer focal lengths. Fast lenses are expensive and heavier than their slower counterparts, but the cost is well worth it, so purchase the fastest and longest focal length lens you can afford.

Image Stabilization

Nearly every current lens contains an image stabilization system, designed to counteract camera shake that causes blurred images. In a few models, it resides in the camera itself. "Image Stabilization" (IS) is Canon's terminology: Nikon calls it "Vibration Reduction" (VR). Other manufacturers use similar terms.

FIXED-LENGTH LENSES FOR BIRD PHOTOGRAPHY

- Canon EF 500mm f/4L IS II USM
- Canon EF 600mm f/4L IS II USM
- Nikon AF-S NIKKOR 500mm f/4E FL ED VR
- Nikon AF-S NIKKOR 600mm f/4E FL ED VR
- Canon EF 400mm f/4 DO IS II USM
- Canon EF 400mm f/5.6L USM (lightweight but *not* image stabilized)
- Canon EF 300mm f/2.8L IS II USM
- Nikon AF-S NIKKOR 300mm f/4E PF ED VR
- Sony FE 400mm f/2.8 GM OSS

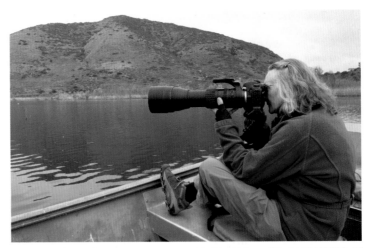

Figure 2.9: The author tests out a Tamron SP 150–600mm f/5–6.3 Di VC USD G2 lens, shooting handheld from a boat. Photo courtesy of Krisztina Scheeff.

Figure 2.8: Photographer Richard Day carries a Canon 100–400mm zoom lens in addition to a tripod-mounted super-telephoto.

Zoom Lenses

Zoom lenses were once considered less sharp than primes, but today's models deliver excellent sharpness as well as being budget friendly and versatile. A zoom can extend the lens to the longest focal length for bird portraits and flight shots, or zoom back to the short end for flocks, birds in habitat, or general scenery. A zoom is an excellent choice if you're new to bird photography and your budget can accommodate only a single lens, or if you need a birding lens that's also suitable for general use.

Many pro wildlife photographers carry both a fixed-length, long telephoto for tripod use and a shorter prime or zoom lens on a second body to handhold for birds in flight (figure 2.8).

Third-party, or aftermarket, brands provide good quality and economical alternatives to major brand lenses. Tamron and Sigma offer versatile, compact 150–600mm zoom telephotos that have become popular with bird photographers. I recently tested the Tamron SP 150–600mm f/5–6.3 Di VC USD G2, and, although it is a little slow and not ideal for low-light situations, I would recommend it for bird photographers on a budget (figures 2.9 and 2.10). The Tamron and Sigma telephoto zooms come with either a Canon or a Nikon mount. Either model would make a versatile travel lens.

ZOOM LENSES FOR BIRD PHOTOGRAPHY

- Nikon AF-S NIKKOR 200–500mm f/5.6E ED VR
- Nikon AF-S NIKKOR 80–400mm f/4.5–5.6G ED VR
- Canon EF 100–400mm f/4.5–5.6L IS II USM
- Sony FE 100–400mm f/4.5–5.6 GM OSS
- Tamron SP 150–600mm f/5–6.3 Di VC USD G2
- Sigma 150–600mm f/5–6.3 DG OS HSM Contemporary

Figure 2.10: Western Grebe calling, photographed from a boat.
Canon EOS 7D Mark II camera, Tamron SP 150–600mm f/5–6.3 Di VC USD G2 lens at 600mm, handheld, 1/1250 sec., f/6.3, ISO 1000. Escondido, California.

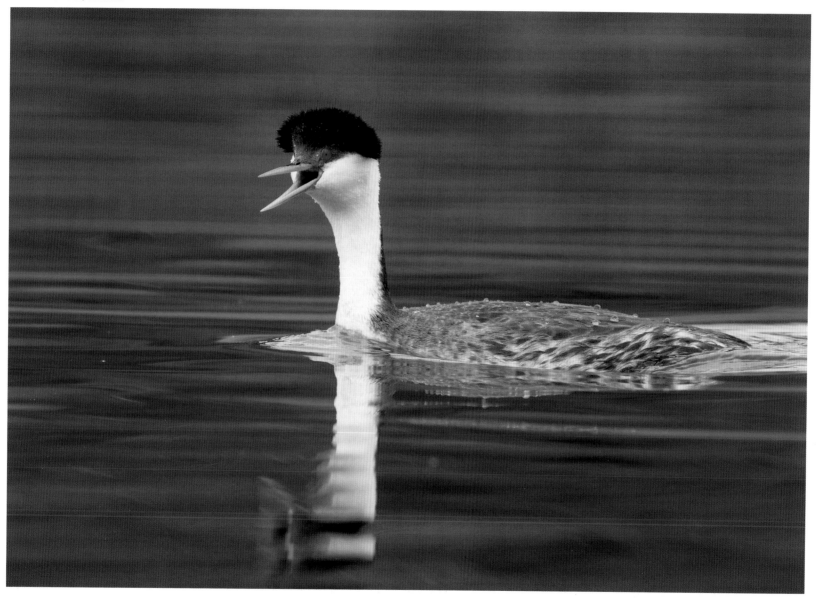

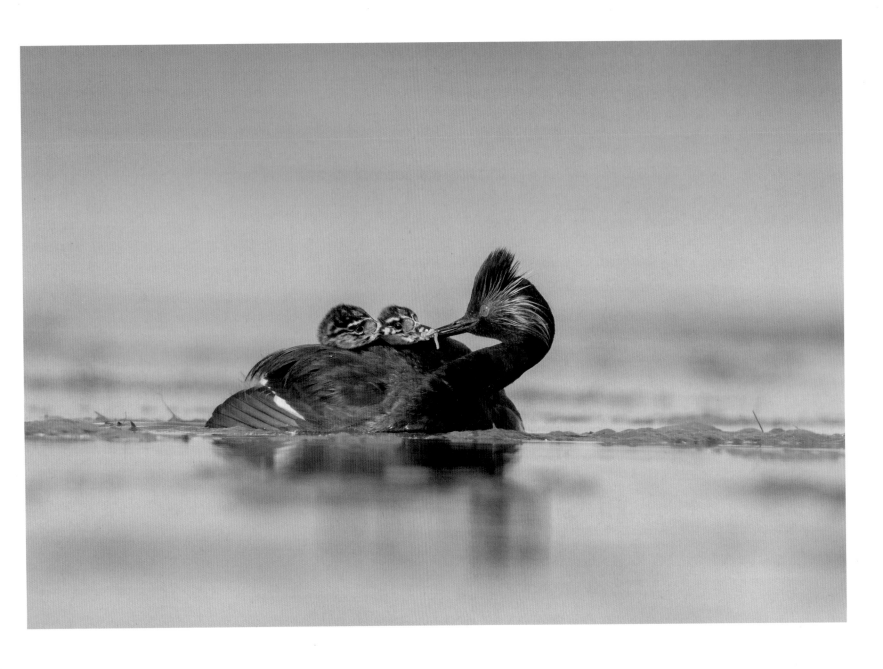

Teleconverters

Bird photographers, especially those who shoot small birds like I do, constantly crave more reach. An economical and lightweight way to increase the effective focal length of your existing lens is to add a teleconverter. (I prefer this more common name, although Canon refers to these small supplementary lenses as extenders.)

Canon offers teleconverters with 1.4× and 2× magnification factors, increasing a 500mm lens to 700mm and 1000mm respectively. Nikon offers 1.4×, 1.7×, and 2× teleconverters. I keep a Canon 1.4× attached to my 500mm lens most of the time. In my opinion, it has negligible effects on sharpness and image quality, but I'm more hesitant about using a 2× converter, as I explain below.

The downside is that adding a teleconverter allows in less light, lowering the maximum aperture of your lens and slowing the camera's autofocus (AF) speed. A 1.4× converter reduces the light

by one stop, making a 500mm f/4 lens a 700 mm f/5.6. However, a 2× converter robs you of two stops of light. That same lens is now a 1000mm f/8, lowering AF speed considerably and leaving only the central AF point functional in many cameras. In fact, certain cameras lose autofocus capability completely once the effective maximum aperture reaches f/8 or smaller. This makes teleconverters much less useful with slower lenses, such as the Tamron and Sigma zooms described above.

Another issue is camera shake. Adding a teleconverter magnifies not just

the subject, but also any camera movement, resulting in blurred images—a particular problem with a 2×. Yet, while photographing Eared Grebe families, I needed the extra reach—they were a little too far away to give a satisfactory subject size. Using a 2× teleconverter is a situation in which you can't compromise good technique. By steadying the camera/lens as much as possible (see chapter 3) and using a fast shutter speed, I obtained a number of sharp shots (figure 2.11).

Figure 2.12: Wilson's Phalaropes fly over Mono Lake's iconic tufa formations at sunrise.

Canon EOS 5D Mark II with EF 70–200mm f/4L IS USM (at 200mm), 1/1000 sec., f/11, ISO 400. Mono Lake, California.

Figure 2.11: Eared Grebe feeds a damselfly to one of two chicks riding on its back. To ensure sharp images while using a 2× teleconverter, I steadied the gear by holding the camera firmly and resting my left hand solidly on the lens barrel.

Canon EOS 7D Mark II with EF 500mm f/4/L IS II lens, 2× III teleconverter, Skimmer Ground Pod, 1/1000 sec., f/8, ISO 800. Bowdoin National Wildlife Refuge, Montana. (Left)

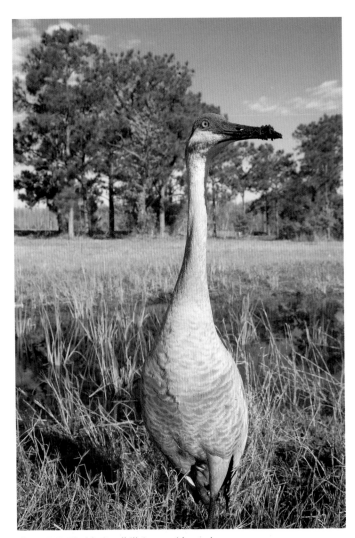

Figure 2.13: Florida Sandhill Crane wide-angle closeup to include the bird's wetland habitat.
Canon EOS 1Ds Mark II with 28–105mm lens at 35mm, hand-held, 1/1000 sec., f/10, ISO 500. Near Orlando, Florida.

Short Telephotos and Wide-Angle Lenses

Don't disregard smaller lenses for bird photography. Short to mid-range telephotos, in the 70 to 300mm range, are perfect for flocks or birds in their habitat. With a short telephoto and a good eye for composition, you can produce unique images that are as compelling as frame-filling portraits (figure 2.12).

Wide-angle lenses—focal lengths shorter than 50mm—can be used to portray birds in the landscape or create closeups with great impact. Wide-angles are so named because they encompass a wider field of view than the human eye naturally takes in.

Wide-angle shots portraying birds that fill a large part of the frame are uncommon because birds are usually too skittish to tolerate the necessary close working distance. However, for large species that are tolerant of people, you may be able to get close and creative with a wide-angle lens for a unique perspective, as in the image of the Florida Sandhill Crane in its habitat (figure 2.13).

A wide-angle lens can also be used in conjunction with a remote-triggering device, thereby removing the scary human from the scene entirely. Place the camera equipped with a wide-angle lens close to a spot where you expect the bird to arrive (for instance a nest or favorite perch) and trigger the shutter remotely from a distance. My remote trigger of choice is a wireless Pocket-Wizard Plus II Transceiver kit (described later in this chapter). (Note: Proceed slowly and use extreme caution when placing equipment very close to nests to minimize the risk of abandonment. See chapter 8 for safe methods for working at nests.)

Tripods and Other Supports

Many bird photographers these days, even those using big glass, opt to hand-hold gear. That's certainly the way to go for birds in flight, for which you need maximum mobility. For tack-sharp images using long telephotos, though, a sturdy tripod makes a huge difference. A good tripod is expensive but it's an investment well worth making. Top brands include Gitzo, Really Right Stuff

Figure 2.14: Gitzo tripod with legs splayed out at right angles to permit shooting at or near ground level. Note the lack of a center column, which would prevent this configuration.

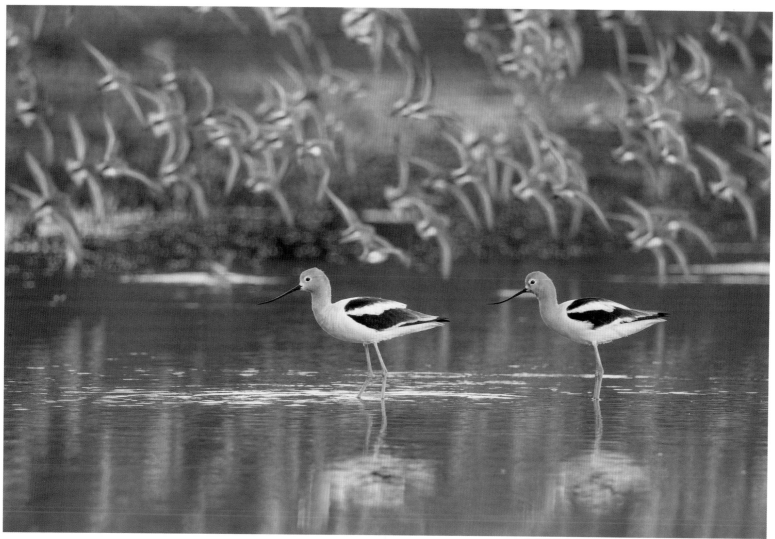

Figure 2.15: American Avocet pair with Western Sandpipers flying in the background, photographed from near ground level using the tripod configuration shown in figure 2.14.

Canon EOS 7D Mark II with EF 500mm f/4/L IS II lens, 1.4× III teleconverter, Gitzo tripod with UniqBall head, 1/800mm, f/5.6, ISO 2000. San Joaquin Wildlife Sanctuary, Irvine, California.

(both excellent quality but expensive), and Induro (more economical). All offer well-made products in a variety of sizes and styles.

Choosing a Tripod

Select a tripod with rigid legs that feels solid, not flimsy or wobbly when set up. Carbon fiber construction is preferable—light, rigid, strong, and best at dampening vibration—as aluminum can flex leading to instability. Check manufacturer's specifications to make sure the tripod model and head are rated to handle the combined weight of your camera and lens.

The ideal tripod allows you to shoot both while standing and at ground level. The tripod should be tall enough to raise the camera to your eye level when standing, so you avoid stooping to reach the viewfinder. Ideally, it should do this without extending the center column (if present), which introduces instability. At the opposite extreme, the tripod legs should collapse down and splay out for working near or at ground level (figures 2.14 and 2.15). Center columns prevent low-angle shooting, so bird photographers often dispense with them completely.

Tripod Heads

What's on top of the tripod base is important, too. Popular tripod head designs for bird photography are ball heads and gimbal heads. Most heads come with quick-release clamps for attaching gear, requiring you to equip lenses and camera bodies with quick-release plates. For long lenses, the plate is usually attached to the foot of the lens's rotating tripod collar. For certain lenses, the manufacturer's tripod collar foot can be replaced with one that has an integrated quick-release mount. Plates and replacement lens feet can be purchased from Really Right Stuff, Wimberley, and Kirk Enterprises. Make sure you buy the correct sizes for your gear.

Yes...bird photography can be an expensive pastime!

Ball Head
Structured like a ball-and-socket joint, a ball head lets you adjust the camera and lens in any plane of movement by means of a single control knob (figure 2.16). Top brands are Gitzo, Really Right Stuff, Kirk, and Arca Swiss. Ball heads are great for stationary subjects, but when tracking a moving subject, you must use your own strength against gravity to level the gear and stop it from flopping around uncontrollably. This can lead to shoulder and back fatigue. Instead, many bird photographers prefer gimbal heads for shooting moving birds.

Figure 2.16: The classic Arca Swiss Monoball. Ball tripod heads work fine for stationary subjects.

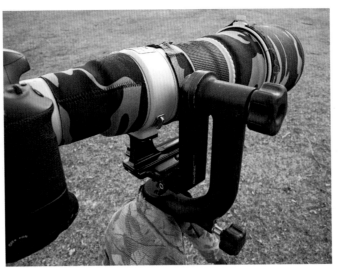

Figure 2.17: The Wimberley II gimbal tripod head. The camera/lens combo is mounted on a swinging arm and balanced to allow effortless panning. Note that the rig can be set up with the swinging arm on the left or right. I happen to prefer it on the right.

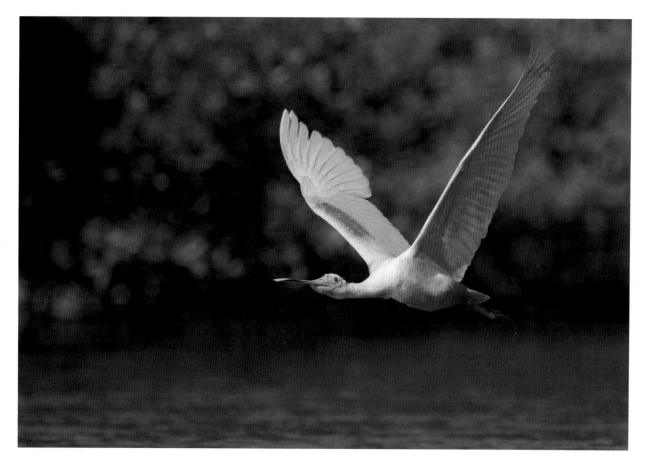

Figure 2.18: Roseate Spoonbill in flight. Canon EOS 7D with 500mm f/4L IS USM lens, 1.4× converter, Gitzo tripod, Wimberley II gimbal head, 1/2500 sec., f/7.1, ISO 400. Tampa Bay, Florida.

Gimbal Head

A gimbal head balances the camera and lens at the natural center of gravity on a swinging arm (figure 2.17). Movement is limited to panning (horizontal) and tilting (vertical). The lens cannot flop around like it can with a ball head. The design makes handling a big lens seem effortless. Panning to follow a fast moving bird is far easier and more fluid than using a conventional ball head, as well as being less tiring. I used the classic Wimberley II gimbal head to capture the Roseate Spoonbill in figure 2.18. Other high-quality brands include Jobu Design, Really Right Stuff, 4th Generation Designs, and Induro.

Make sure the tripod base is level or panning will produce images in which the horizon is not straight. Many tripods have a built-in bubble level.

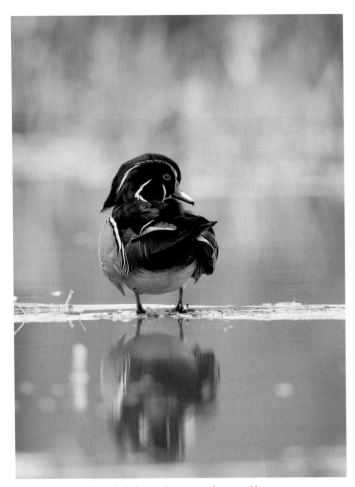

Figure 2.19: Wood Duck drake resting on a submerged log.
Canon EOS 7D Mark II with EF 500mm f/4/L IS II lens, 1.4× III teleconverter, Gitzo tripod with UniqBall head, 1/1000 sec., f/5.6, ISO 1600. Ithaca, New York.

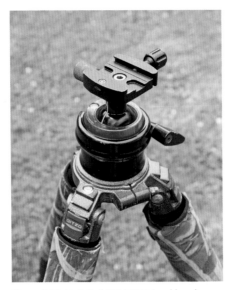

Figure 2.20: UniqBall UBH45X tripod head.

UniqBall Head

The UniqBall is a modified ball head that provides stability and smoothness during panning without the weight of a gimbal head. The design features two balls, one within the other, with two separate controls. The inner ball is used during shooting and differs from a conventional ball head in that movement is restricted to that of a gimbal head (i.e., panning and tilting). It is controlled by a knurled knob that can be left loose for panning or locked down when needed. The outer ball, controlled by a lever, serves as a leveling base (bubble level included). Once the tripod base is leveled, lock the outer ball to prevent side-to-side rotation. Using a UniqBall made it easy for me keep the water surface level in figure 2.19. As a compact, lightweight alternative to a gimbal head, the UniqBall has become my go-to tripod head for airline travel (figure 2.20).

Lens Supports for Vehicles

There are several camera support options for photography from a vehicle. The most common is to rest the lens on a beanbag over the open window. Select one with a broad platform to keep the lens from rolling sideways as you work, such as the Apex beanbag I use (figure 2.21). Another popular brand is the LensCoat LensSack. (Tip: The filling need not be dry beans—sunflower seeds are lighter, making the beanbag easier to handle. For travel, I pack the bag empty and buy seed on location. In a pinch, I have even filled it with balled-up newspaper!)

One problem with beanbags is that friction from the fabric hinders swinging the lens smoothly while tracking moving birds. To solve this issue, you can use a window mount with an integrated tripod head that clamps over the partially raised window glass. The best models are heavy-duty enough to support super telephotos (for instance the heavy-duty, Multi-Purpose Window Mount ball head from Kirk Enterprises,

Figure 2.21: Apex beanbag in use in a vehicle. The broad platform prevents the lens barrel from rolling sideways off the beanbag during use.

which converts for use as a ground pod, too). Beware of cheaper, lighter-weight models with smaller ball heads that may not be strong enough for heavy lenses.

My Apex beanbag converts for use with a tripod head to enable smooth panning. A metal plate onto which any style of head can be mounted slides into a pocket on the beanbag platform. Using this configuration I captured the Canada Goose taking flight in figure 2.22, a shot that I likely would have missed using a beanbag alone.

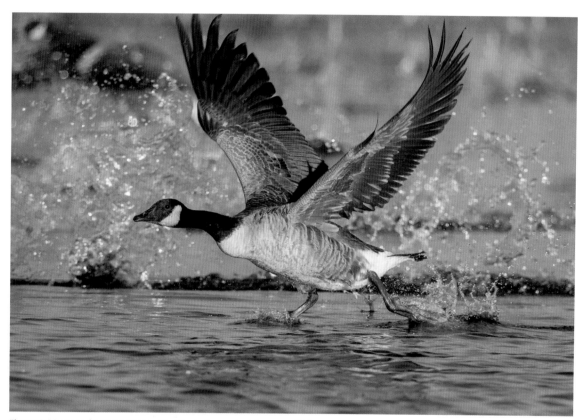

Figure 2.22: Canada Goose taking flight, photographed from a vehicle.
Canon EOS 7D Mark II with EF 500mm f/4/L IS II lens, 1.4× III teleconverter, Apex beanbag with UniqBall head. Montezuma National Wildlife Refuge, New York.

Ground Pods

For ground level shooting, it's best not to simply rest the camera on the ground to avoid damage from water, sand, or dirt getting into delicate moving parts or scratching lens glass. Instead, use one of the following options. A beanbag can be used, although its weight impedes easy movement across the terrain. Some window mounts can be converted into ground pods. The best option is a Skimmer Ground Pod (figure 2.23). Shaped like a shallow, flat-bottomed pie-dish, it is designed to slide easily across the ground, including through sand and mud, while keeping gear out of the dirt. Attach a tripod head using the central captive screw, mount the camera lens combo, and from a lying position, push the whole thing ahead of you as you crawl toward the subject (figure 2.24). For comfort, wear long sleeves and use knee and elbow pads, or lie on a foam

Figure 2.23: Skimmer Ground Pod with a Wimberley II gimbal tripod head, and with gear mounted.

pad. I used a Skimmer to photograph the Eared Grebe family in figure 2.11.

Accessories

We've covered the basic equipment needed for bird photography: camera, lens, and camera support. The following is an assortment of additional items I use in my work.

Memory Cards

Within the camera, image files are stored on a removable memory card. SanDisk, Lexar, and Delkin are top brands. There are several formats. Most commonly used is Compact Flash (CF), but certain entry-level cameras (for instance the Canon Rebel series) use only SD-format cards. Recent top-of-the-line Canon bodies can use CF or the newer

Figure 2.24: The author using a Skimmer Ground Pod for low-angle shooting.

CFast cards (Nikon's equivalent is XQD format).

Especially when photographing action, bird photographers generate many images very quickly. So that your camera can keep up, use high-capacity cards with a fast write speed, such as the SanDisk Extreme Pro 32GB 160MB/s CF cards I currently use (figure 2.25). Examine the face of the card: Capacity is shown in GB and write speed is in MB per second. A fast write speed lets images clear quickly from the camera's buffer, so you can continue shooting uninterrupted. (CFast and XQD formats were developed to solve this issue.)

Figure 2.25: Compact Flash card

For downloading images to a computer, instead of connecting the camera to the computer via a USB cable, the download will go much faster if you remove the memory card and use a card reader. Many brands and models are available. I use a Lexar Professional LRW400 Dual Slot SD & CF Reader, which is compact and easy to pack for travel.

Electronic Flash

I prefer to photograph in natural light
and rarely use electronic flash as the
sole means of illumination. But under
certain circumstances, such as on over-
cast days or in forest interiors, I may use
what's termed "fill flash," combining
subtle use of flash with the available
natural (or ambient) light. The goal is to
balance the ambient light with flash to
achieve natural-looking shots. The addi-
tion of flash also improves color balance
and adds a catchlight to the bird's eye
(figure 2.26).

Beware the Evil Eye!

Don't mount the flash directly on the
camera's hot shoe or you risk produc-
ing ugly eye-shine termed "red-eye" or
"steel-eye," especially in dark surround-
ings. This results from the camera pick-
ing up light reflected off of the bird's
retina because the flash is too close to
the lens's axis. The solution is to get the
flash off-camera. Mount it on a flash
bracket above the camera and con-
nected to the hot shoe by means of a
TTL flash cord as shown in figure 2.27.

Adding a flash extender—a Fresnel
lens that concentrates the flash beam—
effectively boosts flash output, project-
ing the light beam farther. The top
choice is Better Beamer made by Visual
Echoes.

Refer to chapter 5 for my easy-to-
use fill flash settings. Technology buffs

Figure 2.26: Two Pileated Woodpecker nestlings keep a lookout for lunch.
Shooting after leaf-out in the woods, I used fill-flash to remove a green
color cast and add a catchlight to the birds' eyes.
Canon EOS 7D with 500mm f/4L IS USM lens, 1.4× teleconverter, Gitzo tripod, Canon Speed-
light 580EXII, Better Beamer flash extender, 1/250 sec., f/5.6, ISO 1250. Ithaca, New York.

Figure 2.27: Electronic flash setup to photograph the Pileated Woodpecker nest in figure 2.26. A Canon Speedlite 580EXII is mounted on a Wimberley flash bracket attached to the arm of a Wimberley II tripod head, and is well above the axis of the telephoto lens barrel. The flash is connected to the camera's hot shoe by means of a Vello TTL flash cord. A Better Beamer flash extender is mounted onto the front of the flash head.

desiring an in-depth exploration of flash theory and multi-flash setups should refer to the books I recommend in the Resources section at the end of this book.

Remote Triggering Devices

Certain photographic situations require that the camera be triggered remotely. The system I use is a pair of PocketWizard Plus II Transceivers. One of these small radio devices communicates with the camera through a cable (purchased separately) as shown in figure 2.28. The other, held in your hand at a distance, communicates wirelessly with the camera-mounted unit to trip the shutter. Other remote triggering methods include simple cable releases; motion-sensing or infrared camera traps; and the high-tech CamRanger, which can trip the shutter and even adjust camera settings wirelessly from a laptop computer, iPhone, or other device.

Into the Field

In addition to camera, lens, and tripod, I carry a selection of accessories in the field. For short hikes, I wear a photo vest with pockets that hold spare batteries, a wallet containing memory cards, a wide-angle zoom lens, and sometimes a flash. I always have a small cleaning/tool kit (lens cloth, soft paintbrush for

Figure 2.28: PocketWizard Plus II Transceiver remote-triggering device attached to a camera body, ready to photograph wide-angle close-ups at a Great Crested Flycatcher nest. A second transceiver (not visible) communicates wirelessly with the camera-mounted unit to trip the shutter. See figure 8.25 for an image from this setup.

cleaning sand or grit off of gear, miniature screwdrivers, and a small Allen wrench), as well as compact binoculars to scan for subjects.

I carry the camera and tripod-mounted 500mm lens over my shoulder, made more comfortable with an EPGear Pod Pad Tripod Shoulder

Cushion. (Alternatively, you can protect your shoulder with a folded sweatshirt or towel.)

If I expect opportunities for birds in flight along the way, I bring a second camera with a 100–400mm zoom lens carried on a Black Rapid Camera Strap— a cross-torso, sling design that takes the weight off shoulders and neck, unlike a normal camera neck strap. If precipitation is likely, I bring waterproof covers (LensCoat Raincoat or Vortex Storm Jacket) to protect my camera gear (large plastic bags work too).

For long distance hikes, the big rig and accessories go in my camera backpack (the Lowepro Lens Trekker) with the tripod carried separately.

On level terrain (well-worn trails or beaches, for instance) I may transport gear in a beach cart with large, stable wheels. What a luxury it is to arrive at the location without sore shoulders and back!

OK, now we have the gear. Next, we'll discuss how to use it for the best results.

Chapter 3

FOCUSING AND IMAGE SHARPNESS

Lunch on the go for a Tricolored Heron! Again and again it comes half running, half flying over a shallow Florida pond, occasionally stabbing its beak into the water to catch a fish. I plant myself securely on the bank and adjust my camera settings to capture the lightning fast action: fast shutter speed, continuous shooting rate, and autofocus system optimized to track the heron's erratic movements. My own internal switch is set on "fastest reaction time," too!

Figure 3.1: Painted Bunting male.
Canon EOS 1D Mark III with 500mm f/4L IS USM lens, 1.4× teleconverter, Gitzo tripod, fill-flash, 1/640 sec., f/5.6, ISO 400. Wichita Mountains National Wildlife Refuge, Oklahoma.

It's a given that birds are always moving, even when they seem still! Small songbirds (figure 3.1) are notoriously twitchy, and, of course, birds in flight pose a whole range of challenges that take determination and practice to overcome, even when the camera is doing everything it can to help. I recently conducted a casual poll of bird photographers on social media. The overwhelming majority, regardless of skill level, considered focusing on a moving subject and obtaining sharp images to be their toughest challenges.

As a first priority, the photographer needs to understand how three different factors—autofocus, shutter speed, and stability—work together to ensure sharply focused images. This chapter covers the basics of these three components and introduces the inevitable tradeoffs that the real world of light and action throw into the mix.

We'll explore the following topics, which are essential to successful bird photography:

- Using the camera's autofocus system
- Choosing the right shutter speed and other camera settings
- Working with long telephoto lenses

The Autofocus System

The most significant factor in bringing the ability to create high-quality bird images within reach of any dedicated photographer is the recent advancement in autofocus (AF) technology. Learning how to get the best out of your camera's sophisticated AF system should be your first step. Here, we'll cover the basic components of AF and their functions and we'll delve deeper into advanced AF shooting when we cover birds in flight in chapter 10. (Note: Canon cameras and terminology are used. I'll include Nikon equivalents where possible.)

Don't be daunted; AF settings can seem bewilderingly complex at first even in entry-level cameras. Most photographers eventually settle on a set of often-used camera settings that cover their typical shooting situations, adjusting them if necessary.

The camera body controls most of the AF system functions, but AF must first be activated by ensuring the switch on the lens is set to AF not MF (Manual Focus, only occasionally used in bird photography).

Achieving Focus

The standard focusing method is via the camera's shutter-release button: Press it halfway to acquire focus, and then press

Figure 3.2: Ridgway's Rail foraging through pickleweed in a saltmarsh.
Canon EOS 7D Mark II with EF 500mm f/4/L IS II lens, 1.4× III teleconverter, Gitzo tripod.
AF/drive modes: AI Servo AF, High-speed Continuous. 1/1600 sec., f/5.6, ISO 500.
Bolsa Chica Ecological Reserve, California.

it completely down to take the picture. (Note that pressing the button halfway also activates the automatic exposure system and the lens's image stabilizer.) Some photographers prefer a different focus method termed "back-button focus."

BACK-BUTTON FOCUS

In Back- (or Rear-) Button Focus, the AF-ON button on the back of the camera (Canon and Nikon) takes over the function of the shutter-release button to focus on the subject. Your thumb operates AF-ON and your index finger presses the shutter button only when you want to take the picture. Users of this method find it easier and less tiring than maintaining a constant pressure with the index finger on the shutter button when tracking subjects. Back-button focus can be enabled by setting a custom function.

Autofocus Mode

Two autofocus system settings that should be addressed before proceeding are the AF mode and the configuration of AF points.

The autofocus mode you select depends on whether your subject is moving or stationary. Canon's AF choices are One-Shot, AI Servo, and AI Focus. (Nikon's equivalents are AF-S, AF-C, and AF-A.)

One-Shot AF (Nikon AF-S) is intended for still subjects. When you press and hold the shutter button halfway, the camera acquires focus and then locks, at which point you press the button fully to take the shot. For the next shot you must refocus.

AI Servo AF (Nikon AF-C), which is intended for moving subjects, is the mode most used by bird photographers. When you hold the shutter button halfway, the camera focuses continuously as the subject moves and the focusing distance changes.

AI Focus AF (Nikon AF-A) is a hybrid mode that automatically switches between the two other modes, but because there can be a delay while the camera analyzes whether or not the subject is moving, bird photographers avoid this mode.

I work in AI Servo mode 99 % of the time. My goal is to photograph bird behavior and action so there is always movement, be it slow, such as a rail foraging at the edge of a saltmarsh (figure 3.2), or fast, such as the flight displays of courting terns. However, I also use AI Servo for stationary subjects. Even when a bird is resting, its head is

Figure 3.3: Eastern Screech-Owl roosting in a tree cavity in winter.
Canon EOS 7D Mark II with EF 500mm f/4/L IS II lens, 1.4× III teleconverter, beanbag over vehicle window. AF/drive modes: One-Shot AF, Single. 1/500 sec., f/5.6, ISO 800. Lansing, New York.

rarely still, and for a shot to be successful the eye and face must be in sharp focus. AI Servo solves the challenge by automatically adjusting focus regardless of how subtle the bird's movements are.

On occasion, I will switch to One-Shot AF to critically focus on a still subject. Take the roosting Eastern Screech-Owl in figure 3.3. In AI Servo mode, the camera struggled to hold focus on the owl's face, and even though the bird was motionless, my images were not sharp. This was a low-light, low-contrast scene. Such conditions are often challenging for AF systems, which need good light and contrast to function optimally. If the owl's eyes had been open, creating contrast between the eye and the facial feathering, this problem might not have occurred. But this owl was snoozing, and I was not about to disturb it. After switching to One-Shot AF and refocusing before each exposure, I had more success.

Drive Mode

Although not directly relevant to focusing or sharpness, another setting to adjust now is the Drive mode. This setting tells the camera whether to capture images one at a time or in a quick succession of exposures. Canon's Drive mode options include Single, High- or Low-speed Continuous, Silent, and Self-timer. (Nikon cameras use similar terms.)

In general, I choose the High-speed Continuous setting, because I want to be prepared to capture action sequences (especially important for birds in flight). To capture single images you can select Single, or you can stay in High-speed Continuous and simply be careful when you fully press the shutter button, pressing it smoothly, being careful not to jab. When in a Continuous mode, the camera will continue exposing images as long as you hold the shutter button down (or until the buffer fills up, the memory card fills up, or the battery dies!). The Silent setting (Nikon's equivalent is Quiet) can be used to avoid spooking wary subjects. (Be aware that Silent mode reduces capture rate.)

Autofocus Points and Areas

The job of obtaining focus falls to one of an array of AF points distributed across the camera's sensor field, ranging from a dozen or fewer in entry-level cameras to a hundred or more in pro bodies. You can limit which points are actively obtaining focus by manually selecting a single point or an area varying in size from a small cluster of points to a large zone, or you can let the camera choose automatically from all the available points.

For that all-important tack sharp eye, your goal is to position the active AF point as close to the bird's eye as possible. Depending on how large the bird appears in the frame, and whether it's moving around and how fast, this is no trivial exercise!

Manually Selecting AF Points

AF points and clusters can be manually selected from various locations around the sensor array to suit your composition. I often start out using a central point or cluster, moving its position as the composition dictates. For instance, once the Yellow Warbler in figure 3.4 settled on a perch and began to sing, I chose an off-center single AF point and placed it over the bird's head for a

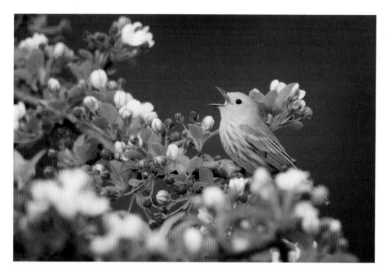

Figure 3.4: Yellow Warbler male singing among apple blossoms. I selected an off-center autofocus point to create a pleasing composition.
Canon EOS 7D with 500mm f/4L IS USM lens, 1.4× teleconverter, Gitzo tripod, 1/400 sec., f/5.6, ISO 640. Ithaca, New York.

Figure 3.5: Courting American Oystercatchers. Rather than selecting a single AF point, it is easier to maintain focus on moving birds by using an AF point cluster.
Canon EOS 7D with 400mm f/5.6L USM lens, handheld, 1/2500 sec., f/8, ISO 400. Fort De Soto Park, Florida.

pleasing composition that included the apple blossoms. If you're new to bird photography, keep things simple at first by choosing the central AF point. As your focusing skills develop, experiment with off-center AF points or areas.

Developing the skill to efficiently select the number and position of AF points will pay dividends down the line. Practice makes perfect. Learn to select and move points by touch alone, without having to look for the correct button or dial. The camera may have more than one method to make these choices. Pick whichever feels most comfortable to perform and stick to it.

Expand Your Options

I often select a single AF point to critically focus on a stationary bird. However, for moving birds, such as the courting American Oystercatchers in figure 3.5, and especially for flying birds, I find it easier to acquire and maintain focus by using an AF point cluster. To achieve this, Canon bodies offer AF Point Expansion mode. The Nikon equivalent is Dynamic Area AF mode.

Canon's AF point expansion has two options: (1) a primary point plus four adjacent AF points forming a five-point, cross-shaped cluster, or (2) a primary

point plus all eight surrounding points for a total of nine. I most often use the five-point option.

Automatic AF Point Selection

When a bird is moving quickly and erratically, it's often hard to keep it in the frame let alone hold even an expanded focus point over its head! Think of a Reddish Egret running this way and that in pursuit of fish, or territorial American Avocets chasing each other around a contested pond (figure 3.6). In such situations, you may have better success

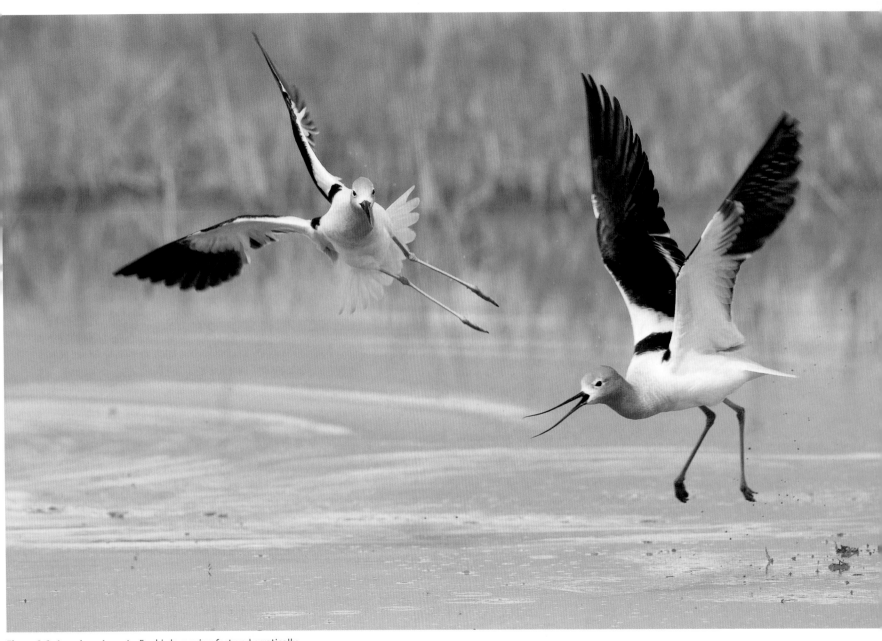

Figure 3.6: American Avocets. For birds moving fast and erratically,
Automatic AF Point Selection may improve your chances of obtaining a successful image.
Canon EOS 7D Mark II with 500mm f/4L IS lens, Gitzo tripod, 1/2000 sec., f/5.6, ISO 400.
Bear River Migratory Bird Refuge, Utah.

maintaining focus by using Automatic AF Point Selection. In this fully automatic mode the entire AF point array is activated and the camera chooses where to focus. Nikon has similar options: Auto-Area AF and Group Area AF. These modes are great for birds in flight, especially fast fliers with erratic flight paths such as nighthawks, swallows, or small terns.

I find the fully automatic mode works best when the subject is against a clean background and not too close. If the subject takes up a large part of the frame, the camera may switch focus to whatever is closest, which may be a wing rather than the bird's face.

In Automatic AF point Selection mode it's best to acquire initial focus with the bird centered, because the central AF point is always the most accurate, even if the bird subsequently moves off-center.

We've covered a lot of technical information about the complex topic of autofocus. As a review, the sidebar lists my preferred AF settings (Canon cameras).

MY AUTOFOCUS SYSTEM SETTINGS (CANON)

Autofocus Mode:
- One-Shot for still subjects
- AI Servo for moving subjects

Drive Mode:
- Single for one image at a time
- High-speed Continuous for sequences and high-speed bursts
- Silent for sensitive subjects to minimize disturbance

AF Points/Areas:
- Single AF Point for stationary subjects
- AF Area Expansion (5 points) for moving subjects including birds in flight
- Automatic AF point Selection for fast, erratic action and birds in flight

Let Autofocus Do Its Job

The various autofocus options offered in modern cameras can be challenging to master, much less to adjust on the fly while working in the field. You can learn a lot about your focusing skills by enabling the AF Point Display option in the camera's playback menu. When you examine your images on the LCD screen, this lets you see which AF point was active at the moment of exposure for each image (figure 3.7). Was the active AF point where you intended it to be? If not, this can help explain why some of your shots appear soft—not as crisply focused as you'd like. There may be certain images, though, for which the AF

Figure 3.7: During image playback, enabling the AF Point Display shows where the active AF point was positioned at the moment of exposure. In this frame, the AF point was over the bird's eye, and the bird's face is sharply focused.

point seems perfectly positioned over the bird's head yet the image still is not sharp. What's going on?

We expect AF to function blazingly fast but the system does need a little time to function accurately and attain the sharpest possible focus, especially in low-light or low-contrast situations. It can be tempting to jab the shutter button down as soon as a bird appears in your frame and before it has a chance to leave! Instead, take a breath and give the AF system time to acquire initial focus before releasing the shutter.

To ensure sharpest focus, some Canon cameras offer two features that delay shutter release until the camera has properly completed focus. These are

Figure 3.8: A courting Ruddy Duck male displays by slapping his bill rapidly against his chest to stir up a froth of bubbles.
Canon EOS 7D Mark II with EF 500mm f/4/L IS II lens, 1.4× III teleconverter, Skimmer Ground Pod, 1/1600 sec., f/5.6, ISO 400. Bowdoin National Wildlife Refuge, Montana.

Basic Settings: Shutter Speed, Aperture, and ISO

Shutter Speed and Image Sharpness

Image sharpness is all about freezing movement—the faster the movement the briefer the exposure time must be to prevent image softness, regardless of how accurate the photographer's focusing skills may be. Of the three camera settings that form the exposure triangle—shutter speed, aperture, and ISO—**shutter speed** has the greatest impact on image sharpness.

As a general rule, for crisp images of birds, choose as fast a shutter speed as the situation allows. Motion blur caused by using too slow a shutter speed is a major cause of soft images and can counteract an otherwise proper choice of autofocus settings. The right shutter speed is particularly important when the subject is actively moving: swimming or walking around, feeding or preening, and, especially, flying. Fast shutter speeds also help prevent blurred shots due to camera shake (see next section).

Which shutter speed to select depends on the size of the bird and what it is doing. Small, active species obviously need a faster speed than large, ponderous ones. Speeds such as 1/1000 second or faster can freeze the motion of most species. To capture a courting male Ruddy Duck performing his bubble

AI Servo 1st Image Priority and AI Servo 2nd Image Priority, found in your camera's AF menu. You can either use their default settings for now or customize them. To do the latter, refer to chapter 10, which explores them in detail in a section that addresses fine-tuning AF system performance.

Figure 3.9:
Baltimore Oriole female.
Canon EOS 5D Mark III with EF 500mm
f/4/L IS II lens, 1.4× III teleconverter, Gitzo
tripod, 1/320 sec., f/5.6, ISO 1250.
Freeville, New York.

display, for instance, I picked a shutter speed of 1/1600 second to keep the constantly moving bill sharp (figure 3.8).

It is perfectly possible to achieve crisp focus using slower speeds if the subject is still at least some of the time, and if you practice good long-lens handling technique. Timing your shots helps—wait until the subject stops moving before releasing the shutter, as I did for the female Baltimore Oriole in figure 3.9. On this overcast morning, even using an ISO value higher than I prefer and at maximum aperture, my shutter speed was only a moderately fast 1/320 second, but it was adequate to render the oriole sharp when she paused briefly on a branch.

How can you tell whether a soft shot was caused by subject motion or camera shake? The sidebar explains.

SUBJECT MOTION BLUR OR CAMERA SHAKE?

Figure 3.10: American Goldfinch. Softness due to subject motion blur.
Canon EOS 7D Mark II with EF 500mm f/4/L IS II lens, 1.4× III teleconverter, Gitzo tripod, 1/320 sec., f/5.6, ISO 800. New York.

Figure 3.11: Razorbill. Softness due to camera shake.
Canon EOS 7D Mark II with EF 100–400 mm IS II lens (at 400mm), handheld, IS on, 1/500 sec., f/5.6, ISO 1000. Witless Bay, Newfoundland, Canada.

Assuming accurate focus was acquired in the first place, when the cause is **subject movement,** only the bird or its moving part looks blurred or soft, but other elements in the image are sharp. The American Goldfinch in figure 3.10 demonstrates image softness due to subject motion. Notice its moving head is blurred but its wing and the twig are sharp.

Solution? Select a higher shutter speed or time your shots for when the bird keeps still.

When **camera shake** is to blame, the entire image takes on a blurred, almost smeared, appearance, as the image of a Razorbill in figure 3.11 shows. This image was shot handheld from aboard a wave-rocked boat. Even though my shutter speed should have been adequate and the lens's image stabilizer was switched on (as always), the entire frame is blurred. The next frame was sharp!

Solution? Hold equipment steady, pick your timing, use a tripod where feasible, and ensure the IS system is operating.

Aperture and Image Sharpness

The aperture setting determines depth of field: the zone between the nearest and farthest areas of the subject that appears sharply focused. Depth of field alone cannot make up for image softness caused by failing to acquire focus on the bird's face and/or eye in the first place, or from using too slow a shutter speed.

In certain circumstances, though, increasing the depth of field has a direct impact on sharpness. One example is a close subject. Using a large aperture for a bird at point-blank range results in such a shallow depth of field that even if the bird's eye is sharp other important elements in the frame may not be. Stop down—in other words, decrease the diameter of the aperture—by choosing a higher f-stop number, which will increase the depth of field. Compare the two images of a Tricolored Heron. In figure 3.12, shot at f/6.3, only the bird's face is sharp. Its prey is in front of the zone of sharpness and therefore is out of focus. In figure 3.13, I stopped down the aperture to f/11, which rendered the eye, bill, and fish all sharp, as well as enhancing the crown and neck feathering.

Depth of field also comes into play when you have two or more birds in the frame and you want them all sharp. Unless they all are on exactly the same plane of focus, you will need to choose a smaller aperture to increase the depth

Figure 3.12:
Tricolored Heron with a fish taken with a wide aperture and a shallow depth of field.
Canon EOS 7D Mark II with EF 500mm f/4/L IS II lens, 1.4× III teleconverter, Gitzo tripod, 1/2500 sec., f/6.3, ISO 400. Bolsa Chica Ecological Reserve, California.

Figure 3.13:
Tricolored Heron with a fish taken with a stopped-down aperture to increase depth of field.
Canon EOS 7D Mark II with EF 500mm f/4/L IS II lens, 1.4× III teleconverter, Gitzo tripod, 1/1000 sec., f/11, ISO 400. Bolsa Chica Ecological Reserve, California.

of field. With single birds I often shoot wide open—i.e. at maximum aperture size—but to keep both the Piping Plover chick and its parent sharp in figure 3.14, I stopped down the aperture to f/8.0.

Aperture and shutter speed both affect the amount of light that reaches the image sensor. To maintain the correct exposure, stopping down the aperture means you either must reduce the shutter speed or increase the effective sensitivity of the sensor—the ISO.

ISO and Image Sharpness

Camera manufacturers love to brag about their latest models' ever-higher ISO capability for low-light shooting. For bird photography, notching up the ISO to a high value would seem the perfect solution to needing both a fast shutter speed and a large depth of field—but it is not a panacea. Using a high ISO increases digital noise, which appears as graininess, especially in smooth-toned or dark areas of an image. Noise lowers image quality by degrading fine detail and decreasing sharpness. High ISOs cannot portray the crisp feather detail that bird photographers require. Full-frame and professional-level camera models can better deal with the high ISO noise problem, but it worsens with most crop-sensor cameras.

As with other camera settings, choosing ISO is a compromise. Increase the

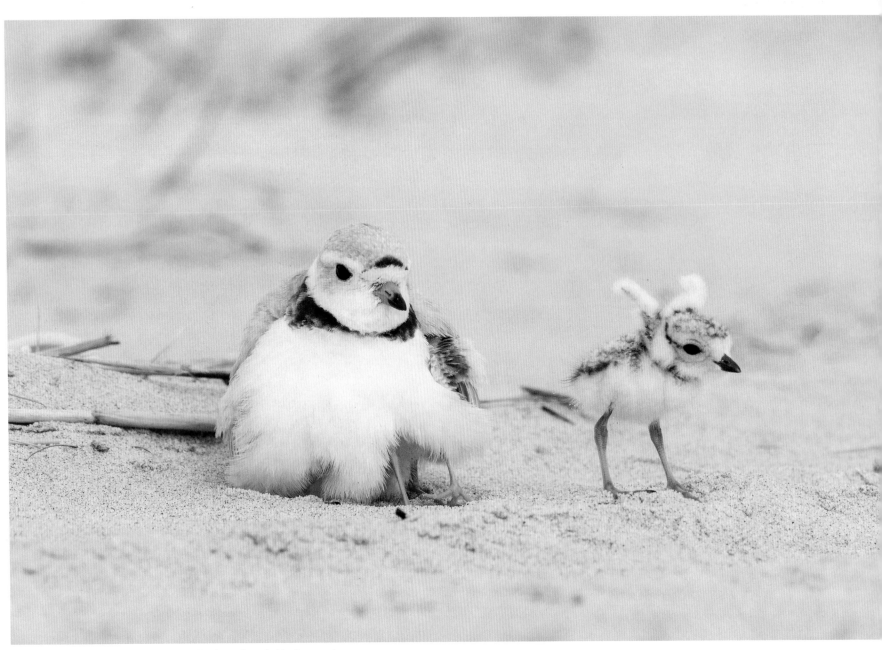

Figure 3.14: Piping Plover chick stretches after being brooded by its parent.
Canon EOS 7D with 500mm f/4L IS USM lens, 1.4× teleconverter, Gitzo tripod, 1/800 sec., f/8.0, ISO 800. Northern Massachusetts.

ISO for a fast shutter speed when your goal is to stop fast action. Reduce the ISO when you're offered an opportunity for a portrait with fine feather detail.

On a sunny day, my default ISO value of 400 easily gives me all the shutter speed I need. I shoot with the aperture wide open much of the time, and regularly obtain shutter speeds of 1/2000 second or faster. Under overcast skies, I go to ISO 1250 or higher, but rarely above ISO 2500. Of course, you can apply noise reduction software during postprocessing to reduce the grainy appearance, but that itself can soften feather detail.

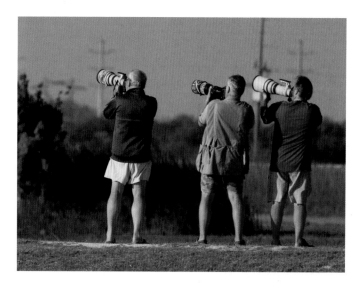

Figure 3.15: Bird photographers in Florida handholding super-telephoto lenses.

Long-Lens Technique for Stability

As important as autofocus and shutter speed settings are, equally critical is how you handle your telephoto lens in the field. Camera shake is a major cause of image softness. The longer the telephoto and the heavier the camera/lens combination, the more difficult it is to keep it steady, something that becomes even more critical if the subject is moving. Using a tripod provides a solid support for your gear and invariably leads to crisper shots (as well as facilitating more deliberate and creative composition). Nevertheless, many bird photographers nowadays are dispensing with a tripod and opting to handhold even

super telephotos (figure 3.15). It's easy to understand why—a tripod limits your mobility.

There's a fine line between the need for stability and mobility. Hand carrying gear lets you move around quickly if the bird changes location. You can more easily navigate difficult terrain, and you can more easily swing the lens in any direction to track a moving or flying bird. But the trade off is instability resulting in soft images. For some people, a monopod can be a good compromise, but from my limited experience I have found using one to be awkward and unstable. I recommend using some means of camera support whenever possible. Tripod or not, however, to achieve tack

sharp shots it's essential to use the best techniques for working with a long lens.

Working with a Tripod

First, set up the tripod correctly. Extend the telescoping leg sections to the required height, make sure the tripod base is level, and then tighten the leg locks (twist locks or levers depending on the model). Double-check that the base is secure and that the legs won't collapse when you add the weight of the camera and lens. Never use a center post extension to achieve the needed height; it will degrade stability. With a telephoto lens, avoid attaching the camera body itself to the tripod head, which makes the rig

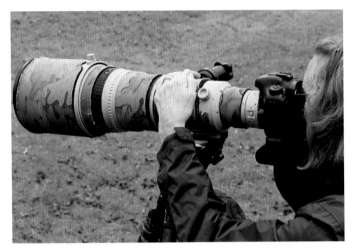

Figure 3.16a: One way to keep tripod-mounted gear steady is to place your left hand firmly on top of the lens about halfway down the barrel and push down slightly. You can even lean on the lens if necessary.

Figure 3.16b: Another way to steady your gear is to grip the lens foot on the tripod collar and push up with one or more fingers against the bottom of the lens barrel if you wish.

front-heavy and unstable. Instead, the attachment point should be the lens's tripod collar.

To prevent the lens tipping forward or back if tripod controls need to be loosened, make sure the rig is balanced. A balanced rig is safer and more stable, which translates into sharper images. The easiest way to attach the lens to the tripod is with a quick release system: a quick release plate on the lens's tripod collar and a tripod head with a quick release clamp (see chapter 2). Seat the lens plate in the clamp, slide it back and forth until the rig seems balanced, and then tighten the clamp securely. Note that adding or removing a teleconverter or other accessory alters the weight distribution, and so the rig must be rebalanced.

Keeping Gear Rock Steady

Landscape and closeup nature photographers are usually advised to lock down tripod controls and use a cable release to prevent vibrations for maximum sharpness. This isn't helpful advice for bird photographers—our subjects rarely keep still for long enough for that! Instead we more often work with tripod controls loose, panning—smoothly swinging the lens from side to side to track a moving bird—and constantly adjusting composition as the subject changes direction or strikes a different pose. How do you

avoid camera shake and get sharp images under these conditions? Switching on the lens's image stabilizer helps but it's good practice to minimize shaky gear in the first place. You achieve this by using your body's own resistance to steady the rig.

To do so grip the camera body firmly with your right hand, finger resting lightly on shutter button, and press your face against the camera as you look through the viewfinder. Place your left hand on top of the lens or drape your left arm over it about halfway down the barrel (figure 3.16a) and push down firmly. Another method is to grip the lens foot on the tripod collar (figure 3.16b). Some photographers also push up against the bottom of the lens barrel with one or more fingers.

For stationary birds, by all means lock the tripod controls down if possible, but even so I recommend bracing the gear with your body as described to keep everything rock steady. Doing so was vital on the wind-buffeted headland where I once photographed nesting Atlantic Puffins. Luckily most activity was near the birds' nest burrow (figure 3.17), so I was able to work with tightened tripod controls, but that alone failed to prevent camera shake caused by the wind. I braced the gear firmly whenever I pressed the shutter button. Keeping a low profile improved stability, too (figure 3.18).

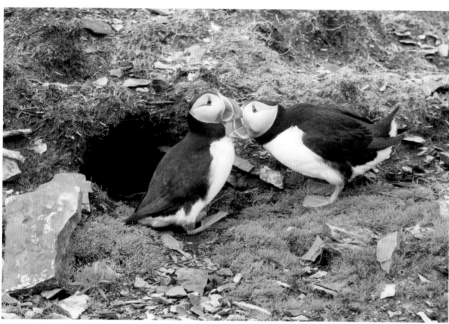

Figure 3.18: On a windy Newfoundland headland, keeping a low profile and holding down the gear was essential to prevent camera shake and obtain sharp images. Photo courtesy of Peter Wrege.

Figure 3.17: Atlantic Puffin pair outside their nesting burrow.
Canon EOS 7D Mark II with EF 500mm f/4/L IS II lens, 1.4× III teleconverter, Gitzo tripod, 1/1600 sec., f/5.6, ISO 640. Elliston, Newfoundland, Canada.

Hold Tight! Best Practices for Handheld Shooting

If you're handholding gear, your body must provide a solid support, starting with how you stand—legs slightly apart and one foot slightly in front of the other for stability.

For optimal steadiness, support the lens by cradling the lens barrel in your left hand, tucking your elbows in to your sides to act as a brace (figure 3.19a). Avoid the less stable position with the supporting arm held away from the body (figure 3.19b). If the lens has a tripod collar, I recommend rotating it so the lens foot is uppermost allowing you to cradle the lens barrel in your hand rather than holding the lens foot as a handle. If you're seated or kneeling, rest your elbows on your knees for maximum stability (figure 3.20).

Pay particular attention to shutter speed if you're handholding, and make sure the image stabilization system is switched on. Canon's Image Stabilization (IS) and Nikon's Vibration Reduction (VR) technology were originally developed for handheld shooting. The time-honored rule for handheld shooting is that the minimum shutter speed should be the reciprocal of the lens's focal length. For example, using a 500mm lens, you should use no slower than 1/500 second. However, IS/VR allows photographers to achieve sharp shots handheld at shutter speeds slower than the rule of thumb suggests.

Like many bird photographers, I also use IS when I'm using a tripod. It's important to keep in mind that IS/VR only prevents softness caused by unsteady

Figure 3.19a:
Handheld shooting. Stable position.

Figure 3.19b:
Less stable position.

Figure 3.20:
Optimal long-lens technique for shooting handheld while seated: The photographer cradles the 500mm lens with its tripod collar lens foot rotated out of the way and rests his elbows on his knees for stability.

gear. It does *not* prevent softness due to the subject moving.

Evaluating Sharpness

How can you tell if your image is sharp? You can get a fair idea in the field by playing back the images. In playback mode, magnify the image on the camera's LCD screen, zooming in on the face and eye as in figure 3.21. (Tip: To make this more efficient, many cameras let you set the magnify button to automatically jump to 100% with one press.)

Figure 3.21: During image playback in the field, zoom in to the subject's face and eye to check for sharpness. For critical evaluation, download images to a computer and examine at 100% magnification.

To critically evaluate sharpness, though, you need to download the images onto your computer and examine them at 100% magnification. Keep in mind that there will be varying degrees of sharpness in any group of images. Sharpness is a continuum from "oops… totally out of focus" to "OMG! Jaw droppingly tack sharp" and everything in between! All RAW images need optimization, including some amount of sharpening, during postprocessing, and many slightly soft shots can be improved dramatically with a little work.

Why Aren't My Photos Sharp?

Remember that getting sharp images is one of the biggest challenges that bird photographers face, especially when they're first starting out. I've been photographing birds for more than 30 years, and I still struggle with getting sharp shots—something that's not going to improve as my strength and stamina decline with age! Remember, too, that lack of sharpness is very rarely the fault of your equipment. Review the sidebar for possible explanations.

Minimize these issues with your own gear and practice good technique at every opportunity. Study the photo captions throughout this book paying particular attention to the camera settings and noticing whether or not a camera support was used (figure 3.22). Add in the benefit of experience and you'll soon be joining the ranks of seasoned sharp shooters!

IMAGE SOFTNESS CHECKLIST

Focusing issues:
- Failure to position or maintain auto-focus point or area over the bird's face or neck
- Failure to allow the AF system time to acquire focus and track subject
- Low-light or low-contrast subject/scene affecting AF functioning
- Shooting through heat shimmer can also affect AF functioning

Subject motion blur:
- Shutter speed too slow for situation, subject moved

Camera shake:
- Unsteadiness from handholding
- Poor panning skills
- Unstable or flimsy tripod
- Wind shake
- Failure to stabilize gear with own weight when tripod controls loosened
- Jabbing the shutter button rather than pressing smoothly
- Jerking lens up at the end of a burst of shots

High ISO:
- Image noise obscures fine detail

Miscellaneous reasons:
- Dirt or condensation on lens glass

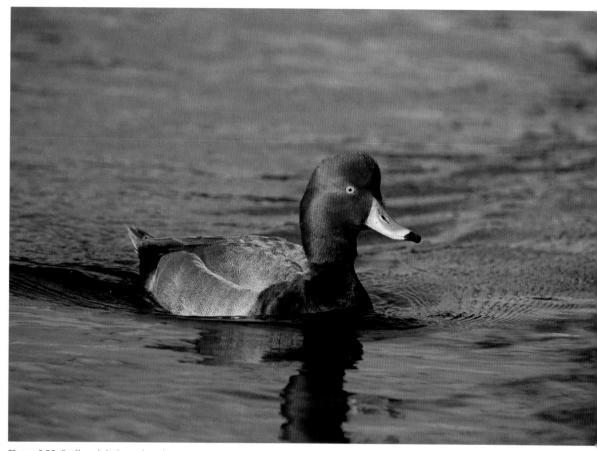

Figure 3.22: Redhead drake swimming.
Canon EOS 1Ds Mark II with 500mm f/4L IS USM lens, 2× teleconverter, Gitzo tripod, 1/500 sec., f/8, ISO 200. Bolsa Chica Ecological Reserve, California.

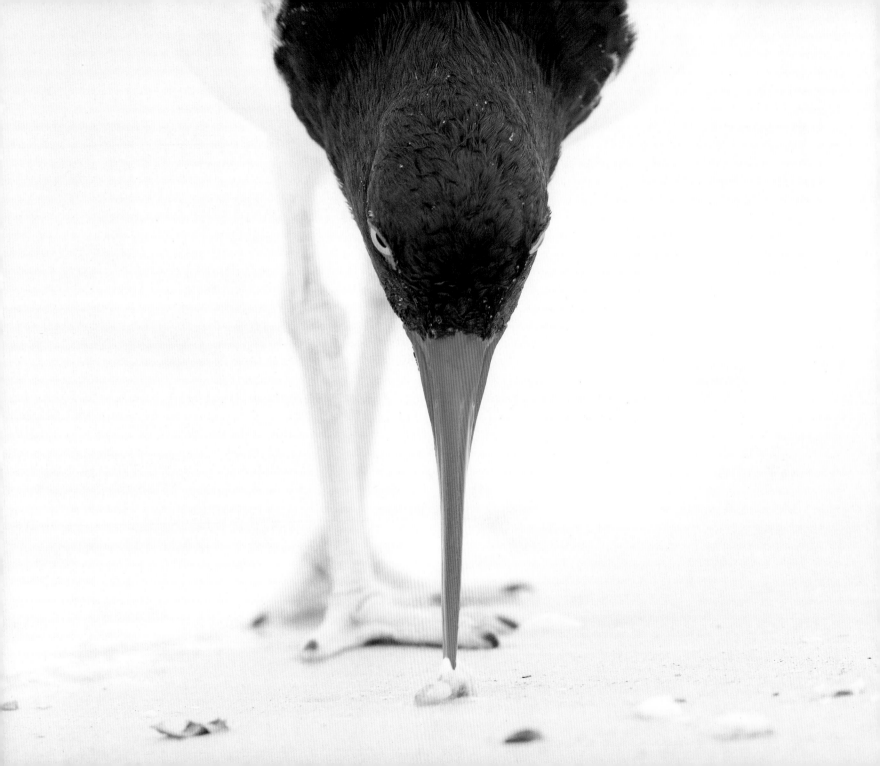

Chapter 4
GETTING CLOSE

Sitting on the damp sand just shy of the waterline, I watch as an American Oystercatcher forages along the beach. It is moving toward me while it runs in and out of the surf in search of tiny shellfish, which it deftly pries open to reach the tasty flesh inside. Closer and closer it comes until my 400mm lens can include only a part of it in the frame. Contorting my body into a low position that would impress a yoga guru, I capture an almost abstract view of the bird while it is processing a clam using its colorful, chisel-like bill.

Figure 4.1:
Great Roadrunner closeup, photographed from a vehicle.

Nikon F5, Fuji Provia film, Nikkor 500mm f/4 AF lens, 1.4× teleconverter, camera settings not recorded. Bosque Del Apache National Wildlife Refuge, New Mexico.

Nothing beats the thrill of being up close and personal with a wild bird going about its life. Achieving that special experience takes more than a big telephoto lens...you also have to be physically close. But most birds are wary and skittish. To capture their spirited beauty, we must first gain their trust. Knowing how to close the distance successfully and ethically—or, even better, being willing to wait until birds approach you—are among a bird photographer's most essential skills.

We'll explore several strategies for approaching birds: stalking them, letting them come to you, hiding from them, or using something to attract them. Certain attraction methods, most notably feeding owls and using sound recordings, are controversial. I address these techniques not because I condone them, but because people already use them and my advice may help reduce the impact on the birds involved.

Location Matters

Getting close to birds is a lot easier at locations where they are used to people. I've made many memorable images at such places—friendly Acorn Woodpeckers on trees among the picnic tables in a suburban California park, Greater Roadrunners in a much-visited New Mexico wildlife refuge (figure 4.1), and courting Mallards on a local duck pond.

Scout out your own region for a park, lake, or beach that has friendly birds, or visit one of North America's bird photography hotspots, all famous for their approachable birds (see chapter 15).

Even if birds see people regularly, just like us, they have their own safety zone or personal space—the minimum distance at which they feel secure but within which they will flee. It's our job to learn what that distance is by observing the bird's body language. Crossing that invisible boundary means not only a missed opportunity, but even worse, possible stress or harm to the bird.

The Slow Stalk

Successfully stalking a bird on foot requires caution. Your mantra should be "low, slow, and indirect." Birds are highly visual creatures, easily frightened into taking flight by sudden movements. Use existing cover, such as rocks in open areas or trees in forested habitats to conceal your approach (figure 4.2). Stay low and even crawl, especially if you're traversing a beach or other open terrain. The smaller you appear, the less of a threat you pose to your quarry.

Before you advance, turn on your camera and make the appropriate settings, and if you're using a tripod, adjust it to the height you estimate you'll ultimately need. Move slowly and calmly, avoiding large arm movements and

loud talking. If you're walking, take a few steps at a time and pause at regular intervals to regain the bird's trust. It can help to take a somewhat indirect path rather than moving straight toward the bird. If you're crawling, inch your tripod along or push your ground pod ahead of you as you move.

Pay attention to behaviors that signal alarm; for instance, if the bird stops what it is doing, stands upright and stares at you, or starts giving alarm calls. If that happens, stop and let the bird relax again before proceeding. Once in range, if you need to change camera settings or adjust gear, keep hand movements slow and close to your body.

Become Part of the Scenery

You'll often have more success by letting birds come to you rather than stalking them. If you're patient and allow plenty of time, acting like you're part of the scenery often results in birds ignoring you and going about their normal activities, sometimes remarkably close to you and your camera.

Find a spot where birds gather naturally, such as at sources of food or nest material. Sit or stand where you can keep still and quiet for an extended period of time as I did to photograph a Red-breasted Sapsucker feeding at its sap wells in the trunk of a low tree (figures 4.3 and, 4.4).

Figure 4.2: A photographer keeps a low profile by sitting behind a rock while approaching California Gulls. It's best to avoid white clothing when photographing birds, except for at a white sand beach. Mono Lake, California.

Minimize your visibility by avoiding white or brightly colored clothing; instead choose muted garb or camouflage to help you blend in with the environment. If you really want to hide in plain sight, try a hunter's ghillie suit! I often wear a camouflage mesh bug jacket to help me blend in with the habitat. Its hood has a large veil I can pull over my face while looking through the viewfinder, which helps to break up my profile and improves concealment.

For comfort, sit on a folding camp stool or use a stadium seat on the ground. Don't try to get too close at first. If your subject stays away, move back so your presence is less threatening. While waiting for the subject to arrive, support

Figure 4.3: The author photographing a Red-breasted Sapsucker. Wearing a camouflage mesh bug jacket makes me less conspicuous.

Figure 4.4: A Red-breasted Sapsucker feeds from sap wells it has drilled in a tree trunk.
Canon EOS 7D Mark II with 500mm f/4L IS lens, 1.4× teleconverter, Gitzo tripod, Canon Speedlight 580 EXII, Better Beamer flash extender, 1/320 sec., f/5.6, ISO 640. Lee Vining Canyon, California. (Right)

The downside of a blind is that if the action takes place beyond your reach, you can't move closer or improve your angle. Furthermore, your view is limited to the lens ports or viewing windows so you could easily miss a photo opportunity that is developing just out of your sight range. For this reason, it pays to carefully consider where to set up the blind at the outset (figure 4.5).

Blinds can be cramped, uncomfortable, hot, or all of the above! But as the saying goes, "No pain, no gain." A blind may be the only way to photograph wary species or seldom-captured activities. You'll forget your discomfort when something exciting happens right before your eyes! The Spotted Sandpiper in figure 4.6 foraged so close that I struggled to frame it without chopping off its tail. The hours I've spent voluntarily imprisoned in a blind must number in the thousands by now, but the memories of watching birds' lives unfolding before me are priceless.

your gear on a tripod adjusted to eye level rather than handholding it. Then, when you are ready to shoot, you won't have to raise the camera up to your eye and risk spooking the bird. Using a tripod helps avoid fatigue, too.

Acting like a bump on a log for long stretches of time gets uncomfortable—if you're the fidgety type, you may do better by using a photography blind.

Blinds for Bird Photography

A blind is a structure in which you and your gear are entirely concealed. In Europe they are termed "hides"—a much more logical name. The obvious advantage of hiding yourself is that if birds don't know you're there, they behave naturally, sometime performing activities that otherwise could not be photographed at such close quarters.

Types of Photography Blinds

For many years, I constructed my own blinds—frameworks of plastic plumbing pipes with sewn canvas covers. Now, you can purchase commercial, portable models of various levels of sophistication. Permanent blinds for long-term use can be custom designed and constructed of wood or other material.

Some things to look for when shopping for a portable blind are opaque fabric for good concealment, waterproof and rugged construction, lens ports on all sides and at various heights (including ground level), viewing windows so you can see what's happening outside, easy to set up and take down, and lightweight for transport.

I use several portable blinds each of which has good and bad points.

Figure 4.5: One of my photo blinds (a Rue Ultimate blind, no longer sold) set up at a local pond. While scouting I noticed various birds were drawn to a muddy area where a small seep ran into the pond. I placed the blind near the spot with a view of the entire pond and with the morning sun behind it.

Figure 4.6: A Spotted Sandpiper enthusiastically jabs at underwater prey, photographed from the blind shown in figure 4.5. Several shorebirds often foraged within a few feet of the blind.

Canon EOS 7D with 500mm f/4L IS USM lens, 1.4× converter, Gitzo tripod, 1/2000 sec., f/5.6, ISO 400. Caroline, New York. (Right)

Figure 4.8: Cliff Swallows gather at a small puddle to gather mud for nest material. Photographed using a Kwik Camo blind.

Canon EOS 1D Mark III with 500mm f/4L IS USM lens, 1.4× teleconverter, Gitzo tripod, 1/1600 sec., f/5.6, ISO 500. Mono Lake Basin, California.

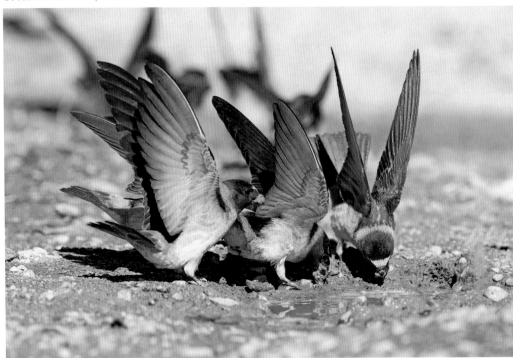

Figure 4.7: Kwik Camo blind in use. This versatile pullover blind can be used while standing or seated.

Kwik Camo Blind

The simplest type of blind is a camouflage fabric bag that you drape over yourself and your gear. A popular model is the EP Gear Kwik Camo Blind (figure 4.7). It has a full-length opening in front, secured by hook-and-loop fasteners, and an opening for the lens at the top, above which is a mesh viewing window. The LensCoat LensHide Blind is similar. Both are lightweight, packable, and ideal for travel. Photographing Cliff Swallows on a trip to California (figure 4.8), I found that even slight hand movements while adjusting camera settings spooked the birds until I concealed myself with a Kwik Camo blind.

Pluses: Well made, affordable at about $120, and versatile for quick concealment. It's shower proof and can be used standing or seated. Small footprint lets a pullover blind fit into tight spaces where a framed blind would be cumbersome, such as amid dense shrubbery or in a boat (see later in this chapter).

Minuses: Your movements may still be somewhat visible in a pullover blind because the frameless design means the fabric clings to your body and gear and moves along with you. I do not recommend this blind for very wary subjects or if you can't keep still for long periods. And because the fabric rests on your head, it helps to wear a hat with a brim or a visor to keep the fabric off your face and save your hairdo!

Figure 4.9: Ameristep Outhouse blind showing window modification for bird photography.

Figure 4.10: Inside the Ameristep Outhouse blind showing camouflage netting attached to the partially open window by means of clothespins.

Ameristep Outhouse Blind

This is a lightweight, pop-up style blind, supported by a spring steel hoop frame. It's designed as a hunting blind but with some modification to improve concealment, it works fairly well for bird photography, too (figure 4.9).

Pluses: I like this 78-inch tall blind because it lets me stand comfortably to photograph birds in trees, in addition to being able to shoot seated or near ground level. It has windows with zip closures on all four sides (one of which opens all the way to the ground forming the entrance) and a dark interior lining for good concealment. The blind pops up as you open it and collapses into a compact circle for carrying...once you've got the hang of how to fold the frame! Fabric is water repellent but lightweight. Easy to use, affordable, and available in many sporting goods stores. Approximate price: $50–$80.

Minuses: Like other hunting blinds, the Ameristep Outhouse has large windows—far from ideal for bird photography—which requires full concealment. However, closing the window tightly around the lens prevents a view of the outside. I solve this problem by draping camouflage mesh over a partially open window as shown in figures 4.9 and 4.10. Low-angle shooting is only possible through the entrance or by cutting holes in the other sides. Its design—curved frame on only two sides—means it is not free standing and must be staked down (wire stakes and guy lines are included). Its high profile makes it unstable in windy conditions. The fabric soon degrades after exposure to the elements and rips easily. Despite its limitations, the Ameristep Outhouse is my go-to blind for many projects, particularly in the backyard. This is a good choice for beginning bird photographers who are on a budget.

Figure 4.11: Tragopan V4 blind in place on the bank of the pond where figure 4.12 was obtained.

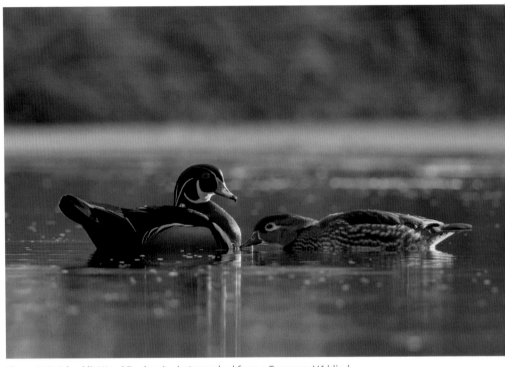

Figure 4.12: A backlit Wood Duck pair photographed from a Tragopan V4 blind.
Canon EOS 7D Mark II with 500mm f/4L IS lens, 1.4× teleconverter, Gitzo tripod, 1/1250 sec., f/5.6, ISO 2500. Ovid, New York.

Tragopan Blind

Tragopan blinds are designed for serious wildlife photographers, and they have many special features including customizable lens openings on all four sides. I have an older Tragopan V4 model, as shown in figure 4.11, but there are several newer models available, one with a hoop frame and others supported by a hub system. All models are well-made, portable, and suitable for professional projects. They are worth the higher price for the many special features for photography. Approximate price: $160–$335 depending on model.

Pluses: Well designed, roomy and versatile, made of rugged, waterproof fabric providing full concealment. Lens ports are customizable using a variety of mesh and solid fabric lens sleeves, allowing shooting while seated or at ground level in any direction. Mesh viewing ports on all sides, plus dedicated openings for flash. Four-way zippers let you extend one tripod leg outside the blind for more room, especially useful when shooting at ground level. Wall pocket keeps small items off the ground and accessible. Quick to set up, freestanding and stable, but best staked down for security (stakes and guy lines included).

Minuses: All Tragopan models are low profile, ideal for mid- to low-angle shooting, for instance for ground-dwelling birds such as grouse, water birds (figure 4.12), or birds in low shrubbery, but not so good for birds perched up higher. In the field, the blinds take

Figure 4.13: Belted Kingfisher female with a crayfish, photographed from a blind overlooking the perch.
Canon EOS 7D Mark II with 500mm f/4L IS lens, 1.4× teleconverter, Gitzo tripod, 1/2000 sec., f/5.6, ISO 640. Lansing, New York.

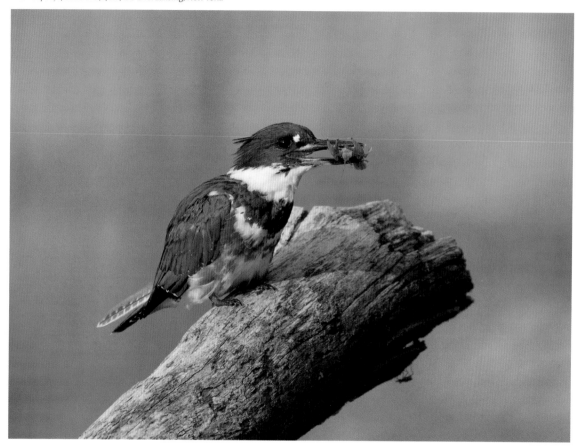

Figure 4.14: The Belted Kingfisher blind overlooking a creek. The red circle shows the bird's habitual perch in the sunlit creek beyond the blind. Over the course of several weeks I captured many images of this normally wary species.

up more space than the previous two blinds. I find the hoop framed Tragopan V4 challenging to collapse for transport—there are online instructional videos to show how it's done. Newer hub-framed models are easier to set up and take down.

Positioning the Blind

Locations to which birds are drawn naturally are good places to set up a blind. You find such spots by scouting: spending time in the field watching birds' activities and noticing predictable habits. For example, at a local creek, I noticed a

perch where a Belted Kingfisher repeatedly processed its catch (figure 4.13). Once you have a target location choose a flat spot for the blind with an unobstructed view and good lighting. You may need to visit the location at different times of day to determine the ideal light direction. Don't try to get too close

Figure 4.15: Short-eared Owl shaking itself after preening on a rustic fencepost.
Canon EOS 5D Mark III with EF 500mm f/4/L IS II lens, 1.4× III teleconverter, beanbag over open car window, 1/2000 sec., f/5.6, ISO 500. Boxelder County, Utah.

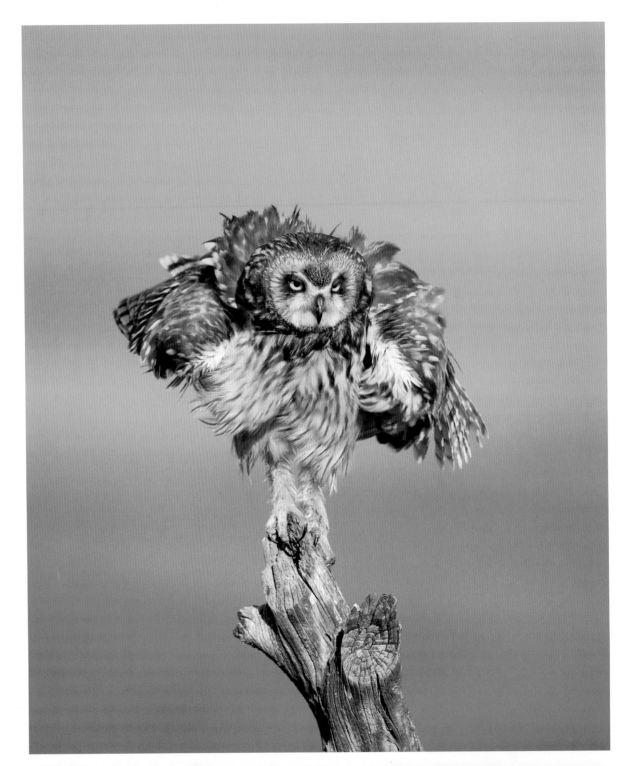

at first. I usually set up at a distance of at least 50 feet away, initially, and move the blind closer over several days to allow the birds to get used to it. This is particularly important if your target is a nest site, a situation in which you should always minimize disturbance. (We'll explore photography at nests in chapter 8.)

Blinds work more because they disguise the human form than because they blend in with the environment. However, the more undisturbed you leave the site, the more likely the bird will be to tolerate the blind's presence. For the kingfisher, I removed several tall plants that obscured the perch but otherwise left vegetation in place to partially hide the blind (figure 4.14). Depending on your subject's wariness and the openness of the terrain, you actually may want to add vegetation to break up the blind's outline, for example by attaching branches and greenery to the frame.

Once you've put up the blind, sit inside and look through the lens ports to check for any potential distractions in the background or surroundings. Adjust location as necessary. When you're satisfied, stake or tie the blind down securely and, ideally, leave it in place for an extended period of time so that birds accept it as part of their environment.

Once you're ready to shoot, don't risk scaring your subject away by entering the blind while the bird is present. The bird may then regard the blind with fear. Instead, enter the blind before the bird arrives and stay put until after it has left. Kingfishers are notoriously wary. To remain undetected, I was in place at first light with gear set up before the bird made her first catch. In addition to camera gear, bring along everything you might need for your own comfort, including snacks, water, and weather-appropriate clothing.

Your Vehicle: The Ideal Movable Blind

You need look only as far your own driveway to find the perfect bird photography blind: your car! There are many places in North America where you can approach birds far more closely in a vehicle than you can on foot. National wildlife refuges and other nature sanctuaries often have driving routes specifically designed to offer visitors good views of birds and other creatures from the comfort of their vehicles.

One caveat is that photography from a car is not ideal for water birds or ground dwellers, because you are necessarily shooting at a downward angle, made even steeper if the birds are close and you drive a giant SUV. Car photography excels, though, for birds perched in trees and shrubs, or on roadside fence posts. Whether in refuges or on public

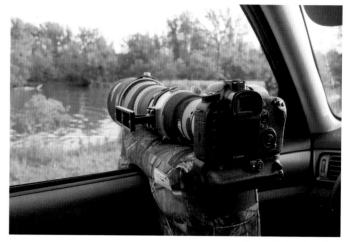

Figure 4.16: A beanbag over the open window ledge is one option to support your camera/lens when shooting from a vehicle.

roads, wildlife often ignores passing vehicles.

In a promising area, I drive along with my window open and a lens support set up ready to shoot. This strategy has netted me images of a wide variety of birds—Eastern Meadowlarks and Upland Sandpipers calling from fence posts, Dickcissels on roadside bushes, Loggerhead Shrikes processing prey on barbed wire fences, and many others. Although I prefer natural perches, I won't pass up a fencepost with a Short-eared Owl on it (figure 4.15)!

Unless your lens is light enough to handhold, you'll need a window mount or a beanbag placed over the window ledge to support your long telephoto (figure 4.16). For more information about camera supports for vehicles, see chapter 2.

Figure 4.17:
Pileated Woodpecker, male.
Canon EOS 7D Mark II with 500mm
f/4L IS lens, 1.4× teleconverter, beanbag,
1/400 sec., f/5.6, ISO 800.
Dryden, New York.

Procedure

Once you've identified a potential
subject along a road, look ahead for
somewhere you can pull off safely to
photograph it. Before proceeding, put
your beanbag or window mount on the
lowered window and mount the camera
and lens on it securely. Swing the side
mirror out of the way if needed. Turn on
the camera and set the correct exposure
ahead of time. Securing the gear with
your left hand and steering with your
right, drive slowly until you've reached
the bird and have a satisfactory back-
ground. Turn the engine off to prevent
blurry shots caused by engine vibration.

For a shy species that you hope will
return to a certain spot, for instance to
a source of food or nest material, try
hanging camouflage material over the
car window to conceal yourself, as I
did to capture a Pileated Woodpecker
returning to its feeding excavation in a
roadside tree trunk (figure 4.17). Attach
the fabric by catching it between the
door and the car frame or hang it from a
safety handle or window shade.

When shooting from an open car
window in cold weather, dress warmly.
Wear gloves or fingerless mittens over
thin glove liners to keep your fingers
nimble and have air-activated heat
packs available. If the outside air is
extremely cold, avoid running your
car heater at high temperature. Air tur-
bulence caused when the hot and cold

air meet may confuse your camera's autofocus system and cause soft images. (Watch for this problem too when shooting through an open house window on a very cold day.) It's a similar problem to the "heat shimmer" that appears on extremely hot days, which itself can cause autofocus malfunction.

Photographing from a Boat

Water birds can be photographed from the shore if they come within range, but take to the water yourself and your images will have the unique perspective that comes from being part of the bird's world.

To get close to marine birds such as puffins (figure 4.18), albatrosses, gannets, and petrels out at sea, your best bet is to join a pelagic birding or whale-watching tour offered by various companies in coastal areas. I prefer smaller companies rather than those that use enormous vessels: Larger vessels may be more stable on the open ocean, but on a smaller craft, you will be closer to the water's surface for a more intimate view of swimming birds. Furthermore, smaller tour groups may be more accommodating to photographers, allowing you the extra time needed to obtain good shots. A company that caters especially to photographers is ideal.

Figure 4.18: Atlantic Puffin takes flight from water.

Canon EOS 7D Mark II with EF 100–400 mm IS II lens (at 400mm), photographed from a boat, handheld, 1/2000 sec., f/5.6, ISO 400, burst mode. Witless Bay Ecological Reserve, Newfoundland.

Out at Sea

Shooting successfully from a tripod on the deck of a boat is virtually impossible: not only do the birds move, but the boat rocks constantly, too. Good hand-holding skills are essential (see chapter 3). Carry your gear on a camera strap for security and adopt a wide stance for stability. Another way to keep steady is to brace yourself against the boat's side rail (figure 4.19) as I did to photograph nesting Black-legged Kittiwakes in Newfoundland. Turn the image stabilizer on, and set a fast shutter speed. Once you've acquired focus, shoot in High-speed continuous mode (i.e., burst mode), trying to time your shots with the ocean swells. Burst mode is especially important for birds in flight and for takeoffs.

Figure 4.19: Photographing from a tour boat. With my gear on a sling-style strap, I leaned against the side of the boat with my left arm over the railing, braced against it. For shooting birds swimming and taking flight from the water, I sat on a side seat for a lower vantage point, bracing myself against the railing in a similar fashion.

Salt water can severely damage photography gear. Minimize salt spray contact by keeping camera gear covered whenever possible. A waterproof rain sleeve such as the LensCoat Raincoat protects gear while allowing you to continue shooting. A cheaper, short-term solution is to simply use a large plastic bag in which you can punch a convenient hole through which to reach camera controls. Your own comfort is equally important: Wear a waterproof hooded jacket and pants (avoid ponchos which flap around in the wind), and a close fitting hat that won't blow away in the wind. Don't forget seasickness medication if you're motion sensitive.

Take to the Lake

Loons, grebes, and other freshwater species can be hard to photograph from shore, but if you're in a small, non-motorized watercraft these birds can be surprisingly tolerant of approach. When choosing a boat, consider the kind of water in which you're likely to be working. Canoes are fairly stable and have large cockpits for transporting camera gear, and their relatively flat-bottomed hulls allow for tripod use. Avoid aluminum models, which are noisy. Kayaks are lightweight, have a low profile and are more maneuverable than a canoe, but are less stable (especially the sit-on-top models) with a higher risk of tipping

yourself and your gear overboard. Kayak cockpits also tend to be small, making gear transport and handling tricky.

In my experience, the ideal boat for bird photography is a Phoenix Poke Boat: a canoe/kayak hybrid that combines the maneuverability of a kayak with the stability of a canoe. It's perfect for paddling around in marshes and lakes. My Poke Boat was invaluable during a project to photograph Black Terns (figure 4.20). It has a low center of gravity and a roomy cockpit for photo gear. I purchased the ultra-lightweight Kevlar model for ease of loading on top of a vehicle.

Whatever your craft, paddle slowly and quietly to avoid spooking the bird. Avoid hitting the side of the boat and making noise. Use a double-headed kayak paddle so you don't have to switch sides. As you get close to the subject, stop paddling and let the boat drift.

Many photographers opt for hand-held shooting in any small boat, and it may be your only option on choppy water. For heavier gear, a tripod can be

Figure 4.20: I knew from the whitewash that this Black Tern pair would likely return to this perch on which I first saw them while paddling my Poke Boat through a wetland. I tied up to a nearby log, set up my gear, and pulled a Kwik Camo blind over everything. Eventually, the pair returned and began courting.
Canon EOS 1D Mark III with 500mm f/4L IS USM lens, 1.4× teleconverter, Gitzo tripod, 1/500 sec., f/5.6, ISO 400. Montezuma National Wildlife Refuge, New York. (Right)

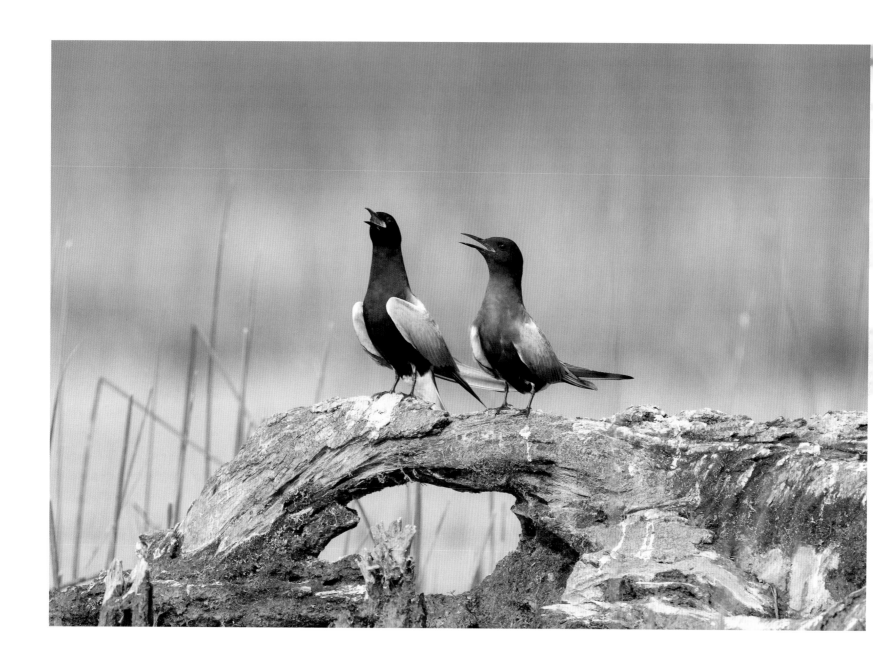

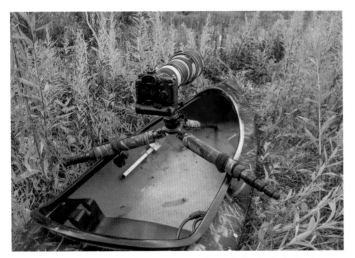

Figure 4.21: Tripod-mounted gear set up in the cockpit of a Poke Boat.

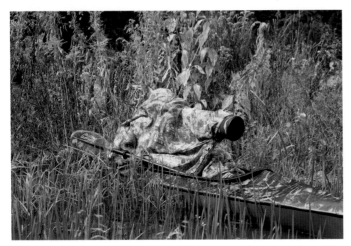

Figure 4.22: Once I'm in place with my gear set up, I often conceal myself using a Kwik Camo blind.

used on calm water, but take great care to avoid knocking over your rig when repositioning yourself or the boat. I use tripod-mounted gear only if I intend to stay in one spot for a while and then only after anchoring the boat, such as by backing the stern into reeds or by tying up to a log or some other stable object in the water.

When paddling, I transport my gear in a waterproof dry bag (available from an outdoor store or paddling outfitter). Once at my desired location, I set up the tripod with one leg extending forward and the other two legs spread wide over the sides of the cockpit (figure 4.21). This lowers the center of gravity and reduces the risk of tipping. To prevent the tripod sliding sideways while in use, I wind something (usually an old sock) around each lateral leg just inside the cockpit. Finally, I mount the camera and lens on the tripod and, if necessary, pull a Kwik Camo blind over everything (figure 4.22).

Don't risk paddling with tripod-mounted gear set up. Before repositioning the boat more than a few yards, I lay the camera and lens down in the cockpit, leaving the tripod in place.

Take special care when photographing nesting birds from a boat. Nesting birds are particularly sensitive to disturbance, and the welfare of your subject should always take precedence over getting the perfect shot. Keep your distance from nesting islands, and obey all local restrictions. Do not land on a nesting island, or you risk flushing the birds off their nests, exposing the vulnerable eggs and chicks to predation or the elements. Wherever possible use a blind.

Attracting Birds in the Field

Increase your chances for successful bird photography by providing attractants such as perches, food, water, or nest sites. Playing audio recordings of birds' sounds also can be used to bring birds within range.

Add Perches and Nest Sites

A promising field site can be improved by adding attractive perches or by repositioning an existing perch to improve the background. Birds prefer to perch higher than their surroundings to watch for potential prey or predators. In open areas with few trees, sinking a tall perch into the ground may attract a bluebird, kestrel, or kingbird. Place a partly submerged log along the edge of a pond for waterfowl to rest on. Secure an upright snag in the water to entice a heron or kingfisher to land. Set up nest boxes to

Figure 4.23: Two Wild Turkey toms strut their stuff to impress the hens.
Canon EOS 1Ds Mark II with 500mm f/4L IS USM lens, Gitzo tripod, photographed from a blind, 1/800 sec., f/8, ISO 400. Newfield, New York. (Right)

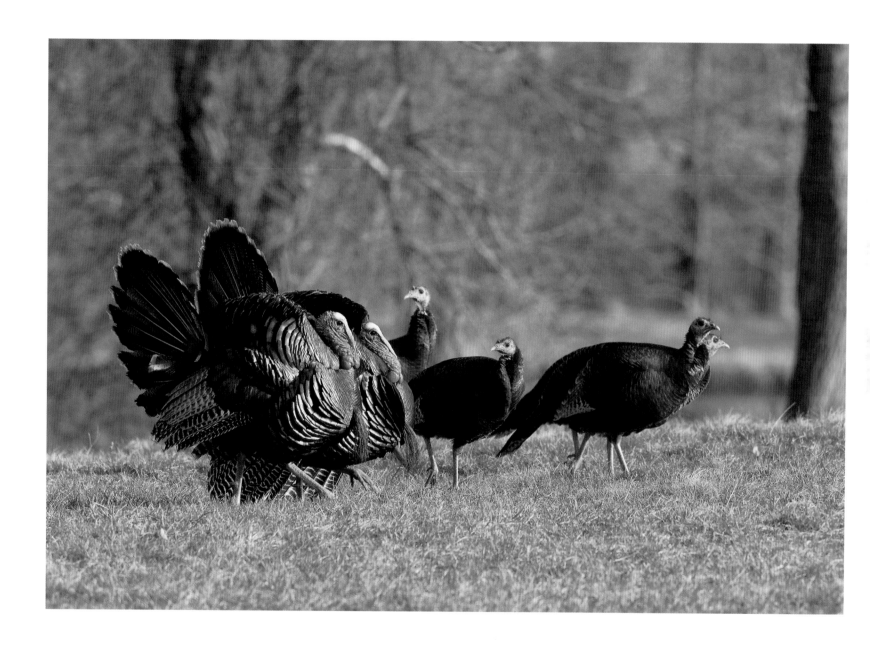

attract bluebirds to open areas, screech-owls to woodlands, or Wood Ducks and Hooded Mergansers to wetlands.

Attracting Birds with Food

Probably the most obvious way to attract birds is with food. You may need to provide the food on a regular basis before birds notice it and start coming consistently. Cracked corn or millet can be spread to attract geese, ducks, quail, or turkeys. Early one spring, a neighboring birder had a flock of Wild Turkeys visiting her property for a handout of corn every morning. From a blind nearby, I photographed the turkeys strutting their stuff (figure 4.23). I have sometimes spread millet along the edge of a field to bring Snow Buntings in close and I have tossed out sunflower seeds in forest campgrounds to lure in tame Steller's Jays and Mountain Chickadees. People love to feed ducks and gulls in public parks or on beaches, providing great opportunities for photographers to get close. Be aware of local laws, because feeding wildlife may be prohibited. Offer cracked corn or birdseed instead of bread, which can be bad for birds' health.

Various other foods can be used to bait birds within camera range. Stocking a pond with fish may attract a kingfisher or osprey. Mealworms attract bluebirds. A road-killed animal carcass may draw in carrion-eating birds such as ravens, magpies, caracaras, eagles, or other raptors depending on your region. Consider relocating the carcass away from the road to a spot that is safer for the incoming birds and yourself. In fact, attracting birds with any kind of food should always be done away from roads, because many bird deaths are caused by collisions with vehicles.

Feeding birds forms the basis of backyard bird photography, the subject of chapter 9.

The Ethics of Baiting

In recent years, baiting wintering owls using live or decoy prey to entice them into close range for photography has become a much-debated and extremely controversial ethics topic. Snowy, Great Gray, and Northern Hawk Owls, all of which are active during the day on their wintering grounds, are the species most affected (figure 4.24). Among many concerns is that the owls learn to associate humans with an easy meal, which may draw them dangerously close to roads or result in them becoming dependent on being fed. In the case of baiting with artificial prey, the owl expends energy but receives no food for its effort. With live prey (e.g., mice), there are additional animal abuse issues.

I am personally conflicted about the issue, and it may well be one that cannot be resolved. Currently, baiting owls is legal in most regions of the United States and Canada that are outside a National Park or Wildlife Refuge. However, most of the top North American and international nature photography contests prohibit photos of baited owls, most nature magazines will not publish such images, and the practice is very much frowned upon by many birders, wildlife photographers, and nature photography organizations. As a photographer, you must consider not only your ethical stance on this issue but also how you will use the photographs if you obtain them by baiting.

Attracting Birds with Water

Particularly in arid regions, birds can be drawn to a source of water, in the form of a shallow birdbath or even a depression in the ground lined with a plastic sheet to hold the water. You can then photograph them bathing or drinking, or posing on perches that you have erected nearby. For a long-term situation, you might want to put in the effort of building a permanent pond.

Attracting Birds with Audio Playback

Audio playback—playing a recording of the species' song or call—is often used to attract birds within camera range, though this practice is becoming more controversial.

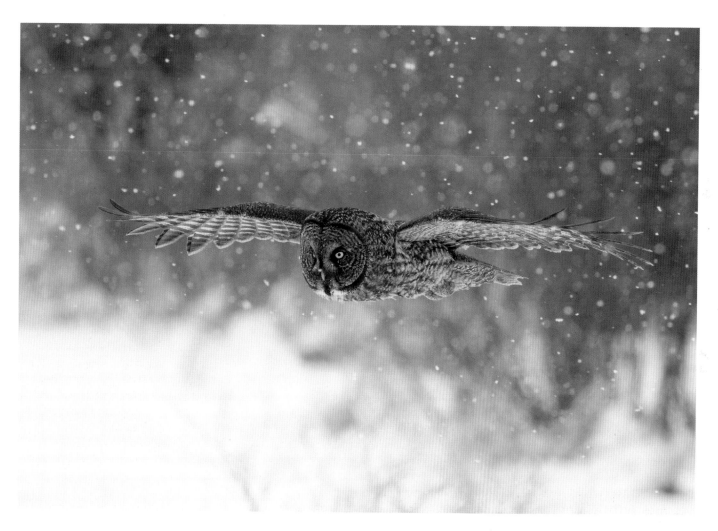

Figure 4.24:
Great Gray Owl in flight during a snowstorm, photographed from a vehicle (natural behavior, without bait).
Canon EOS 7D Mark II with EF 100–400 mm IS II lens (at 300mm), handheld, 1/2000 sec., f/5.6, ISO 1000. Sax-Zim Bog, Minnesota.

Many birds, including grebes, rails, woodpeckers, and passerines—particularly during the breeding season when they are strongly motivated to defend their breeding territories—react strongly to their species' sounds and will approach the sound's source. However, it is an easily abused method and, if used at all, it should be used sparingly. It is vital not to over-tax the bird—territorial response costs the bird energy and may increase its level of stress hormones. The sidebar at the end of this section offers tips to minimize stressing the bird.

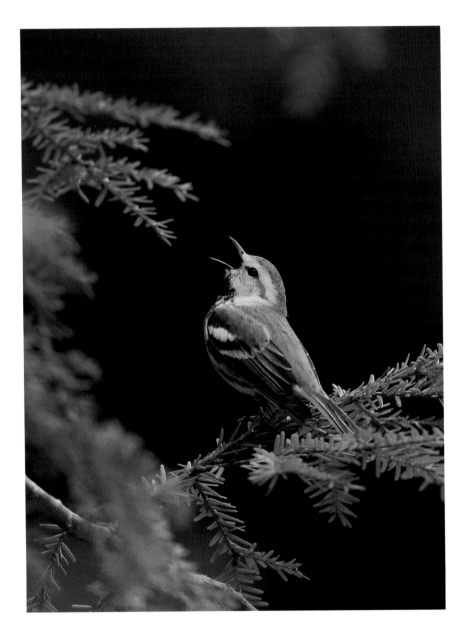

Figure 4.25:
Black-throated Green
Warbler male sing-
ing from a hemlock
branch. Audio playback
brought the bird
within camera range.
Canon EOS 1D Mark III with
500mm f/4L IS USM lens,
1.4×teleconverter, Gitzo
tripod. 1/640 sec., f/5.6,
ISO 1000. Ithaca, New York.

At one time, I frequently used audio playback, but now I do so only rarely, occasionally resorting to the technique in special circumstances, for instance to show a woodland tanager or warbler in its correct nesting habitat. Consider the Black-throated Green Warbler that nests high in the canopy of hemlock forests (figure 4.25). During spring migration it can sometimes be photographed in low shrubbery at migrant traps such as Magee Marsh in Ohio, but it is much more difficult to portray in its breeding habitat. To capture a male on a hemlock branch, I played the species' song to bring one down from the treetops. Images such as this, that show birds in the correct environment, can be used to support conservation efforts.

What You Need to Proceed
The technique involves playing a recording on a smartphone, tablet, or other electronic device connected to a small wired or wireless speaker placed near where you want the bird to perch. The photographer operates the device from a distance. Various bird field guide apps contain bird vocalizations that can be downloaded onto the device. An app with the option to loop a sound track is best.

Devise a way to efficiently access and operate your playback equipment in the field. I carry an iPod Touch and a speaker in a pouch strapped to the top of one tripod leg. During use, the iPod

Figure 4.26: iPod Touch attached to the tripod.

Figure 4.27: Motorola wireless speaker in a conifer. I put the speaker in a mesh bag so I can easily tie it to a branch or position it wherever needed.

attaches to the outside of the pouch by hook-and-loop material (figure 4.26) letting me operate it without taking my attention off the bird. I hang or tie the speaker in a camouflage mesh bag onto a tree branch (figure 4.27) or place it on the ground.

Tips and Tricks

The reaction of each species and each individual to recorded sounds will vary. Some individuals boldly approach the speaker while others may simply fly back and forth overhead and never cooperate. In the latter case, to avoid stressing the bird you must be willing to adapt or even abandon your effort.

Once I locate a target bird, I look for an existing perch onto which to attract it (you can also provide your own perch). Where you put the speaker is important. To lure a bird into a small shrub, for example, I put the speaker in the middle of it, move back to a safe distance and play the recording. As soon as the bird approaches and enters the bush, I turn off the recording. Typically the bird will explore the bush then, finding no rival, it will move toward the top where, with any luck, it will pop into view and sing to proclaim victory over the now silent "intruder." That's the time to fire off a burst of shots! If the bird perches in a less-than-ideal spot, reposition the speaker and repeat the playback.

For a subject high in a tree, I hang the speaker from the lowest branch or place it on the ground below, as I did for the Black-throated Green Warbler in figure 4.25. Once the warbler came within range, I turned off the recording, and he soon relaxed and began to sing. For woodpeckers and nuthatches, place the speaker at the base of a tree trunk.

Doing so lured a Pygmy Nuthatch close enough to give me a satisfactory closeup of the tiny bird (figure 4.28).

Sometimes, trying to entice a bird to what you consider the perfect perch simply doesn't work. Rather than playing the bird's song repeatedly in frustration, it's best to accept what you are given. To photograph the Eastern Towhee in figure 4.29, I hung the speaker on a branch near the center of an apple tree, played the bird's song a couple of times and waited to see where it would choose to perch before slowly edging myself to a spot with a clear view. After getting a few nice shots, I left the towhee in peace.

Figure 4.28:
Pygmy Nuthatch.
Canon EOS 1D Mark III with
500mm f/4L IS USM lens, 1.4×
teleconverter, Gitzo tripod,
1/1600 sec., f/5.6, ISO 400.
Mono Lake Basin, California.

AUDIO PLAYBACK GUIDELINES

Audio playback may be easily overused.
Playing a bird's song can stress the sub-
ject because it draws the bird away from
its normal activities and causes it to
expend energy investigating a perceived
intruder. Despite the risk of negatively
impacting the bird, many photographers
rely heavily on this method. I don't con-
done its general use, but it's used, I urge
you to follow these guidelines:

- Stop the playback if the bird shows
 signs of stress, including gaping (hold-
 ing bill open), fluttering wings, flying
 back and forth agitatedly but not land-
 ing, or giving constant alarm calls.
- Limit how often you repeat the song
 and keep the volume to the minimum
 needed to attract the bird's initial ap-
 proach. If the bird does not land where
 you want it within a short period of
 time, repeating or increasing the vol-
 ume will likely make matters worse.
- Use a blind or wear camouflage cloth-
 ing. Disguising your presence avoids
 compounding the bird's stress level of
 having to overcome its understand-
 able fear of a human in order to ap-
 proach the sound.
- Do not play vocalizations near the
 subject's nest; to lure endangered or
 threatened species; nor in national
 wildlife refuges, nature sanctuaries, or
 anywhere it is prohibited.

Figure 4.29: Eastern Towhee male singing amid apple blossoms.
Canon EOS 1D Mark III with 500mm f/4L IS USM lens, 1.4× teleconverter, Gitzo
tripod, 1/1250 sec., f/5.6, ISO 500. Ithaca, New York.

Chapter 5

SEEING THE LIGHT

Lying on my belly on the lakeshore, I fidget in frustration, mentally pleading with the family of Eared Grebes framed in my viewfinder to swim a little faster toward me. The early morning light is perfect but the grebes are too far away even for my long lens. They stay at the far side of the mats of algae floating offshore where they're finding plenty of prey to feed their young.

Normally, I wouldn't be so impatient but I keep hearing rumbles of thunder and a dark veil of storm clouds is heading toward me from across the lake. Will the grebes come within range before the storm hits?

At last the grebes are close enough for a pleasing image size, but now the clouds are racing across the sun and the water is blue-black. Now my pleas turn to the sun to break through! Finally my wish is granted, and the clouds open for a few precious minutes. Illuminated by some of the most extraordinary light I have ever seen, I capture a grebe with its piggybacking chicks just moments before torrential rain drives me to shelter.

Figure 5.1: Golden-fronted Woodpecker perches in the warm light of late afternoon.
Canon EOS 5D Mark II with EF 500mm f/4L IS lens, 1.4× teleconverter, Gitzo tripod, 1/250 sec., f/5.6, ISO 400. Rio Grande Valley, Texas.

Reading Natural Light

The ability to understand and evaluate a variety of natural lighting conditions in the field is among the most essential skills a bird photographer must develop. Rather than limit your photo forays to clear, sunny days, go out and shoot under a variety of lighting conditions, paying close attention to how the light affects your subject in terms of color and contrast. Experiment with light quality and angle, and you'll discover how to go beyond conventional imagery, using light to influence the mood of an image and allowing you to express your creativity.

Knowing your camera is equally important. Learn how your camera's light metering system interprets the light falling on your subject and its surroundings. Once you can read the light, your bird photographs will improve dramatically as you apply your expertise to obtain correctly exposed and impactful images. We'll cover exposure in detail in the next chapter, but here we'll explore the characteristics of light and its effect on an image's aesthetic quality.

Light Quality

Light quality varies with time of day and weather conditions. At one extreme, the light on a cloudless, sunny day is hard and strongly directional. Under clear skies, the optimal times for bird photography occur at the ends of the day when the light is at its softest. Birds look best in the sweet light of early morning, at sunrise or for an hour or two after sunrise, and in the golden glow of late afternoon for a couple of hours before sunset (figure 5.1). At these times, while the sun sits low in the sky, its rays pass through more of Earth's atmosphere, thus softening the light and filtering out the blue wavelengths to produce flattering warm tones.

Once the sun rises high in the sky, the light becomes cooler in color with a harsh and unflattering quality. Colors get washed out and sharp-edged, distracting shadows can form. Pay attention to the changing light. Learn by experience when to stop shooting on a clear morning and when to resume in the afternoon, especially in mid-summer when the sun climbs into the sky so steeply that high-contrast situations persist even late in the day.

High, thin clouds developing on an otherwise bright, sunny day can be cause for celebration, especially if they arrive when the sun's height is approaching the point at which a bird photographer might otherwise leave

for the day. By softening the sun's hard directionality, high cloud conditions let you keep shooting longer in the day. You still get feather detail, contrast, and that all-important catchlight in the bird's eye, but shadows become softer and less distracting. Lingering mist or light fog can have a similar softening effect.

As the clouds thicken and cover the sky, light becomes softer and non-directional. Some of my favorite and most widely published images, especially of colorful songbirds like Baltimore Orioles (figure 5.2), have been made under a bright-overcast sky in which there is still a hint of the sun's position in the sky but the cloud cover acts like a giant diffuser. Distracting shadows don't occur and the even, low-contrast illumination typical of

Figure 5.2: Baltimore Oriole male perched amid plum blossoms. Backyard setup with an out-of-focus redbud tree forming the background. High cloud cover created the soft lighting typical of my signature style.
Canon EOS 7D Mark II with 500mm f/4L IS lens, Gitzo tripod, 1/640 sec., f/7.1, ISO 640. New York.

Figure 5.3: A male Magnolia Warbler shows the saturated color and fine feather detail revealed by bright-overcast lighting conditions.
Canon EOS 1Ds Mark II with 500mm f/4L IS USM lens, 1.4× teleconverter, Gitzo tripod, 1/200 sec., f/5.6, ISO 500. New York.

Figure 5.4: Four Cedar Waxwings pluck crabapples in synchrony. Snow on the ground reflects light onto the birds from below.
Canon EOS 7D with 500mm f/4 IS USM lens, Gitzo tripod, 1/800 sec., f/5.6, ISO 800. Ithaca, New York. (Right)

bright-overcast days allows you to shoot in any direction and at any time of day. Best of all, bright-overcast conditions produce vivid, saturated colors and reveal exquisite feather detail such as in the breeding plumaged Magnolia Warbler (figure 5.3). This soft, even lighting produces a painterly effect that is a big part of my signature style.

Maybe it reflects my childhood in gray, rainy England, but I rarely shy away from cloudy days for bird photography. That's a good thing because at some of my favorite locations—whether close to home in upstate New York, well-known for its long winters, or far away on Alaska's fog-shrouded Pribilof Islands—overcast is what you get a lot of the time. The best strategy is to embrace whatever challenging conditions Mother Nature sends your way and use them to your advantage. By doing so, you may be blessed with wonderful surprises!

On a frigid February day, I experienced one of those surprises when I headed to a park near my home where flocks of hungry Cedar Waxwings often feasted on fruit-laden crabapple trees. I love to photograph these elegant birds close up, and this time I decided to try capturing groups of waxwings rather than individuals. One quartet formed a nice composition (figure 5.4), but when all four plucked a fruit at the same time I couldn't believe my luck! That moment alone made it a special shot, but the

weather conditions had conspired to make it even better. Counteracting the gloomy light was a thin blanket of snow on the ground, including under the tree in which the waxwings were perched. The snow reflected light up onto the birds from below and made them appear to glow from within. Seconds later, the group dispersed and the unique convergence of composition, behavior, and light was over!

Light Quality Changes Appearance

It can be very educational to see how a bird's appearance changes under various lighting conditions, as demonstrated by the sequence of Barn Swallow images. They show the same perch, and most likely the same bird, photographed as the light changed one morning. (I also moved position slightly between images.)

In figure 5.5a, under full sun, the contrast is so great that only a small amount of detail can be seen in some parts of the plumage, and shiny hotspots are visible on others. A less than ideal sun angle means the bird's face is partly obscured by its own shadow.

In figure 5.5b, a high cloud had partly obscured the sun. The plumage is more evenly illuminated, there is better detail in the facial area, and the attractive shine is retained on the back feathers,

Figure 5.5a:
With full sun.

Figure 5.5b:
With high clouds.

Figure 5.5c:
Under an overcast sky.

All three images:
Nikon F4 with Nikkor 400mm f/3.5 IF manual focus lens, Fuji Provia film (ISO 100). Camera settings not recorded.

Figure 5.6: Chipping Sparrow, photographed with front lighting.
Canon EOS 5D Mark II with EF 500mm f/4L IS lens,1.4× converter, Gitzo tripod, 1/1250 sec., f/5.6, ISO 400. Ithaca, New York.

Light Direction

Front Lighting

In addition to being hard or soft in quality, light has direction. The angle at which the sun strikes the subject greatly influences its appearance. When the sun is shining from directly behind the photographer, this is called *front lighting* and it is the standard illumination used to capture the majority of bird photos, such as the Chipping Sparrow shown in figure 5.6. The side of the bird facing the camera is evenly illuminated and there is ample feather detail. Metering and obtaining the correct exposure is straightforward (assuming you understand your camera's metering system, as we'll cover in chapter 6). If you're new to bird photography and are still learning about light and exposure, front lit subjects are the best place to start.

For perfect front lighting, position yourself so the sun and the subject are in exact alignment with you. Check over your shoulder as you move from side to side until this is true. If you're in a car, you'll need to inch the vehicle back and forth to do this, as I did to photograph an Eastern Meadowlark (figure 5.7). (Tip: watch for traffic and don't block roads!) If you're on foot, another way to be sure you're at the correct angle for perfect front lighting is when you can see your shadow points straight at the bird.

as is the catchlight in the eye. Overall color is improved as light cloud cover reveals the rich blue of the upper parts and chestnut throat. This image is my favorite of the three.

Figure 5.5c was taken with 100 % cloud cover. Reduced contrast makes the bird appear flatter and more one-dimensional, although there is still some fine detail in the feathering and good color is retained. The catchlight in the eye is diffused and less compelling.

Figure 5.7: Eastern Meadowlark singing on a fencepost. Photographed from a vehicle with lens supported on a beanbag over the open window. Canon EOS 1Ds Mark II with 500mm f/4L IS USM lens, 1.4× teleconverter, 1/3200 sec., f/7.1, ISO≈320. Florida.

evocative, and compelling your images will become. Contemporary bird photography is not simply subject driven. It's also about light, mood, and emotional connection with the subject.

Side Lighting

When illumination comes from the side, the bird is no longer evenly lit: one side of its body is in shadow as it is with the American Bittern in figure 5.8. Side lighting is most effective when the sun is fairly low in the sky. Many photographers dislike such a situation because the uneven lighting means the bird's shaded side lacks detail. While this is true, side lighting actually provides more texture to the bird's plumage and the shadowing makes the subject appear more three-dimensional. Side lighting accentuates texture in the surroundings, too.

Direct front lighting is ideal for showing what the bird looks like—the typical identification-style image. Many photographers swear that "pointing their shadow at the bird" is the best way to portray the subject. On the other hand, because they're relatively easy to obtain, front-lit portraits are commonplace.

How do you make images that stand out from the crowd? Although there are many ways to create eye-catching bird images, one method is to use unconventional lighting. Of course, in some

circumstances front lighting itself can be very dramatic—consider the contrast of early morning sunlight against the dark sky of an approaching storm (see the image of Eared Grebes at the beginning of this chapter).

Nontraditional lighting can be achieved by changing position so the sun is no longer in direct alignment with the photographer and the subject, but instead is shining from an angle. The further you stray from conventional front lighting, the more artistic,

Some would argue that because one of the bittern's eyes is in shadow, it detracts from the face-on impact. To me, the shadowing conveys a sense of intimacy and mystery: the elusive bittern emerges from the shadows to hunt as evening descends upon its marshy home, ready to creep back into the safety of darkness if necessary. The world is full of typical picture-perfect bird portraits, so it's refreshing to have a more spontaneous and natural look.

Figure 5.8: American Bittern with evening sunlight coming from the side. Photographed from vehicle, lens supported by a beanbag over an open window.
Canon EOS 1Ds Mark II with 500mm f/4L IS USM lens, 1.4× teleconverter, 1/800 sec., f/5.6, ISO 160. Montezuma National Wildlife Refuge, New York.

Figure 5.9a: The bird's face turned away from the sun.

Figure 5.9b: The bird's face turned toward the sun results in a superior image.
Both images Canon EOS 7D Mark II with 400mm f/5.6 L USM lens, handheld, 1/2000 sec., f/5.6, ISO 400. Fort De Soto Park, Florida.

The angle of a bird's head is always important; our visual attention is innately drawn to the face and eyes of our subject. Working with off-angle lighting means you need to take extra care in deciding when to release the shutter. When photographing side-lit birds, be sure to wait until the bird's face turns

toward the sun to make the exposure. Doing so ensures a catchlight in the eye, which attracts the viewer's attention.

Compare the two shots of an American Oystercatcher coming out of the surf with prey, taken a few seconds apart. In figure 5.9a, with no light on the bird's face, the viewer's eye is drawn instead to its white rear end! All it took was a slight turn toward the sun to illuminate the face, bill, and eye, making figure 5.9b much more compelling.

Backlighting

When the sun is directly behind the subject, uniquely beautiful and evocative bird images can result. Yet many photographers shy away from shooting toward the sun, perhaps because their primary goal is to show detail in the side of the bird facing the viewer or because they believe (correctly) that accurate exposure for backlighting is trickier to obtain than it is for front lighting.

Birds make ideal subjects for backlighting because they have indistinct edges. Fluffed feathers or raised crests or plumes with the sun shining through them can outline the bird with a magical halo of light. The best results occur when the sun is low in the sky and the background is darker than the bird. White or very light-colored birds—egrets, swans, spoonbills, or terns—make particularly effective subjects.

Figure 5.10: Backlighting outlines the nuptial plumes of a displaying Great Egret in a rookery. Canon EOS 1Ds Mark II with 500mm f/4L IS USM lens, 1.4× teleconverter, Gitzo tripod, 1/3200 sec., f/5.6, ISO 400. Orlando, Florida.

Egrets with outspread wings or raised nuptial plumes (such as the Great Egret performing its courtship display in figure 5.10) look spectacular with the sun behind them. Depending on the contrast, there may be little or no detail in the side of the bird facing the viewer, but that's not the intent of an image such as this.

Backlighting can dramatically enhance such things as splashing water droplets, blowing snow, and the steam of exhaled breath, especially against a dark background. The right background

Figure 5.11: Backlit Snowy Owl. I composed the image so the distant shaded hillside fell behind the owl to best reveal the blowing snow.

Canon EOS 7D with 500mm f/4L IS lens, Gitzo tripod, 1/1250 sec., f/11, ISO 400. Barrie, Ontario, Canada.

can reveal something that otherwise would be far less visible.

One frigid, windy day in winter, I came across a Snowy Owl on a snow bank surrounded by wind-whipped snow (figure 5.11). With the sun behind me, the background and surroundings were stark white and the blowing snow was barely visible. But when I moved slowly and cautiously around to the other side of the owl, the swirling snow was revealed brilliantly. Even so, my position with respect to the background was critical. I edged sideways and raised my tripod as high as possible (having to stand on tiptoe to do so!) until the entire background was filled with the distant shaded hillside. A fast shutter speed stopped the snow particles in midair.

Figure 5.12: American Avocet pair silhouetted in the reflection of a sunrise sky.
Canon EOS 1D Mark III with 400mm f/5.6L USM lens, 1.4× converter, handheld, 1/2000 sec., f/8, ISO 800. Bolsa Chica Ecological Reserve, California.

Silhouettes

The combination of strong backlighting and surroundings that are much lighter than the main subject creates ideal conditions for silhouettes. By basing exposure on a meter reading of the bright surroundings, the main subject is reduced to its most abstract form: a dark shape, a simple graphic element that can be very striking, especially against colorful sunrise or sunset skies.

To intensify the warm tones, try increasing the camera's white balance setting to a higher color temperature (see sidebar below). Remember that the best sky color can develop up to an hour before sunrise and an hour after sunset, so either get to your location early or don't leave too soon, or you might miss it!

When composing silhouettes, make sure the subject does not overlap any dark areas in the background and that multiple subject elements are separated.

A WORD ABOUT WHITE BALANCE

Setting the white balance refers to changing the color temperature in your camera so that colors in your images appear natural and white areas appear neutral without any obvious color cast. Color temperature, measured by means of the Kelvin scale, refers to the fact that all light is colored. Early or late on a sunny day, the light is *warm* and is composed of yellow and orange tones. Warm light has a low Kelvin rating. In the middle of the day, the sunlight is bluish or *cool* and has a high Kelvin rating. On cloudy days, light is cooler than on sunny days, and white areas of a bird's plumage can take on a bluish color cast. In shade, light is even bluer.

To obtain accurate color and neutral whites, you can either choose the auto white balance (AWB) setting or one of the presets that cameras offer for natural light—Sunny, Cloudy, and Shade—as well as several for artificial light sources. The AWB setting gives pretty good results, and many photographers rely on it. Otherwise, select the preset that best matches your ambient lighting conditions. In either case, the camera then adds the opposite color so that whites have no color cast.

Finally, you can customize color temperature numerically on the Kelvin scale using the K setting. (I occasionally do this to intensify sunset colors.) In general, I use the Sunny or Cloudy presets. Although it's a good idea to get an accurate white balance in-camera I often tweak the color balance of my RAW files during postprocessing.

Figure 5.13: Red-winged Blackbird with a bad case of lens flare caused by shooting directly into the sun.
Canon EOS 7D Mark II with 500mm f/4L IS lens, 1.4× converter, Gitzo tripod, 1/1600 sec., f/5.6, ISO 800. Ithaca, New York.

at the sun through your lens can cause severe and permanent retinal damage, so if you intend to include the sun in the frame, do so only when it's very low on the horizon or muted by mist or light cloud cover.

Beware of Flare!

Shooting directly toward a low sun sometimes introduces lens flare: artifacts such as bright blobs or streaks, polygonal shapes, or sometimes a subtle veil of light falling across part of the frame that can cause reduced contrast as it does in the image of a backlit Red-winged Blackbird (figure 5.13).

Lens flare is caused by stray light reflecting and bouncing off various elements inside the lens. You can avoid the problem by using a lens hood (something you should do anyway to protect the front glass of your precious lens). If flare persists, try holding a piece of card or even the stiff brim of a hat over the lens so that it extends beyond the hood and shades the lens even farther (but be sure your shade doesn't protrude into the frame). If that doesn't solve the problem, a slight change in camera angle may help: Adjust the tripod up or down slightly, or move a short distance (even just a couple of inches) to one side so the sun is not shining directly into the lens.

Otherwise, if elements merge into a single black shape, it can be hard to decipher the image. It is also important to wait until the bird presents a side view, at least of its head, so that it is recognizable.

For the sunrise silhouette of two American Avocets (figure 5.12) I waited to release the shutter until the birds had moved slightly apart so they did not overlap but they still formed a cohesive grouping. A word of warning: staring

Catchlights

A bird's eye is usually the first thing that draws the viewer's attention in a photograph. Unless your intent is backlighting or a silhouette, it's essential that the face and eye are well illuminated and the eye is in sharp focus, ideally having a catchlight (figure 5.14). A catchlight is the reflection of the light source. It provides depth and dimension to the eye thereby making the subject come alive.

Depending on the ambient lighting, catchlights vary in shape and size from a tiny pinpoint highlight formed by the reflected sun on a clear day to a diffuse reflection of a cloud-covered sky.

Colorful eyes, such as the vivid red iris of an Eared Grebe or the yellow iris of a Snowy Owl, can do the job of grabbing the viewer's attention even without a catchlight, as can black eyes surrounded by colored eye-rings like those of the Horned Puffin. In general, though, a catchlight is preferred. All it takes is a subtle tilt of the head for the catchlight to show, so watch through the viewfinder and release the shutter at the right time. Even under the cloudiest of conditions, you can usually see at least some hint of a reflection in the subject's eye.

On overcast days, certain birds may be afflicted with a serious case of disappearing eye syndrome. Particularly problematic are birds with black eyes and black caps or facial masks such as

Figure 5.14: Lit by the sweet light of early morning, this Limpkin has a nice catchlight in its eye.
Canon EOS 1D Mark III with 400mm f/5.6L USM lens, 1/2000 sec., f/5.6, ISO 640. Viera Wetlands, Florida.

chickadees and many terns, as well as birds whose upper parts are mostly black, for instance razorbills and murres. One way to cure this malady is to add electronic flash to lighten the facial area (see next section). Alternatively, during postprocessing, try subtly lightening the bird's eye ring or the upper part of the eye as I did with the Sandwich Tern pair (figure 5.15).

Combining Natural Light with Flash

In certain cases, natural lighting can be improved with the addition of electronic flash, but the effect is most appealing when it is subtle. The strategy is to balance the flash output with the ambient light, the goal being to improve plumage color or to fill in shadow areas to bring out detail. Photographers refer to this technique as *fill flash*. (See chapter 2 for more on flash.)

I like to use fill flash in combination with bright-overcast lighting to brighten the colors and to add a catchlight to the bird's eye, resulting in images with a little extra pop. It's especially useful if the bird has white or pale-colored plumage, such as the breast of a Rose-breasted Grosbeak (figure 5.16). Fill flash makes whites cleaner by removing the bluish color cast that can result from shooting on a cloudy day.

Figure 5.15: Two courting Sandwich Terns call and droop their wings distinctively. During image editing, I subtly lightened the upper parts of each tern's eye.
Canon EOS 7D Mark II with 400mm f/5.6L USM lens, handheld, 1/1000 sec., f/5.6, ISO 1000. Fort De Soto Park, Florida.

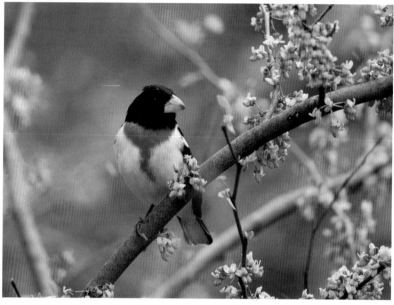

Figure 5.16: Rose-breasted Grosbeak male perched in flowering eastern redbud, bright-overcast sky plus fill flash.

Canon EOS 5D Mark II with EF 500mm f/4L IS lens, 1.4× converter. Gitzo tripod, Canon Speedlight 580EX II, ETTL, −1²/³ EV, Better Beamer flash extender, 1/320 sec., f/5.6, ISO 800. Freeville, New York.

Figure 5.17: Rose-breasted Grosbeak male perched in flowering eastern redbud, bright-overcast sky, no flash.

Canon EOS 5D Mark II with EF 500mm f/4L IS lens, 1.4× converter, Gitzo tripod, 1/320 sec., f/5.6, ISO 800. Freeville, New York.

Compare the two grosbeak images; one captured with the addition of flash and the other without (figures 5.16 and 5.17). To me there's no contest: the addition of flash has evened out the illumination on the upper- and under-parts of the bird, resulting in brighter, cleaner whites and revealing fine feather detail in the red chest patch.

To keep things simple, I use a basic rule of thumb to ensure a subtle, natural look in most situations with fill flash: I adjust my camera settings as if I were going to shoot with ambient light alone, (using Manual exposure mode, the mode I use for most of my work). The flash is set to ETTL mode. I reduce the flash power output, rotating the dial on the back until it shows a flash exposure compensation value of −1 to −2, depending on how close I am to the subject and how much of an effect I want. After taking a test shot, I may change camera or flash settings as needed.

I find fill flash to be essential when photographing birds in a forest interior after leaf out. Light filtering through the leaves can produce an ugly green color cast that can ruin the appearance of, for instance, the yellow plumage of a Canada Warbler male (figure 5.18a). Backlighting from the bright sky makes the situation even worse. In figure 5.18b fill flash has greatly improved the image by brightening the bird's shaded side, removing the color cast and adding a catchlight in the eye.

Fill flash is also a good solution if the subject is strongly backlit but you want

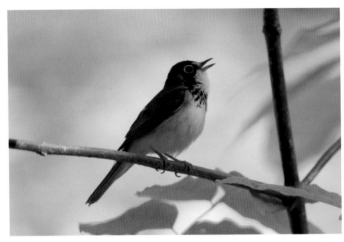

Figure 5.18a: Canada Warbler. Without flash, notice the green cast on the yellow plumage.

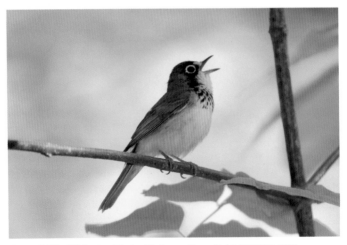

Figure 5.18b: Fill flash added with Canon Speedlight 580EX II, ETTL, −1 1/3 EV, Better Beamer flash extender.
Both images Canon EOS 7D with 500mm f/4L IS USM lens, 1.4× converter, Gitzo tripod, 1/400 sec., f/5.6, ISO 800. Freeville, New York.

to show detail on its shaded side, as I did with a Yellow-bellied Sapsucker on an old tree outside my house one spring (figure 5.19). One dead limb was strongly resonant, tempting the sapsucker to choose it for a drumming post, which it visited repeatedly throughout the day to rap out its territorial claim to the yard—sometimes starting the percussion performance before dawn, much to our dismay!

Nature had provided the perfect photo op, but in the morning, when the bird was most active, the snag was strongly backlit. Fill flash solved the problem. Why didn't I simply shoot from the other side of the tree? Because my house would have formed an unattractive, cluttered background and, besides, I liked the way the backlighting outlined the bird with a magical rim of gold.

Figure 5.19: Yellow-bellied Sapsucker male, backlighting plus fill flash.
Canon EOS 1D Mark III with 500mm f/4L IS USM lens, 1.4× teleconverter, Gitzo tripod, Canon Speedlight 580EX II, ETTL, −1/23 EV, Better Beamer flash extender, 1/125 sec., f/5.6, ISO 400. New York.

Chapter 6

EXPOSURE

As I crest the hill at Cape Saint Mary's, a vista such as fills a bird photographer's dreams opens up before me: towering cliffs alive with tens of thousands of gannets, murres, and kittiwakes, all busily performing the tasks of nesting. Still more birds fill the sky and the ocean beyond with their noisy comings and goings.

Many human visitors to this Newfoundland gem—the most accessible Northern Gannet colony in North America—never see the full extent of the colony because it is usually shrouded in fog that is sometimes thick enough to obscure the waves pounding the rocks below. But I am in luck: This is a rare, clear day. Why then, as I approach the colony, does a feeling of apprehension creep into my excitement? Ever aware of light conditions, I am concerned by how strong the sunlight still is, even at 7:30 on this mid-summer evening. Exposing these big white birds correctly in such bright sun is going to be a challenge.

Figure 6.1: Harris's Hawk with prickly pear cactus. My camera's suggested standard exposure was perfect for this evenly illuminated, middle-toned bird and its surroundings.

Canon EOS 1D Mark III with 500mm f/4L IS USM lens, Gitzo tripod, Manual exposure mode, Evaluative metering pattern, EV 0, 1/2500 sec., f/5.6, ISO 400. Rio Grande Valley, Texas.

Taking Control of Exposure

Controlling exposure is essential to get the best images from your camera and to fulfill your creative vision. Today's cameras have highly sophisticated and accurate exposure meters, making it easier than ever to obtain correctly exposed images, but these systems are not foolproof. The trick is to understand the information provided by the camera's metering system and to use that information to set the correct exposure.

If you've allowed the camera to be in charge up until now, the first step toward control is to muster your courage, grit your teeth, and rotate the mode dial away from Fully Automatic or Program mode.

Phew! There...that wasn't so bad, was it? Now you have two decisions to make—select an exposure mode and a metering mode:

- **Exposure mode** determines how much control you have over the exposure and how much you are willing to leave to the camera.
- **Metering mode** (sometimes referred to as metering pattern) refers to how much of the framed scene the camera uses when it's measuring subject brightness and calculating exposure settings.

We'll consider the various choices and weigh their pros and cons. Finally, we'll tackle some real-world examples.

Before we get started, if you're not already familiar with the camera's exposure level indicator, now is the time to learn how to interpret it.

READING THE EXPOSURE LEVEL INDICATOR

The exposure level indicator is the camera's light meter display. Depending on the camera model, it can be found at the bottom or on the right side of the viewfinder. It also appears on the LCD panel. Rotating the camera dials moves the marker side to side (or up and down) on the scale as you increase or decrease the amount of light that reaches the camera's sensor.

Some scales use numbers while others use a system of marks representing stops of light (or fractions thereof). The center of the scale (0 on a numerical scale) indicates the camera's suggested standard exposure for the scene being metered (figure 6.1). Positive numbers, or marks on the right, or above the center, indicate an exposure brighter than the camera's suggested setting, whereas negative numbers or marks on the left, or below the center, indicate an exposure darker than the camera's suggested setting.

It's important to be aware that, depending on which exposure mode is being used, the exposure indicator value means different things, as you'll discover below.

Exposure Modes

Let's explore the differences between Automatic and Manual exposure modes.

Automatic Exposure

Depending on which of the two auto-exposure modes is in use—Aperture Priority or Shutter Priority—after you select the ISO, the camera automatically sets the exposure by automatically changing either the shutter speed or the aperture, respectively. Then, by applying exposure compensation, you can increase or decrease the exposure setting to render the scene as desired. (On Canon cameras, exposure compensation is set by rotating the Quick Control dial on the back of the camera. Nikons have a dedicated Exposure Compensation button. For other brands, check your user guide.)

In the Auto modes, the exposure level indicator shows you the amount of exposure compensation you currently have dialed in. Note that this amount will remain the same, regardless of where you point the camera, until you change it again.

EXPOSURE COMPENSATION

When using an auto-exposure mode, exposure compensation is the mechanism by which you can direct the camera to increase or decrease the exposure setting from what the camera suggests.

Exposure compensation is often stated in f-stops of light (e.g., $+1^{2/3}$ stops or simply +1), but you may also see it stated in terms of exposure value (EV). One EV is equivalent to one f-stop of light. Hence +1 EV equals doubling the amount of light in the exposure, −1 EV equals halving the amount of light. An EV of 0 simply indicates that the photographer wants to use the camera's suggested settings. Exposure compensation can be achieved in 1/3-stop increments. For example $+1^{2/3}$ EV means one-and-two-thirds stops of light are added to the suggested settings, whereas −1/3 EV means one-third stop of light is subtracted from the suggested setting.

Manual Exposure

By manually selecting the three parameters that contribute to exposure—shutter speed, aperture, and ISO—you have complete control over the amount of light that reaches the camera's sensor. In Manual (M) mode, you can change one or more of these parameters to increase or decrease the exposure to render the scene as desired.

When using the Auto modes, the settings automatically change with each new exposure. However, when you are

MANUAL MODE WITH AUTO ISO

If you are wary of taking the plunge into full Manual mode, you have another option: Manual mode with Auto ISO. For this, you set the shutter speed and aperture, but you choose Auto ISO rather than a specific ISO setting. The ISO then varies automatically, allowing the camera to adjust exposure for changing scenes, while the shutter speed and aperture remain fixed until you change them manually. Manual mode with Auto ISO gives you the control of setting the aperture and shutter speed plus the freedom of having the camera adjust the ISO to ensure getting the correct exposure (which can be useful under quickly changing lighting conditions). Auto ISO can, of course, be used in any of the Auto exposure modes, too.

But there's a catch: When using Manual mode with Auto ISO (as in any auto-exposure mode), if you want to deliberately lighten or darken a scene, exposure compensation must be applied, however, not all camera models offer a straightforward way to do this. Some models require that certain buttons be customized in order to control exposure compensation. In some entry-level cameras, exposure compensation in Manual mode with Auto ISO may not be possible at all. Check your own camera.

You should be aware that when using Auto ISO in low light, the camera might select a very high ISO setting, which could result in noisy photos, depending on the camera. When using Auto ISO, you have the option to set minimum and maximum ISO values to avoid such issues.

in Manual mode, the settings remain the same until you change them again.

In Manual mode, the exposure level indicator shows how the selected settings differ from the exposure the camera would have suggested given the results of the current metering. Therefore it will change depending on where you point the camera.

A twist on traditional Manual mode is to use Auto ISO instead of setting an actual ISO value. With this mode you have only two, rather than three, parameters that you can adjust.

Why I Use Manual Exposure (and Why You Should, Too!)

I'm a control freak! I want to have ultimate control over what my images look like. And so, like many professional and serious amateur bird photographers, I primarily use full Manual mode in my work, and I recommend you do the same. Why is this so? With all the amazing advances in camera technology, why can't you trust auto-exposure? For the answer, you need to understand auto-exposure's limitations.

In-camera meters base their exposure readings on the assumption that every subject is middle toned: halfway between the lightest and darkest tones. The camera calculates its suggested exposure settings assuming that the photographer wants the bird or scene to appear middle toned, too.

This premise is true in many circumstances because many birds and their surroundings actually are middle toned. Take a gray morph Eastern Screech-Owl roosting in a gray tree trunk (figure 6.2)—it's about as middle toned as you can get! Birds clothed in brown, blue, or red plumage amid green foliage, perched on gray-brown bark, or surrounded by blue sky or water are average toned subjects, for which you can confidently use either manual or auto-exposure to arrive at the correct exposure value.

Problems arise, though, if the subject, the background, or both are not middle toned but differ substantially from average tonality. If you rely on auto-exposure in these circumstances, without understanding the need for exposure compensation, inaccurate and inconsistent results can occur.

Consider an American Robin perching on snow on a bright sunlit day: a middle-toned bird in surroundings that are significantly brighter than average (figure 6.3). Using auto-exposure, the suggested settings from a camera metering this entire, mostly white scene would produce an underexposed bird on gray snow. Furthermore, the size of the main subject in the frame affects metering accuracy resulting in inconsistent exposure values. In this case, the robin forms only a small part of the scene and so the meter is substantially influenced by the white surroundings, which leads

Figure 6.2: Eastern Screech-Owl roosting in a large tree cavity.

Canon EOS 5D Mark II with EF 500mm f/4L IS lens, 1.4× converter. Gitzo tripod, 1/100 sec., f/5.6, ISO 1250. Manual exposure mode, Evaluative metering pattern, EV 0. Rio Grande Valley, Texas.

Figure 6.3: American Robin perched on snow-covered ground: a middle-toned bird against much brighter surroundings. To ensure the robin was correctly exposed and the snow remained white, I metered a large patch of mid-brown shrubbery in the same lighting as the robin but just outside the frame, and then recomposed the frame as seen.

Canon EOS 1Ds Mark II with 500mm f/4L IS USM lens, 1.4× teleconverter, Gitzo tripod, 1/1000 sec., f/5.6, ISO 250. Manual exposure, Evaluative metering, EV 0 (for metered vegetation). Ithaca, New York.

Figure 6.4a: Great Blue Heron against a medium-blue background: the bird is correctly exposed. 1/500 sec., f/5.6, ISO 200.

Figure 6.4b: Seconds later, influenced by the dark background, the camera automatically added 1 stop of light, and overexposed the white face and crown. 1/250 sec., f/5.6, ISO 200.

Both images: Aperture Priority mode with no exposure compensation (EV 0), Evaluative metering. Canon EOS 1Ds Mark II with 500mm f/4L IS USM lens, 1.4× teleconverter.

to incorrect exposure. If the robin had filled much of the frame, it's likely that auto-exposure would expose it correctly.

High-contrast scenes with extremes of lighting are also particularly prone to causing the camera meter's suggested settings to be wrong. For instance, a sunlit white bird against a dark background would likely end up with what are referred to as *blown-out* or *burned-out* highlights (overexposed white areas containing no detail).

Finally, relying on auto-exposure is particularly problematic if the subject is moving through surroundings that vary widely in tonality. Imagine a gull flying along. At first it is against a blue sky, but then it passes in front of a shaded cliff face. Auto-exposure would function correctly with the blue sky but would produce burned-out highlights in the shots with the dark cliff behind the bird. In Manual mode, presuming the light on the bird stayed the same, the gull would be correctly exposed regardless of the background.

To illustrate the problem of auto-exposure with changing backgrounds, compare two images of a slowly walking Great Blue Heron, captured seconds apart and taken a number of years ago when I actually was a die-hard auto-exposure user. For both shots, I used Aperture Priority (Av), Evaluative metering, with no exposure compensation.

In figure 6.4a, when the heron is first framed against blue water, it is correctly exposed and there is feather detail in the white areas on its cheek and crown. Given a middle-toned subject and background, auto-exposure will function accurately without need for exposure compensation.

However in figure 6.4b the heron walked past a dark background. While still in auto-exposure mode, the camera settings suggested by the meter rendered the scene incorrectly. The camera saw a frame that was mostly dark, assumed it should be middle toned and automatically increased the exposure (via a slower shutter speed in this case), thereby overexposing the heron's face and crown, robbing them of detail.

Of course, in Av mode you could solve the heron problem by reducing the exposure using the Exposure Compensation dial...if you can judge tonality well enough to know how far to go and are quick enough to do so before the heron moves yet again. But doing so takes your attention briefly away from your subject. (And don't forget that the compensation setting you selected would then be applied to all subsequent images unless you remember to return it to its previous setting.)

Furthermore, if, after metering, you decided to recompose with the heron off-center, the camera settings might change because the meter would be reading a different part of the scene. You'd need to lock the original settings by pressing the Auto-exposure Lock

I realize I won't convince everyone to switch to Manual exposure, and many bird photographers will continue to rely on auto-exposure. If that's you, you should generally choose Aperture Priority mode (Canon: Av, Nikon: A) rather than Shutter Priority mode (Canon: Tv, Nikon: S).

Because birds are constantly moving, a fast shutter speed is required to render them sharply focused. In Aperture Priority mode you set the aperture and, although shutter speed will vary with the light, it will always be the fastest possible for the current lighting conditions. If you determine the shutter speed is too slow, risking soft images, simply open up the aperture or, if it's already wide open, increase the ISO.

When might you want to use Shutter Priority? In some situations, you might want to lock in a specific shutter speed, for instance to produce intentional blurring for artistic effect. We'll explore creative use of shutter speed in chapter 13.

button on the back of camera. Those are a lot of things to think about while the heron has probably walked off round the corner by now and is enjoying a latté in the local coffee shop!

Manual mode actually makes all this much easier: Once your camera settings are made, you can forget them unless the light changes. Your attention stays on the bird wherever it goes.

One situation in which I would switch to auto-exposure is when I want

to continue shooting but the light is changing constantly, as when fast-moving clouds intermittently obscure the sun. Otherwise, for consistently reliable exposure, I use Manual exposure and I suggest you do, too.

Metering Modes

Modern camera models offer several methods of measuring subject brightness via the internal metering system. The differences between these metering modes lies in how much of the frame the meter covers. My strategy is to keep things simple; therefore, for efficiency in the field, I rely on the two patterns lying at the opposite extremes of metering coverage. Canon's Evaluative metering is my usual mode of choice, but when a particularly challenging exposure situation arises, I sometimes switch to Spot metering. Let's explore how these two metering patterns work.

Evaluative or Matrix Metering

With Evaluative (Canon) and Matrix (Nikon) metering, the entire scene in the frame is used to calculate the exposure. (Since I am a Canon user, I will refer to Evaluative throughout the book.) The camera's sophisticated algorithms analyze the tonal values across the scene, based on the results of which the

camera automatically sets exposure. This metering pattern works best for subjects and surroundings composed of even tonality and lighting. If your overall scene is middle toned, such as a Blue Jay amid autumn foliage on a bright-overcast day (figure 6.5), you can rely on Evaluative metering and the camera's suggested settings to provide the correct exposure.

However, if your overall scene is lighter than middle toned (refer back to figure 6.3, the robin in the snow), then, using Evaluative metering, you would need to increase the camera's suggested exposure settings, allowing more light to fall on the sensor. If your overall scene is darker than middle toned, using Evaluative metering, you would need to reduce the suggested exposure setting. Remember that without any intervention, the meter will tend to render the scene as middle toned. The goal is to keep light subjects light and dark subjects dark.

Note that when we refer to increasing or decreasing the exposure from the camera's suggested setting, this is done differently in Auto mode than it is in Manual mode. In an automatic mode, we simply dial in an exposure compensation value for how much we want to increase or decrease the exposure. In Manual mode, we change the camera settings (any combination of shutter, aperture, or ISO) until the exposure level matches the setting we want.

Figure 6.5: Blue Jay with colorful autumn foliage.
Manual exposure, Evaluative metering, EV 0. Canon EOS 7D with 500mm f/4L IS USM lens,
Gitzo tripod, 1/400 sec., f/5.6, ISO 640. New York.

Spot Metering

With Spot metering, the metering is limited to a very small spot in the viewfinder. On most Canon cameras, the spot is located at the center of the frame. Canon professional bodies allow the option of having the spot follow the focus point. On Nikon cameras, the spot always follows the focus point. Limiting the metering to a small spot enables you to obtain an accurate exposure reading from a specific part of the bird. Spot metering is especially useful for subjects with an extreme range of tonality or lighting, for instance backlit White Ibis against a dark background (figure 6.6). This is a situation in which using Evaluative metering would most likely result in an incorrect exposure reading, overexposing the white birds.

For scenes composed of very uneven lighting, it's a good idea to use the Spot meter and meter the brightest area. Here you would place the Spot meter area over the brightest whites on one of the ibis and add $1^{2/3}$ to 2 stops of light to the exposure reading the camera suggests thereby achieving accurate whites while retaining some feather detail. In contrast, to achieve the correct exposure using Evaluative metering, you may need to subtract as much as 2 stops of light for this scene due to the dark background.

Confused about when you add or subtract light? Join the club! Many people, including myself, have struggled with this concept. Remember, whether you add or subtract light depends on how much of the scene is being metered. In the high-contrast example in figure 6.6, you add light if you Spot meter a single white bird. You subtract light when using Evaluative metering because the meter reading is based on the entire, mostly very dark scene.

Other Metering Modes

In Center-weighted metering mode is averaged for the entire scene but more weight is given to the area in the center of the frame. Partial metering mode measures a large spot at the center of the frame. I do not use either of these modes.

Figure 6.6: White Ibis flying in against a dark background to join a flock resting on a sandbar. Back lighting and high contrast create a situation that calls for spot metering.
Canon EOS 7D with 400mm f/5.6L USM lens, handheld, 1/2500 second, f/9, ISO 1000. Tampa Bay, Florida.

Figure 6.7: Soft back lighting and snowy surroundings produce a scene of a Snowy Owl in flight that is very light in overall tonality.
Canon EOS 7D with 400mm f/5.6L USM lens, handheld, 1/1600 sec., f/5.6, ISO 800. Manual exposure mode, Evaluative metering, +1 EV. Barrie, Ontario, Canada.

settings unchanged. If the light changes, I repeat the process. This method works well in many, but not all, situations. For example, if I can't quickly see anything that is average toned and convenient to meter, I either meter the entire scene (as I did for a Snowy Owl in figure 6.7), or I switch to Spot metering the main subject. In either case, I increase or decrease the exposure according to how much the metered area differs from a middle tone. For figure 6.7, I added 1 stop of light (+1 EV) to the camera's suggested settings to keep the light tones light.

Making and Evaluating Exposures

Before we put exposure theory and metering pattern to work with some real-world examples, pay attention to two important camera functions that will help you get the best exposure possible in the field: the highlight alert and the histogram display.

Highlight Alert

If your image contains white or very light-colored areas, turn on your camera's highlight alert function and pay particular attention to it. Watch for the "blinkies!" Any bright areas that have lost detail through overexposure will show up as blinking areas during image

Hybrid Metering Method

In practice, I usually use a hybrid metering method in combination with Manual exposure mode. The camera is set to Evaluative metering mode but in essence I turn my telephoto lens into a giant spot meter. In situations where the subject is hard to meter accurately (for instance if it's moving around a lot) or for subjects or scenes that contain

wide extremes of tonality, I often set the exposure ahead of time thus: I meter something nearby that is in the same light as my main subject and is of known tonality. For me that is usually a middle-toned area—a patch of green grass or shrubbery, for example. I fill the viewfinder with that area, obtain a meter reading, adjust my settings until the exposure level indicator scale reads 0, then recompose and shoot leaving the

playback. Take test shots and reduce your exposure by 1/3-stop increments until the blinkies disappear.

Histogram

Locate your camera's histogram display. Make a habit of checking the histogram when you play back your images in the field. Examine the figures below. The histogram graphs the range of tonalities in your image. Darkest areas are shown on the left side of the graph, mid-tones appear in the middle, and the brightest areas are on the right. The histogram's appearance will vary depending on the range of tones in a given image.

In general, you should be doing what is referred to as *exposing to the right* (ETTR). This involves setting the exposure so the image's light tones fall well to the right of the center of the

histogram but do not touch the right edge (which would indicate overexposed or *clipped* highlights). The reason to expose to the right is to take full advantage of the camera's dynamic range and record the maximum number of tones possible. This approach also has the added benefit of minimizing the amount of noise in the image. If your subject has white areas, these should lie as close as possible to the right side of the histogram without touching the edge, ensuring that the brightest whites retain some detail. If data touches the left side it means dark areas are underexposed and lack detail.

Assuming you shoot RAW images, image-editing software can do an excellent job of recovering detail in light areas even if slightly overexposed. But it's always best (and vital if you shoot only JPEGs) to get the best possible exposure in-camera in the field, rather

than assume that exposure errors can be fixed later in the computer.

Fixing overexposed white areas isn't the only issue. Underexposed dark tones cause problems too: Lightening shadow areas during post-processing makes any ugly *noise* (the digital equivalent of film grain) that is present in dark areas much more visible.

Interpreting the Histogram

The image of a Baltimore Oriole in figure 6.8a is composed primarily of mid-tones. Its histogram shows the data is concentrated in the center of the graph. Notice the data does not touch the left side, reflecting the fact that the oriole's black head has feather detail.

The image of Northern Gannets in figure 6.8b contains bright white areas on the central bird's breast and under

Figure 6.8a: Histogram of a mid-toned scene.

Figure 6.8b: Histogram of a high-contrast scene.

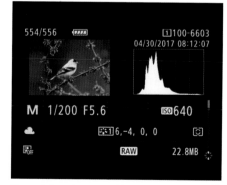

Figure 6.8c: Histogram of a dark scene.

wing, and a large expanse of dark-blue ocean. The white areas are represented by data on the right side of the histogram, but notice the data barely touches the right side, telling us that the whites are correctly exposed and that they maintain detail. The large peak on the left of the histogram represents the dark blue water.

The image of an American Goldfinch in figure 6.8c shows the bird against a dark background. Most of the image is dark in tone skewing the data toward the left side of the histogram. The small amount of data tailing off toward the right side represents the bird's light-yellow plumage.

Solving Real-World Exposure Issues

Now that we've covered taking control of our cameras, we can focus on how best to use them in the field to capture perfectly exposed bird photographs.

Into the Field

My typical procedure in the field is to size up the light direction and quality, and then determine the correct exposure before I start shooting. My camera is set to Manual exposure mode and Evaluative metering by default. I select the ISO: My default for birds on sunny days is ISO 400. Next, I choose an aperture: For individual birds my default is to shoot wide open (usually f/5.6 depending on which lens I'm using).

I take an in-camera meter reading from a middle-toned area of the surroundings that is in the same light as my subject (for instance, I might meter a patch of sunlit green grass or gray rocks). Next, I adjust the shutter speed until the marker on the camera's exposure scale lies in the center.

Suppose there is no mid-toned area to meter? You can meter anything for which you know the tonality; for instance in a winter marsh I might meter a patch of sunlit dead cattail stems that are light tan in color. Judging them to be about 1 stop brighter than mid-tone, I adjust shutter speed until the marker on the camera's exposure scale sits at one stop to the right of center. Finally, depending on whether or not I expect to shoot action, if the resulting shutter speed is not fast enough, I increase the ISO until I obtain a satisfactory one. Now I'm good to go!

Pick a Strategy, and Stick With It

Don't forget, there are several ways to achieve correct exposure—there's no one right way. My suggestions are just that: suggestions. It's up to you to experiment with different methods, to practice shooting under a variety of lighting conditions, and to evaluate the resulting images in the field. Once you discover which method consistently works best for you, stick with that strategy.

Let's explore real-world exposure issues with some examples from the field.

Even Front Lighting with a Middle-Toned Subject and Background

An evenly illuminated, overall mid-toned scene such as a group of preening Roseate Spoonbills (figure 6.9) standing in blue water is a straightforward exposure. I metered a patch of the blue water by pointing my lens slightly off to the side of the birds. Since both the pink birds and the blue water are middle toned, all I had to do was zero my camera's exposure level scale marker (by changing the shutter speed in the case of this film image, since the ISO was fixed) and use the resulting settings. Finally, I recomposed to include the birds and made the exposure.

White Subject, Middle-Toned Background

Exposing white birds correctly requires particular care...there's a fine balance between showing the brilliance of pure white plumage and retaining detail in the feathers. Consider a Snowy Egret taking flight over medium-blue water

Figure 6.9: A flock of preening Roseate Spoonbills in blue water on a sunny morning.
Nikon F4 with Nikkor 400mm f/3.5 IF manual focus lens, Fuji Velvia film, matrix metering mode, EV 0. Camera settings not recorded. J.N. "Ding" Darling National Wildlife Refuge, Florida.

(figure 6.10). Following exposure theory, if you metered only the mid-toned blue water and then recomposed to include the egret in the frame, the whites should be correctly exposed. In practice, however, this often isn't true; the white plumage ends up overexposed and lacking detail. You need to reduce light from the suggested settings. Much depends on the quality of light hitting the bird, so it's essential to avoid photographing white birds in the harsh light that develops when the sun is high in the sky.

I had a great advantage here: predictable behavior. The egret repeatedly

Figure 6.10: Snowy Egret in flight against blue water on a sunny day.

Manual exposure, Evaluative metering. Metered water −1 EV. Canon EOS 1D Mark III with 400mm f/5.6L USM lens, handheld, 1/5000 second, f/5.6, ISO 500. Viera Wetlands, Florida.

returned to the same perch, flying out over the water again and again to pick up prey from the water's surface. While the bird was perched, I metered the blue water and changed my settings manually until the exposure level indicator read −1, recomposed to include the bird in the frame, and waited for it to take flight.

Another strategy would have been to spot meter the whitest part of the egret (this is often the head or back), and change settings until the exposure level read +1²/₃ or +2.

Especially with white subjects, it's best to take test shots, play back your images, check the histogram, and pay attention to the highlight alert, watching

for blinking hotspots. Then adjust exposure as necessary.

Overall Light-Toned Scenes

Scenes that are mostly very light overall, such as those in which snow fills a large part of the frame, require more light than the camera's meter would suggest to avoid underexposure. The camera's tendency to render a given scene middle toned would cause a snowy scene with a Northern Cardinal, portrayed small in the frame (figure 6.11) to end up with dull, gray-colored snow and a too-dark bird. Working from a backyard blind on a bright-overcast day, I made my exposure settings before the cardinal arrived by metering the snowy branches and changing my settings until the exposure level indicator scale read +1$^{2/3}$ stops. This enabled me to keep the snow white.

In another very light-toned scene, soft back lighting shines through the outspread wings of a Great Egret coming in for a landing (figure 6.12). High cloud cover reflected on the water, plus the white bird, combine to produce a scene that overall is substantially brighter than middle tone. To retain the light, airy look, I changed my settings until the exposure level read +1$^{1/3}$. Unlike front lighting, back lighting portrays birds impressionistically. The "correct" exposure is open to interpretation. You're free to experiment. This image

would have been just as compelling, although projecting a different mood, if it had been 1 EV (or even more) darker or lighter.

Backlighting and Silhouettes

The silhouette is a familiar method of portraying birds creatively, reducing the subject to its most basic graphic form:

a black shape in bright surroundings. Silhouetting occurs when a subject is strongly backlit amid very bright surroundings. It's most effective, of course, when the surroundings are colorful: a vivid sunrise or sunset sky, or the sky's reflection in a body of water.

If the sun is near the horizon, you have the choice of whether or not to include it in the image. For a silhouette without the sun in the frame, take an

Figure 6.11: Northern Cardinal perched amid snow-covered branches under a bright-overcast sky. Manual exposure mode, Evaluative metering. Metered snow +1$^{2/3}$ EV. Canon EOS 5D Mark II with EF 500mm f/4L IS lens, 1.4× converter, Gitzo tripod, 1/500 sec., f/5.6, ISO 400. New York.

Figure 6.12: A backlit Great Egret about to land.

Manual exposure, Evaluative metering. Metered entire scene + 1$^{1/3}$ EV. Canon EOS 1D Mark III with 400mm f/5.6L USM lens, handheld, 1/3200 sec., f/5.6, ISO 400. Bolsa Chica Ecological Reserve, California.

exposure reading from the bright surroundings, and then either go with the camera's suggested settings or increase or decrease the exposure, depending on how bright you want the surroundings to appear. Settings for silhouettes can be subjective...you can generally vary the exposure by a stop or more in either direction to change the mood of the shot while still silhouetting the main subject. Finally, recompose to frame the bird or birds, and make the exposure.

For silhouettes or other situations in which the "correct" exposure can be quite subjective, some photographers prefer to turn on the camera's Live View function and evaluate the scene on the camera's LCD monitor instead of looking

through the viewfinder. In Canon cameras, while in Live View, enable Exposure Simulation to obtain an accurate estimation of how the image will look with the current settings. Adjust settings until you get the appearance you want before taking the shot.

By the time I came upon two Double-crested Cormorants perched on a log in a lake (figure 6.13), the sun was already too high to be included. I metered the bright water and changed my settings until the exposure level indicator read +1. I also changed the camera's white balance to the Shade setting (color temperature 7000 K) to warm the color of the water. Then, I recomposed to include the birds. Luckily for me, one cormorant maintained its distinctive wing spread pose while I made these settings, and when the other threw back its head to yawn, I had my shot!

Figure 6.13: Double-crested Cormorants in silhouette.

Manual exposure mode, Evaluative metering. Metered bright water +1 EV. Canon EOS 7D Mark II with EF 500mm f/4/L IS II lens, 1.4× III converter, 1/4000 sec., f/5.6, ISO 640. Montezuma National Wildlife Refuge, New York.

Including the Sun in the Frame

A telephoto lens produces a greatly magnified sun that, when included in the frame, can be quite sensational. A dire warning though: It's vital to realize the very real risk of eye damage that can occur when viewing the sun through your lens. This is a case where it would be much safer to use Live View. In general, it's best to avoid including the sun unless it's very low on the horizon or partly shrouded by mist or thin cloud.

Because the sun is so bright, including it in the frame presents an exposure challenge. If you do intend to include it, don't try to obtain an exposure reading while the sun or any part of it is in the frame—which risks the rest of the frame being substantially underexposed—even if the sun is at the horizon or is muted by mist or haze. Instead, meter an area adjacent to the sun and then recompose to include it as I did for a scene of Sandhill Cranes in flight at

sunrise (figure 6.14). Avoid increasing the exposure setting, or the sun will end up being an overexposed white disk.

Light or White Subject with Dark Background

American Avocets forage by walking through water while sweeping their bills from side to side. If an avocet catches prey, it raises its bill briefly from

Figure 6.14: Greater Sandhill Cranes take flight at sunrise.

Manual exposure, Evaluative metering. Metered an area not including the sun, EV 0. Canon EOS 7D Mark II with Canon EF 100–400 mm IS II lens (at 349mm), handheld, 1/2500 sec., f/11, ISO 400. Platte River, Nebraska.

Figure 6.15: American Avocet foraging.

Manual exposure, Evaluative metering. Metered sunlit vegetation outside frame, EV 0. Canon EOS 1Ds Mark II with 500mm f/L4 IS USM lens, 1.4× teleconverter, Gitzo tripod, 1/1600 sec., f/5.6, ISO 500. San Joaquin Wildlife Sanctuary, California.

the water in mid-sweep, often creating a splash that shows up dramatically against a dark background (figure 6.15).

The high-contrast scene presents an exposure challenge: very uneven lighting with the sun coming strongly from the side. To solve this, I used the hybrid metering strategy described earlier. I metered some mid-toned sunlit vegetation a short distance outside the frame by swinging the lens to the side and filling the viewfinder with the foliage. I adjusted the settings until the exposure level indicator read 0 and then—leaving the settings unchanged—swung the lens back to frame the avocet in the deeply shaded water.

Finding a Common Loon in a shrinking pool of light surrounded by dark water just before the sun went down (figure 6.16), I had to work quickly with no time for my usual hybrid exposure method. Using Evaluative metering mode the conventional way (in other words, to meter the entire scene), I changed the settings until the exposure level read −2 to compensate for the dark background. This enabled me to keep detail in the very small amount of white in the frame.

Figure 6.16: Common Loon preening in the last light of day.
Manual exposure mode, Evaluative metering, metered entire scene −2 EV. Canon
EOS 1Ds Mark II with 500mm f/4L IS USM lens, 1.4× teleconverter, Gitzo tripod,
1/500 sec., f/5.6, ISO 250. Michigan.

Going Forward with Exposure

Exposure is a topic that many new photographers struggle to understand. Taking the first step toward using Manual exposure mode may seem daunting, but I believe it's the best way to be able to fully express your creativity. And you'll find it really isn't as difficult as it seems. As with all photographic techniques, the best way to overcome your fears is to go out there and practice!

We have considered exposure examples that range from straightforward subjects composed mostly of mid-tones to challenging subjects containing extremes of light and dark tones. Now it's up to you to put the strategies I've described in this chapter into practice. Start with the easiest situations— evenly lit mid-tones such as the female Northern Cardinal in figure 6.17—and then, when you feel confident of your exposures, step outside your comfort zone to experiment with more challenging subjects and more unconventional lighting situations.

One of the huge advantages of digital photography is the ability to immediately evaluate your results in the field, and in no aspect of photography is that more useful than in checking exposure. When playing back your images, make it a habit to examine the histogram and watch for highlight alerts so you can adjust the exposure as needed and try another shot. Keep practicing and you'll soon be making exposures like a pro!

Figure 6.17: Female Northern Cardinal on a winter day. An example of a mid-toned scene and a good subject to pick when first practicing exposure methods.
Canon EOS 1Ds Mark II with 500mm f/4L IS USM lens, 1.4× teleconverter, Gitzo tripod, 1/800 sec., f/5.6, ISO 640. New York. (Right)

Chapter 7

COMPOSITION BASICS

I can't yet see them through the photo blind's peephole, but the buzzy voices coming from the tree overhead tell me that a flock of Common Redpolls has arrived in the yard. Soon, they are fluttering down like falling snow onto the branches set up near the bird feeder. Once within view, a particular female with snowflakes adorning her head catches my eye, but just as I focus on her another appears in the background forming an intriguing out-of-focus shape. Holding my breath, I slowly swing the lens to the side to frame both birds and for an instant I have a lovely composition with the second redpoll mirroring the first. No sooner have I captured the image than they are gone.

Figure 7.1: A close-up, vertical composition transforms a displaying Peacock into an artistic design.
Canon EOS 1D Mark III with 500mm f/4L IS USM lens, Gitzo tripod, 1/200 sec., f/8, ISO 640. Irvine, California.

Amid the excitement of seeing a beautiful bird in the viewfinder it's all too easy to be preoccupied with technique and to forget artistry. We often lose sight of the fact that composition—how the subject and surrounding elements are arranged within the frame to form a cohesive whole—is equally important. Compelling composition has the potential to elevate an image from the level of documentation to that of art (figure 7.1) and can forge a strong emotional connection with the viewer. This chapter introduces some guidelines to help you avoid common compositional mistakes and we will explore basic design principles to guide you toward creative, impactful images.

Quick-Start Guide to Better Composition

While reviewing bird photographers' images, especially beginners but even seasoned shooters, I notice the same composition errors coming up again and again. Listed below are remedies for the most common faults. I'll address each of them in detail in the following pages, and present some additional pointers for designing pleasing images.

- **Give the bird some space:** When showing an entire bird, don't frame too tightly.
- **Vary the image orientation:** Explore vertical as well as horizontal framing.

- **For close-ups, avoid cutting off body parts:** Frame carefully but decisively.
- **Place the subject off center:** Avoid the boring bullseye look.
- **Avoid cluttered backgrounds:** What's behind the bird can make or break the shot.
- **Keep distractions out of the frame:** Check for distractions before pressing the shutter button.
- **Shoot from bird's eye level:** Shoot at eye level for a sense of connection with the subject.
- **Wait for a good head angle:** A slight turn of the head can make a big difference.

Framing the Image

When you're thrilled with the magnification power of your new telephoto lens, your first inclination is to fill the frame with the entire bird to wow your viewers! Full-frame birds quickly become boring, though. They may work fine as identification aids in a field guide but, if your goal is to keep your audience interested, resist the temptation to tightly frame every subject.

A cramped subject leaves the viewer with a sense of visual discomfort. What happens when you look at the tightly cropped White-faced Ibis in figure 7.2a? Your attention first rests on the bird but soon your eye starts to wander whereupon it immediately collides with the

Figure 7.2a: White-faced Ibis. Framing a bird tightly may seem appealing but it results in a cramped composition.

image's frame. Ouch! Leaving some space for the bird to figuratively move or look into creates a better sense of balance (figure 7.2b). The actual amount of space is somewhat subjective but a good rule of thumb is to leave twice as much space in front of the bird as there is behind it, and leave slightly more space above the bird than below.

Increase Your Composition Options

Once you frame the main subject too tightly, the options for interesting composition, especially with regard to the image's orientation, are severely limited. One of the first composition decisions you should make is whether the photo works best oriented as a vertical (sometimes called *portrait*) format or as a horizontal (*landscape*) format. To

Figure 7.2b: Leave some space around the bird for a more balanced composition.

Both images: Canon EOS 1D Mark III with 500mm f/4L IS USM lens, 1.4× teleconverter, Gitzo tripod, 1/640 sec., f/5.6, ISO 500. San Joaquin Wildlife Sanctuary, Irvine, California.

a certain extent, this is constrained by the shape of the bird and how large it appears in the image. A full-body shot of a woodpecker clinging to a tree trunk can only be oriented vertically, whereas a tightly framed swimming duck would naturally be horizontal. These are compositional dead ends.

Instead, free up your options by framing loosely, even to the point of showing the main subject quite small and including its habitat or surroundings. In this way, a woodpecker in its habitat could be oriented horizontally or a duck could be portrayed as a vertical (figure 7.3). Not only will your compositions have the potential be more artistic, but also by

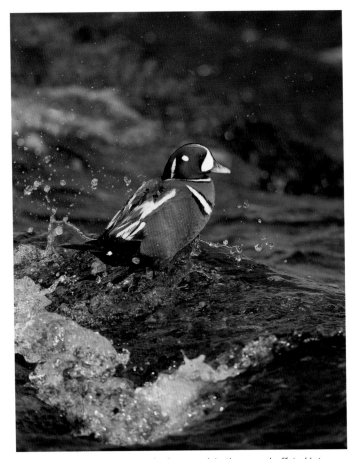

Figure 7.3: Harlequin Duck perched on a rock in the wave-buffeted intertidal zone. Framing loosely to include a bird's habitat increases your options for composition as well giving you the ability to create story-telling images.
Canon EOS 1Ds Mark II with 500mm f/4L IS USM lens, 1.4× teleconverter, Gitzo tripod, 1/1600 sec., f/5.6, ISO 320. Barnegat Inlet, New Jersey.

including the bird's habitat, your images can become more journalistic—telling a story about birds' lives. (We'll discuss portraying birds in habitat in chapter 11.)

Alternatively, you can frame very tightly by approaching closer, adding a teleconverter, or zooming your lens to a longer focal length, to show just part of the bird such as a head and shoulder portrait.

Before you press the shutter button, think more creatively about how to compose your images. Captivate your audience with an interesting variety of compositions and formats rather than a string of tight portraits that all look similar.

Horizontal or Vertical? Vary the Orientation!

Novice bird photographers, especially if they're handholding gear, tend to shoot only horizontal images. One reason may be simply that camera bodies are easier to grip and more intuitive to operate when held horizontally. Instead, explore the subject in both orientations and take advantage of compositions that would be better as verticals. (Tip: Use a tripod! Exploring composition thoughtfully and deliberately is much easier and less tiring if gear is supported by a tripod rather than handheld.)

SWITCHING IMAGE FORMAT

Switching from horizontal to vertical or *vice versa* is easy if your telephoto lens has a tripod collar and is mounted on a tripod: Simply loosen the tripod collar and rotate the lens barrel ninety degrees. With handheld gear, operating the camera vertically is far less comfortable unless the camera has a vertical grip that puts an entire duplicate set of controls, including the shutter button, within easy reach. In professional camera bodies, vertical controls are part of the built-in battery compartment. For other cameras, a vertical grip/battery pack is an optional accessory that may be purchased separately. It's worth the money!

Avoid Random Amputations

Deciding where to make the cut-off line when zooming in for a head shot or partial body shot is tricky and somewhat subjective. One important thing to avoid, though, is cutting off body parts randomly. Instead, frame or crop decisively. A common mistake among beginners is an image that is neither a full body nor a true close up—in the desire for a large subject size just the tail tip or feet may be inadvertently cut off! Notice how awkward the unfortunate Limpkin in Figure 7.4 appears. Either frame tighter or move back to include the feet.

If doing the latter, what if the feet are hidden such as under water or behind vegetation? It still looks better

Figure 7.4: The absence of feet makes this Limpkin appear decidedly awkward! When composing, either include the feet or frame tighter for a head and shoulders shot.
Canon EOS 1D Mark III with 400mm f/5.6L USM lens, handheld, 1/2000 sec., f/5.6, ISO 640. Viera Wetlands, Brevard County, Florida.

to include space below the bird's body where the feet would appear if they were visible.

When framing a head and neck shot, a useful rule of thumb is to include part of the bird's back and/or shoulder as well to act as a compositional anchor, as the Great Blue Heron in Figure 7.5 shows.

Where to Place the Subject

Shooting loose to include surroundings comes with a challenge: where to position the bird in the frame. I see far too many bird photos with the subject dead center—a static composition that quickly loses the viewer's attention. Many photographers rely heavily on the central autofocus point(s) and the result is a bullseye image. To create more visually stimulating compositions, get comfortable with moving autofocus points around the frame so you can position the bird off center, leaving space in the direction in which it is facing or moving. Of course, there are situations in which centering the subject is perfectly acceptable, even desirable; for example a tall, vertical close-up such as the displaying peacock in figure 7.1, a close bird flying straight toward you, or a shot in which the main point is action. Otherwise, particularly if the bird takes up only a small part of the frame, off-center placement creates a much more dynamic composition.

Figure 7.5: Great Blue Heron portrait, I framed carefully to include the heron's back and neck, including the beautiful nuptial plumes.
Canon EOS 1Ds Mark II with 500mm f/4L IS USM lens, 1.4× teleconverter, beanbag over vehicle window, 1/1000 sec., f/8, ISO 160. Montezuma National Wildlife Refuge, New York.

Figure 7.6: Heermann's Gull with 3×3 grid to illustrate the rule of thirds.
Nikon F5 with Nikkor 500mm f/4 AF lens, Fuji Provia film, camera settings not recorded.
Orange County, California.

Figure 7.7: Acorn Woodpecker with some of its stored acorns. Including a bird's habitat or surroundings in the frame can tell a story about its life.
Canon EOS 1Ds Mark II with 500mm f/4L IS USM lens, 1.4× teleconverter, Gitzo tripod, 1/200 sec., f/8, ISO 400.
Irvine, California.

The Rule of Thirds

The classic guideline for subject placement is known as the rule of thirds. It's a way of organizing the main subject and other elements of your image into a well-balanced arrangement rather than placing them randomly. Looking through your viewfinder, imagine there are lines dividing the frame into thirds both horizontally and the vertically. Compose so that the subject or its most important part (usually the eyes and face) is positioned approximately where the lines intersect (these intersections are sometimes referred to as *power points*). For example, in figure 7.6, the face of the Heermann's Gull is near

the upper-right power point. To understand how the rule of thirds applies to multiple birds, look at the image of two Common Redpolls at the beginning of this chapter. Imagine the 3×3 grid being overlaid on this image and notice that the foreground bird is positioned over the left vertical line with its face near the upper-left power point, and the background bird is positioned over the right vertical line with its face near the upper-right power point.

In a composition in which the bird is only a small part, such as a bird in its habitat, you would place the entire bird on or near one of the power points or over one of the grid lines, as I did with the Acorn Woodpecker in figure 7.7. Including the habitat in a composition is a great way to tell a story about the bird's life. To illustrate unique acorn storing behavior of this species, I filled much of the frame with the acorns, each in its individual hole and placed the bird to one side. This created a composition that

Figure 7.8: Northern Cardinal perched in mesquite. The twigs in the background are distracting.
Canon EOS 1D Mark III with 500mm f/4L IS USM lens, Gitzo tripod, 1/640 sec., f/5.6, ISO 400. Rio Grande Valley, Texas.

Figure 7.9: Northern Cardinal after the bird moved to allow for a more pleasing, out-of-focus background.
Canon EOS 5D Mark II with EF 500mm f/4L IS lens, 1.4× converter, Gitzo tripod, 1/320 sec., f/5.6, IS 500. Rio Grande Valley, Texas.

GRID DISPLAYS TO AID COMPOSITION

It's hard to perform mental geometry at the same time as trying to focus on a moving bird! Luckily, cameras can display a grid to aid composition, visible in the viewfinder or on the back of the camera when shooting in Live View mode. Scroll through the camera's menus or refer to the user guide for "viewfinder grid display." The available grid patterns might not be 3×3 (in the Canon EOS 7D Mark II for instance the pattern is 6×4) but any grid pattern will help you avoid the boring bullseye look and create more interesting compositions.

encourages the viewer's eye to explore the entire frame rather than staying on the bird. Train yourself to recognize interesting and meaningful compositions in the field, and capture them in-camera, although you always have the option of cropping during postprocessing to improve your design.

Background Check

What's behind the bird can make or break an image. A clean background allows your subject to stand out from its surroundings whereas clutter behind the subject is confusing and distracting. Before you click the shutter, take time to look past the bird at the background. Flaws like the twigs directly behind the Northern Cardinal's head in figure 7.8 may be obvious when you're reviewing images, but they can be surprisingly easy to overlook when you're intently staring through the viewfinder. Shooting from a fixed blind, I had no way to remedy the situation other than to wait until the bird perched against a more distant background of out-of-focus vegetation (figure 7.9).

Figure 7.10a: Yellow-headed Blackbird with a distracting stem behind its head.
Canon EOS 7D Mark II with EF 500mm f/4/L IS II lens, 1.4× teleconverter, beanbag over vehicle window, 1/1250 sec., f/5.6, ISO 500. Bear River National Wildlife Refuge, Utah.

Figure 7.10b: Yellow-headed Blackbird after slightly changing my position to avoid a cattail stem behind the subject's head.
Canon EOS 7D Mark II with EF 500mm f/4/L IS II lens, 1.4× teleconverter, beanbag over vehicle window, 1/1250 sec., f/5.6, ISO 500. Bear River National Wildlife Refuge, Utah.

Improve the Background by Changing Perspective

Something as simple as a small change in perspective can improve the background substantially. Moving from side to side or slightly raising or lowering your tripod alters the spatial alignment of elements within the frame and thereby enables you to omit distractions from the background. For instance, the Yellow-headed Blackbird in figure 7.10a initially had a distracting cattail stem behind its head, but by moving my vehicle a few feet forward, I repositioned the offending stem in the frame so it no longer interfered with the bird (figure 7.10b).

Shooting from a slightly lower or higher angle can help avoid having a bold horizon line behind the bird's head, neck, or body; such as where shoreline meets water or tree line meets sky. A horizon line, unless it is distant and out of focus, can appear to cut the subject in half. Changing the tripod height to reposition the horizon in the frame is one way to solve the problem.

Once you have a cooperative bird in the frame, rather than stay in one position, it's well worth taking time to explore the subject from multiple angles to see how you might improve the background or the composition in general.

The Lowdown on Low-Angle Shooting

Images captured from a bird's eye level are always compelling. For birds on the ground or on water, get as low down as you can by sitting or lying on the ground. The problem with shooting downward from a higher angle is that the immediate surroundings, which are on essentially the same focal plane as the bird, form the background. While those surroundings—whether fallen

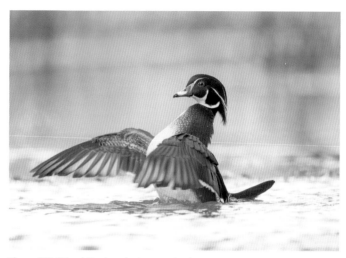

Figure 7.11: Wood Duck male, low angle view.
Canon EOS 7D Mark II with EF 500mm f/4/L IS II lens, 1.4× III teleconverter. Gitzo tripod, 1/800 sec., f/5.6, ISO 800. Ithaca. New York.

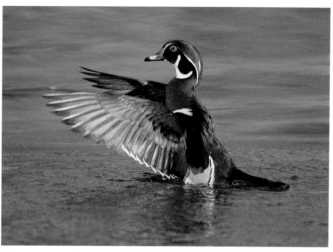

Figure 7.12: Wood Duck male with a higher angle of view.
Canon EOS 1D Mark III with 500mm f/4L IS USM lens, 1.4× teleconverter, Gitzo tripod, 1/1000 sec., f/5.6, ISO 400. Near Cleveland, Ohio.

leaves on the ground or ripples on water—may sometimes be attractive or form interesting patterns, they also compete with the bird for attention.

Shooting from a low angle, on the other hand, separates the subject from the background. It also creates a powerful sense of connection with the subject. Compare the two Wood Duck images, one taken from close to water level (figure 7.11) and the other taken from a boardwalk above a pond (figure 7.12). Although both images may be considered good, the duck portrayed from a lower angle appears more engaging and stands out better from the background.

Shooting angle is only one of several factors that influence how well the main subject stands out from its surroundings. Subject-to-background distance is obviously important—the bird will stand out better from a distant background. Photographer-to-subject distance and lens focal length are also important: Approaching closer or using a longer focal length lens will also help separate the bird from the surroundings. Another factor is aperture setting, referred to by the f-stop or f-number.

Aperture, Depth of Field, and Background

Recall that the size of the aperture controls the image's depth of field: the zone between the nearest and farthest areas of the image that appears sharply focused. Depth of field can be used creatively: A shallow depth of field (small f-number) isolates the main subject from the background whereas a deeper depth of field (large f-number) brings attention to the surroundings or background elements as well. The following two examples illustrate creative use of depth of field.

Figure 7.13: Horned Puffins. A small aperture produces a large depth of field, ensuring all the birds are within the zone of acceptable sharpness.
Canon EOS 7D Mark II, EF100–400mm f/4.5–5.6L IS II USM lens at 170mm, 1/125 sec., f/16, ISO 1250. St. Paul, Pribilof Islands, Alaska.

Figure 7.14: Horned Puffins. A large aperture produces a shallow depth of field, isolating the foreground subject from the background.
Canon EOS 7D Mark II, EF100–400mm f/4.5–5.6L IS II USM lens at 135mm, 1/2000 sec., f/5.6, ISO 1250. St. Paul, Pribilof Islands, Alaska.

The Horned Puffins in figures 7.13 and 7.14 were captured handheld using a 100–400mm lens and at the same ISO. In figure 7.13, since the puffins were spaced fairly close together, I used the standard method for multiple birds in the same frame: I stopped down to a small aperture (in this case to f/16) so the entire group fell within the zone of acceptable sharpness.

Minutes later, another puffin landed slightly closer to me but was more separated from rest of the group. I backed off a couple of feet and zoomed the lens to a slightly shorter focal length to include the newcomer in the frame (figure 7.14).

In contrast to the previous shot, though, I opened up the aperture to f/5.6 for a shallow depth of field and used selective focus to isolate the foreground bird from those in the background. Note that the foreground bird does not overlap any of the background puffins, which otherwise might have been distracting. To achieve this, rather than step to the side (since I was on the edge of a fifty-foot cliff!), I cautiously leaned side to side while looking through the viewfinder until there was good separation between the foreground and background birds.

Figure 7.14 demonstrates that a completely smooth, even-toned background is not necessary to create bird photos with great impact. As long as out-of-focus background elements don't overwhelm the main subject, you may want to include them in the composition. Consider the out-of-focus bright highlights formed by the sun reflecting off of water drops and other reflective objects. Some photographers find them unattractive, but I view them as having great creative potential and often include them in a composition (figure 7.15). (We'll explore this concept further in chapter 13.)

Figure 7.15: A backlit Red-winged Blackbird displays in a cattail marsh. I purposely included the out-of-focus highlights in the composition.

Canon EOS 5D Mark III with EF 500mm f/4/L IS II lens, 1.4× converter, Gitzo tripod, 1/1250 sec., f/5.6, ISO 500. Ithaca, New York.

When to Break the Rules

Sometimes there are good reasons *not* to portray a bird well separated from its background but blending in with its surroundings instead. Elusiveness and camouflage may be a unique character and a strategy for survival for a particular species; something a photographer might want to show in a composition. Think of the American Bittern's strategy of hiding in a marsh by standing tall with its bill pointing skyward, gently swaying to and fro to mimic the cattails moving in the wind, or the Brown Creeper's camouflaged plumage that hides it against a pattern of bark (figure 7.16). Images such as this force the viewer to work harder, but that may actually enhance the image's appeal, particularly if the overall composition contains an interesting or intriguing pattern.

Figure 7.16: Patterned plumage camouflages a Brown Creeper against tree bark.
Canon EOS 1Ds Mark II with 500mm f/4L IS USM lens, 1.4× teleconverter, Gitzo tripod, 1/200 sec., f/5.6, ISO 500. Sequoia National Forest, California.

Head Angle

In an image of any living creature, the eyes are what first attract our attention. In a bird portrait, eye contact is something to strive for, and that depends in large part on the bird's head angle. Compelling eye contact is easily achieved with owls and diurnal birds of prey such as the Peregrine Falcon in figure 7.17, which have forward-facing eyes and binocular vision. Most other species—including shorebirds, waterfowl, and songbirds—have eyes on the sides of their heads, making eye contact more challenging to achieve. Photos of these birds tend to show the head in profile view, parallel to the plane of the sensor to ensure both eye and bill are in focus, but this pose lacks a sense of connection with the viewer. Instead, wait to press the shutter button until the head is turned very slightly toward you, like that of the Northern Cardinal in figure 7.9. With a slight change in head angle, the tip of the bill usually will remain in approximately the same plane of focus as the eye, unless you are shooting at very close range. If you are concerned about the depth of field, stop down the aperture slightly.

When considering the bird's head angle, don't forget the catchlight! This reflection of the light source (whether that is a bright sun or an overcast sky) provides dimensionality to the eye and makes the bird come alive. Make sure a

Figure 7.17:
Peregrine Falcon juvenile female.
Canon EOS 1D Mark III with 400mm f/5.6L USM lens, handheld, 1/1000 sec., f/5.6, ISO 800. Long Beach, California.

catchlight is visible before you press the shutter release.

Stare Down!

There's no need to be swayed by convention—many birds look very dramatic, even bizarre, when viewed face-on. The most successful shots are those in which both eyes are visible and the depth of field is large enough to ensure that eyes and bill both appear in sharp focus. To achieve an adequate depth of field for the Red-faced Cormorant in figure 7.18, for instance, I stopped down the aperture to f/11. An alternative and somewhat unconventional way to optimize your depth of field in a close up, face-on image such as this is to wait

Figure 7.18:
Red-faced Cormorant.
Canon EOS 7D Mark II with
EF 100–400 mm IS II lens
(at 360mm), handheld,
1/125 sec., f/11, ISO 1000.
St. Paul, Pribilof Islands,
Alaska.

until the bird's bill is pointed directly
downward or upward so that it is on or
near the same focal plane as the eyes.

The Over-the-Shoulder Look

The glance back over a shoulder is one
of the most appealing poses a bird can
adopt (and one that human fashion
models employ frequently!). Any time a
bird turns its head to look in a dramati-
cally different direction from the one
in which it was previously facing or
moving, there is potential for a dynamic,
eye-catching image (figure 7.19).

This head position works particularly
well with a woodpecker clinging to a
tree trunk (figure 7.20). It introduces
an element of surprise, contrasting
with the more often seen—and rather
static—view of a woodpecker facing a
tree. When the bird turns its head away
from the tree, it changes from a simple
vertical shape to one with a diagonal
line formed by its bill. The result is much
more dynamic and visually compelling,
giving the viewer the impression that
the woodpecker is about to take flight.
And often that is exactly what the bird
does!

Figure 7.19: Common Loon and its chick look back at the photographer.
Canon EOS 1D Mark III with 500mm f/4L IS USM lens, 1.4× teleconverter, Gitzo tripod, 1/640 sec., f/8, ISO 250. Michigan.

Figure 7.20: Red-bellied Woodpecker male strikes a dynamic pose by looking back over its shoulder.
Canon EOS 7D Mark II with EF 500mm f/4L IS II lens, Gitzo tripod, 1/640 sec., f/5.6, ISO 640. Ithaca, New York.

Visual Rhythm

Be on the lookout for multiple birds arranged in such a way that they form a pattern; a series of repeated shapes that work together as a whole. Such "visual rhythm" can produce an eye-catching composition. I immediately realized the potential of a nicely aligned group of three Black Skimmers (figure 7.21). After focusing on the closest bird's face, I carefully edged side to side and adjusted the tripod height until the group's heads and bills formed an interesting diagonal pattern while keeping some separation between them. (Note that a distracting out of focus bird on the far left of the frame that could not have been omitted without ruining the juxtaposition of the skimmers was removed during postprocessing.) You might find visual rhythm

Figure 7.21: Three Black Skimmers form a pleasing line-up.
Canon EOS 1Ds Mark II with 500mm f/4L IS USM lens, Gitzo tripod,
1/2000 sec., f/5.6, ISO 200. Fort De Soto Park, Florida.

with a single bird, too, for instance, by including another object in the composition, such as a curved branch that happens to mirror the bird's shape.

Figure 7.21 illustrates several additional factors that are pertinent to the composition process. First, diagonal lines and patterns are compelling design elements, conveying a sense of dynamism and visual tension.

Next, when photographing groups of birds, an odd number in the frame makes a more interesting composition than does an even number. Again, it involves visual tension: An odd number creates a slight sense of imbalance that attracts the eye, whereas an even number makes a more comfortable, and therefore static, composition.

Finally, when you have more than one bird in the frame, beware of "merges." Overlapping bodies can be acceptable, but because our attention is instinctively drawn to eyes, it's best that faces and eyes don't overlap and become hidden.

Cropping to Improve Composition

Try as you might to get the perfect composition in the field, there are likely to be many images that benefit from cropping during postprocessing.

Examine your images for any space that does not serve a good purpose and

Figure 7.22a: Original version of an aggressive interaction between two Crested Caracaras. The birds were framed too far to the left, which resulted in an unbalanced composition.

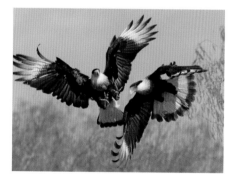

Figure 7.22b: Crested Caracaras. This cropped version has created a more balanced arrangement.
Both images: Canon EOS 1D Mark III with EF 70–280 mm f/2.8L IS USM lens at 280mm, 1.4× teleconverter, handheld, 1/2000 sec., f/6.3, ISO 400. Rio Grande Valley, Texas.

that could be cropped to improve the balance of your design. It often happens, for instance, that you've captured some exciting action but the framing is less than ideal. Once, I photographed a sudden aggressive interaction between two Crested Caracaras but the images were poorly framed with the birds so far to the left that I clipped the wingtips of one of them. Despite that flaw, I felt that one image warranted saving (figure 7.22a). Notice the caracaras' strong sense of movement toward the left of the frame but how the empty space on the right of the frame sets up a feeling of visual imbalance, which draws the eye away from the main action. By cropping away that empty space I achieved a better-balanced composition (figure 7.22b). It bears noting that if the birds had been moving in the opposite direction—i.e., into the frame—the original, uncropped composition with the subjects off-center would have worked quite well.

Certain images can benefit from being cropped to a different orientation than the original. While photographing a pair of Royal Terns, I was struck by how they seemed to cross bills as they circled each other during their dignified courtship ritual (figure 7.23a). I shot the original as a horizontal, but in hindsight, it would have been better to get closer and rotate the camera body ninety degrees because later, during postprocessing, I decided the image had much more

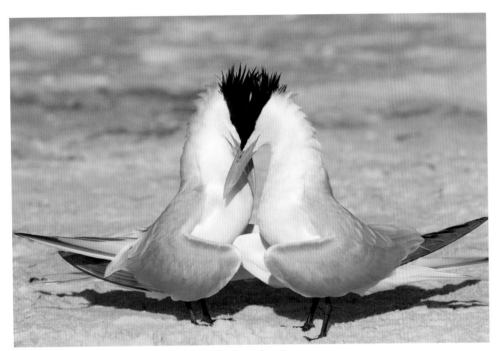

Figure 7.23a: Royal Tern pair courting. Original horizontal capture.

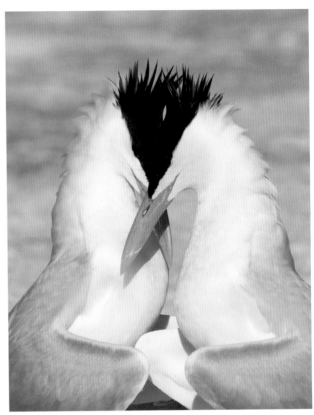

Figure 7.23b: Royal Tern pair courting. Cropping to a vertical closeup created a more impactful image. (Note: I also lightened the dark beach detritus in the background.)

Both images: Canon EOS 7D with EF 400mm f/5.6L USM lens, handheld, 1/3200 sec., f/8, ISO 500. Fort De Soto Park, Florida.

impact as a close-up vertical (figure 7.23b). The crop tool came to the rescue!

Be aware that you lose pixels when cropping during post-processing. Unless your camera model is capable of capturing large files, image quality may suffer from drastic cropping, limiting how large you can satisfactorily reproduce the photo. (Note that certain photo contests require images to be only minimally cropped during postprocessing.) But don't let that prevent you from experimenting with cropping: You may come up with a fun surprise, such as a tall, narrow crop of a Brown Pelican's face (figure 7.24).

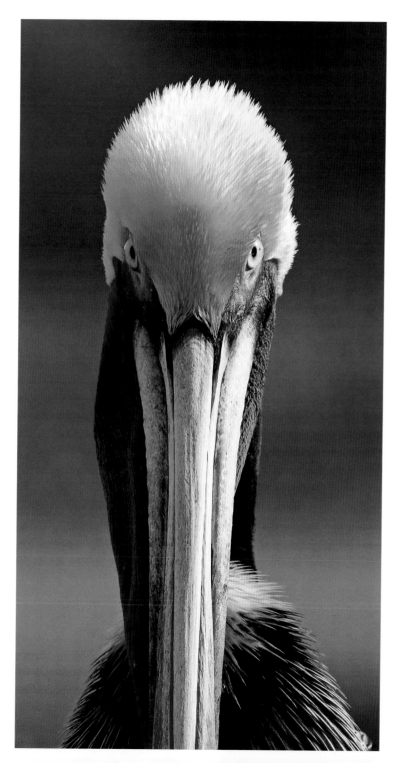

Follow Your Vision

Remember that the "rules" of composition are not rigid: Think of them as suggestions or guidelines. Once you understand them and can apply them to your images, feel free to pursue your own vision by bending and breaking the rules. Portraying birds by means of unconventional compositions can be a great way to create images with impact.

Figure 7.24: Brown Pelican closeup.
Canon EOS 1D Mark III with 400mm f/5.6L USM lens, 1.4×
teleconverter, handheld, 1/800 sec., f/11, ISO 1000. Bolsa
Chica Ecological Reserve, California.

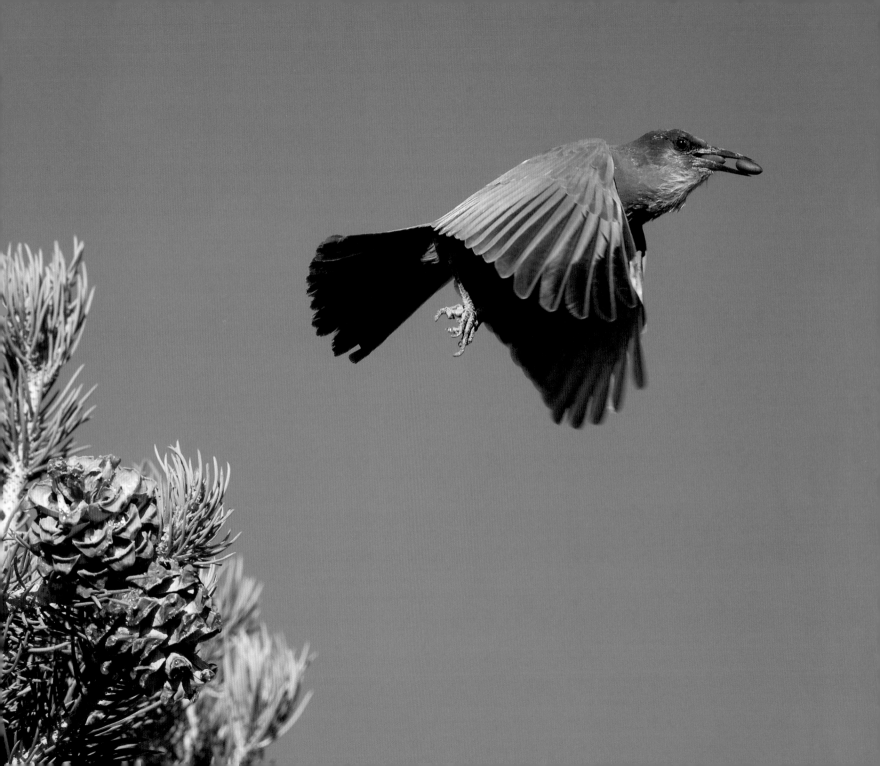

Chapter 8

CAPTURING BIRD BEHAVIOR

High-pitched nasal cawing alerts me they are coming—Pinyon Jays!

For weeks I saw only glimpses of these gregarious birds roaming in flocks through the pinyon-juniper woodlands. My goal to capture their distinctive habit of harvesting pine nuts to store as winter food seemed less and less likely, while the nomadic jays continued to elude me. But I found the mother lode of pine nuts—a pinyon pine loaded with ripe cones—so I resolved to wait nearby.

Suddenly, there is so much action I hardly know where to point my lens. Some jays swoop in to snatch nuts on the wing while others cling to the cones, prying nuts out with their bills. And then, as suddenly as they'd arrived, the noisy throng of Pinyon Jays—throats bulging with nuts—are gone, flying off to bury their stash, leaving me with full memory cards and a big smile!

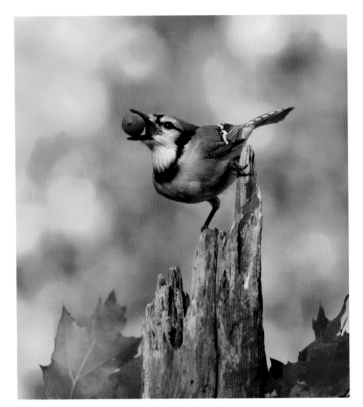

Figure 8.1: Blue Jay with an acorn on backyard setup.
Canon EOS 7D with 500mm f/4L IS USM lens, Gitzo tripod, 1/800 sec., f/5.6, ISO 640. Freeville, New York.

What does it take to capture the spirit, the unique essence, of a bird? I believe the answer lies in photographing behavior. Because behavior shots lend themselves to storytelling, they tend to be more meaningful and compelling than bird portraits, and sometimes that elusive avian spirit is revealed.

But great behavior shots rarely happen simply by luck, nor are they guaranteed by owning the best or newest equipment. Instead, they result from many factors coming together, including knowing the subject's habits, planning, good concentration, quick reflexes, and, above all, persistence—being willing to wait, sometimes for long periods, for the decisive moment.

My goal for this chapter is to inspire you to explore this rewarding genre for yourself. It may take more effort to capture images showing behavior, but your work will stand out from the crowd and you'll gain a window into birds' hidden lives that few people share. We'll mostly be covering how to photograph bird behavior in the field but, as you'll discover, there are opportunities in your backyard, too (figure 8.1).

The Power of Knowledge

Predictability is the foundation for many good photo opportunities. Knowing the range of behaviors your subject might perform lets you predict what might happen next. Behavior can be viewed as one of two types: the behaviors performed by all members of a species during its life history or the habits and peculiarities of the very individual(s) you're planning to photograph. Being familiar with both allows you to know what to expect when you encounter the bird in the field.

Learn about Bird Life History

One characteristic that top bird photographers have in common is a deep understanding and curiosity about birds and their lives. You can see it in the quality of their work. Understanding what makes birds tick is one of the most important factors that contribute to better images. So give yourself an edge: Become a better bird photographer by becoming a better naturalist. You can find a wealth of information about the characteristic activities and life history of a species from books or exploring online resources. However, nothing beats being in the field, studying birds closely, and discovering their ways for yourself. It pays to be a bird *watcher* even when you're not wearing your bird photographer's hat!

You'll learn that all individuals of a given species engage in certain activities in a predictable way. Consider the distinctive ways in which certain species feed—Acorn Woodpeckers store acorns, foraging American Avocets walk through shallow water swishing their bills from side to side, while Anhingas spear fish and swallow them whole (figure 8.2). The elaborate courtship rituals of prairie chickens, grouse, and grebes consist of predictable sequences of postures. And, across many taxonomic groups, birds use the same kinds of postures and movements when they bathe and preen.

Get to Know the Locals

Like humans, individual birds have regular day-to-day routines and personalities, information about which can help you envision a shot and develop a shooting plan. Observation in the field is the best way to discover the habits of individual birds, unless you employ a guide with local knowledge or link up with another photographer who is familiar with the local birdlife. When you're scouting an area, watch for any repeated activity patterns—a flycatcher that returns to the same perch after catching prey, a meadowlark that sings from a favorite fencepost, or a harrier on the hunt that takes the same route each time it quarters a field. Such patterns can help

you determine when and where to position yourself, or the best place to set up a blind to capture the behavior.

Feeding Methods

One behavior category where knowing what to expect can lead to exciting images is feeding. Birds have a huge variety of ways of obtaining and processing food. Knowing that fruit-eating birds—such as waxwings, robins, and bluebirds—habitually toss berries into the air before swallowing them enabled me to capture the image of a Cedar Waxwing in figure 8.3. Watching through the viewfinder, I focused on the bird's face and pressed the shutter release the instant it flipped up its bill. Other species that swallow whole prey act in a similar way: A kingfisher will often flip a fish into the air to reposition it in its bill, as will a flycatcher with a large insect or an ibis with a shrimp. When you have to wait for the decisive moment, having your gear on a tripod or other camera support prevents the fatigue of handholding. Fatigue means missed shots from lost concentration or image softness due to camera shake. Shoot in burst mode (High-speed Continuous) using a fast shutter speed to stop the action.

Gulls are opportunistic feeders, willing to eat almost anything. They are often dismissed as garbage eaters or scavengers, but sometimes they feed

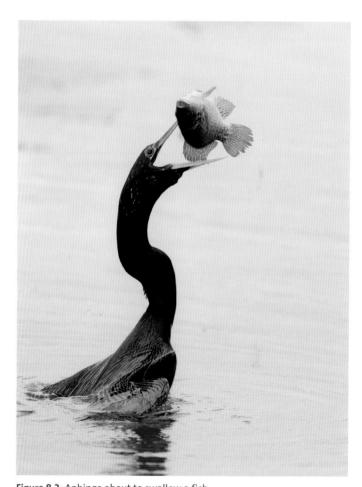

Figure 8.2: Anhinga about to swallow a fish.
Canon EOS 1D Mark III with 500mm f/4L IS USM lens, 1.4× teleconverter, beanbag over vehicle window, 1/640 sec., f/8, ISO 500. Viera Wetlands, Florida.

Figure 8.3: Cedar Waxwing tosses back a crabapple.
Canon EOS 7D with 500mm f/4L IS USM lens, 1.4× converter, Gitzo tripod, 1/1250 sec., f/5.6, ISO 800. Ithaca, New York.

Figure 8.4: California Gull chases alkali flies.
Canon EOS 1D Mark III with 400mm f/5.6L USM lens, handheld, 1/2500 sec., f/6.3, ISO 500. Mono Lake, California.

in ingenious ways. For instance, I've photographed Franklin's Gulls catching damselflies in midair, Herring Gulls are known to drop shellfish onto hard surfaces to break their shells, and Western Gulls sometimes specialize in capturing small octopi. One of the most bizarre strategies is used by California Gulls on the mudflats at Mono Lake, where they run bulldozer-like back and forth through swarms of alkali flies, snapping up the insects with their bills (figure 8.4).

To capture the action, I sat on the ground with a handheld camera/lens combo, panning as the gulls ran along.

These examples illustrate another point: Where food is highly concentrated, the best strategy is to hang out

Figure 8.5: White-winged Crossbill prying seeds from the cone of a Douglas fir.
Canon EOS 1Ds Mark II with 500mm f/4L IS USM lens, 1.4× teleconverter, Gitzo tripod, Canon Speedlight 580 EXII, Better Beamer flash extender, 1/500 sec., f/5.6, ISO 500. Ithaca, New York.

Plumage Care: Bathing, Preening, and Flapping

Some of the most photogenic poses occur while birds are engaged in plumage care. Preening and bathing birds make for great images, as do the wing flaps that usually occur afterward. Equally appealing are wing stretches, which you can expect from any bird after rousing from a nap or after a bout of preening. Shorebirds, such as American Avocets, often perform an elegant head-down-wings-up stretch (figure 8.6). Perched songbirds or resting ducks may stretch like this too, but sometimes they stretch one wing downward at a time.

To capture wing stretches or flaps, don't frame too tightly or you risk clipping wingtips. Loons, ducks, and geese rise up out of the water to flap or shake. Flapping shorebirds are so light that they may pop up into the air for just a split second. In either case, you'll want to leave space at the top of the frame to accommodate the wings. To freeze the action, set a fast shutter speed and begin shooting as soon as you sense the bird is finished preening. To capture the Common Loon with flying water droplets in figure 8.7, I focused on the bird's neck while it was still bathing and fired a burst of shots as soon as it started to rise up out of the water. Birds' body care rituals take time, and you may have to wait for the final flourish. Don't lose your concentration, but *do* use a tripod

near the food source. That could mean insect swarms for flycatchers or swallows, schools of fish for gannets or terns, mast-laden trees for jays or turkeys, or flowering fruit trees for orioles in spring. But being in the right place doesn't have to entail extensive travel. Instead, find out where sources of bird food are in your own area. When central New York was treated to a rare invasion of White-winged Crossbills, I checked out areas

near my home with cone-laden spruces and firs where they might be feeding (figure 8.5). Feeding is also one of the easiest bird behaviors to capture in your backyard. Don't dismiss that robin having a tug-of-war with an earthworm, for instance!

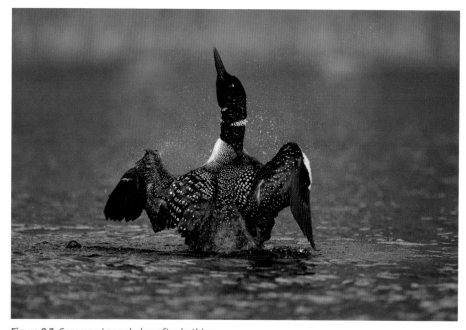

Figure 8.7: Common Loon shakes after bathing.
Canon EOS 1Ds Mark II with 500mm f/4L IS USM lens, 1.4× teleconverter, Gitzo tripod,
1/2500 sec., f/5.6, ISO 250. Onaway, Michigan.

Figure 8.6: An American Avocet stretches after preening.
Canon EOS 1D Mark III with 500mm f/4L IS USM lens, 1.4× teleconverter, Gitzo tripod.
1/2500 second, f/5.6, ISO 500. Bolsa Chica Ecological Reserve, California.

to avoid fatigue otherwise you risk missing the shot.

Perhaps the most elegant preening pose—and definitely an image to strive for—occurs when the bird slides a single feather from base to tip through its bill, like the Belted Kingfisher in figure 8.8

is doing. For you to capture body-care images like this, your subject will need to be pretty relaxed in your presence, which is usually easily achieved where birds are used to seeing people. Kingfishers, on the other hand, are wary and easily spooked. Because I was hidden in

a blind, however, this particular female was oblivious to me.

Figure 8.8: A Belted Kingfisher preens a single feather.
Canon EOS 7D Mark II with 500mm f/4L IS lens, 1.4× teleconverter, Gitzo tripod, 1/800 sec., f/5.6, ISO 1250. Lansing, New York.

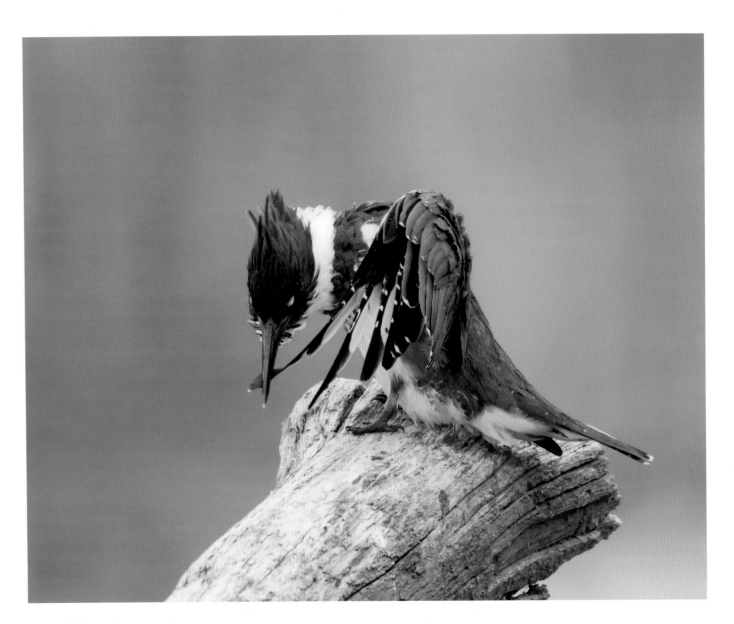

Figure 8.9: A Sandhill Crane's distinctive slow lean forward signals its intent to take flight.
Canon EOS 7D II camera, EF 500mm f/4/L IS II lens, 1.4× III teleconverter, Gitzo tripod, 1/2500 sec., f/5.6, ISO 640. Bosque Del Apache National Wildlife Refuge, New Mexico.

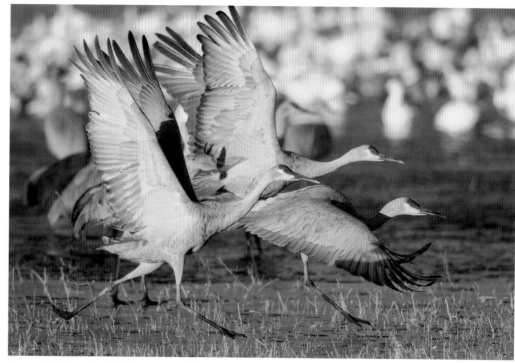

Figure 8.10: Three Sandhill Cranes take flight. I anticipated the action by recognizing their preflight behavior.
Canon EOS 7D II camera, EF 500mm f/4/L IS II lens, 1.4× III teleconverter, Gitzo tripod, 1/2500 sec., f/5.6, ISO 640. Bosque Del Apache National Wildlife Refuge, New Mexico.

Behavior Cues and the Decisive Moment

Birds often give subtle behavioral cues that something is about to happen. Recognizing those signals allows you to anticipate the behavior—a huge advantage for a photographer.

Diving ducks and mergansers, for instance, sleek down their plumage the instant before diving from the water's surface to forage underwater. Male Yellow-headed Blackbirds fluff their throat feathers just before displaying. Mallard pairs face each other and bob their heads repeatedly before mating.

These are just a few examples of the many cues, but few are described in books or online bird guides. You discover them by observing birds in the field and learning to read their body language. Train yourself to watch closely and react immediately when you notice the cue. The concentration skills you'll develop while doing this will improve your photography, too.

As we explore various types of behavior, I'll share the body language cues that I rely on to help me capture the action. You will undoubtedly discover many more as your photography and observation skills grow.

Perhaps best known are preflight cues: postures that signal a bird's intention to take wing. Eagles, spoonbills, and herons crouch and may defecate just

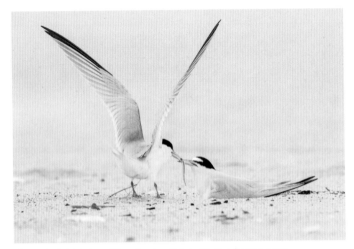

Figure 8.11: Male Least Tern feeds a fish to his incubating mate.
Canon EOS 7D Mark II with 500mm f/4L IS lens, 1.4× teleconverter, Gitzo tripod, 1/1000 sec., f/9, ISO 1250. Northern Massachusetts.

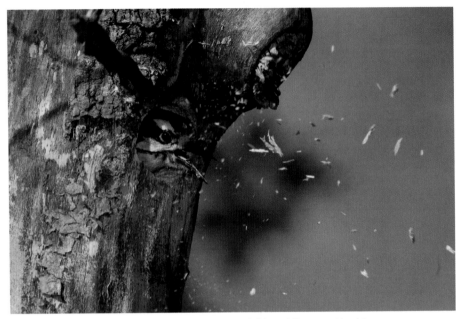

Figure 8.12: Downy Woodpecker male tosses out wood chips while excavating his nest cavity.
Canon EOS 7D with 500mm f/4L IS USM lens, 1.4× converter, Gitzo tripod, Canon Speedlight 580 EXII, Better Beamer flash extender, 1/1250 sec., f/5.6, ISO 400. Lansing, New York.

before taking off. Ducks and geese stand up tall and flip their heads agitatedly, while cranes slowly lean forward before running along to lift off (figures 8.9 and 8.10). We'll explore photographing take-offs and birds in flight in chapter 10.

Sound Cues

Most pre-activity cues are visual but sometimes birds' calls alert you to impending action. A good example is the nesting Least Terns in figure 8.11. The male was regularly bringing fish to his mate on the nest, but the actual food transfer took just a split-second before the male took flight again. I captured it by paying attention to the bird's call: Terns circling the colony carrying fish always gave a distinctive two-note call. Another vital piece of information that allowed me to anticipate the shot was that the male usually arrived from the left. Composing the shot with ample space on the left, I focused on the female's face, and I listened. Each time I heard the call close by, I fired off a burst of shots. After several attempts I caught the instant the pair exchanged a fish.

Interestingly, it was by listening for silence that enabled me to capture the Downy Woodpecker excavating its nest hole in figure 8.12. The bird digging inside the nearly complete cavity was not visible, but I could hear his tapping. Every so often that tapping stopped—my cue that shortly the bird would emerge and toss out a beakful of wood chips.

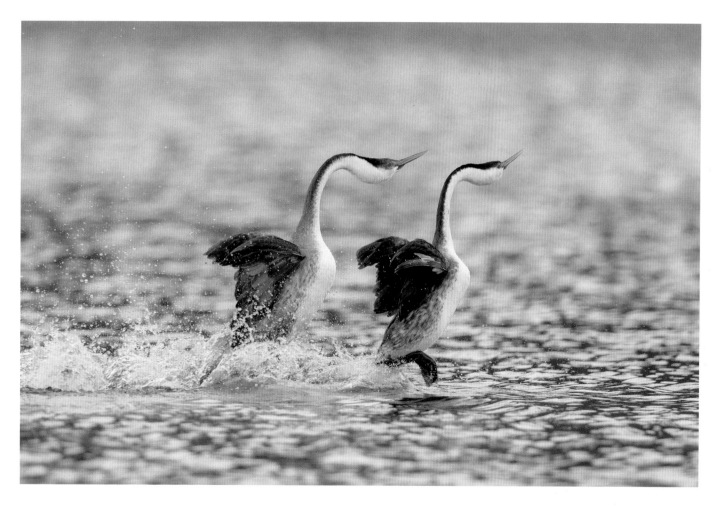

Figure 8.13:
Courting Western Grebes perform the "rushing" display.
Canon EOS 7D Mark II with EF 500mm f/4/L IS II lens, 1.4× III teleconverter, Gitzo tripod, 1/1250 sec., f/5.6, ISO 1000. Escondido, California.

Courtship and Mating Rituals

Few avian activities are as exciting and photogenic as those associated with courtship. Some courtship displays are protracted, allowing the photographer plenty of time to compose the frame. Wild Turkey toms strut their stuff for as long as there are females nearby to impress, and Great Egrets spread their elegant nuptial plumes for minutes at a time. Other courtship behaviors take just seconds, such as the "rushing" displays of grebes (figure 8.13) or the bizarre postures of amorous ducks. These brief activities can be hard to capture unless you learn to recognize the behavioral cues that precede them.

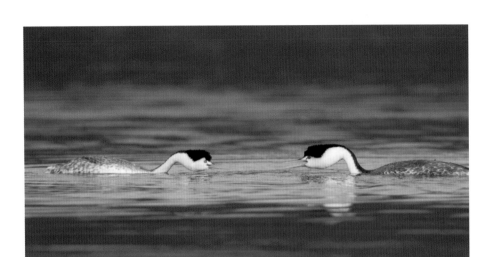

Figure 8.14: Clark's Grebes, behavior immediately preceding the "rushing" display.
Canon EOS 7D Mark II with EF 500mm f/4/L IS II lens, 1.4× III teleconverter, Gitzo tripod, 1/1250 sec., f/5.6, ISO 400. Escondido, California.

Courting Western and Clark's Grebes perform a dramatic display in which two or more run across the water in synchrony while producing a splashing wake. The ritual, termed "rushing," usually takes just a few seconds. Once it starts, it can be difficult to focus on and frame the running birds, but it is easier when you can anticipate the display by recognizing the preceding behavioral cues. Watch for two grebes swimming toward each other with heads held low, giving loud, raspy calls, as in figure 8.14. That's your cue to focus on them, and start firing a burst of shots immediately when they rise out of the water and begin running. Pan along with them, and don't stop shooting until they slow down and sink onto the surface again.

Waterfowl courtship displays last for just a split second, so brief that, in fact, many people never notice them. Hooded Merganser and Redhead drakes perform dramatic head throws, Ruddy Ducks stir up a froth of bubbles with their bills, and Red-breasted Mergansers strike a bizarre "salute-curtsey" pose (figure 8.15).

Even the often-overlooked Mallard has some entertaining courtship moves. Photogenic though they may be, duck displays are hard to predict and the preceding cues are very subtle. Capturing them is challenging, and you may make many failed attempts. Don't get disheartened: Waterfowl courtship and pair formation continues throughout fall and winter, so there is plenty of opportunity to practice at the local duck pond!

My strategy is to hold focus on a male that has recently displayed and follow it as it swims along, watching through the viewfinder for the subtle hesitation that often precedes a display, at which point I fire a burst. Mallards and other dabbling ducks might also give subtle headshakes before displaying.

Don't ignore your own backyard: Some of the most common birds have endearing courtship behaviors, too. Early in spring, Northern Cardinal males start feeding their mates in preparation for breeding (figure 8.16). If you missed the interaction the first time, keep trying because it likely will happen again soon. Stay focused on the female, and eventually the male will offer her a seed. Your reward will be a shot in which the two appear to be kissing! Even much-maligned Rock Pigeons are photogenic when they're acting lovey-dovey. Watch for them preening one another as they gear up to nest.

One particularly photogenic mating ritual is the post-copulatory display performed by Black-necked Stilts and American Avocets. As the act of mating ends the male dismounts leaving one wing draped over the female's back and crossing his bill with hers (figure 8.17).

Figure 8.15: A courting male Red-breasted Merganser performs the "salute-curtsey" display.
Canon EOS 7D Mark II with EF 500mm f/4/L IS II lens, 1.4× III teleconverter, Gitzo tripod, 1/2000 sec., f/5.6, ISO 500. Cayuga Lake, New York.

Figure 8.16: Northern Cardinal male feeds his mate in spring.
Canon EOS 7D Mark II with EF 500mm f/4/L IS II lens, 1.4× III teleconverter, Gitzo tripod, 1/400 sec., f/5.6, ISO 1250. Freeville, New York.

Figure 8.17: Black-necked Stilts perform the post-copulatory display.
Canon EOS 7D Mark II with EF 500mm f/4/L IS II lens, beanbag over vehicle window, 1/2000 sec., f/7.1, ISO 400. Bear River Migratory Bird Refuge, Utah.

Figure 8.18: A Sandhill Crane colt with its parent.
Canon EOS 1D Mark III with 400mm f/5.6L USM lens, handheld, 1/640 sec., f/5.6, ISO 320. Orlando, Florida.

The pair takes a few steps together like this before moving apart. To capture the ritual, first recognize when the pair is going to mate: The female will hold an obvious, horizontal pose, sometimes for several minutes, inviting the male to mount her. Once mating starts, stay focused on the birds and start shooting a burst of images the instant the male starts to dismount.

Parents and Young

Nothing elicits a chorus of *oohs* and *aahs* from an audience more than images of cute baby birds! The more appealing the photo, the more emotionally connected to the subject the viewer will feel. People react most strongly to those avian youngsters that hatch down-covered with eyes open, and that are able to run or swim around immediately. Termed "precocial," they include ducklings, goslings, and the chicks of shorebirds, loons, grebes, cranes, and game birds. On the other hand, altricial young that hatch naked, blind, and helpless, such as those of songbirds, surely have faces only a mother could love!

Play up the cute factor by showing the size difference between a newly hatched chick and an adult, such as the week-old Sandhill Crane (termed a "colt") with its tall parent in figure 8.18. Or go in close for a tight portrait of a

gosling with just its parent's legs in the background for a sense of scale.

Parental Behavior

Images that show nurturing behaviors, such as parent birds brooding or feeding young, are especially appealing. Despite having a downy covering, precocial chicks need frequent brooding for warmth. Young loons, grebes, and mergansers climb onto the parent's back and snuggle into their plumage. Shorebird parents crouch and fluff out their belly feathers, allowing their youngsters to nestle under them, as the Piping Plover adult in figure 8.19 is doing.

Plovers and their chicks are famously fast runners, but once they start brooding, they often stay put for a while. This allowed me to cautiously crawl toward them over the beach. When one particular chick vainly tried to find space under mom (or dad) to join its three siblings, I had the chance to shoot many images, of which this is my favorite. I like the fact that the adult's head is turned slightly toward the incoming chick, suggesting a connection, and that the chick's posture, leaning forward with one foot raised, makes it appear hesitant and vulnerable.

Hungry young birds pay constant attention to their surroundings and usually start begging when they see an adult carrying food approaching. To

Figure 8.19: A Piping Plover chick approaches its parent to be brooded.

Canon EOS 7D Mark II with 500mm f/4L IS lens, 1.4× teleconverter, Skimmer Ground Pod, 1/500 sec., f/8, ISO 1000. (Distractions removed during postprocessing.) Northern Massachusetts.

capture a youngster being fed, my typical strategy is to focus on its bill (since that's where the food will ultimately end up) and wait for the begging to let me know that the adult is about to arrive, rather than try to focus on the incoming adult. It's a strategy I've used successfully with tern and grebe chicks, as well as with fledgling songbirds such as swallows. But sometimes circumstances dictate the opposite strategy, as I discovered when photographing a family of American Oystercatchers (figure 8.20). An adult would come trotting over the beach toward where the young were sitting, but then would stop well short of that, drop its prey and stand with its bill pointing toward the ground.

Figure 8.20: American Oystercatcher chick takes prey from its parent.

Canon EOS 7D Mark II with EF 500mm f/4/L IS II lens, Gitzo tripod, 1/1250 sec., f/8.0, ISO 800. (Distraction removed during postprocessing.) Long Island, New York.

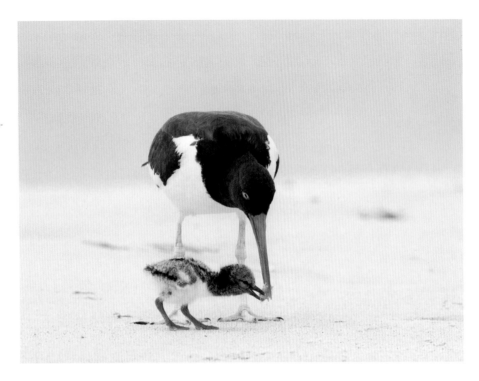

Eventually, the chicks figured out that they were supposed to "come and get it," but often it took the adult picking up and dropping the prey several times before a youngster finally ate it! I quickly figured out that I needed to focus my attention on the incoming adults instead of the chicks. So, while it helps to have an initial plan, it's vital that you be flexible and change it when needed.

Up to this point, we have been considering parents and young outside the confines of a nest. If your goal is to photograph woodpeckers or other cavity-nesting species feeding their young, the stage of the nesting cycle is important to consider. Unless you'd be satisfied with a shot of an adult sticking its head into a hole, wait until late in the nestling period when the young will be visible. Knowing approximately when incubation had begun at the Pileated Woodpecker nest in figure 8.21, I calculated my return date to coincide with the time the youngsters would be old enough to look out of the nest entrance to be fed.

The Ethics of Nest Photography

This leads us to the controversial topic of photography at nests.

As you've learned, many photo opportunities rely on predictable behavior, and few avian activities are more predictable than those at nests. However, nest photography should be undertaken only after careful consideration. Rewarding as it may be, if one proceeds with the level of caution needed to do it ethically, nest photography can be very time consuming, not to say frustrating! Yet, done carelessly it may cause nest failure from abandonment or predation. No photo is ever worth jeopardizing the safety of birds and their young.

Cavity nests, such as those of woodpeckers, are fairly safely photographed from a distance, but open-cup songbird nests and nests on or near the ground are very vulnerable. It can be tempting to get some shots of, say, the Killdeer nest you've found in a parking lot or the nesting Chipping Sparrow in your backyard, but consider the cost to the birds if their nest fails versus the benefits (if any) to yourself, public education, and conservation. What purpose will your photos serve? If you have no answer other than bragging rights or social media "likes," consider leaving the birds in peace. If you decide the risks to the birds are worth it, the sidebar on pages 164–165 offers important tips to minimize your impact.

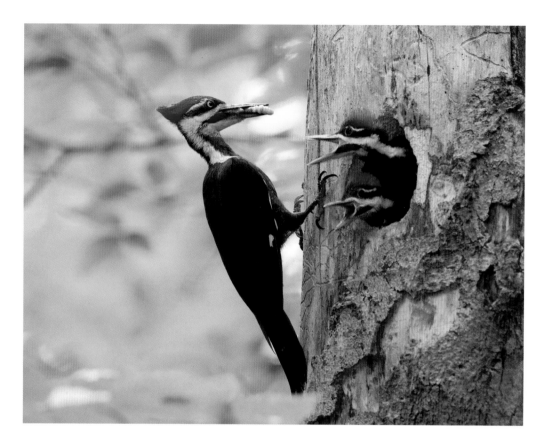

Figure 8.21: A male Pileated Woodpecker brings a large beetle larva for its soon-to-fledge youngsters. Canon EOS 7D with 500mm f/4L IS USM lens, Gitzo tripod, Canon Speedlight 580EXII with Better Beamer flash extender, 1/250 sec., f/5.6, ISO 1000. Ithaca, New York.

I used a remotely triggered camera to capture Great Crested Flycatchers that have nested in the same cavity in an old apple tree in my yard several times over the past few years. I have often photographed them with a telephoto lens, but one year I envisioned something different: a wide-angle shot taken from close to the nest entrance that included some of the surrounding habitat.

After noticing the female bringing nest material, I placed a dummy tripod/camera tied to a ladder (figure 8.25) about 30 feet away from the nest tree. I watched from a distance to make sure the female would tolerate this, which she did immediately. It's important to realize that this particular pair was used to humans and garden paraphernalia. More sensitive birds would require

proceeding much more cautiously (if at all); for instance, taking several days to habituate them to the gear and camouflaging it if necessary.

The next day, I switched in the real camera on a monopod, tied to the ladder and slowly moved this closer over the course of several hours until it was about two feet from the entrance hole, checking each step of the way that the

female was not put off from coming to the nest.

The shutter release was tripped remotely using a PocketWizard Plus II Transceiver kit—one transceiver unit cabled to the camera through its remote control terminal and the other unit in my hand while I watched at a distance of 80 feet. When the female flew to the nest, I triggered the camera by pressing the transceiver button (figure 8.26). To minimize disturbance the camera drive mode was set to Silent. Four young fledged successfully from the nest later that summer.

Figure 8.25: The remote setup used for nesting Great Crested Flycatchers. The camera, mounted on a monopod tied to a ladder, was moved incrementally closer, eventually being about two feet from the nest entrance. It was tripped remotely using a PocketWizard Plus II Transceiver kit, one unit of which is cabled into the camera and mounted on its flash shoe.

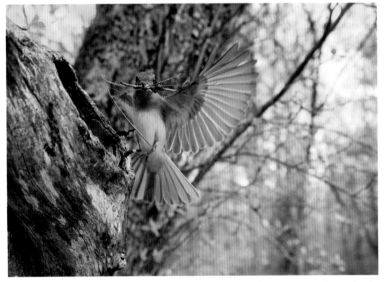

Figure 8.26: Great Crested Flycatcher brings nest material to a cavity in the author's backyard.
Canon EOS 5D Mark III with EF24–105mm f/4L IS USM lens at 40mm, manual focus, 1/2000 sec., f/5.6, Manual exposure with auto ISO, Silent Drive Mode. Freeville, New York.

NEST PHOTOGRAPHY DOS AND DON'TS

- Wait to begin photography until late in incubation or after hatch, by which point the pair is well invested in their reproductive effort and less likely to abandon. Be extra careful when young are close to fledging when approaching too aggressively may frighten them off the nest prematurely.

- Proceed slowly and patiently. Start at a distance and slowly move closer over time (depending on the species this could mean minutes, hours, or days). Watch for signs of stress: constant chipping or alarm calls, wing flicking or fluttering, distraction displays (e.g., by ground nesters such as Killdeer).

- Be especially aware of birds' unwillingness to return to the nest. Eggs and un-feathered nestlings quickly chill and may die unless their parent returns promptly to incubate or brood them. You must move away if the birds stay away too long. What constitutes "too long" depends on the species, the stage of the nesting cycle, and the weather. A safe strategy, before you even start, is to determine how long the parent birds are normally away from the nest by observing at a distance through binoculars.

- Use a photo blind. Many birds will ignore a human concealed in a blind. Again, proceed slowly: Introduce the blind at a distance and gradually move it closer to the nest site over time to allow the birds to get used to it.

- Keep quiet and still. Become part of the bird's environment, and the birds are more likely to remain calm. Professionals strive for shots that show natural behavior, not images of alarmed birds that are obviously uncomfortable with your presence. Do not play the birds' songs or calls near its nest.

- Once within shooting range, do not remove vegetation to get a better view of the nest contents; instead, accept the situation for what it is. Birds hide their nests to avoid detection by predators and to shelter vulnerable young from the elements. Removing that protection is an invitation to disaster.

- Nests on or close to the ground—for instance those of Killdeers and other shorebirds, Bobolinks and Ovenbirds (figure 8.22)—are particularly vulnerable to predation. Repeatedly walking up to and around them leaves a scent trail that may lead raccoons, snakes, or feral cats straight to an easy meal.

- Use electronic flash sparingly or not at all. Flash use at nests is controversial. Opinions differ widely on the health effects of flash on nesting birds, especially still-developing young and nocturnal species. It is best to err on the side of caution.

- At public spots such as tern and skimmer colonies on beaches or wading bird rookeries, obey signage and stay outside barriers. They are there for the birds' protection. Be courteous to others and don't behave in ways that reflect badly on all photographers.

- Remotely controlled cameras have often been used at nests, especially of small songbirds. A camera with a short focal length lens is placed close to the nest, and the photographer fires the shutter from a distance using a wired or wireless shutter release. Birds may find this method less intrusive than having a human nearby, but, as with introducing a

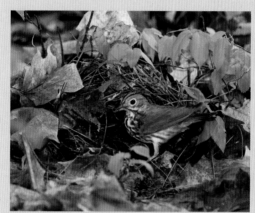

Figure 8.22: Ovenbird approaches its nest hidden under fallen leaves on the forest floor. Rather than approach the nest and possibly leave a predator-attracting scent trail, I set up at a distance and hid under a Kwik Camo blind.
Canon EOS 7D Mark II with EF 500mm f/4/L IS II lens, Gitzo tripod, 1/200 sec., f/5.6, ISO 1600. Ithaca, New York.

Figure 8.23: A dummy camera/tripod (made of plastic pipes and a box painted black) simulates actual camera gear to familiarize nesting birds with a strange object near their nest.

Figure 8.24: Remote camera setup. The camera is fired remotely using a Pocket-Wizard II Transceiver.

blind, they need time to accept a strange object in their environment. To avoid exposing actual camera gear to the elements while the birds get used to it, I use a dummy camera/tripod (figure 8.23), first placing it at a distance and then moving it closer over a period of several days. I finally exchange the real camera for the fake one when I'm ready to shoot (figure 8.24). Either setup may need to be camouflaged before the birds will tolerate it, and it must be removed if it keeps birds off the nest too long.

Migration and Flocking

The changing seasons have a significant influence on bird activity. Many species gather into flocks to migrate and spend the winter, offering excellent opportunities to photograph them en masse. To photograph the migration spectacle, follow the birds, for instance, to staging areas along migratory pathways or to migration hotspots where birds on the move build up due to an area's geography.

Weather conditions become important—a passing front may usher in wind from the wrong direction and migration will stall and the birds become grounded. That can give you photo opportunities you might rarely have otherwise.

Bad weather worked in my favor at Cape May, New Jersey—one of North America's top migration hotspots—where my goal was to capture migrating Tree Swallows. In particular, I wanted to capture a flock on a beach, but only when the right weather conditions occurred did I succeed. Sunny days were useless—the swallows dispersed high in the sky to chase flying insects. But on windy, drizzly days, fewer insects are on the wing and the swallows descend onto the wax-myrtle shrubs along the beach to feed on waxy berries. On one such day I achieved my goal (figure 8.27).

To best show the extent of a large flock, shoot from a high vantage point if possible, otherwise raise your tripod to its full height. Select a small aperture (i.e., an f-stop with a high number) to maximize the depth of field. To get a unique view looking down onto the enormous flock (termed a "raft") of Redheads and Ring-necked Ducks in figure 8.28, I stood on a high bluff overlooking the bay on a large lake where the raft had been reported by members of the local birding community.

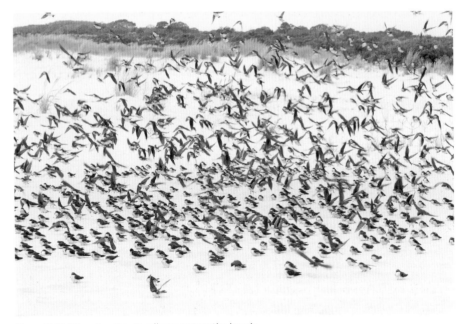

Figure 8.27: Migrating Tree Swallows rest on the beach.
Canon EOS 7D Mark II with EF 100–400 mm IS II lens at 100mm, handheld, 1/320 sec., f11, ISO 1000. Cape May, New Jersey.

Figure 8.28: A dense raft of Redheads and Ring-necked Ducks overwintering on a lake.
Canon EOS 5D Mark II with EF 500mm f/4L IS lens, 1.4× converter, Gitzo tripod, 1/400 sec., f/18, ISO 800. Cayuga Lake, New York. (Right)

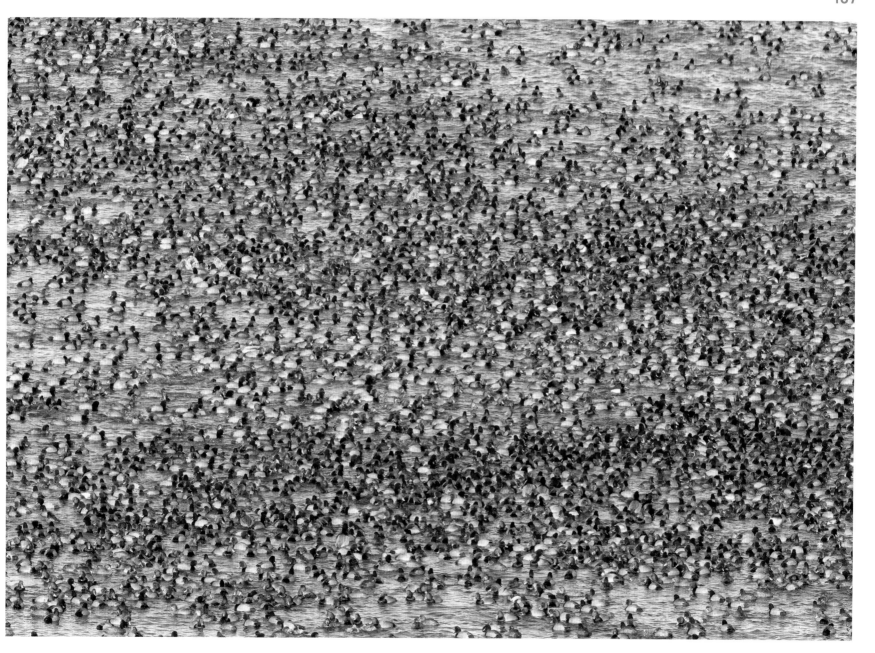

Figure 8.29: Great Blue Herons get into a food fight.
Canon EOS 7D Mark II with EF 100–400 mm IS II lens (at 400mm), hand-held, 1/2000 sec., f/5.6, ISO 1000. Viera Wetlands, Florida.

Figure 8.30: Red-headed Woodpeckers battle a European Starling.
Canon EOS 7D with 500mm f/4L IS USM lens, Gitzo tripod, 1/2500 second, f/5.6, ISO 400. Montezuma National Wildlife Refuge, New York.

Aggression and Conflict

Aggression between birds makes dramatic images, but like other interactions, it can be brief and unpredictable. The best strategy is to expect the unexpected. In a promising situation, be ready ahead of time with camera set on a fast shutter speed to freeze motion, and react immediately when any action occurs. Stay alert wherever birds gather in close proximity to each other. Birds often bicker if one invades another's personal space.

Altercations often occur over limited resources, such as nest sites, nest material, perches, and especially, food. When many birds are attracted to a concentrated food source, such as gulls and terns diving into a school of fish, the feeding activity itself makes exciting shots, of course, but watch out for aggression, too. A gull or tern with a large fish may be chased mercilessly by others trying to steal its catch. In a wetland packed with wading birds, I once captured a food fight between two Great Blue Herons, one of which had caught a giant salamander (figure 8.29).

Aggression heightens during the breeding season. Tree Swallows fight on the wing over feathers for nest lining, while egrets squabble in midair over possession of a nest site at a dense rookery. Territorial Canada Geese aggressively drive out rival pairs, and crows engage in long aerial chases to harass passing hawks.

Watch for behavior patterns that help you anticipate the action. Doing so helped me capture a pair of Red-headed Woodpeckers battling a persistent European Starling that for several days repeatedly attempted to take over their nest cavity (figure 8.30). Each morning I set up my gear with a good view of the nest tree and waited for the starling to make its move, framing the fast action

Figure 8.31: Male Wood Duck gets the cold shoulder from the females.

Canon EOS 7D Mark II with EF 500mm f/4/L IS II lens, 1.4× III teleconverter, Gitzo tripod, 1/1250 sec., f/5.6, ISO 1600. Freeville, New York.

as best I could. The woodpeckers prevailed, and, eventually, the starling gave up.

Don't forget that a little humor adds a lot to an image even if the underlying sentiment is aggressive. While the female Wood Ducks in figure 8.31 were snoozing on a floating log, a young male tried to join them. They made it very clear he was not welcome!

Value Added

Capturing bird behavior can be challenging and time consuming as well as immensely rewarding. Those rewards go far beyond the actual photos. Long hours in the field watching and waiting for the decisive moment are part of what makes bird photography such a rich experience. Whether tragedies,

comedies, successes, or failures, the extraordinary moments you'll experience as birds' lives unfold before you form memories that will remain with you forever.

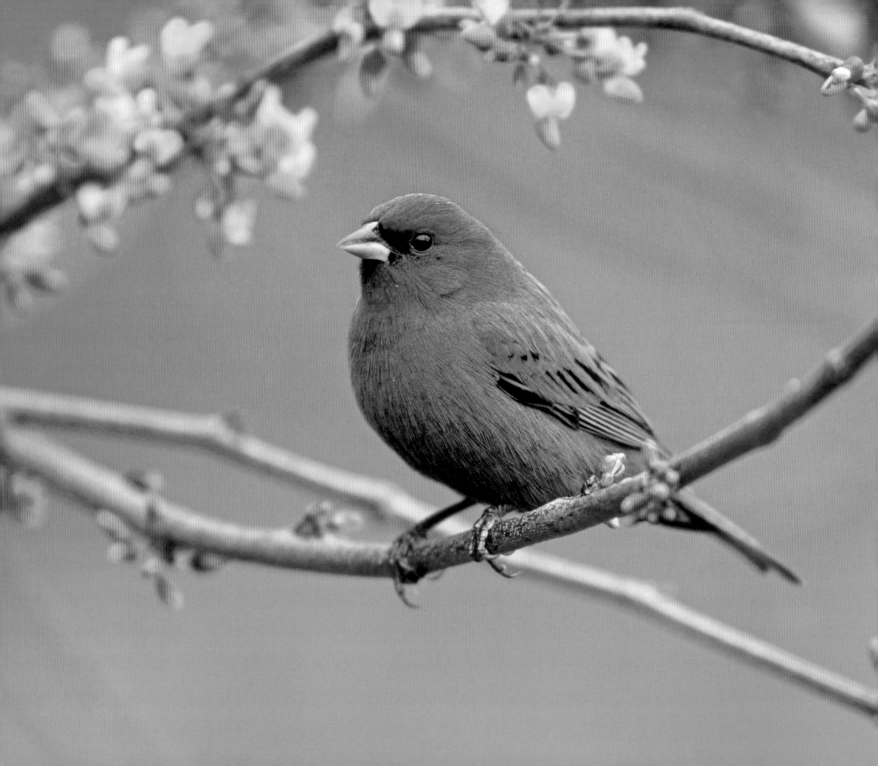

Chapter 9

BEAUTY CLOSE TO HOME

Long ago, I planted a small tree—an eastern redbud barely five feet tall with a few spindly branches. It marked the beginning of landscaping my backyard for bird photography. Every spring since then I've photographed the birds that perch among the redbud's flowers en route to the bird feeders I've placed nearby—goldfinches, grosbeaks, orioles, hummingbirds, and cardinals making a lavish spread of color. But the best surprise happened only once: I captured a brilliant blue Indigo Bunting in a perfect flower-framed spot. Many times its original size now, the redbud still blooms profusely each spring, and the birds captured among its blossoms have appeared in calendars and magazines too numerous to count!

Figure 9.1: The author's bird-feeding garden in summer: coneflowers, black-eyed Susans, bee balm, and cardinal flowers.

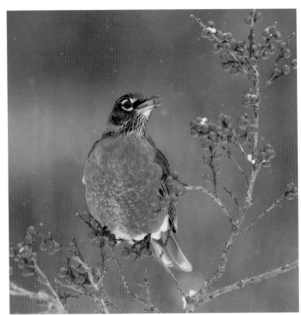

Figure 9.2: American Robin feeds on winterberry fruit in the author's backyard.
Canon EOS 1D Mark III with 500mm f/4L IS USM lens, Gitzo tripod, 1/800 sec., f/5.6, ISO 500.

Search the Internet for "bird photography," and you'll be overwhelmed with enticements to visit exotic spots teeming with birds and invitations to join an endless number of workshops and tours. Travelling for bird photography certainly is exciting and can be very productive, but it's also expensive. Luckily, you can have the perfect bird photography hotspot close to home—in your backyard. Birds are easy to bribe! If you already feed them, you have photo ops right outside your door. Otherwise, now is the time to start offering birds a free lunch.

For the widest diversity of species, offer a variety of foods. Sunflower and nyjer (thistle) seeds attract seed-eating sparrows, finches, chickadees, and cardinals. Suet entices woodpeckers and nuthatches. Orioles love orange halves and grape jelly, and sugar-water attracts hummingbirds. Consider adding a birdbath, especially if you live in an arid area: Water for drinking and bathing is a magnet for birds, even those that typically don't come to feeders, such as warblers. You'll get still more bird diversity if you create a backyard habitat by providing safe shelter and nest sites in addition to food and water.

Once birds are visiting regularly, you're on your way to having your own backyard bird photography studio where you can create beautiful bird portraits on perches that you provide. With ingenuity and luck, you can get behavior and action shots, too. Unless otherwise noted, all photos in this chapter were

Figure 9.3: Rose-breasted Grosbeak male on a set up perch decorated with coreopsis flowers, with garden flowers forming a colorful background.

Canon EOS 7D with 500mm f/4L IS USM lens, Gitzo tripod, 1/640 sec., f/5.6, ISO 400.

obtained in my backyard near Ithaca, New York.

The Bird-Friendly Backyard

Bird-friendly gardening will increase the avian diversity in your backyard. Many books have been written about this topic, a couple of which are in the Resources section. To get you started, a few basic suggestions follow.

Birds need shelter as well as food and water. Plant evergreen, coniferous trees as year-round cover in bad weather and safe places for birds to hide from predators. Conifers provide safe nest sites, too. Make a brush pile of downed branches where ground-dwelling species can hide.

Provide natural foods for birds by growing plants native to your area (figure 9.1). For seed-eating species such as sparrows, finches, and chickadees, popular choices include sunflowers, coneflowers, and black-eyed Susans. To entice hummingbirds, plant columbines, bee balm, cardinal flowers, penstemon, salvia, or trumpet vines. Fruiting trees and shrubs, such as elderberry, serviceberry, winterberry, viburnum, and crabapple are magnets for waxwings, robins, catbirds, and bluebirds. With a little luck, you may be able to photograph birds actually feeding on these plants (figure 9.2), otherwise the colorful gardens can form great backdrops for artificial perches (figure 9.3).

Use bird-friendly landscaping and gardening practices. For instance, when it's time for yard cleanup—don't! Leave it messy. Leave spent flowers standing so that finches can eat the seeds. Use fallen leaves as mulch instead of bagging them up for removal—ground-feeding sparrows, towhees and thrashers will scuff through them in search of prey. Leave dead twigs and grasses to provide nest material, and leave dead tree trunks and limbs in place for woodpeckers to forage and excavate nest holes. Insects are essential bird food, especially for raising healthy young, so avoid spraying insecticides.

Keep birds safe: Outdoor cats kill millions of birds annually, especially vulnerable fledglings, so keep cats indoors. Doing so saves birds, and keeps cats healthier and safer, too.

Figure 9.4:
Northern Cardinal
male perched in
a conifer during a
snowstorm.
Canon EOS 1Ds Mark II with
500mm f/4L IS USM lens,
1.4× teleconverter, Gitzo
tripod, 1/640 sec., f/5.6,
ISO 400.

Take Advantage of Existing Plantings

A backyard bird photography studio can be as simple or as ambitious as you like, ranging from a single perch next to a feeder to an elaborately constructed set. But the easiest way is to place a feeder next to an existing tree or shrub, as I did to capture the male Northern Cardinal in figure 9.4. Evergreen trees make attractive perches, especially during drab northern winters. You can photograph birds wherever they choose to land naturally in the tree or, in winter, draw them to a specific spot by sprinkling seeds on the snow-covered branches. Make sure the seeds don't show in the photo (or clone them out later if you wish).

Evaluate the location of your tree or shrub when placing the feeder. Look for low branches with uncluttered surroundings and pleasing backgrounds. Check that those branches receive good lighting and then place the feeder nearby (figure 9.5). For flexibility, use a feeder pole with a free standing base (sometimes called a "patio base") rather than a pole that must be twisted into the ground. That way it will be easy to fine-tune the feeder location if needed (plus your lawn will not end up full of holes!).

Next, decide where to position yourself and your gear. In most backyard situations where birds are used to people,

Figure 9.5: American Goldfinches crowd onto feeders hanging next to a redbud tree. Note that when actually shooting, I remove all but one feeder so that birds must perch in the tree and wait their turn to feed.

a telephoto lens in the 300–400mm range is often adequate to capture a frame-filling subject, unlike in a field situation where birds may be skittish and a longer telephoto is needed. Even so, to be close enough yet still have birds relaxed and acting naturally, it helps if you are concealed. That means hiding in some kind of photography blind or other structure. It could be your house, a garden shed, or another structure from which you could photograph through an open window. Otherwise, purchase a blind from an outdoor store or photography supply company or construct your own. (See chapter 4 for more about photography blinds and their uses.) Get a comfortable seat, set up your gear, and you're good to go!

Pay Attention to the Background

Once birds are regularly visiting the tree, you'll discover that certain branches become favorite perches. If you don't like how they look, you can either reposition the blind or move the feeder to encourage birds to use a different perch or another part of the tree. Tie back or prune off any distracting twigs as needed.

When you finally have a bird in your viewfinder, take a good look behind it before you press the shutter button to make sure there are no distractions in the background. Recall from chapter 7 that bold lines in the background can be particularly distracting. Avoid having stray twigs, shadows of trunks or branches, or other obvious lines behind the bird, especially if they lie directly behind its head or neck. Bright highlights in the frame can draw attention away from the main subject, too. To keep distractions out of the frame, fine-tune the position of the blind or try raising or lowering your tripod.

Elements behind the bird can be OK as long as they're far enough away to be out of focus and not distracting, as is the case with the flowers behind the American Goldfinch in figure 9.6. Resist the temptation, though, to always insist on a featureless, single-color background. If you do so you risk your photos appearing contrived or suffering from the "bird on a stick" syndrome! I much prefer to

Figure 9.6: American Goldfinch male in eastern redbud.
Canon EOS 7D with 500mm f/4L IS USM lens, 1.4× teleconverter, Gitzo tripod, 1/500 sec., f/5.6, ISO 800.

have some texture and interest in my backgrounds.

When photographing close to human habitation, at some point it's inevitable that a recognizably man-made element will get in the way and ruin the shot: an obvious roofline or unattractive aluminum siding intruding into the frame, for instance. Sometimes a slight change in viewing angle (either side to side or up and down) is all that is needed to keep the offending distraction out of the frame. Other ways to solve the problem are to get closer to the bird, add a teleconverter, or use a wider aperture (smaller f-stop number) so that less of the background is in focus. For a long-term solution, use your ingenuity

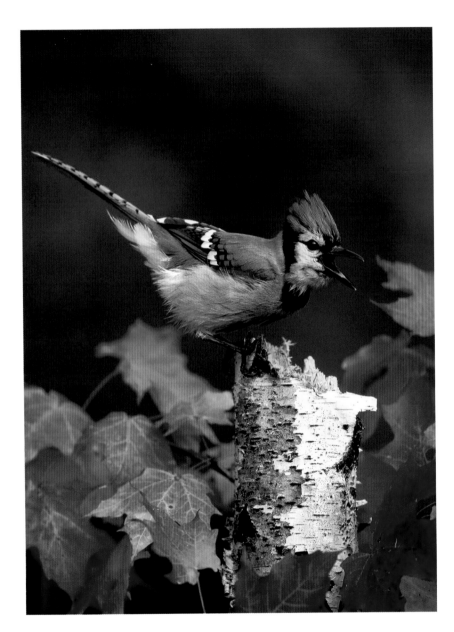

Figure 9.7: Blue Jay calling in autumn.
Nikon F5 with 500mm f/4 IS lens, 1.4× teleconverter, Gitzo tripod, Fuji Velvia film, camera settings not recorded.

to come up with a way to disguise the human artifact or block it from view. For instance, to block the view of a tool shed behind one of my photo setups, I put a wooden plant trellis on which I grow vines.

Backyard Setups

For ultimate control of your subject's surroundings and background, you'll want to use artificial perches. Place them where they will get optimal light and then use bird feeders to entice birds to land on them. Some of my favorite and most-published images have been photographed this way, including the calling Blue Jay in figure 9.7, which has appeared on book and magazine covers and in calendars.

To capture the image, first I sank a metal fence post into the ground and wired a birch trunk to the front of it, far enough away from the pine trees in the background that they would be out of focus. I moved a bird feeder close to the trunk, expecting the local jays would land on the trunk before proceeding to the feeder. Once they were doing so consistently, I beautified the trunk by attaching sprays of maple leaves to it (using bungee cords) and then I hid in a photo blind nearby. Quick reflexes let me press the shutter button the instant this jay arrived. The fact that it's calling was sheer luck!

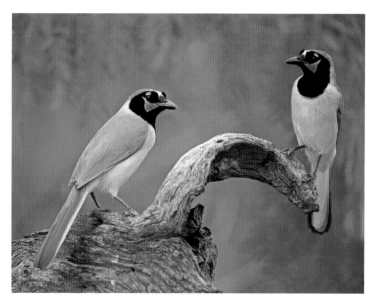

Figure 9.8: Green Jays on an unusually shaped perch against a natural background of newly leafed-out mesquite.
Canon EOS 5D Mark II with EF 500mm f/4L IS lens, 1.4× teleconverter, Gitzo tripod, 1/250 sec., f/5.6, ISO 800. Rio Grande Valley, Texas.

Figure 9.9: A backyard setup for woodpeckers and nuthatches. A birch trunk wired to a fencepost is supported on a cinder block to raise it to the correct height. Note the artificial background, made up of sprays of fall leaves arranged on shrubbery.

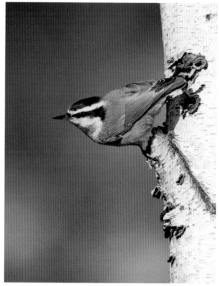

Figure 9.10: Red-breasted Nuthatch male photographed at the setup shown in figure 9.9.
Canon EOS 1D Mark III with 500mm f/4L IS USM lens, 1.4× teleconverter, Gitzo tripod, 1/2000 sec., f/7.1, ISO 320.

Selecting and Arranging Perches

Be on the lookout for fallen branches and snags to serve as perches. The right perch can make the photo (figure 9.8). Avoid straight, horizontal branches—images of birds on them are commonplace. Instead, make a collection of perches with character: gnarled, lichen-covered branches, curved boughs, snags with interestingly textured bark, moss-covered logs, odd-shaped pieces of

driftwood, or fallen sprays of pinecones. Where it is appropriate and legal to do so, you can cut sprays of live foliage or flowers, either for birds to perch on directly or to use as perch decorations. When you're arranging your perch, remember that diagonal shapes and lines add drama and interest to images.

Find solutions for perch supports online or from home-and-garden stores: garden fence posts, bird feeder poles (with free standing base or with an

auger that screws into the ground), Christmas tree stands, and cinder blocks, to name a few ideas. Attach perches to supports using wire, bungee cords, cable ties, or twine.

A vertical tree trunk baited with suet is ideal for photographing woodpeckers and nuthatches—birds that forage while clinging to bark (figures 9.9 and 9.10). Attach a wire suet cage to the trunk to initially attract the birds, but when you want to actually shoot, remove it

temporarily. That way the feeder isn't visible in the frame and your subjects don't have messy suet fragments stuck to their bills! The birds will still come and search for food for a short time but, to keep them interested, replace the feeder as soon as you notice a decline in activity or once you're satisfied with your images.

Locate your perch where it can receive optimal lighting and where you can position a blind with the sun directly behind you. An uncluttered background beyond the perch is equally important. Check through your lens to make sure the background is far enough away that it appears softly blurred, which will enable the subject to stand out.

Some backyard photographers set up multiple perches at once, but I prefer to use just one. The reason is that if you offer birds many perch options you can't be sure where they will land, and, since small birds rarely stay put for long, they may jump off the perch before you can aim and focus. At most, I work with two perches at once in order to photograph birds with different feeding styles. For example, within shooting range of my blind I might have both a vertical trunk for woodpeckers and nuthatches and a branch for cardinals and chickadees next to a sunflower feeder.

To decorate perches, strive for a natural look, especially if you're using live flowers or foliage. Avoid leaning flower

stems flat against a perch—plants don't grow that way naturally. Instead separate stems from the perch slightly by inserting a small fragment of wood or other material as a shim between the stem and the perch, or put the decorations on a separate support. Use florist's wire or grocery bag twist ties to attach and critically position flowers and leaves, orienting them in ways that would be typical if they were growing in the wild.

Nothing says "artificial set up" like droopy vegetation. Keep flowers and foliage fresh by putting each cut stem in a floral tube of water. Purchase floral tubes from florists or craft stores. Alternatively, place multiple stems in a larger container of water next to the perch: Insert each stem in a block of florist's foam to hold them upright and arrange them artfully around your perch. (Who knew that the Flower Arranging class you took long ago would come in so handy!)

The Perfect Place

Sometimes, despite your best efforts, those darned birds just won't perch where you want them! Here are a few means of coercion.

- Limiting birds' access to food encourages them to perch while waiting their turn at the feeder, so avoid placing multiple bird feeders near your

perch. If the remaining feeder has multiple feeding ports, cover all but one.
- Birds are more likely to land on an obstruction-free part of a branch. For example, to photograph a Baltimore Oriole, I chose to set up a branch that was naturally flower-free for part of its length (figure 9.11). As I expected, the oriole landed on the flower-free

Figure 9.11: A setup for orioles using a cut orange. An apple tree branch tied to a support snag by means of a bungee cord serves as the perch, and the orange is attached to the upright using a nail. The redbud tree in the distance forms the background.

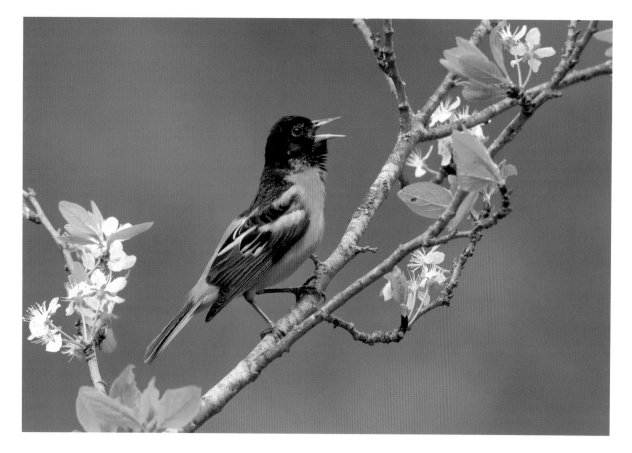

Figure 9.12: Baltimore Oriole singing on apple tree branch, photographed at the setup shown in figure 9.11.
Canon EOS 7D with 500mm f/4L IS USM lens, Gitzo tripod, 1/500 sec., f/5.6, ISO 500.

part (figure 9.12) before hopping onto the cut orange that I'd used to attract it. The bird's vocal performance was a nice surprise! If your perch has many leaves or flowers, try clipping one or more of them off to open up the perfect landing spot. Disguise the clipped part, if necessary, by rubbing a little mud or soil on it.

▸ To entice woodpeckers and nuthatches to precise spots on natural or set-up tree trunks and snags, press fragments of suet, peanut butter, or individual sunflower seeds into crevices in the bark, or drill small holes in the wood and do the same. For a natural appearance, make sure the food isn't visible in your photographs.

Keep it Interesting: Foregrounds and Backgrounds

Backyard setups have always played an important role in my work, but it's challenging to come up with fresh ideas year after year to obtain images that go beyond simple bird portraits. One autumn I replicated an effect I've

Figure 9.13: Setup for figure 9.14. A spray of leaves was placed between the camera and the perch. A bird feeder is several feet to the left of the perch, not visible in this photo. I arranged the leaves so they did not cover the spot where the bird would land.

Figure 9.14: White-breasted Nuthatch photographed at the setup in figure 9.13.
Canon EOS 7D with 500mm f/4L IS USM lens, 1.4× teleconverter, Gitzo tripod, 1/250 sec., f/5.6, ISO 500.

Figure 9.15: Winter backyard setup for Common Redpolls: feeder, alder branch tied to a second feeder pole as a perch, and photo blind.

employed occasionally in the field—shooting through vegetation to produce a softly out-of-focus vignette effect.

I attached a spray of red maples leaves to a low bird feeder pole, and placed it between my camera and the perch (figure 9.13). A bird feeder was several feet to the side of the perch and beyond was one of several photo blinds that I use (Ameristep Outhouse blind, see chapter 4 for more information). It took much fiddling and rearranging, and constant checking through the lens to

be sure the leaves weren't obscuring the nuthatches and chickadees using the perch, but eventually I got the appearance I wanted (figure 9.14).

Another way to introduce variety is to change backgrounds. Usually, I do this by moving perches and feeders around to different spots in the yard to take advantage of seasonal plantings. In summer, the background might be the colorful flowers in my bird-feeding garden (see figure 9.1), whereas in autumn, it might be shrubbery with bright berries.

I sometimes enhance natural backgrounds by placing sprays of natural vegetation or even garlands of artificial leaves or berries at a distance behind the perch, as in figure 9.9. Other photographers create completely artificial backdrops, such as painted sheets or giant photo prints portraying out-of-focus vegetation, which they erect behind perches. As with any artificial enhancements, be sure that colors and shapes look natural and are far enough behind your subject that they are blurred and not recognizable as artificial.

I prefer to make backyard images that convey a natural-history message as well as being pretty. One way I achieve this is to select as perches the kinds of plants that my subject species might naturally feed on. As an example,

Figure 9.16: Common Redpoll male perched in an alder with falling snow.
Canon EOS 5D Mark II with EF 500mm f/4L IS lens, 1.4× teleconverter, Gitzo tripod, 1/400 sec., f/5.6, ISO 800.

Common Redpolls' natural food includes birch and alder seeds, so when I photographed redpolls one winter, I chose an alder branch for the perch. I could have used a spray of bright red berries instead—that certainly would have made an eye-catching photo. But redpolls are seed-eaters—they don't eat berries in the wild. Figure 9.15 shows the setup. To the left of the hanging sunflower seed feeder is a second feeder pole with the alder branch attached to the top. The redpoll image in figure 9.16 serves a dual purpose: It is not just a calendar-worthy shot but biologically meaningful as well.

Notice the photo blind in the background. Among many advantages of backyard photography is being able to leave a blind in place for extended periods of time without risk of it being stolen or disturbed. What's more, over time, it becomes part of the scenery; the birds become accustomed to its presence and eventually ignore it.

Attracting Bluebirds for Photography

Bluebirds are perennially favorite subjects for photography. If you live near the right habitat—open country with scattered trees and sparse ground cover—you may be able to attract them by putting up a nest box. My property is wooded, but there's a bluebird trail not too far from my home where I can

Figure 9.17: Eastern Bluebird pair trained to come to a perch for mealworms. Their nest box is in the background.

Figure 9.18: Closer view of the dish of mealworms attached to the pole. A perch is attached separately and replaced with a more photogenic one for photography.

always find a pair of Eastern Bluebirds raising a family in spring. One spring I trained them to come to a perch for mealworms (purchased from a pet store), with the goal of photographing them. I fed them once daily and they would eventually come flying in for their treat when I whistled!

I placed a bird feeder pole several yards from their nest box and attached a small plastic dish to hold the mealworms (figures 9.17 and 9.18). Attached

separately to this pole was a temporary perch beyond which was an optimally positioned photo blind. For the actual photography, I replaced the temporary perch with a more photogenic one, such as a branch cut from a flowering tree in my yard (figure 9.19).

Another method is to attach a perch directly to the nest box, but this must be done with great care to minimize disturbance and avoid abandonment. Attach the perch such that it won't prevent the

Figure 9.19: An Eastern Bluebird male flutters his wings on an arranged perch. Canon EOS 1D Mark III with 500mm f/4L IS USM lens, 1.4× teleconverter, Gitzo tripod, 1/640 sec., f/8, ISO 250. Dryden, New York.

birds from entering or exiting nor give a predator easy access.

Photographing birds sometimes provides poignant memories unrelated to the actual photos. While my bluebirds were feeding young in late April, a freak snowstorm occurred. Bluebirds capture prey on the ground, but on that day their prey was hidden under several inches of snow. As you can imagine, they were mighty pleased to see me when I arrived with an extra supply of mealworms. I filled the dish multiple times, and they immediately seized as many mealworms as they could carry

before flying to the nest to feed their young and coming back for more. I worried about the nestlings on that cold day, but all survived and fledged successfully. I like to think my supplemental feeding had a hand in their survival.

Elaborate Sets to Capture Bird Behavior

With imagination and ingenuity, you can capture avian activities in your backyard studio that may be fleeting and difficult to obtain in the wild. One such example is food hoarding: Various woodpeckers, jays, nuthatches, chickadees, and other species store acorns, nuts, and seeds in autumn to provide a winter food source. Using setups, I've photographed Red-bellied Woodpeckers (figure 9.20) and Blue Jays with acorns in autumn as a way to show how important these food resources are to their survival.

One autumn, I built an elaborate set for Blue Jays. I placed a photogenic tree stump on a plywood table supported by cinder blocks, and I covered the plywood with fallen leaves (figure 9.21). The goal was to simulate what would be seen at

Figure 9.20: Red-bellied Woodpecker female holding an acorn in autumn.
Canon EOS 7D with 500mm f/4L IS USM lens, Gitzo tripod, 1/320 sec., f/5.6, ISO 800.

Figure 9.21: The set decorated with fallen leaves awaits avian visitors.

Figure 9.22: The hidden plastic tub initially contained sunflower seeds, but once jays were feeding consistently, I replaced the seeds with acorns. (Right)

ground level on a forest floor. I baited the set initially with sunflower seeds in a plastic tub hidden behind the jagged edge of the stump (figure 9.22). Once the jays were regularly feeding from that, I replaced the seeds with acorns and waited in a blind nearby for the perfect pose (figure 9.23).

Don't assume that setups always make bird photography easy! You still have to put in the time and effort to get something special. And of course, there's no guarantee that the birds will perform as you intended. In my particular case, the jays were none too pleased with the change in food. Several hours went by before I got my hoped-for shot of a Blue Jay posing attractively with an acorn in its bill. Mostly, they simply tossed out the acorns in search of the preferred seeds or faced away from the lens at the decisive moment, ruining the shot.

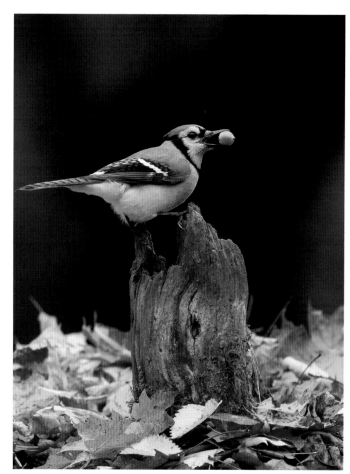

Figure 9.23: Blue Jay holding an acorn in autumn, photographed at the set shown in figure 9.21.
Canon EOS 7D with 500mm f/4L IS USM lens, Gitzo tripod, 1/250 sec., f/5.6, ISO 640.

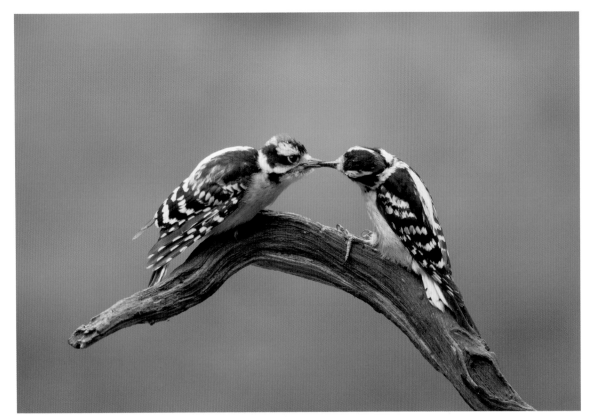

Figure 9.24: Downy Woodpecker fledgling (left) being fed by its father.
Canon EOS 7D Mark II with 500mm f/4L IS lens, 1.4× teleconverter, Gitzo tripod, Autofocus, 1/1000 sec., f/5.6, ISO 500.

Figure 9.25: Setup for Blue Jay family. A branch is attached to the feeder.

Feathered Families: Autofocus or Manual Focus?

If you feed birds all year round, as I do, birds nesting nearby may bring their fledglings to your feeders. Choose a perch that can accommodate more than one bird, and set it up near the feeder.

Now you have the chance to capture special moments in birds' family lives that might be quite difficult to obtain in a field situation, for no other reason than birds are always on the move.

By using a set-up perch you know the precise spot where the birds usually land. Prefocus on that spot ahead of time, and then once the subject arrives, you'll find it easier to acquire and maintain focus. (See chapter 3 to review focusing methods.)

For the Downy Woodpecker fledgling being fed by its father in figure 9.24 autofocus was vital because the young bird constantly shuffled about in anticipation of being fed, while the adult flew back and forth from the feeder. Using autofocus, I was able continuously track the fledgling and be ready to capture the food transfer.

Although I primarily rely on autofocus for backyard work, there are certain situations in which manual focus is a better choice. One such example occurred when I photographed a family of Blue Jays. One important issue was that they visited only occasionally, but to always be ready for them I needed to hold focus on the perch, sometimes for long periods of time. When I tried doing this

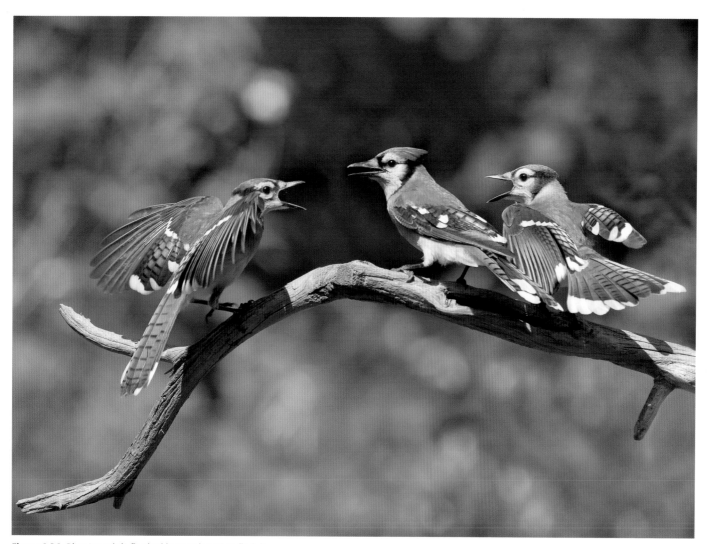

Figure 9.26: Blue Jay adult flanked by two begging fledglings.
Canon EOS 7D II camera with 500mm f/4 IS lens, manual focus, 1/800 sec., f/5.6, ISO 400.

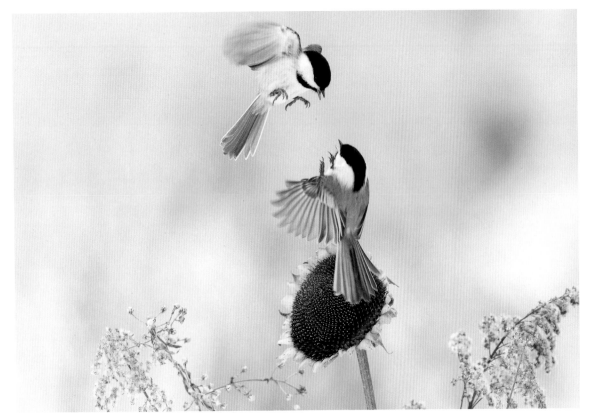

Figure 9.27: Black-capped Chickadees during a midair argument above a sunflower head.
Canon EOS 1D Mark III with 500mm f/4L IS USM lens, 1.4× teleconverter, Gitzo tripod, manual focus, 1/2000 sec., f/5.6, ISO 800.

envisioned the entire family in the frame (figure 9.26), it was vital to orient the perch so its entire length would be on the same plane of focus to keep all the birds sharp. Finally, I framed the shot loosely by shooting from quite far away to increase the depth of field. In fact, I was on my deck 40 feet away in a comfy chair and, depending on the time of day, with a cup of tea or a glass of wine by my side. One of the many luxuries of backyard photography!

Backyard Drama: Fight and Flight

You may think you live in a peaceful neighborhood, but I bet there's no lack of avian drama in your backyard for you to capture. Take what happened one winter when I set up a dried sunflower head to feed the local Black-capped Chickadees. Usually, a wintering chickadee flock has a dominance hierarchy. Each chickadee knows its place and waits its turn to land on a food source. A couple of feisty individuals obviously hadn't heard this rule, and if they arrived together, they'd get into a midair scuffle.

To capture the action, I used what I call the "prefocus-and-wait" strategy in combination with manual focus. I framed the sunflower with plenty of space around it, manually focused on the seeds in the middle of the sunflower, and then waited in a blind nearby.

using autofocus, my camera's AF system became confused by the mostly bird-free space in the frame and frequently lost focus on the thin perch, switching to the background instead. Rather than risk losing precious time struggling to refocus when the birds arrived, I decided that manual focus was a safer choice. It

helped, too, that the fledglings generally stayed in the same spot on the perch, with minimal risk they would move out of the plane of focus, while the parents hopped to and from the feeder with seeds for them (figure 9.25).

I prefocused on the middle of the perch and turned AF off. Since I

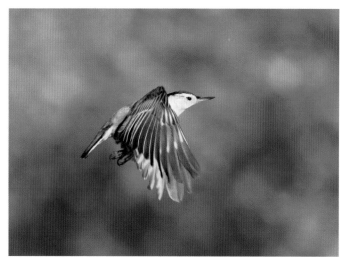

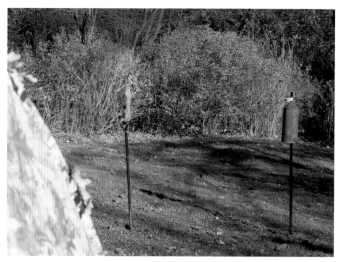

Figure 9.28: White-Breasted Nuthatch in flight. Staging perch cropped out.

Canon EOS 7D Mark II with EF 100–400 mm IS II lens (at 400mm), Gitzo tripod, 1/3200 sec., f/5.6, ISO 800.

Figure 9.29: Setup for the flying White-breasted Nuthatch in figure 9.28.

Here's the trick: Because I wasn't concerned about focusing, I watched over the top of the camera through the mesh window of my blind rather than through the viewfinder. Doing the latter, I probably would have reacted too slowly to press the shutter release in time, but looking over the camera let me see the chickadees approaching. Whenever two birds flew in together, I immediately fired a burst of images without waiting for them to actually start fighting. Anticipatory shooting meant I deleted a lot of dud shots in which no argument happened, but the reward was a few gems like figure 9.27.

Another backyard situation in which to use the prefocus-and-wait strategy is for birds in flight, such as the White-breasted Nuthatch in figure 9.28. The trick is to limit the bird's flight path to and from a feeder. You achieve this by restricting the size of the food source so the bird lands in a very precise spot. I temporarily replaced my regular feeder with a tiny plastic dish of seeds, attached to the top of a pole using a strip of duct tape (figure 9.29). Next, I placed a "staging" perch (a spot on which birds land before proceeding) a short distance away from the feeder (8 feet in this case).

It's vital that both the staging perch and dish be exactly the same distance from the camera (23 feet in this case) to ensure the bird's entire flight path is on the same focal plane. I focused on the perch manually, recomposed the shot with it on the far left, and fired shots whenever the nuthatch took flight. To capture the landing, you can simply focus on the feeder and recompose with space on the opposite side. In order to freeze the action of fast-flying small birds, a fast shutter speed is essential.

For larger species such as jays, cardinals, or woodpeckers you may find you need to increase the distance between

Figure 9.30: Backyard setup for hummingbirds. A cardinal flower in a floral tube of water is tied to a bird feeder pole. The camera, equipped with a short telephoto lens, is prefocused on the flower and triggered remotely using a PocketWizard Plus II transceiver kit.

Figure 9.31: A medical syringe is used to inject a few drops of sugar water into the flower. Replenish the food after each time the hummingbird feeds.

the staging perch and the feeder in order to obtain a pleasing wing position. For short distances, these birds may simply jump toward the feeder but not fully open their wings. Be aware, too, that woodpeckers usually take off by swooping downward off a perch, so adjust your framing accordingly. Be prepared to go through much trial and error with this flight technique.

Photographing Hummingbirds in Flight

Few creatures are as fascinating as hummingbirds, darting around on whirring wings, flashing their jewel-like colors. Flying hummers can be photographed in flight using natural light, but to truly do justice to their iridescent plumage and to freeze wing motion, you need flash. Hummingbird specialists employ elaborate sets involving artificial backgrounds and multiple flash units in which wing motion is stopped

by the flash duration rather than shutter speed. This highly technical method is beyond the scope of this book, but for other books on the topic see the Resources section.

The natural light method I use requires a remote triggering device as shown in figure 9.30. Mine is a Pocket-Wizard Plus II transceiver kit (see chapter 2), but several types are available.

First, attract hummingbirds by means of a hummingbird feeder filled with sugar water. When you are ready to photograph, replace the feeder with a flower in a tube of water. To be true to nature, select a flower that hummingbirds prefer naturally. Locate the setup where it receives good light against either a distant natural background or an artificial backdrop. Use a short- to mid-range telephoto lens on a tripod-mounted camera placed a few feet away from the flower. Using a medical syringe with a fine needle, inject a small amount of sugar water into the flower (figure 9.31). Manually prefocus on the flower, framing it off to one side to allow space for the hummingbird. When the hummingbird arrives, fire a burst of shots.

Here are a few tips that may be helpful:

- A very fast shutter speed is vital to stop the motion of a flying hummer with natural light, so shoot at the time of day when the light is

strongest. This means a compromise between light quality and intensity. I've found a shutter speed of at least 1/2000 second can work, but I much prefer 1/3200 second or faster. Even so, there may be some wing blurring.

- A hummingbird's typical strategy is to insert its bill into the flower, drink, then back out and briefly hover in place before repeating the process, sometimes multiple times if the flower has been generously spiked with sugar water. To show the bill unobscured, press the shutter release when the hummer backs out of the flower as I did for figure 9.32. Otherwise, fire when it's actually feeding.

- You can use the set-up flower technique either by shooting remotely using a short telephoto lens or by shooting conventionally using a longer lens at a distance (for which you would want to use autofocus rather than manual focus). I've used the latter method to capture hummers feeding at live plants in gardens and in the wild, as well as at set ups.

As you've seen, your own backyard can offer numerous opportunities to capture not just beautiful bird portraits, but also images of behavior and birds in flight. If this chapter has piqued your interest in photographing birds on the wing, that's our next topic.

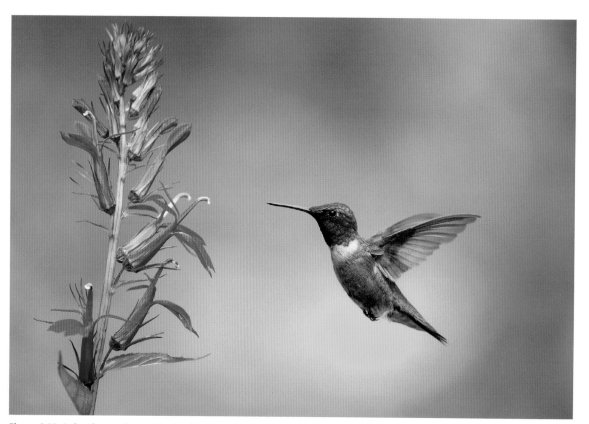

Figure 9.32: Ruby-throated Hummingbird hovers while feeding at the setup described previously. The background is the author's flower garden.
Canon EOS 5D Mark III with 100–400mm IS II lens at 300mm, Gitzo tripod, manual focus, natural light. Camera triggered remotely using a PocketWizard Plus II Transceiver kit, 1/2500 sec., f/5.6, ISO 1250.

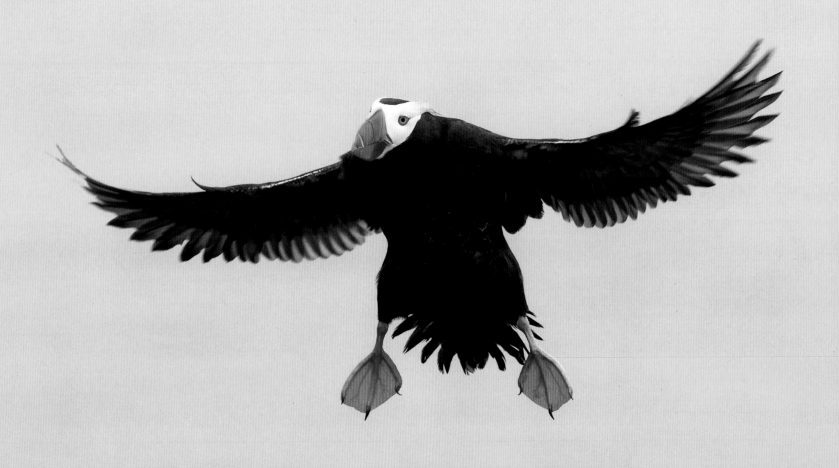

Chapter 10

ON THE WING

High on a cliff top, I gaze out over the Bering Sea, with nothing but gray water between Russia and myself. Hundreds of puffins, murres, auklets, and kittiwakes swirl through the air around me, winging their way to and from nests on the steep cliffs. A single bird holds my attention: the Tufted Puffin that almost landed on a rock ledge seconds earlier. I'm betting it will soon be back for another try at what is likely its favorite perch, but I'll need all my concentration to keep track of it among the chaos of other birds flying to and fro. I watch the fast-flying little puffin as it traces a wide arc far out over the ocean before turning back toward the colony. My pulse quickens. Keeping the still-distant puffin in sight, I raise the viewfinder to my eye, center the bird, and lightly press the shutter button. The puffin pops into focus, and as it comes in to land I fire off a sequence of shots. What a thrill it is to capture birds in flight!

Figure 10.1: Black-bellied Whistling Duck pair flying in close formation. Successfully capturing images of birds in flight depends on a combination of optimal camera settings, technical skill, strategy, and fieldcraft.
Canon EOS 7D Mark II with 500mm f/4L IS lens, Gitzo tripod. 1/1600 sec., f/5.6, ISO 400. Venice, Florida.

Figure 10.2: An Elegant Tern shakes in midair after diving for fish.
Canon EOS 1D Mark III with 400mm f/5.6L USM lens, handheld, 1/2500 sec., f/8, ISO 640. Bolsa Chica Ecological Reserve, California.

The power of flight is what makes a bird a bird. Apart from a handful of flightless ground-dwellers, birds are creatures of the air. The apparently effortless skill with which they wing their way across the sky is a major part of their appeal, symbolizing an enviable freedom that we earthbound humans crave.

Capturing the essence of that freedom makes photographing birds in flight the most exciting and rewarding genre of bird photography, but it is also the most challenging, fraught with potential frustrations. This chapter explores techniques and strategies to help you successfully capture these fast-moving creatures on the wing.

Optimize Camera Performance for Birds in Flight

Successfully photographing birds in flight involves technical skill, strategy, and fieldcraft (figure 10.1). You'll bring all your abilities to this venture: physical attributes such as strength, stamina, and panning skill, as well as fieldcraft factors such as recognizing a workable situation, reading weather and light, and predicting bird behavior. But first comes equipment—it's essential to select the best camera settings, especially those that optimize autofocus performance.

Modern DSLRs feature fast, accurate autofocus (AF), high ISOs, and super-fast shutter speeds, enabling photographers to capture birds frozen in the midst of lightning-fast action such as an Elegant Tern's midair shake (figure 10.2). To get optimal results from the technology, the following camera parameters should be set correctly: shutter speed, AF mode, Drive mode, and AF area mode. Advanced shooters may want to fine-tune autofocus performance still further. We'll explore each of these parameters in detail.

If I expect to shoot birds in flight, I adjust my camera settings as soon as I arrive at a field site so that once the action starts I won't be scrambling to switch settings and possibly making errors.

Shutter Speed, Aperture, and ISO

To obtain sharply focused images of flying birds or any fast action, a fast shutter speed is the top priority. Aperture, or f-stop, affects depth of field, but it can't compensate for a shutter speed that is not fast enough to freeze motion. At best a too-slow shutter speed means blurred wings; at worst the entire image will be blurred. To obtain a fast shutter speed, select a wide aperture and increase the ISO as necessary. I choose an ISO that gives at least 1/1000 second, preferably 1/1600 second or higher.

For a bird photograph to be successful, the subject's eye and face should be sharp, but some wing blur may be acceptable and even desirable. The Osprey in figure 10.3 had been standing in a shallow creek cooling off, and the takeoff took me by surprise. My shutter speed of 1/640 second was too slow to freeze wing motion as its wings swept forward—ideally, it should have been at least 1/1600 second. However, the Osprey's face and eyes are sharp as is the splashing water, and the blur in the wings creates a pleasing impression of movement.

Photographing flying birds using intentionally slow shutter speeds—termed "pan-blur"—is a way to portray

Figure 10.3: An Osprey takes flight from shallow water.

Canon EOS 7D Mark II with 500mm f/4L IS lens, 1.4× converter, Gitzo tripod 1/640 sec., f/5.6, ISO 640. Lansing, New York.

Figure 10.4: Allen's Hummingbird hovers near a flower.
Canon EOS 7D Mark II with EF 500mm f/4/L IS II lens, 1.4× III teleconverter, Gitzo tripod, 1/2500 sec., f/6.3, ISO 400. Bolsa Chica Ecological Reserve, California.

movement more artistically. We'll explore the technique in chapter 13.

Shutter Speed Examples

Determining a shutter speed depends on the size of the bird and its flight speed, as well as how close it is to you. For large, slow-flying birds such as pelicans, large herons, geese, and eagles, 1/500 second may be adequate. For smaller, fast-fliers like shorebirds, puffins, and ducks—such as the Black-bellied Whistling Ducks in figure 10.1— you'll need 1/1600 second or faster. For small songbirds and natural-light images of hovering hummingbirds (figure 10.4), 1/2500 second or faster is needed to freeze wing motion. (Note: Traditional hummingbird photography uses a specialized technique with multiple flash units, in which wing motion

is stopped by the flash duration rather than shutter speed. Multi-flash use is outside the scope of this book, but see Resources section for other books.)

Autofocus Operation and Drive Modes

As you learned in chapter 3, camera bodies offer several autofocus (AF) operation modes to match different shooting situations. For birds in flight (or otherwise moving fast), pick the one intended for moving subjects (Canon: AI Servo AF, Nikon: AF-C). In this mode, the camera's focus tracking function is activated. As long as the shutter release button (or the AF-ON button if you use back-button focus) remains partly depressed, the camera maintains focus on the moving subject even if the focusing distance changes.

Drive mode determines the frame rate, i.e. how fast images are captured. For birds in flight, choose the fastest Drive mode (Canon: High-speed Continuous, Nikon: Continuous High), which enables you to shoot in bursts (rapid sequences of shots) giving you the best chance of getting a keeper. The actual number of frames per second your camera can capture depends on the model.

Autofocus Points and Areas

To render a flying bird's eye and face sharply focused, the photographer must position the AF point or points over the bird's head or neck—no trivial exercise! When the Short-eared Owl in figure 10.5 took off with its prey, I struggled to acquire and hold focus, even though I was already focused on approximately the spot in the tall grass where it had landed when it pounced. Choosing the optimal AF area can help. You learned about choosing and positioning AF points and AF areas in chapter 3, so this is a good time to review that material if necessary.

Here's a quick reminder. The camera lets you choose AF points or AF areas of different sizes. Depending on the camera model, the options range from a single AF point to expanded AF point clusters to still larger AF zones. Alternatively, you can choose automatic mode in which the camera selects an active point from the entire AF point array. Manually selected AF points/areas can be repositioned in the frame according to your desired composition. In practice, acquiring focus off-center is difficult for flying birds, and so I usually keep the AF point or area centered in the frame.

Figure 10.5: Short-eared Owl carrying prey in flight. AF point expansion (5 points centered on the bird's neck).

Canon EOS 7D Mark II, EF 500mm f/4/L IS II lens, 1.4× III teleconverter, Gitzo tripod, 1/2000 sec., f/5.6, ISO 500. Box Elder County, Utah.

Figure 10.6: An illustration of a Canon viewfinder showing AF Point Expansion 5 AF point option (red squares) used to capture a flying Great Egret. Note that the squares corresponding to the selected AF area appear red only during mode selection. During shooting, they are black.

Autofocus Area Settings for Birds in Flight

With a stationary subject, I may use a single AF point for critical focus, but for birds in flight, I switch to Canon's AF Point Expansion in which a small cluster of AF points is used. (The Nikon equivalent is Dynamic Area AF Mode.) Canon offers two AF point expansion options: 5 points in a cross-shaped cluster or 9 points in a larger cluster. I primarily use the 5-point option, illustrated in figure 10.6, but either choice is a lot more forgiving than struggling to keep a single point on a flying bird.

For birds with fast, erratic flight paths (such as nighthawks, swallows, or small terns), fully

Figure 10.7: Common Nighthawk turning in flight.
Canon EOS 7D Mark II with EF 100–400 mm IS II lens (at 400mm), handheld, Automatic AF point Selection, 1/2500 sec., f/5.6, ISO 500. Malta, Montana.

automatic AF point selection can produce better success than one of the manual options. Common Nighthawks are famous for midair acrobatics and sudden changes of direction. To photograph the one in figure 10.7, I used Canon's Automatic AF point Selection (Nikon's equivalents are Auto-Area AF or Group Area AF). Within the camera's sensor array, the central AF point is the most accurate, so it's a good idea to acquire initial focus with the bird centered when using automatic AF point selection, even if the bird subsequently moves off-center.

We've covered a lot of technical information so far! Time for a review: See the sidebar "Suggested Camera Settings for Birds in Flight (Canon)."

> **SUGGESTED CAMERA SETTINGS FOR BIRDS IN FLIGHT (CANON)**
>
> **Shutter Speed, Aperture, and ISO:** I usually keep the aperture wide open and select an ISO that gives a shutter speed of at least 1/1000 second. In good light I prefer 1/1600 second or higher, especially for fast fliers.
>
> **AF and Drive Modes:** AI Servo AF, High-speed Continuous
>
> **AF Points/Areas:** AF Area Expansion (5 points) or Automatic AF point Selection

Optional Adjustments: Fine-Tuning the AF System

Autofocus systems are engineered to work superbly well with a wide range of moving subjects. The AF settings described so far are perfectly adequate for shooting birds in flight and action shots of birds, so you may want to just stick with them for now. It's best to keep things simple, especially if you are new to this genre of bird photography.

However, if you're more experienced and ready to take the next step toward more advanced shooting techniques, this section introduces two options for Canon users to fine-tune autofocus performance that may help you achieve even better results: **AF Configuration Tool** and **AI Servo 1st/2nd Image Priority.** Scroll through the AF menus on your camera body and refer to your camera's

user guide as we delve into these somewhat complex options.

AF Configuration Tool (Canon)

Many cameras allow the photographer to fine-tune the continuous focus-tracking performance of the AF system to match the characteristics of moving subjects. In Canon cameras, this is done by means of the **AF Configuration Tool,** a drop-down menu offering six "Cases"—preset combinations of the three following parameters.

Tracking sensitivity determines how quickly the AF system responds to a distracting obstacle appearing in the frame.

Accel./decel. tracking allows the camera to accurately track a moving subject even if it frequently changes speed.

AF pt auto switching applies to Automatic AF point Selection and determines how quickly the camera switches to a different AF point based on changes in the subject's location within the frame.

(Note that older Canon bodies may lack the AF Configuration Tool but the parameters may be individually adjustable.)

Case 1 is a versatile, multi-purpose setting. Each of the other five Cases matches the characteristics of moving subjects in various situations. Pick the Case that best matches the flight characteristics of your current subject. (Tip: As you scroll through the AF Configuration Tool offerings, press the Info button for useful details about each Case.) You can also

customize any or all of the Cases as you wish.

Two examples of Cases I find particularly useful are as follows.

In Case 2 (figure 10.8), the Tracking sensitivity value is negative, thereby directing the camera lock focus on the bird regardless of any distractions that might appear in the foreground or background (for instance as might happen if the flying bird passes briefly behind a signpost). I used a customized version of Case 2 to capture the Peregrine Falcon in figure 10.9

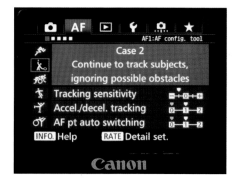

Figure 10.8: Canon's AF Configuration Tool consists of six "Cases," preset combinations of parameters that match the characteristics of moving subjects. You can fine-tune AF performance by picking the case that best matches the flight characteristics of your subject. In Case 2, shown here, Tracking sensitivity has a negative value, directing the AF system to hold focus on the main subject while ignoring obstacles suddenly appearing in the frame. The default values can be customized: I usually customize Case 2 by setting Tracking sensitivity even lower than shown.

Figure 10.9: A juvenile Peregrine Falcon streaks past the steep cliffs where she was raised. Distractions such as the dark and light areas in this scene can sometimes cause the AF system to switch focus onto the background instead of the bird, if you inadvertently allow AF points to move off the subject, however briefly. Fine-tuning AF performance (in particular, setting Tracking Sensitivity to its lowest, least-responsive value) can help keep focus locked on the bird.
Canon EOS 1D Mark III with 400mm f/5.6L USM lens, handheld, 1/640 second, f/5.6, ISO 800. Long Beach, California.

Figure 10.10:
Reddish Egret chasing fish. Stop/start action during the highly active foraging strategy typical of this species challenges both the photographer and the camera's AF system to maintain focus as the bird speeds up, slows down, stops, and changes direction. Fine-tuning AF performance, in particular Accel./decel. tracking, can help.
Canon EOS 7D Mark II with EF 400mm f/5.6L USM lens, handheld, 1/2000 sec., f/8.0, ISO 400. Fort De Soto Park, Florida.

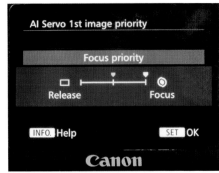

Figure 10.11: Canon's AI Servo 1st image priority feature is shown set to Focus priority, which directs the camera to delay shutter release, if needed, to ensure the sharpest focus for the first image in a sequence.

In Case 4, the Accel./decel. tracking preset is positive, directing the camera to continue tracking and maintain focus on the subject even if its speed changes suddenly. An example in which I would use this setting is the stop/start action of a Reddish Egret running and flying short distances hither and thither through shallow water chasing fish (figure 10.10).

Nikon Equivalent: For Nikon users, fine-tuning AF system responsiveness is achieved via the **Focus Tracking with Lock-on** menu. Depending on the model, various options include the Blocked Shot setting (influencing how long the camera will ignore a distracting obstacle obscuring the subject) and the Subject Motion setting (addressing steady or erratic subject movement).

AI Servo 1st and 2nd Image Priority (Canon)

During continuous shooting, the camera's on-board computing system rapidly evaluates and recalculates focus between shots. We expect AF to function instantaneously, but it does need a little time to attain the sharpest possible focus, especially in low-light or low-contrast situations. **AI Servo 1st image priority** and **AI Servo 2nd image priority** are two separate settings that direct the camera whether or not to take the time needed to confirm focus before allowing the shutter to be released.

AI Servo 1st image priority refers to the initial shot in a sequence. The **Focus priority** setting (figure 10.11) directs the camera to delay shutter release, if needed, for sharpest focus; **Release priority** enables the fastest possible shutter release timing.

AI Servo 2nd image priority refers to the second and subsequent shots in a sequence. As before, setting **Focus priority** prioritizes sharpest focus. **Speed priority** directs the system to shoot at the fastest possible frame rate even if sharpest focus is not fully attained for each shot.

An example of a situation where these settings become important is when fast action occurs. Do you want to fire immediately and continuously to capture it, possibly at the cost of truly tack-sharp images? If so, set Release priority and Speed priority respectively. If you'd rather be sure of maximum sharpness, possibly at the risk of missing the peak of the action, set both to Focus priority.

I am notoriously trigger-happy and there have been many instances when my flight shots could be sharper, and so I often set both AI Servo 1st and 2nd image priority to Focus priority when shooting birds in flight.

If you're like me, at this point, your eyes have glazed over from information overload! Let's escape from camera settings and explore strategy, fieldcraft, and panning technique for birds in flight. Ironically, after exploring autofocus in depth, the first strategy we'll cover involves manual focus!

Prefocus-and-Wait Strategy for Flying Birds

The easiest way to capture flying birds is by using what I call the "prefocus-and-wait" method. Focus on a spot where you expect a bird to land, wait, and then press the shutter release when it flies into the frame. It's perfect for situations where birds regularly fly to a precise, predictable location such as a favorite perch, food source, or nest site. A good example is a hole-nesting species, such as a swallow, bluebird or woodpecker, flying to or from its nest. I have great success using manual focus with this method but autofocus is appropriate in certain circumstances.

Prefocus-and-Wait with Manual Focus

For the Tree Swallow bringing a feather to its nest in figure 10.12, I chose manual focus because using autofocus on the almost-invisible entrance hole (given that my lens was oriented perpendicular to the box) would have been next to impossible. I manually focused on a stick temporarily placed in the center of the hole as a focusing aid. After composing with space on the right of the frame, I watched over the top of the viewfinder, using landmarks in the background to define the edges of the frame. Each time a swallow entered the frame, I fired a burst of shots. When using manual focus this way, the closer the bird is to its intended target, the more likely it is to be in the correct plane of focus. To increase the chance of a keeper with a nice wing position, be prepared to shoot many images. Make sure you have high-capacity memory cards!

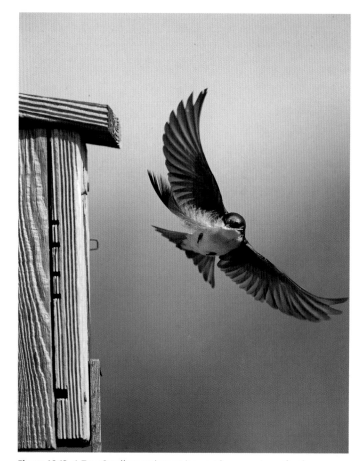

Figure 10.12: A Tree Swallow arrives at its nest box carrying a feather as nest lining.

Canon EOS 1Ds Mark II with 500mm f/4L IS USM lens, 1.4× teleconverter, Gitzo tripod, manual focus, 1/2500 sec., f/5.6, ISO 320. Ithaca, New York.

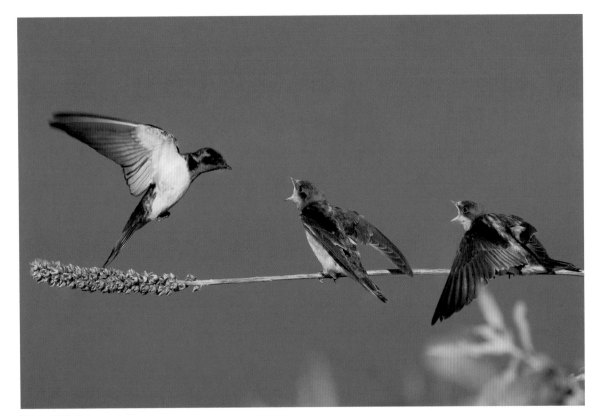

Figure 10.13: Barn Swallow adult arriving to feed one of two fledglings.
Canon EOS 1Ds Mark II with 500mm f/4L IS USM lens, Gitzo tripod, AI Servo Autofocus, center AF point, prefocused on central fledgling's face, 1/1600 sec., f/8, ISO 400. Ithaca, New York. (Note: Distracting plant stems cloned out.)

In situations like this in which you must wait for action to occur, supporting your gear on a tripod is essential. Fatigue from handholding gear for long periods of time is the cause of many a missed shot and can introduce camera shake that leads to soft images.

The Active Approach: Practice and Skill Building

Most flight photography requires a more active approach than simply waiting for a bird to fly into the frame. You must acquire focus on and follow an already moving bird, a task that's technically and physically demanding. Even with modern camera technology on your side, it's daunting at first.

Figure 10.14: Brown Pelican carrying nest material. Large slow-flying species such as this make perfect subjects for practicing flight photography.
Canon EOS 7D with 500mm f/4L IS USM lens, 1.4× teleconverter, Gitzo tripod, 1/2500 sec., f/5.6, ISO 400. Tampa Bay, Florida.

Prefocus-and-Wait with Autofocus

Autofocus is the best choice if you can't pinpoint the exact location where the incoming bird will arrive. A good example is when that location is itself a moving bird like the fledgling Barn Swallow being fed by its parent in figure 10.13. To capture the action, I prefocused on the youngster in the middle of the frame leaving space on the left for the incoming adult. Since the fledgling was constantly fidgeting to and fro, autofocus was essential to hold focus on its face. I watched through the viewfinder, and when the young bird started fluttering its wings and begging, I knew the parent was approaching and I fired off a sequence of images.

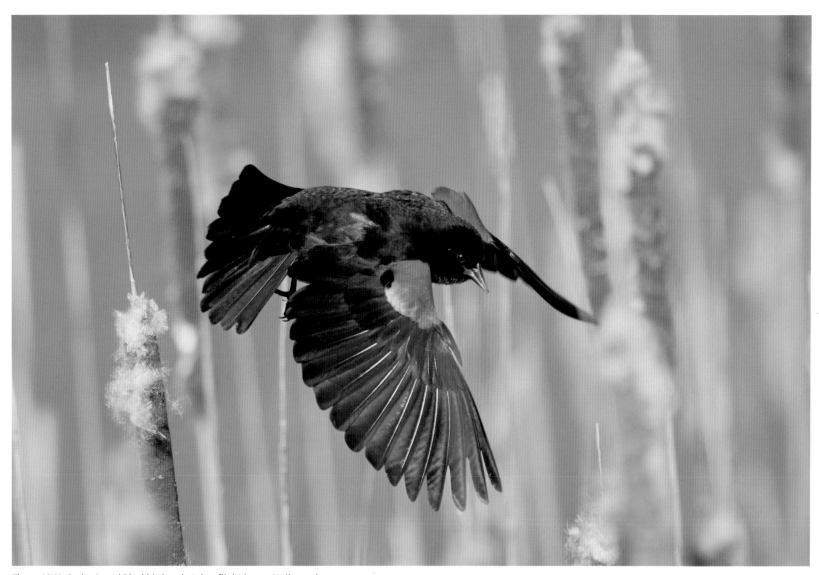

Figure 10.15: Red-winged Blackbird male takes flight in a cattail marsh.
Canon EOS 7D with 500mm f/4L IS USM lens, 1.4× teleconverter, Gitzo tripod, 1/1600, f/8, ISO 400. Ithaca, New York.

The way to improve is through **practice**. Begin with large, slow-flying birds such as pelicans (figure 10.14), geese, herons, or gulls. Find a local spot where the birds are used to people, visit often and shoot lots of images. Don't be afraid to make mistakes. Even if at first you fail, by constantly trying you'll develop strength, fast reflexes, and good concentration—skills that will pay off in the future. You'll be primed for that special moment when a subject does something exciting and dramatic. And when that happens, don't think...SHOOT!

Quick reflexes, honed by years of practice, helped me nail the image of a male Red-winged Blackbird in figure 10.15. I had originally framed the bird off-center for an interesting composition and was expecting it to call and perform its courtship display, but instead it took flight.

Long-Lens Technique for Birds in Flight: Acquiring Initial Focus

It is challenging for both photographer and equipment to capture an image of a subject flying close and fast. You will do better to acquire initial focus on the bird while it's still some distance away and relatively small in the frame, as I did with the Black Skimmer in figure 10.16. Following a bird is physically easier when it is not framed too tightly. Furthermore, this gives the autofocus system a better chance of tracking successfully and producing sharp images.

One challenge when using a long telephoto lens is simply locating the bird in the viewfinder in the first place! Practice will help, but the following strategies will get you started:

- At first, sight the bird by eye, not through the viewfinder. Keep your eyes on the bird, and then raise the viewfinder up to your face without looking down.
- If you're using a zoom lens, zoom looser (i.e., zoom to a shorter focal length), locate the bird, and then zoom tighter (i.e. to a longer focal length) again.
- Prefocus on a stationary object that is about the same distance as the bird. This gets you in the correct focal range to locate the bird more easily in the viewfinder. I use this technique frequently. For the skimmer shot, I first focused close to where the bird was fishing.
- Use the focus range limiter switch of your lens (if present) to restrict how far the AF system has to search back and forth before locking onto the subject. The switch has several positions. Unless the subject is close, avoid the "full" range, which focuses from the lens's minimum focusing distance to infinity. Instead, choose an option that covers an intermediate distance to infinity.

Once you have the subject in the viewfinder, position the AF point (or AF area) over the bird's face, head, or neck. Then press and hold the shutter button down halfway (or press AF-ON if you use back-button focus) to acquire focus and activate focus tracking while you pan smoothly along with the approaching bird.

Panning Technique

Panning involves swinging the lens around at the same speed as the bird, following along with it, keeping the AF point positioned on the bird's face or head. Once the bird fills the frame to your liking, fully press the shutter release to capture a burst of images while continuing to follow it until it turns away from you or flies out of range. (With back-button focus, hold AF-ON down at the same time as pressing the shutter button.) Avoid jabbing down on the shutter button: Instead squeeze it down firmly and smoothly to prevent camera shake. Finally, follow through with the pan and avoid jerking the lens up at the end of the burst.

The trick to successful panning is to do it smoothly and steadily. If you're handholding gear, rotate from the waist, and swing your entire torso. This results in a smoother and more stable movement than rotating just your shoulders and arms. When panning from a tripod,

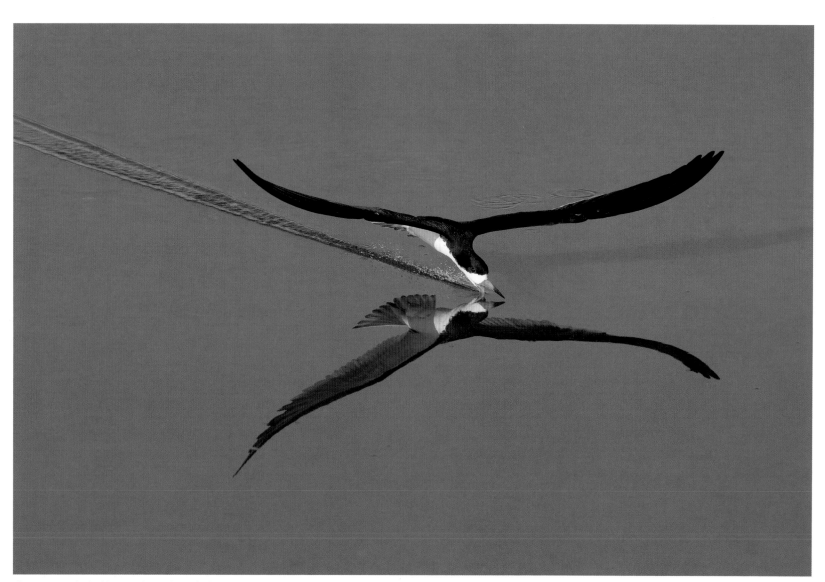

Figure 10.16: Black Skimmer skims through the water using its specialized bill to locate fish just below the surface.
Canon EOS 1D Mark III with 400mm f/5.6L USM lens, handheld, 1/2500 sec., f/8, ISO 640. Bolsa Chica Ecological Reserve, California.

Figure 10.17: Black-necked Stilt in flight over water.
Canon EOS 1D Mark III with 400mm f/5.6L USM lens, handheld, 1/3200 sec., f/5.6, ISO 400.
Bolsa Chica Ecological Reserve, California.

the tripod controls must be slightly loose to allow the lens to swing from side to side. This instability introduces the risk of soft shots so make sure the lens's Image Stabilization (IS, Canon) or Vibration Reduction (VR, Nikon) is turned on. You should further steady tripod-mounted gear by using your body's own resistance, as you learned in chapter 3.

Be aware that IS/VR tends to slow down focus acquisition . Because of this, some photographers turn it off when shooting birds in flight, arguing that it is unnecessary anyway given the fast shutter speeds required. Nevertheless, I keep IS turned on at all times. Depending on the lens model, the IS control may have more than one mode. I have mine set on Canon's IS Mode 2, which is designed to be most effective when following moving subjects.

Regaining Lost Focus

It's bound to happen sooner or later: Despite your good intentions, the AF point slips off the bird, the AF system starts searching back and forth, and suddenly it's locked on the background instead. To recover focus, rather than continuing to hold your finger down while struggling to refocus and reframe at the same time, completely release your pressure on the shutter button. Reframe the bird first and only then try to reacquire focus.

Remember that the AF system works best when it can detect good contrast between the subject and its surroundings. You'll have the best success with birds in flight against even-toned backgrounds, such as blue sky or water (figure 10.17). Busy backgrounds with distracting elements, especially if the bird is small in the frame and/or close to the background, may cause the camera to lose focus easily. Low contrast (like a Snowy Owl flying over snow) or low light can also cause AF problems.

Ditch Your Tripod for Birds in Flight

Bird photographers strive for a balance between stability and mobility. A tripod provides a solid support for your gear for crisply focused shots, but for flying birds it limits your mobility. Handholding gear lets you move around quickly if the bird changes location and you can swing the lens in any direction to more easily track the bird, but at the risk of instability and soft images.

When I'm shooting birds in flight, here is how I decide which method to use.

I **use** a tripod when:
- I expect to wait a while for a bird to take flight.
- I'm using a long, heavy telephoto lens.

I **might use** a tripod when:
- birds are slow-moving, distant and/ or have steady flight paths.

I **ditch** the tripod and switch to a shorter focal length lens when:
- birds are actively flying around and are close.
- birds are flying fast and/or erratically.
- I need more mobility, for instance to switch locations quickly.

While handholding, your body must provide a solid support, especially while you're panning. Review the best practices for handholding gear in chapter 3.

To prevent neck and shoulder fatigue, use a sling-style camera strap (I use Black Rapid brand) rather than the camera's original neck strap. Between bouts of shooting, lower the lens and let the strap take the weight off of your arms and shoulders until the next subject appears.

Anticipation! Reading Birds' Preflight Behavior Cues

As you learned in chapter 8, birds often give behavior cues—subtle changes in body language that signal they're about to do something. Recognizing these signals allows you to anticipate activity rather than reacting to it and possibly missing the peak action. Perhaps the best-known cues are those given preflight. Perched birds often crouch and lean forward before taking flight, as the Roseate Spoonbill is doing in figure 10.18. (They may also defecate.) As soon as you notice these cues, start shooting!

Whether preflight cues are obvious or subtle depends on the size and speed of the bird. Pelicans slowly raise their wings before ponderously taking to the air. Cranes lean forward, "craning" their necks distinctively, before running along to get airborne. Dabbling ducks, such as mallards and teal, flip their heads agitatedly before jumping off the water. Geese, swans, and diving ducks,

Figure 10.18: Roseate Spoonbill signals its intent to take flight by crouching and leaning forward. Canon EOS 1Ds Mark II with 500mm f/4L IS USM lens, 1.4× teleconverter, Gitzo tripod, 1/2500 sec., f/5.6, ISO 400. Orlando, Florida.

such as scaup and mergansers, do the same but with their heavy wing-loading they must run across the water's surface to get airborne, as do loons, grebes, gallinules, and other heavy-bodied waterbirds.

Preflight cues of small, fast birds, such as swallows, can be very subtle, requiring good powers of concentration and quick reflexes. For the Violet-green Swallow in figure 10.19, while maintaining focus on the bird's face, I noticed a slight plumage sleeking and subtle lean forward that signaled she was about to fly.

Once you've acquired initial focus, it's often considerably easier to track and obtain sharp shots of super-fast fliers such, as small ducks, if they are flying side to side rather than coming straight toward you. This may seem counterintuitive,

Figure 10.19: Violet-green Swallow female takes flight carrying a feather as nest lining. Canon EOS 1D Mark III with 500mm f/4L IS USM lens, 1.4× teleconverter, Gitzo tripod, Automatic AF point Selection, 1/2000 sec., f/8, ISO 500. Mono Lake, California.

since a bird coming directly at you should be easier to keep in the frame. If it's flying fast, though, the focal distance will be changing so rapidly that the AF system may fail to keep up. For example, by noticing a Cinnamon Teal's preflight agitation I was able to capture the takeoff (figure 10.20), but once the bird turned toward me, I lost focus. High-end camera models usually can handle these situations, but lesser models may struggle. Front view flight shots are easier with slow-flying birds, but for speedy species it can help if the bird is slowed down by a headwind or is braking to land.

Figure 10.20: Cinnamon Teal drake explodes off the water.
Canon EOS 1D Mark III with 500mm f/4L IS USM lens, 1.4× teleconverter, Gitzo tripod, 1/2000 sec.,
f/5.6, ISO 500. San Joaquin Wildlife Sanctuary, California.

Flight Paths and Behavior Patterns

Maximize your photo ops by noticing birds' predictable flight paths and activity patterns. When you visit a new field site, such as a busy seabird colony, at first you can't decide where to point your lens amid the chaos of birds flying around! But birds are creatures of habit. Colonial seabirds often use consistent flight routes to and from the colony. Watch an individual for a short time and a predictable pattern will likely emerge that will help you determine where to best position yourself. Choose a spot with a good, all-round view of the surroundings and with a clean background. Pay attention to the wind: Flight paths often change from day to day depending on wind direction.

Other predictable flight opportunities include birds flying in to join a flock or returning repeatedly to a source of food or nesting material. The Black-crowned Night Heron in Figure 10.21 repeatedly took a consistent route to and from the tree where it was breaking off twigs as nest material. I focused on the bird in the tree and fired off a burst of shots when it took wing. These kinds of opportunities are all around you—it pays to explore your favorite birding spots, even without your camera, and watch for behavior patterns.

Figure 10.21: Black-crowned Night Heron carrying nest material.
Canon EOS 1D Mark III with 400mm f/5.6L USM lens, handheld, 1/1600 sec., f/5.6, ISO 400. Long Beach, California.

Recognize a Good Situation

To photograph fast flyers with erratic flight paths, having a workable situation can mean the difference between success and frustrating failure. The colony of Barn Swallows nesting under a low bridge in figure 10.22 offered an ideal opportunity for several reasons.

Since it was early spring and the swallows were still claiming nest sites, there was constant activity. A narrow water channel, edged with tall reeds, restricted their flight paths: They typically flew out a short distance, turned, and flew back under the bridge, giving me many chances. They were close enough for me to handhold a mid-range telephoto, making panning easier and less tiring. I had a perfect vantage point at eye-level or slightly above the birds. Finally, they quickly became used to my presence, so I felt I was not disturbing them.

Figure 10.22: Barn Swallows nesting under this low bridge next to a water channel offered a great opportunity to capture these fast-moving birds in flight. Bear River National Wildlife Refuge, Utah.

Figure 10.23: Barn Swallow banking in flight. The birds were so close that I set the focus range limiter switch to its closest range.

Canon EOS 7D Mark II with EF 100–400 mm IS II lens (at 400mm), handheld, AF Area Expansion (5 points), 1/2500 sec., f/5.6, ISO 500. Bear River National Wildlife Refuge, Utah.

In a good situation like this, try the following techniques to help:

- Shoot in burst mode and make repeated attempts.
- After you finish one burst, prepare for the next attempt by immediately refocusing on the spot you consider to be the ideal bird position.
- Speed up refocusing by setting the focus range limiter switch found on the lens barrel.
- If your lens has a Focus Preset button, use it to instantly refocus on a specific spot (see your user guide).

Don't get discouraged at having to delete a large proportion of images due to softness or poor framing. Consider the fact that I shot 750 images during a couple of hours at this spot. Most were out of focus, poorly framed, or wings were clipped, but a handful of stunners, such as in figure 10.23, were ample reward!

Soft images are rarely the fault of equipment. Assuming optimal camera settings, even the best gear is limited by the photographer's skill and technique. Some of the world's top bird photographers admit to tossing out many of their flight shots. The solution? Practice! And more practice!

Wind Direction

Windy conditions can be an advantage when shooting birds in flight. Battling a headwind slows the flight of birds making it easier to acquire focus and track them. Birds tend to take off, fly, hover, and land into the wind. Assuming that front lighting is your goal, for a bird to be facing the light on a windy, sunny day, the wind should be blowing from the same direction as the sun. Therefore, on a sunny morning you need an easterly wind. On a sunny afternoon a westerly wind is best. Avoid the opposite conditions—photos of birds flying directly away from the viewer ("butt shots") are rarely satisfactory!

I noticed a Belted Kingfisher regularly hovering over a deep pool in a local creek as it watched for fish (figure 10.24). I found a spot on the bank with a good view and on the next sunny morning I waited for her to arrive, using a bag blind to conceal both myself and my gear.

Wing Position

One result of shooting bursts at maximum drive speed is that any sequence will include a variety of wing positions from which you can pick your favorites. Most DSLRs can shoot at least 5 frames per second (fps), with some of the pro models now reaching as high as 14 fps. If your camera's frame rate is lower than

Figure 10.24: Belted Kingfisher female hovering.
Canon EOS 7D with 500mm f/4L IS USM lens, 1.4× teleconverter, Gitzo tripod, 1/2500 sec., f/7.1, ISO 400. Lansing, New York.

5 fps in continuous mode, you'll have to more carefully time when to press the shutter release to get a pleasing wing position, rather than "spray and pray!" Doing so is challenging—you'll have more success with slow-fliers like swans or large herons.

Opinions differ over whether wings up or wings down is the more appealing position. For side or partial-side views, I love the wing position at the end of a downstroke, when the flared primary feathers are curved gracefully just before the upstroke begins again, as in the Common Merganser drake in figure 10.25. Whichever you prefer, for side views, either all the way up or completely down looks better than in-between: A half-raised wing can throw a harsh, distracting shadow over the bird's face or block it entirely. For front views, though, any wing position can look fine.

Figure 10.25: Common Merganser male flies low over the water.
Canon EOS 7D with 500mm f/4L IS USM lens, 1.4× teleconverter, Gitzo tripod, 1/1600 sec., f/5.6, ISO 400. Ithaca, New York.

Figure 10.26: Northern Fulmar soars above the waves.
Canon EOS 7D Mark II with EF 100–400 mm IS II lens (at 100mm), handheld, 1/1600 sec., f/5.6, ISO 1250. St. Paul, Pribilof Islands, Alaska.

Look for unusual perspectives. People usually see flying birds from underneath so photographs of them taken from above—for instance, from a cliff overlooking the ocean or a bridge over a river—will be different from the norm. In addition to a unique and compelling top view of the bird itself, from this perspective the surroundings form part of the composition, as does the floating kelp behind the soaring Northern Fulmar in figure 10.26. Capturing a dorsal view is also possible when an incoming bird banks steeply just before landing or when a soaring bird of prey spirals upward to catch a thermal. For the latter, watch carefully as the bird circles and start shooting as soon the upper wing surface begins tilting toward you.

Flocks in Flight

Long telephotos are great for individual birds in flight, but for flocks, try switching to a shorter telephoto, a mid-range zoom, or even a wide-angle lens to encompass all of the birds, maybe even including part of the environment to give a sense of place. A shorter focal length lens gives more depth of field, which you can improve further by closing down the aperture to ensure more birds are in focus foreground to background. Zoom lenses are incredibly versatile. When the huge flock of White Ibis in figure 10.27 took off toward their overnight roost, I quickly zoomed my 70–200mm lens to 75mm to take in the entire flock, including the birds overhead.

Figure 10.27: White Ibis flock flying to roost.
Canon EOS 5D Mark II with 70–200mm f/4L IS USM lens (at 75mm), handheld, 1/1000 sec.,
f/8, ISO 1000. Tampa Bay, Florida.

Figure 10.28: Tundra Swans fly past bare winter trees.
Canon EOS 1D Mark III with 500mm f/4L IS USM lens, 1.4× teleconverter, Gitzo tripod, 1/3200 sec., f/5.6, ISO 400. Cayuga Lake, New York.

When a flock flies across the frame, try to focus on the birds closest to you, particularly if your depth of field is shallow due to using a long focal length lens. Out-of-focus birds in the foreground, especially in the middle of the frame, can be distracting and ruin a photo.

As you consider when to press the shutter release, be aware of how flying birds are grouped together within a flock. A large, densely-packed flock covering the entire frame can be very dramatic, but smaller groups need more care with composition and framing. The relative position of individuals becomes more critical—not so close together that they overlap (especially heads and faces), yet not so spread out such that the flock lacks a cohesive pattern. When the Tundra Swan flock in figure 10.28 first took flight, they remained attractively grouped together, forming the composition shown, but within a few frames they spread apart resulting in a less-pleasing design.

Watch a flying flock through the viewfinder, and notice how patterns and lines form and dissipate as the birds draw closer to each other and move apart. Try to shoot when interesting shapes occur—the distinctive V-shaped skeins of migrating geese, the ever-changing shapes of starling murmurations, the synchronized turns of sandpiper flocks. The opportunities are numerous, so be creative and take advantage of the drama of birds flying en masse (figure 10.29).

Figure 10.29: Wilson's Phalaropes fly over tufa formations at Mono Lake, California. I noticed the phalaropes approaching, and, anticipating a reflection, I zoomed to a focal length that would accommodate the rocky spires and water in the composition.

Canon EOS 5D Mk II with 70–200mm f/4 L IS USM lens (at 100mm), handheld, 1/400 sec., f/14, ISO 400.

Chapter 11

THE BIG PICTURE

The bird's bright red bill catches my eye—a flash of brilliant color against the gray ocean. This stunning Black Oystercatcher has just flown in. The only problem is the fifty-foot drop onto sharp rocks and pounding waves between the bird and me. I am stuck on the edge of a cliff! Even with a 500mm lens and a teleconverter, the bird is disappointingly small and my viewpoint from above means that getting a clean background behind it is out of the question.

Rather than feel frustrated, I will take this opportunity to make an environmental portrait by showing the oystercatcher in its habitat. The bird forages for shellfish along the tideline as it crosses over a complex variety of textures—barnacles, mussels, and variously colored seaweed. The scene tells a story about the bird's life as an inhabitant of the rocky intertidal zone of the Pacific Northwest.

Figure 11.1: Black Oystercatcher. The classic bird portrait: frame-filling subject against an out-of-focus background.
Canon EOS 7D with 500mm f/4L IS USM lens, 1.4× converter, Gitzo tripod, 1/800 sec., f/5.6, ISO 400. Monterey, California.

Figure 11.2: Horned Puffin decides whether or not to take the plunge!
Canon EOS 7D Mark II with EF 100–400 mm IS II lens (at 164mm), handheld, 1/2000 sec., f/5.6, ISO 1250. St. Paul, Pribilof Islands, Alaska.

A great nature photograph tells the viewer something about the subject in addition to what it looks like. This advice was given to me long ago by a mentor... advice I've regularly applied to my work over the years. Yet, even though modern cameras have made technically perfect bird portraits a dime a dozen, many bird photographers still strive for the classic bird portrait—full-frame subject against smooth, out of focus background, showing little other than the bird's appearance (figure 11.1). For photos to stand out from the crowd, you have to go beyond documentation and offer the viewer something more. Although this can be achieved in many ways, this chapter examines one particularly powerful way: making the bird's habitat an important part of the composition.

Include the Habitat to Tell a Story

Through images of birds in their habitat, the viewer learns where the bird spends its life, and how it interacts with and is influenced by the place it calls home. Birds don't live in a vacuum; they live in and engage with the environment. Portraying the bird-habitat relationship—the big picture, so to speak—is a powerful way to help others understand and appreciate the fascinating complexity of the natural world.

Shedding the self-imposed mandate to fill the frame with the bird is a welcome relief if moving closer to the subject is not an option. And if a super-telephoto lens is beyond your means, you're off the hook, too! A shorter focal length lens can be ideal to portray the scene as a whole—the bird *and* its surroundings.

Look for meaningful elements in the environment that speak to the bird's life history: where it finds food, where

it nests, or any adverse environmental conditions it must overcome to survive, for instance. This is where knowing something about your subject can help a lot. The image of a Horned Puffin in figure 11.2 shows the bird dwarfed by the high rocky cliffs on which it nests. Furthermore, looking down from a high vantage point reveals the scene from the bird's point of view, showing the conditions it faces each time it flies to the ocean to feed. Images that tell a story can be more challenging to make than portraits—for no other reason than they need more deliberate composition—but the results are well worth the effort.

Image Format: Vertical or Horizontal?

As you learned in chapter 7, shooting loose allows you far more compositional freedom than tightly framing the subject, including giving you the choice of image format—whether to orient the frame vertically or horizontally.

For instance, a tight, full-body shot of a Yellow-crowned Night-Heron standing tall (figure 11.3) is constrained to a vertical orientation, but a looser view of the species stalking through a mangrove swamp on the hunt for prey works well as a horizontal (figure 11.4)

Figure 11.3: Yellow-crowned Night Heron portrait.
Nikon F5, Nikon 500mm lens, 1.4× teleconverter, Gitzo tripod, Fuji Provia film, camera settings not recorded. J.N. "Ding" Darling National Wildlife Refuge, Florida.

Figure 11.4: Yellow-crowned Night Heron foraging through a mangrove swamp.
Nikon F5, Nikon 500mm lens, 1.4× teleconverter, Gitzo tripod, Fuji Provia film, camera settings not recorded. Fort Myers, Florida.

Be Dynamic!
Place the Subject Off-Center

Compositional freedom comes with a challenge: Where do you put the bird in the frame? The simple answer—especially when the bird takes up only a small part of the image—is, "Anywhere but the center!" A small subject dead center gets boring really fast. If you usually handhold your gear, it's particularly easy to fall back on this default bullseye position because so much of your attention is taken up by just trying to keep the bird in the frame and holding gear steady. Instead, get comfortable with moving AF points or AF areas around the frame, so you can place the bird off-center for a more dynamic design that will hold your viewer's interest, as I did with a Red-winged Blackbird claiming its territory in a cattail marsh (figure 11.5). (Hint: It's easier to do this with gear on a tripod.)

Figure 11.5: Red-winged Blackbird male displaying.
Canon EOS 5D Mark III with EF 500mm f/4L IS lens, 1.4× converter, Gitzo tripod, 1/3200 sec., f/5.6, ISO 640. Ithaca, New York.

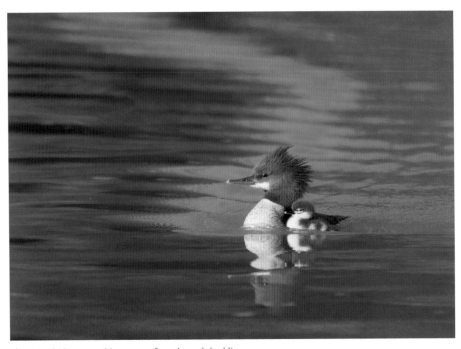

Figure 11.6: Common Merganser female and duckling.
Canon EOS 7D Mark II with 500mm f/4L IS lens, 1.4× teleconverter, Gitzo tripod, 1/2500 sec., f/5.6, ISO 400. Lansing, New York.

In chapter 7 we covered the rule of thirds, the classic method of using an imaginary grid to help you decide where to place an off-center subject in order to create a composition in which the "positive space" (the main subject) is balanced by the "negative space" (the subject's surroundings).

I find a grid very useful for bird-in-habitat images. Each of my cameras is set to display a grid in the viewfinder as a composition aid. I also have the camera set to constantly display the selected AF point(s). The combination of these two in the viewfinder helps immensely when, for instance, I am trying to compose at the same time as tracking a bird moving through the environment, as

occurred with the swimming Common Merganser and duckling in figure 11.6.

Most camera models give you the option to view the grid either in the viewfinder or on the back of the camera in Live View mode. Even though these grids may not actually be 3×3, using one can help you avoid a bullseye composition. They also help you keep the horizon level in the image.

As the mergansers in figure 11.6 swam toward me, my eye was drawn to the sinuous shape of the reflected

Figure 11.7: The same image with 3x3 grid overlaid to demonstrate the rule of thirds.

blue water caused by their wake. Curved lines carefully placed in a design can draw the viewer's eye into and through the frame, and ideally lead directly to the main subject. I composed the image with the birds slightly off center and facing inward. Compositions work best when the bird or birds are facing or moving into, rather than out of, the frame.

Figure 11.7 shows the same image with a rule-of-thirds grid overlaid. It's a good idea to train your eye to recognize good compositions in the field and capture them in-camera, although there is always the option to crop during post-processing to improve composition.

Birds in the Landscape

Sometimes Nature offers you birds in a stunning scene—for instance, a flock flying against a dramatic mountain range or resting along the shore of an iconic lake. When the landscape and the birds demand equal attention, that's your invitation to swap the big glass for a shorter lens and take it all in to create a "birdscape." Images of birds in the landscape have a strong sense of place, especially if the location is easily recognizable such as California's Mono Lake, with its bizarre tufa formations rising from the water (figure 11.8).

As with traditional landscape photography, birdscapes need deliberate

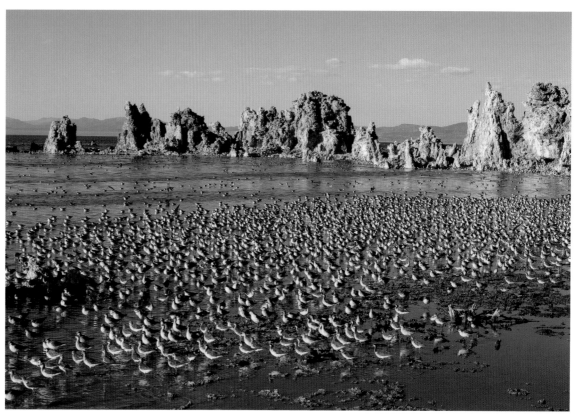

and thoughtful composition. With the potential of multiple elements in the frame, it's important to carefully consider what to include and what to omit. Don't be afraid to move around (slowly!) to explore various compositions, as long as doing so doesn't spook the birds.

Examine the image for potential distractions, such as very bright or dark objects, especially on the side or top

edges of your frame. Adjust the composition if necessary. A zoom lens, either a wide-angle or a short telephoto, such as 70–200mm, is a great help for critically framing a birdscape. To ensure the entire frame is sharply focused from foreground to background, stop down the aperture to increase the depth of field.

Avoid composing with birds so close to the lower edge that they risk falling

Figure 11.8: A birdscape with a sense of place: Migrating Wilson's Phalaropes congregate on the shore on a late summer evening.

Canon EOS 5D Mark II with EF 70–200mm f4L IS lens at 70mm, Gitzo tripod, 1/320 sec., f/16, ISO 500. Mono Lake, California.

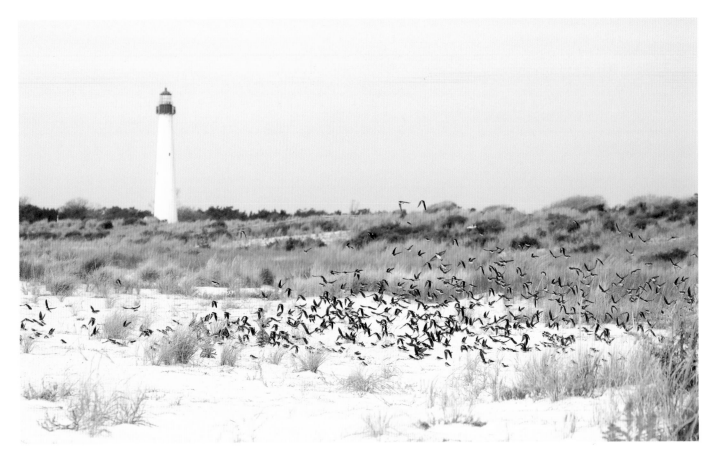

Figure 11.9: Tree Swallow flock landing on the beach during fall migration. I composed to include the iconic lighthouse in the background.

Canon EOS 7D Mark II with EF 100–400 mm IS II lens (at 400mm), handheld, 1/1250 sec., f/5.6, ISO 800. Cape May, New Jersey.

out of the frame, which would draw your viewer's eye out of the frame, too. Instead, change perspective to include something to form a natural border, for instance a stand of plants across the lower part of the frame or a rock in one or both of the lower corners. Even a narrow strip of bird-free water or sand below the flock will work, keeping the birds contained within the image and strengthening the whole composition.

While you're paying attention to the foreground, don't neglect the horizon. Make sure it's level, and avoid placing it dead center in the frame, especially if it's a straight line. Instead, place it off-center, ideally either about one third or two thirds from the bottom of the frame (it's that rule of thirds again!). Use leading lines, such as those formed by rivers or creeks, if present, to invite the viewer's eye into and through the frame.

To improve the juxtaposition of elements in the scene, change your perspective by raising or lowering the tripod to shoot from a different angle or by moving slightly to the left or right. I

needed to do both those things to compose the image of Cape May's iconic lighthouse with a flock of migrating Tree Swallows at this well-known migratory staging area along North America's Atlantic Flyway (figure 11.9).

The Human Environment

As nature photographers, we tend to prefer portraying birds amid the beauty of the natural environment. But as human activities increasingly impinge upon their habitats, birds are increasingly forced to live near people and to contend with the profound impact we have wrought on the earth. If our goal is to photograph birds in the environment, we should not shy away from showing them facing the human-dominated world. The resulting images and the stories they tell can have a deeply emotional impact on viewers.

To give an example, in suburban Florida I once photographed a pair of Sandhill Cranes with twin colts at a nest in a small wetland adjacent to a busy six-lane highway. My delight turned to horror when they began leading the tiny young across the highway during rush-hour traffic to reach the landscaped grounds of a large corporation where they would spend the day foraging (figure 11.10). And they would make this perilous journey back in the opposite direction at night! Much as I dislike including human artifacts in my images, I wanted to show the dangers the cranes and their tiny flightless colts faced every day. These particular young remained safe during my visit, but young cranes regularly are killed or maimed by traffic in Florida as humans encroach into areas that once were their natural homes.

Fortunately, as figure 11.11 shows, there are plenty of light-hearted ways to portray birds in the human environment as well!

Figure 11.10: Sandhill Cranes narrowly escape traffic as they cross a busy highway to reach their foraging area.
Canon EOS 1Ds Mark II with 28–105mm lens at 105mm, handheld, 1/800 sec., f/8, ISO 400. Orlando, Florida.

Figure 11.11: A Royal Tern shows who is king of this castle!
Canon EOS 7D Mark II with EF 400mm f/5.6L USM lens, handheld, 1/1600 sec., f/5.6, ISO 500. Fort De Soto Park, Florida.

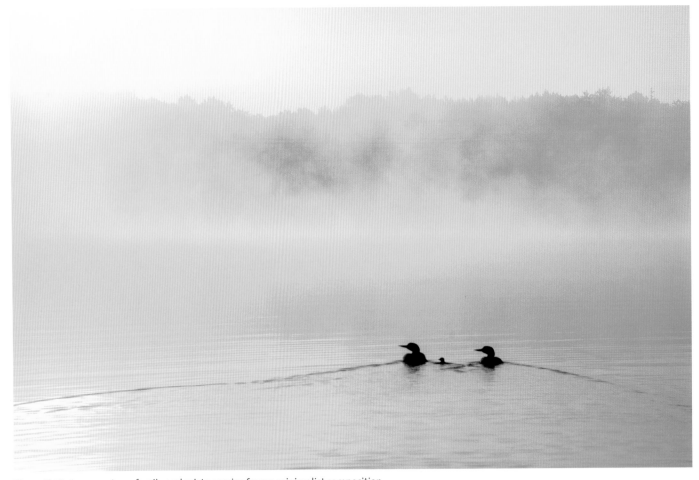

Figure 11.12: Common Loon family and misty sunrise form a minimalist composition.
Canon EOS 1Ds Mark II with 28–105mm lens at 105mm, handheld, 1/3200 sec., f/5.6, ISO 500. Michigan.

Big Picture Artistry

We have spent much of this chapter talking about creating environmental portraits to tell natural history stories. But composing with the bird small in the frame can be a purely artistic means of expression too, as we discuss next.

Image Design Using Negative Space

One way to create standout images is by using a boldly minimalist approach. Negative space—parts of the frame that are empty or less visually significant than the main subject—acts to balance the composition and draw the viewer's attention to the primary area of interest.

Using a wide-angle zoom lens I composed a pair of Common Loons and their chick swimming toward a foggy sunrise (figure 11.12) with the birds strongly off center, letting the negative space—the misty water and indistinct shapes of distant trees—form the major part of the image. Their wakes suggest movement toward the middle distance,

augmented by the fact that all three are facing into the frame. Head angle is always important, even when birds appear very small.

The minimalist approach can have great impact. In this case, for instance, portraying the loon family as only a tiny part of the composition hints at their vulnerability.

Negative space doesn't have to be empty and featureless. Include other elements—particularly something meaningful to the bird's lifestyle—as a balance for the main subject. For the pair of American Oystercatchers on a beach shown in figure 11.13, the negative space is made up of the textures and patterns formed by surf on the sand. These curved shapes lead the viewer's eye on a diagonal path from the bird in the foreground to its out-of-focus mate in the background.

Recognizing Strong Design Elements

Train your eye to notice bold design elements in the environment, whether natural or man-made. I used a short telephoto zoom lens to capture a composition of a Snowy Owl on a fence, in which bird itself is only a small part (figure 11.14). Consider the image purely from a design viewpoint: The two vertical shapes (fence posts) are bridged by a diagonal line (barbed wire) that, combined with the mesh fencing below,

Figure 11.13: American Oystercatchers and beach pattern.
Canon EOS 7D with EF 400mm f/5.6L USM lens, handheld, 1/1600 sec., f/5.6, ISO 500. Fort De Soto Park, Florida.

Figure 11.14: A Snowy Owl prepares to take flight from its perch on a fence.
Canon EOS 7D with EF 70–200 f/4L IS lens at 127mm, handheld, 1/250 sec., f/5.6, ISO 800. Ontario, Canada.

forms a triangle. Artists employ shapes and lines in symbolic ways: Vertical shapes or lines represent strength and power, horizontal forms and lines provide a sense of tranquility, whereas diagonal lines are dynamic and imply action. This owl occupies a strong position design-wise, at the intersection of a vertical and a diagonal line (a location that also happens to coincide with one of the power points of the rule-of-thirds grid).

Compelling natural designs are often fleeting. When they occur, you had better act fast! I captured the image in figure 11.15 just before the Red-winged Blackbird moved to a more stable perch. The bird had landed briefly on some slender cattail stems causing them to bend over the curved leaf to their left to form a cross, flanked on both sides by prominent verticals. What's more, the orange cattails on the right matched the color of the displaying bird's flared wing patches. Image design doesn't get much better than that! I immediately recognized the strong composition, quickly got into position, and rotated the camera to vertical just in time to capture the shot!

Figure 11.15: Displaying Red-winged Blackbird.
Canon EOS 7D Mark II with EF 100–400 mm IS II lens (at 400mm), handheld, 1/500 sec., f/5.6, ISO 1250. Viera Wetlands, Florida.

Figure 11.16: Before the composition process: Roseate Spoonbills and American Avocets.

Canon EOS 5D Mark III with 100–400mm IS II lens at 278mm, 1/200 sec., f/16, ISO 640. Merritt Island National Wildlife Refuge, Florida.

Figure 11.17: After the composition process: The final capture, made five minutes after figure 11.16.

Canon EOS 5D Mark III with 100–400mm IS II lens at 135mm, Gitzo tripod, 1/200 sec., f/16, ISO 640.

The Composition Process

Let's examine how I go about working a scene in order to improve composition. (Tip: If you are using a tripod, you may find the process of composition easier to do with the camera in your hand, then, once you've determined the ideal position, adjust the tripod and mount the camera to take the shot.)

Along a dike road at Merritt Island National Wildlife Refuge in Florida, I came upon a common sight—a mixed flock of spoonbills and avocets gathered in an area of shallow water at the edge of a pool (figure 11.16). Initially, the scene was chaotic, without a strong sense of design: Birds were haphazardly mixed together, dark mangroves along one edge drew the eye away from the birds, and water was ruffled by the wind.

My first task was to simplify the scene. I accomplished this by moving several yards to the right to omit the dark mangroves at the top and right of the frame. Luckily, the weather and birds also were conspiring to work to my advantage: Within minutes, the breeze had dropped, calming the water and clarifying the birds' reflections. And the busy mix of birds had simplified, too: The avocets moved left, and the spoonbills (including some newcomers) arranged themselves on the right (figure 11.17). I knew the spoonbills' bright colors would draw the most attention, so I zoomed my lens out to a slightly shorter focal length to include them all, making sure to not cut any off, while being less concerned about the more muted avocets touching the opposite side of the frame. However, I couldn't avoid the single mangrove without introducing other distractions, so I placed it in the upper right of the frame. Finally, during

postprocessing, I cropped the top and bottom of the frame to produce a slight panoramic shape.

As you work toward improving your composition skills, examine the work of other photographers, especially those whose style includes birds in habitat and landscape. What catches your eye first? How does your eye move through the frame? Analyze what you find compelling about the composition and verbalize it to yourself: Doing so sets you on the path to applying the same principles to your own work and developing the all-important "eye" for an image (figure 11.18).

One of my early mentors, photographer Tim Fitzharris, described a good composition as, "...simple but not boring—interesting but not confusing." It's something to think about as your work evolves.

Figure 11.18: Parakeet Auklets pair perched on lichen-covered rocks.

Canon EOS 7D Mark II with EF 100–400 mm IS II lens (at 234mm), handheld, 1/400 sec., f/8.0, ISO 1250. St. Paul. Pribilof Islands, Alaska.

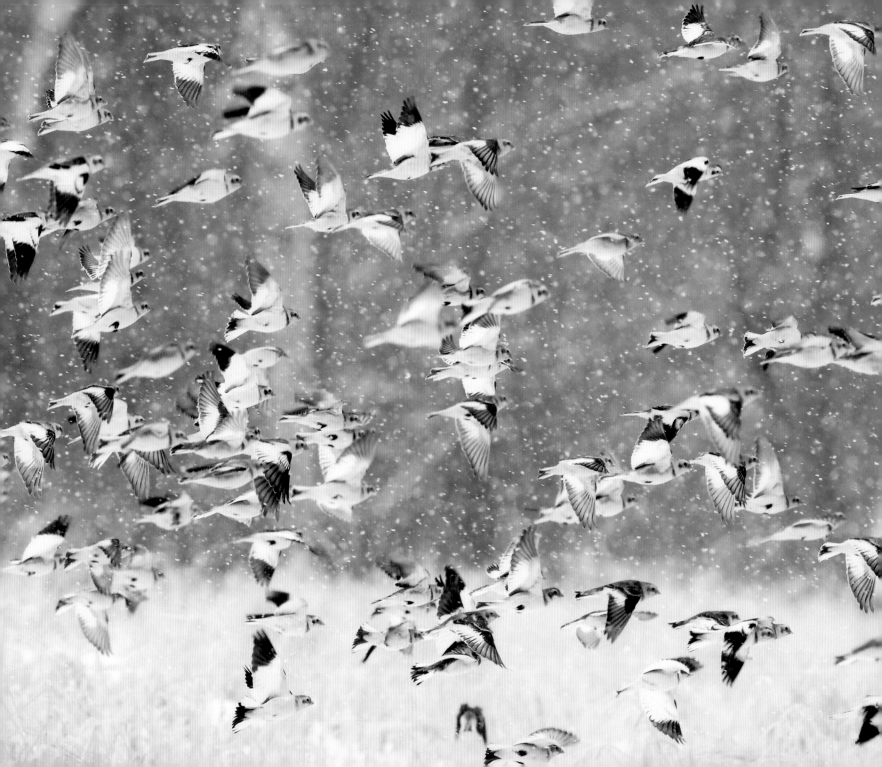

Chapter 12

WEATHER, WATER, AND MOOD

Snow is falling as I scan the wintery field. Somewhere out there are the Snow Buntings that have been foraging here every day. I spot the swirling flock in the distance and start trudging through the snow toward them, glad to be carrying a lightweight camera and lens instead of tripod-mounted gear. Drawing closer, I hunker down, waiting for the flock to approach. Like an ocean wave, the buntings seem to roll over the terrain, as those at the rear of the flock repeatedly fly forward to land ahead of their flock mates at the front that are now running over the snow-covered ground, all of them driven by their relentless search for food. Mesmerized, I begin firing away. Suddenly, with a hiss of massed voices, the flock takes flight and I capture them flying through the falling snow.

Figure 12.1: Northern Cardinal male in a snowy conifer.

Canon EOS 1Ds Mark II with 500mm f/4L IS USM lens, 1.4× teleconverter, Gitzo tripod, 1/640 sec., f/5.6, ISO 400. Freeville, New York.

One powerful way to create evocative bird imagery is to incorporate the elements of weather and water in photos. Images showing birds in adverse weather—snow, rain, ice, frost, and wind—can transcend standard portraits. They reveal the bird's experience of its world and have the power to elicit a strong emotional response in the viewer. Fog and mist give images an air of mystery—even an abstract quality—potentially elevating them to the level of art. Dark, brooding skies warn of an approaching storm or signal its passing. Surface water's varied moods—often caused by weather conditions—provide many opportunities for artistry. Don't let bad weather dampen your enthusiasm and keep you indoors. I've shot some of my best images in the worst weather! Working in the field in such conditions presents physical challenges to the photographer though, so I'll offer tips to protect your gear and yourself from the elements.

Snow

Crisp, fresh snow on a bright winter morning lends a magical, Christmas-card quality to an image (figure 12.1). During cold weather birds fluff up their plumage for added insulation, something that immediately raises any bird's cuteness factor several notches. Cuter still are snowflakes on the bird's head!

When snow takes up a large part of the frame, be sure to expose well to the right—increase the exposure value past what is suggested by the camera's light meter—in order to keep the snow white (review chapter 6 if needed).

Falling snow gives an image a less tranquil mood, creating an atmosphere of survival by revealing the conditions the bird must endure through the winter. Snowflakes show up best against dark surroundings, something to keep in mind when choosing your position with regard to the bird and the background.

SNOW
233

Shutter Speeds for Falling Snow

Falling snow's appearance depends on a combination of how fast and heavily it is falling, and the selected shutter speed. Fast shutter speeds will stop movement and show individual snowflakes—those close to the focal plane of the bird will be recognizable, while those in the background or foreground will appear as out-of-focus spheres, as in the photo of a Hairy Woodpecker captured at 1/1250 second in figure 12.2. In contrast, slow shutter speeds render falling snow-flakes as streaks: The slower the shutter speed the longer the streak. In figure 12.3 the same woodpecker was captured less than a minute later using a much slower shutter speed (1/100 second) resulting in snow streaks.

I personally think a fast shutter speed produces a more magical, artistic appearance. On the other hand, the streaking that results from a slower shutter speed suggests movement and perhaps better shows the drama of the weather. Experiment with shutter speeds until you achieve the desired effect.

Figure 12.2: Hairy Woodpecker male during snowstorm taken with a fast shutter speed.
Canon EOS 7D Mark II with 500mm f/4L IS lens, Gitzo tripod, 1/1250 sec., f/5.6, ISO 1600. Freeville, New York.

Figure 12.3: Hairy Woodpecker male during snowstorm taken with a slow shutter speed.
Canon EOS 7D Mark II with 500mm f/4L IS lens, Gitzo tripod, 1/100 sec., f/5.6, ISO 125. Freeville, New York.

Focusing Difficulties in Heavy Snowfall

During heavy snowfall, the camera may experience autofocusing difficulties, continually hunting back and forth but unable to lock onto the subject. This frustrating problem happened to me while photographing a Great Gray Owl during a Minnesota snowstorm (figure 12.4) and many of my initial shots were soft. The main cause is the AF system being confused by snowflakes constantly appearing in front of the subject. A secondary cause is that heavy snowfall (and even heavy rainfall) reduces the contrast needed for accurate focus acquisition.

Figure 12.4: Great Gray Owl in snowstorm. The heavy snowfall and low light made it impossible for the camera to hold focus on the owl's head. Changing from AI Servo AF to One-Shot AF mode and then manually tweaking the focus helped me get sharp shots.

Canon EOS 7D Mark II with EF 100–400 mm IS II lens (at 360mm), beanbag over vehicle window, 1/1250 sec., f/5.6, ISO 2000. Sax-Zim Bog, Meadowlands, Minnesota.

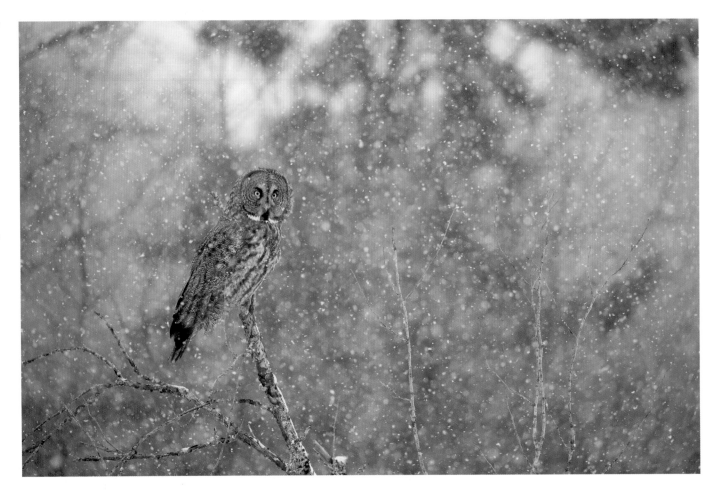

Focus searching can be a particular problem when using AI Servo AF mode (AF-C for Nikon), which is designed to focus continuously. To solve the problem, you may need to manually tweak the focus but this is not possible in AI Servo. Instead set the camera to One Shot AF (AF-S for Nikon), acquire initial focus, and then turn the focusing ring slightly to obtain a more precise focus before taking the shot. Remember that in One Shot mode the focus is now locked. To take another shot, let go of the shutter button completely and repeat the process to refocus. If AF continues to struggle, you may have more success by turning off the AF switch on your lens and using manual focus instead (review chapter 3 if needed).

Rain

Falling rain is perhaps best revealed by using a shutter speed that renders it as streaks. Raindrops are so small that very fast shutter speeds renders them as mere flecks. A dark background will emphasize falling rain but, as with snow, rain can disappear against light surroundings.

Rain can be portrayed indirectly by including visual clues. For floating or swimming water birds for instance, raindrops splashing onto the water's surface would be good indication. Another example is raindrops on a bird's plumage, such as those on the Atlantic Puffin in figure 12.5. In a situation like this, don't hesitate to shoot because at some point the bird will shake the drops off. Of course, the shake itself is worth capturing too! To keep everything sharply focused, pick a fast shutter speed or for a more impressionistic image of the shake try a slow shutter speed.

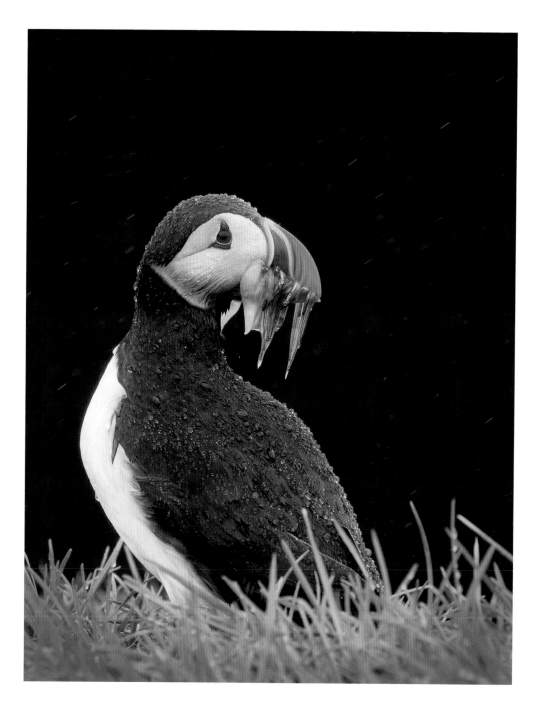

Figure 12.5: Atlantic Puffin covered with raindrops, with a beakful of fish.

Canon EOS 7D Mark II with EF 100–400 mm IS II lens, (at 400mm), handheld, 1/800 sec., f/5.6, ISO 800. Grimsey, Iceland.

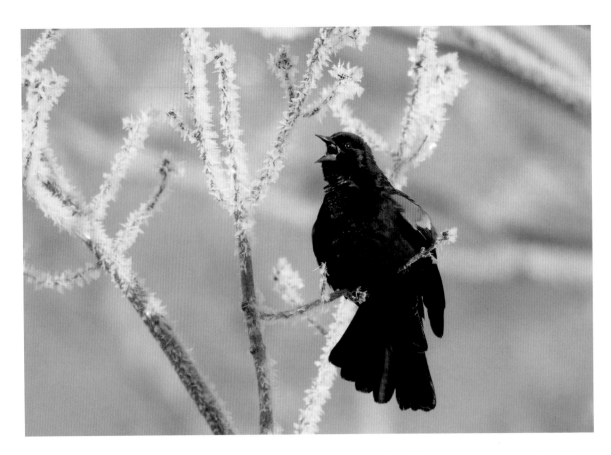

Figure 12.6: Red-winged Blackbird sings from a frost-covered branch.
Canon EOS 7D Mark II with EF 500mm f/4/L IS II lens, 1.4× III teleconverter, Gitzo tripod, 1/1000 sec., f/5.6, ISO 400. Ithaca, New York.

Frost and Ice

Any nature photographer would do well by keeping abreast of weather forecasts. When dramatically changing weather brings frosts or ice storms, the aftermath can be extremely photogenic, despite having potentially negative impacts on living things—birdlife, plant life, and humans alike.

There is truth to the sentiment that April is the cruelest month. Once, during a particularly warm early spring, my local weather forecast predicted plunging overnight temperatures and a heavy frost. The next morning, I headed out before sunrise to a local park to find a magical scene of frost-covered trees, which transformed the Red-winged Blackbirds' singing perches (figure 12.6).

The rising sun soon put an end to this ephemeral beauty, but that April's cruelty would be felt much longer—countless maple and apple blossoms were literally nipped in the bud, robbing the following autumn of its fruit.

During a January bird photography trip to south Texas, my companions and I were grounded by an intense overnight ice storm. The next morning,

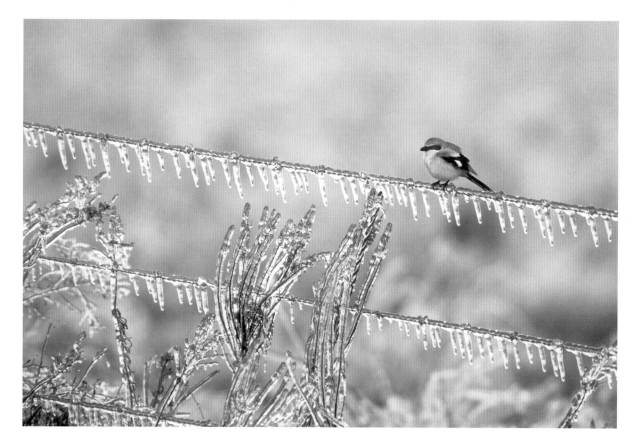

Figure 12.7: Loggerhead Shrike on a fence decorated with icicles after an overnight ice storm.

Nikon F4 with Nikkor 400mm f/3.5 IF manual focus lens, Gitzo tripod. Fuji Provia film, camera settings not recorded. (Note: Distracting element removed during postprocessing.) Anahuac National Wildlife Refuge, Texas.

undeterred by dangerously slippery roads, we headed to a nearby wildlife refuge where an amazing scene awaited us. Layers of ice had glazed every tree and plant into exquisite sculptures and rows of tiny icicles hung from every fence; and amid this scene were chilly-looking birds vainly searching for food. The Loggerhead Shrike in figure 12.7 remains a particularly poignant

memory—I wonder to this day whether it eventually found prey and survived.

At the Edge of Weather

The atmospheric effects that occur when weather is changing—either forming or clearing—can be extremely dramatic. Landscape photographers

are famous for seeking out conditions on the edge of light and weather, but of course birds can be part of the scene too. Once, I found myself in the path of a severe storm moving swiftly over the water at Utah's Bear River Migratory Bird Refuge. I repositioned my vehicle and selected a mid-range telephoto to include a flock of White Pelicans in the composition (figure 12.8). I also

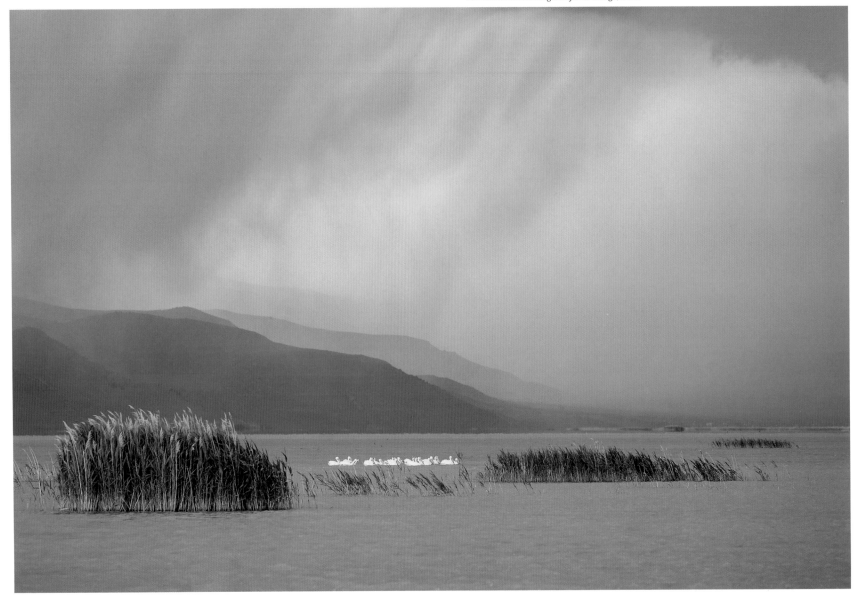

Figure 12.8: White Pelicans in late May with an intense storm approaching. Canon 5D III with 100–400mm IS II lens at 400mm, beanbag over car window, 1/100 sec., f/5.6, ISO 400. Bear River Migratory Bird Refuge, Utah.

intensified the blue tones in the image during postprocessing.

Watch for dark skies, dramatic cloud formations, and, of course, rainbows when storms are approaching or clearing—all can make stunning backdrops for birds.

Fog and Mist

Fog and mist alter the way light diffuses into a scene, drastically changing the mood and potentially transforming what might otherwise be a mundane shot into something magical. Mist forms after chilly nights when moisture condenses from cold air lying over a relatively warm pond, lake, or marsh. On cold mornings, delicate tendrils of mist rise from the water's surface, forming lovely surroundings for waterfowl with their young in spring or for migrating flocks in autumn. The effect can be especially stunning by pointing the lens toward the sun. When doing this, I like to experiment with color by adjusting the camera's white balance setting to Cloudy or Shade to add warm tones to the scene. Alternatively, during postprocessing, you can tweak the image's white balance to your liking as I did for the Common Loon and its chick in figure 12.9.

Depending on how thick the fog is, it may work for or against the bird photographer. At its best, it simplifies

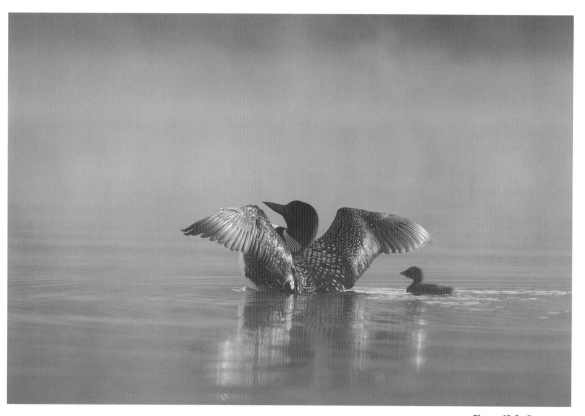

the scene by partially obscuring busy detail and lowering contrast, placing emphasis on shape and form instead. At its worst, though, thick fog can simply ruin a photographer's day! Don't give up too quickly though—it's often worth waiting a while to see if conditions improve. Doing so netted me the image in figure 12.10.

One summer morning I headed to a local lake to photograph the Common Merganser family I'd often seen there, but instead I found socked-in fog! Nevertheless, I settled down to wait, with a 500mm lens on my camera in case my target birds happened by. After a while, the rising sun began to burn off the fog revealing trees along the distant shore and the hillside beyond, plus—far out on the lake—a flock of Canada Geese. On a clear day, they would have blended in with the background and I would not

Figure 12.9: Common Loon and chick on a misty morning.
Canon EOS 1Ds Mark II with 500mm f/4L IS USM lens, 1.4× teleconverter, Gitzo tripod, 1/640 sec., f/8, ISO 400. Onaway, Michigan.

Figure 12.10: Canada Geese and clearing fog form a pleasing, layered composition when captured with a long focal-length lens.
Canon EOS 7D Mark II with 500mm f/4L IS lens, Gitzo tripod. 1/640 second, f/5.6, ISO 400. Cayuga Lake, New York.

have given them a second glance, but the fog simplified the scene and yielded a compelling design that caught my eye.

A long telephoto would not be my first choice for birds in landscape images but in this case—with the main subject at a considerable distance—it worked. By compressing the distance between the flock and the background, the long focal length produced a strikingly layered design with the flock of geese as a compositional anchor.

Scenes filled with mist or fog can often be low contrast and quite bright overall. Regarding the latter, the camera's suggested exposure setting is likely to underexpose the image, unless you increase exposure. Be sure to check the results in the histogram and adjust exposure as necessary.

Fog can fade out background elements and help the main subject stand out. At Newfoundland's famously fog-shrouded Cape St. Mary's gannet colony, my goal was to capture Northern Gannets with nest material flying past those sitting on nests in the colony beyond. The foggy conditions rendered the background birds less distinct, thus enabling the incoming birds to stand out (figure 12.11). When I tried a similar composition on a clear morning, the background birds were clearer and, therefore, more distracting.

In these foggy surroundings, it helped that the incoming gannet was at close range (note the lens's short

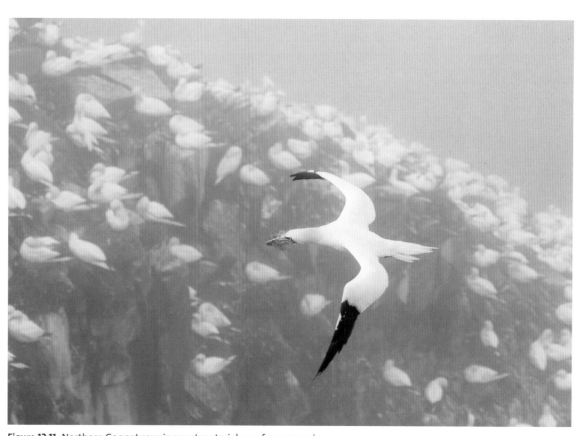

Figure 12.11: Northern Gannet carrying nest material on a foggy morning.
Canon EOS 7D Mark II with EF 100–400 mm IS II lens (at 160mm), handheld, 1/1600 sec., f/5.6, ISO 640. Cape St. Mary's Ecological Reserve, Newfoundland.

focal length in the photo caption), because that meant less fog between the bird and the camera. I also selectively increased the bird's brightness and contrast during postprocessing. (See the workflow for this image in chapter 14.)

It doesn't take long while standing around in fog for you and your gear to become quite damp! This is a good place to introduce ways to keep equipment and photographer functioning optimally in less-than-ideal weather.

PROTECTING YOUR GEAR AND YOURSELF FROM THE ELEMENTS

Cold Weather:

- Carry air-activated hand-warmer packs in your pockets (or in your gloves) to keep fingers nimble. They're available for toes, too.

- Battery power drains quickly in cold weather. Carry spare batteries in an inside pocket (or near a hand-warmer pack) to keep them warm. Replace the warmed batteries in the camera once you notice camera functions slowing down. Cold batteries often recover much of their power in a warm pocket and can be used again.

- Tripod legs are very cold to the touch in cold weather. Purchase foam tripod leg pads or wrap pipe insulation foam around them for your comfort.

- To avoid a cold lens surface fogging up, cover the lens glass tightly or put the camera/lens in your (cold) camera bag before returning to a warm house or car. For the same reason, change lenses or teleconverters in the same temperature as you are shooting to avoid fogging up the camera mirror, too!

Precipitation (Rain, Snow, and Mist):

- Use waterproof camera/lens covers.

- Keep lens angled downward and keep the camera covered when not actively shooting.

- Keep a towel with you to wipe off gear while shooting.

- After you're finished shooting, use a dry towel to thoroughly dry off all camera and lens barrel surfaces.

- Dry off lens glass with soft, clean lens cloth.

Salt Spray:

- Use waterproof camera/lens covers.

- Keep lens angled down and keep the camera covered when not actively shooting.

- Keep a towel with you to wipe off gear while shooting.

- After shooting, wipe off all camera and lens barrel surfaces with a towel moistened with fresh water, then dry with a new towel.

- To remove salt spray from lens glass, gently wipe off using soft, lint-free towel moistened with fresh water, then dry with lens cloth.

Sand and Dust:

- Use a large, soft artist's paintbrush to brush sand, dust, or grit from lens surfaces and camera bodies. Don't rub with a lens cloth or you risk scratching surfaces! You may need to use a blower brush for hard to reach places.

- Check your tripod and remove any sand from the twist lock threads, especially those of the lower leg sections.

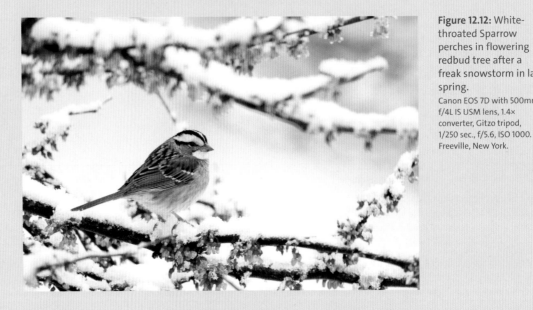

Figure 12.12: White-throated Sparrow perches in flowering redbud tree after a freak snowstorm in late spring.
Canon EOS 7D with 500mm f/4L IS USM lens, 1.4× converter, Gitzo tripod, 1/250 sec., f/5.6, ISO 1000. Freeville, New York.

Ensuring a Functional Photographer:

- To get that special shot, you need motivation and persistence—keeping still for long periods of time, sometimes in weather that would keep most sane people huddled indoors by a warm fire. To stay motivated it's important to be comfortable.

- Don't underestimate the need for weatherproof clothing. Invest in well-insulated jackets and pants for cold weather, and good-quality raingear. Hoods make a big difference. Dress in layers so you can remain comfortable if weather changes.

- There's nothing worse than cold, wet feet, so waterproof footwear is essential, as are insulated boots for work in extreme cold.

- Like your mother always told you: Body heat is lost fastest from head, hands, and feet. In cold weather, wear gloves, a warm hat, and thick, wool socks. I often wear thin glove liners under thick outer gloves with finger flaps that open for easier shooting. Some glove models include pockets for hand-warmer packs. Foot-warmer insoles are available to place in boots.

- Nothing improves motivation like food! Bring snacks and a water bottle to maintain energy and hydration. In cold weather, carry along a thermos filled with a hot drink like coffee or tea, or at least have one in your car.

Including Water in Bird Photos

Water plays an essential role in the lives of birds, as it does for all living things. Some of our most charismatic, photogenic subjects—loons, herons, swans, ducks, puffins, albatrosses, terns, and so on—spend their entire lives on or near water. Other species are drawn to water to drink or bathe. Including water as an element in a composition can create bird photos with great impact, whether for purely artistic creations or for story-telling environmental portraits. Portraying an American Dipper surrounded by turbulent water, for instance, establishes North America's sole truly aquatic songbird in its natural habitat and hints at how it lives its life (figure 12.13).

Reflections

The classic way to effectively use water in a composition is to show the bird's reflection. A perfect, unbroken reflection needs totally calm water with no floating surface material. The best chance for such calm conditions is first thing in the morning (on sunny days the light is at its best then, too). Wind often increases

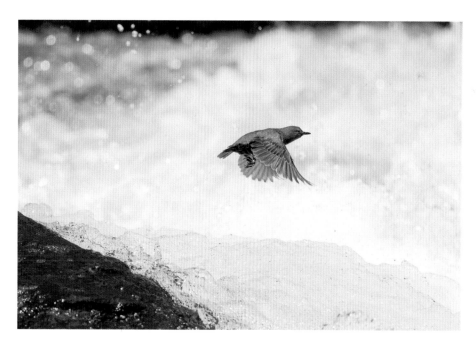

Figure 12.13: An American Dipper flies over the turbulent mountain creek where it makes a living by swimming and walking underwater in search of aquatic insect prey.
Canon EOS 1D Mark III with 500mm f/4L IS USM lens, 1.4× teleconverter, Gitzo tripod, 1/2000 sec., f/5.6, ISO 640. Lee Vining Canyon, Mono Lake Basin, California.

Figure 12.14: Black-necked Stilt and reflection.
Canon EOS 7D Mark II with EF 500mm f/4/L IS II lens, 1.4× III teleconverter, Gitzo tripod, 1/2500 sec., f/5.6, ISO 400. (Note: Distracting highlights on the bill were removed during postprocessing.) Bear River Migratory Bird Refuge, Utah.

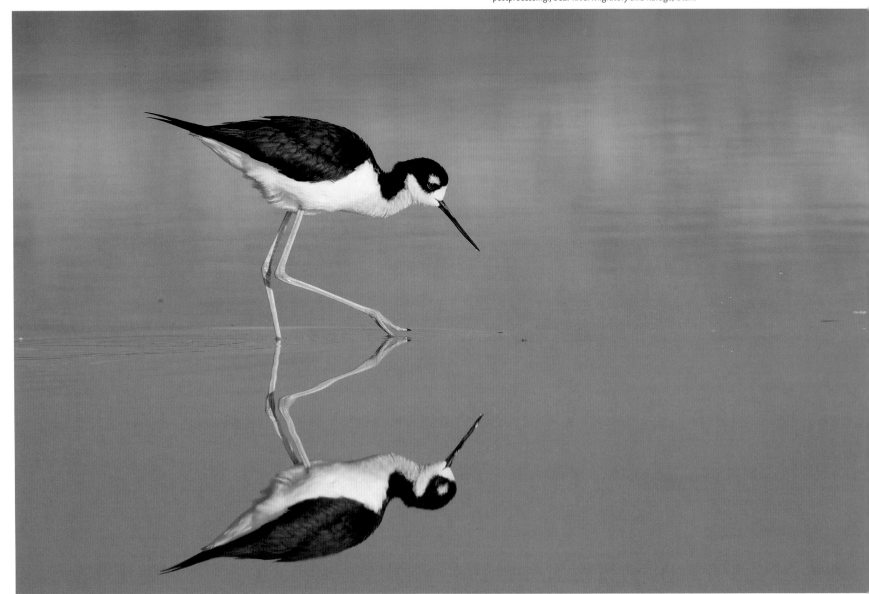

Figure 12.15: Pied-billed Grebe on still blue water.
Canon EOS 7D Mark II with 500mm f/4L IS lens, 1.4× tele-converter, beanbag over car window, 1/1600 sec., f/5.6, ISO 500. Montezuma National Wildlife Refuge, New York.

Figure 12.16:
Pied-billed Grebe. Cattail reflections subtly ruffled by a light breeze form interesting, abstract patterns in the water.
Canon EOS 1Ds Mark II with 500mm f/4L IS USM lens, 2× teleconverter, beanbag over car window, 1/500 sec., f/8, ISO 160. Montezuma National Wildlife Refuge, New York.

later in the morning, although it may settle down as the sun sets, giving you a second chance late in the day. Once a breeze picks up on a large lake, you might still find calm water in sheltered bays.

When composing, treat the bird and its reflection as a single unit when deciding where to place it in the frame. For the image of a Black-necked Stilt in figure 12.14 for instance, I framed the bird/reflection off-center by leaving about twice as much space in front of it as behind it, and I allowed more space above than below it.

With perfect reflections, it's best to include the entire reflection in the composition: Cut it off part way and your viewer may be left searching for the rest! This is less important for broken or indistinct reflections—in fact, some people find a not-quite-perfect reflection to be distracting, so use your own judgment as to whether to include all, part, or none of it in the frame.

Color and Texture of Water

The surface color of water depends on what it reflects: the even blue of a clear sky, the soft green of distant vegetation, or the fiery orange of a sunset. A large body of water on a sunny day will be mostly blue, but in other situations, water may have areas of different colors depending on the surroundings. If you notice a particularly colorful area, reposition yourself (either by moving side to side or raising the tripod up or down) so that it surrounds your subject. If the bird is actively moving around, set up at the colorful water and wait for your subject to swim through it.

Subjects stand out better if the water is still and even-toned, as in the image of a Pied-billed Grebe in figure 12.15, but that doesn't produce the most interesting shots, in my opinion. I prefer the surrounding water to have subtle textures or patterns as in figure 12.16.

Figure 12.17: Western Grebe. Photographing birds on water on windy, heavily overcast days rarely produces pleasing images. Escondido, California.

Figure 12.18: Brandt's Cormorants fly in formation over waves whipped up by a passing storm.
Canon EOS 7D with 400mm f/5.6L USM lens, handheld, 1/2000 sec., f/5.6, ISO 400. Monterey, California.

Reflected shapes of vegetation or other elements in the surroundings can either form interesting design elements or be distractions, partly depending on how close the bird is to the background. Close trees or marsh plants can produce clearly recognizable reflections with bold lines that can overwhelm the subject. On the other hand, reflections of more distant elements—tan-colored cattail stems in the case of figure 12.16—can add impact to an otherwise mundane shot. Water patterns in a composition can elevate an image from a conventional portrait to an abstract design in which the bird itself is only a small part. If you're presented with such opportunities, don't be afraid to follow your own creative vision.

The texture of water varies depending on whether it is moving or still. A delicate breeze disturbing the surface can create interesting effects, whereas a stiff wind makes the water choppy and distracting. Avoid photographing birds on wind-ruffled water on heavily overcast days. As can be seen in figure 12.17, such conditions produce busy, high-contrast reflections and an unpleasant appearance.

The Power of the Ocean

Nothing exemplifies the power of water more than the ocean, with its ever-changing moods. Weather is the driving force behind those mood swings, which seabirds must endure regularly.

Capturing birds and ocean in the same frame can lead to a powerful, story-telling photo. Consider the flock of Brandt's Cormorants flying over a raging ocean in figure 12.18.

The passage of a storm invariably brings wind, whipping up frenzied waves and flinging spray into the air. To freeze the motion of those waves, or any fast-moving water, you need to set a fast shutter speed, which will capture wave crests and flying spray (and birds!) crisply focused. Alternatively, if you encounter a completely still bird surrounded by moving water, switch to a slow shutter speed to smooth out the water movement for a more impressionistic effect.

Light and Water

Unconventional lighting angles, such as side lighting or backlighting can be used to enhance the texture of moving water. In figure 12.19, late evening light shining strongly from the side enhances the texture and dimensionality of the surf through which two White Ibis are foraging. Backlighting, produced by shooting toward the sun, can dramatically accentuate water splashes and airborne droplets, which are produced, for instance, when a heron strikes for prey, a loon shakes after bathing, or geese get into a territorial fight (figure 12.20).

The interplay of backlighting and water can create sparkling out-of-focus highlights in the background, giving an image a magical appearance (figure 12.21).

Making images that include elements of weather or water is a powerful way to explore the artistry of bird photography. The next chapter takes us still further on that creative journey.

Figure 12.19: Two White Ibis forage in the surf.
Canon EOS 7D Mark II with 400mm f/5.6L USM lens, handheld, 1/2500 sec., f/5.6, ISO 400. Fort De Soto Park, Florida.

Figure 12.20: Backlighting accentuates splashing water as two Canada Geese get into a territorial fight.
Canon EOS 7D Mark II with EF 500mm f/4/L IS II lens, 1.4× III teleconverter, Gitzo tripod, 1/800 sec., f/5.6, ISO 500. Ithaca, New York.

Figure 12.21: Backlit Great Egret landing in a wetland.
Canon EOS 7D Mark II with EF 100-400 mm IS II lens (at 312mm), handheld. 1/2000 sec., f/5.6, ISO 400. Viera Wetlands, Florida.

Chapter 13

SHOOTING OUTSIDE THE BOX

Bathed by the warm evening sun and transfixed by the seabirds flying to and fro across the ever-moving ocean, I can feel myself drifting into a trance. Gazing west, I become mesmerized by a shimmering pattern of reflected sky and clouds, and I frame the abstract scene through my viewfinder. While the scene is beautiful in its own right, I need a bird to fly into the frame for the finishing touch. Puffins and murres seem too insignificant in the design, but a much larger cormorant and its reflection are perfect.

Figure 13.1: Backlighting provides a golden outline to a singing Red-winged Blackbird.
Canon EOS 7D Mark II with 500mm f/4L IS lens, 1.4× teleconverter, Gitzo tripod, 1/800 sec., f/5.6, ISO 500. Ithaca, New York.

You've reached the point by now at which you have mastered the basic techniques of bird photography. Your images are consistently well illuminated, correctly exposed, sharply focused, and interestingly composed. You understand how to go beyond simple portraits to create images with mood and emotion by capturing behavior, portraying birds in their habitat and landscape, or incorporating weather conditions and light in unique and interesting ways (figure 13.1).

What's next? Maybe you're happy to continue what you're already doing—it's certainly important to strive for technical perfection. But maybe you have an inner artist yearning to portray birds in more interpretive and impressionistic ways. It's time to step outside the box!

This chapter aims to help you develop your creative vision and nudge your image making in the direction of pure art. We'll explore in-camera techniques you can use to portray birds artistically. Then I'll introduce how to edit your images creatively during postprocessing. Be ready to experiment, break the rules, and take risks!

Develop Your Creative Vision

In order to shoot outside the box you first have to see and think outside the box. Your first priority is learning to see beyond the obvious and to recognize—or imagine—the potential of a situation. Make it your goal to develop this new mindset. Once you've captured some standard shots, step back and consider how you might do things differently. Maybe shoot from a low angle, or try a composition with the bird being only a small part of an overall pattern. Could you shoot toward the light or through vegetation?

When the California Quail in figure 13.2 disappeared behind a snow bank, I expected to wait to resume shooting until it reemerged. When its head popped up briefly above the snow, I recognized a great opportunity. The next time it happened, I pressed the shutter button and captured a surreal headshot! To achieve an out-of-focus foreground like this, the foreground needs to be significantly closer to the lens than it is to the subject. Try sitting low or lying behind a sandy ridge on a beach, or shooting through flowers or leaves for a similar effect.

Figure 13.2: California Quail male emerges from behind a snow bank.
Canon EOS 1D Mark III with 500mm f/4L IS USM lens, 1.4× teleconverter, Canon Speedlight 580 EXII, Gitzo tripod, 1/250 sec., f/5.6, ISO 640. Mono Lake Basin, California.

Imagine the Possibilities

If you're like me, you constantly daydream about images that you would like to capture. Some of my ideas stem from subjects or situations I've seen in the field but was unable to explore at the time, others are entirely imaginary. Whatever the source of the idea, previsualizing a shot can be the first step toward making it a reality.

Creative Use of Shutter Speed

One way to add artistry to bird images is through the creative use of shutter speed. It involves using a slow shutter speed to intentionally blur moving subjects. The trick is to determine what shutter speed gives a pleasing degree of blur, something that is usually arrived at by trial and error.

Factors other than shutter speed also affect blur: how close the subject is, how fast it is moving, and whether or not panning or other camera movement is involved.

Figure 13.3: Common Merganser male taking flight from water captured using the pan-blur technique.

Canon EOS 7D Mark II with EF 100–400 mm IS II lens (at 400mm), handheld, 1/100 sec., f/7.1, ISO 125. Ithaca, New York.

One strategy is keep the camera still and let the subject create the blur. Another is to add deliberate camera movement, such as a slight vertical or horizontal shake. Finally there is the pan-blur method, which combines slow shutter speeds while panning to follow a flying bird (figure 13.3). This results in an image where your subject (or part of it) may be in sharp focus but the background is blurred.

Experimenting with shutter speed results in plenty of throwaways! I often shoot hundreds of images, trying different shutter speeds. The more attempts you make the better chance you'll have of ending up with at least a few that you like. Blurred birds are not to everyone's taste, but whether or not a blurred shot is good is entirely up to you...it's your creative expression. Trust your own instincts. If you can't decide whether or not it's a keeper, leave the image and revisit it at a later date. Does it still work for you?

One factor to consider is the degree of blurring: too much and the main subject is unrecognizable and confusing; too little and the image looks like you simply made a mistake. Consider the flock of Snow Geese taking flight in figure 13.4. The geese in the upper part of the frame are in full flight and are quite blurred, whereas those at the bottom of the frame are just taking flight, and because they are sharper and more recognizable as birds they attract the viewer's eye. Another ingredient that makes a creative blur work for me is a noticeable composition that would be equally interesting if the image were sharp. The layered design due to the different degrees of blur in this particular image makes it stand out among others I took in this situation.

A distinct pattern adds greatly to a creative blur's appeal. Compare the two images of White Pelicans. In figure 13.5a all the pelicans' necks are extended with their bills held vertically, forming a pleasing design, whereas in figure 13.5b they are positioned haphazardly. Another factor in figure 13.5a was deliberate camera shake in a vertical direction during the long exposure, which augmented the pattern and added a soft, dream-like mood.

I first noticed the interesting effects of subtle camera shake during long exposures when it happened by accident, and now I do it deliberately. There's nothing wrong with learning from your mistakes! Try gently pushing the lens barrel up and down or subtly shaking the camera side to side during a long exposure.

Figure 13.4: Snow Geese blast off. Captured using a slow shutter speed.
Canon EOS 7D Mark II with EF 500mm f/4/L IS II lens, 1.4× III teleconverter, Gitzo tripod, 1/15 sec., f/20.0, ISO 100. Bosque Del Apache National Wildlife Refuge, New Mexico.

Figure 13.5a: White Pelicans preening. Creative blur created by using a long exposure plus slight vertical camera shake. The strong pattern makes this image appealing.
Canon EOS 7D Mark II with EF 500mm f/4/L IS II lens, 2× III teleconverter, beanbag over vehicle window, 1 sec., f/40.0, ISO 100. Bowdoin National Wildlife Refuge, Montana.

Figure 13.5b: White Pelicans preening. Creative blur created by using a long exposure with the camera held still. The birds' random poses are less appealing than in figure 13.5a.
Canon EOS 7D Mark II with EF 500mm f/4/L IS II lens, 2× III teleconverter, beanbag over vehicle window, 1 sec., f/40.0, ISO 100. Bowdoin National Wildlife Refuge, Montana.

Pan Blurs

Typically, we choose very fast shutter speeds to stop the motion of flying birds. Although those blink-of-an-eye instants frozen in midair can be thrilling to see, a flying bird actually may appear more alive if there is some motion blur in the wings. The pan-blur technique introduces wing blur and also smoothes out the background by combining a slow shutter speed with panning to follow a moving subject.

Experiment with shutter speeds to determine what works. Much depends on the bird's size and how fast it is flying. Compare the two images of a Hooded Merganser flying along a creek in figures 13.6a and 13.6b. Both were captured by panning using the same equipment and focal length but at different shutter speeds. In figure 13.6a, a slow shutter speed smoothes the water and produces out-of-focus horizontal streaks that add to the impression of forward movement. The blurred wings enhance the sense of motion.

In figure 13.6b, a fast shutter speed freezes motion entirely, rendering the bird sharply focused. But since the surrounding water is also sharp, the ripples and surface imperfections are much more noticeable and distracting.

When using the pan-blur technique the results are best if the bird's face is sharp even if the rest of it is blurred. The trick is to pan at precisely the same speed as the bird is flying...not an easy task! As with any creative blur, the outcome is unpredictable, but when you are playing back your images the element of surprise is part of the fun!

Figure 13.6a: Hooded Merganser drake in flight. Background blur created by using a slow shutter speed while panning.
Canon EOS 7D Mark II with EF 100–400 mm IS II lens (at 400mm), handheld, 1/125 sec., f/5.6, ISO 640. Ithaca, New York.

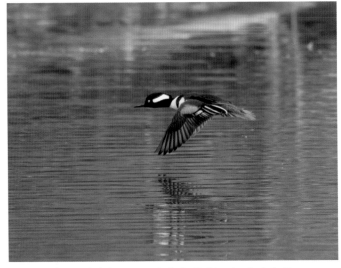

Figure 13.6b: Hooded Merganser drake in flight, using fast shutter speed while panning.
Canon EOS 7D Mark II with EF 100–400 mm IS II lens (at 400mm), handheld, 1/1600 sec., f/5.6, ISO 800. Ithaca, New York.

Other Methods to Depict Movement

Certain other bird behaviors that involve movement are challenging to show convincingly in a still photograph. Consider, for instance, a woodpecker hammering on a tree trunk: A fast shutter speed will freeze the action and give no impression of movement, whereas a slow shutter speed is likely to create an unsatisfying blur. Other than using a slow shutter speed alone, there are a couple of other techniques that may produce the impression of movement more successfully: multiple exposures (either in-camera or during post-processing) and slow-sync flash.

Multiple Exposure Images

The multiple exposure technique refers to shooting one or more exposures that are then merged into a single image. It can be done in-camera (refer to your user guide for how to do this) although I have yet to use the in-camera method successfully for birds. However, it is fairly straightforward to achieve on the computer during postprocessing.

The double exposure of an excavating Pileated Woodpecker in figure 13.7 is composed of two images of the same bird, one that is sharp and the other blurred from using a slow shutter speed. I layered the blurred image over the sharp one in Photoshop (see chapter 14) and then erased much of the top layer leaving only the blurred head and neck.

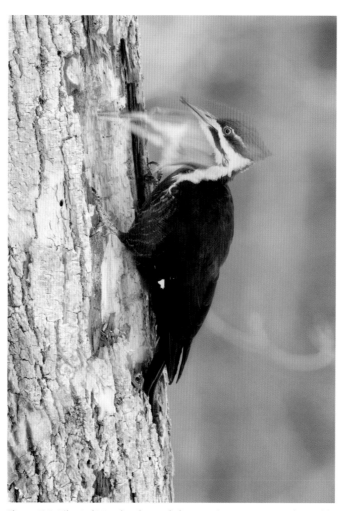

Figure 13.7: Pileated Woodpecker male hammering on a tree trunk. Double exposure constructed in Photoshop from two images to give the impression of movement. The base image is sharp and the blurred image was placed on top of it in a layer, and then it was mostly erased away to leave just the blurred head and neck.

Both layers: Canon EOS 7D Mark II with EF 500mm f/4/L IS II lens, 1.4× teleconverter, beanbag over vehicle window, 1/30 sec., f/9.0, ISO 250. Ithaca, New York.

(Woodpecker aficionados will know that, other than legs, feet, and tail, a woodpecker moves its entire body when it raps on a tree, so to be realistic, the whole bird would be blurred by using a slow shutter speed. I've taken some artistic license with this image.)

Slow-Sync Flash

Another creative option that can render moving subjects in interesting ways is slow-sync flash, which combines a slow shutter speed with electronic flash. I used this technique for the drumming Yellow-bellied Sapsucker in figure 13.8. The technique works because the flash duration is much shorter than the time the shutter is open, and so the sensor records not just an image produced by the flash but one or more additional images, or image trails, produced by the ambient light. This is termed ghosting and the outcome can resemble an in-camera multiple exposure.

Experiment with shutter speed and flash output level until you get a pleasing result. You can also program the flash to fire either at the beginning or the end of the exposure, which will produce differing results. Check your flash instruction guide for "front-curtain" or "first-curtain" sync (the default mode), which fires the flash at the beginning of the exposure; and "rear-curtain" or "second-curtain" sync, which fires the flash just before the shutter closes at the end of the exposure. The latter

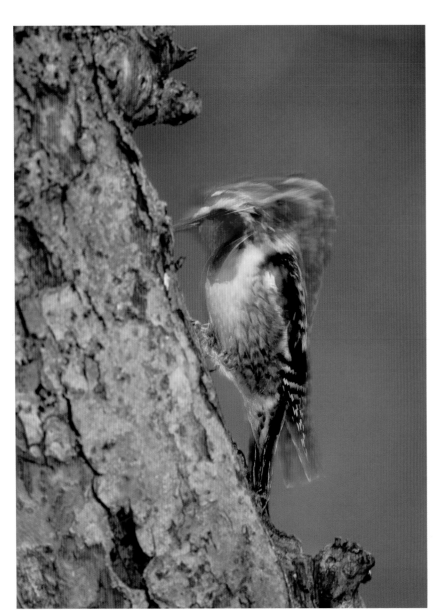

Figure 13.8: Yellow-bellied Sapsucker male drumming. Captured using slow-sync flash.

Canon EOS 1D Mark III with 500mm f/4L IS USM lens, 1.4× teleconverter, Canon Speedlight 580 EXII (front-curtain sync), Better Beamer flash extender, Gitzo tripod, 1/8 sec., f/5.6, ISO 125. Freeville, New York.

produces a blurred image trail following the subject, so it is useful when shooting strongly directional movement, such as birds walking or flying along. (Figure 13.8 was made using the default front-curtain sync setting.)

In a New Light

We covered unusual lighting angles in chapter 5, but it bears repeating during any discussion of bird photography as art how powerful the creative use of light can be. I encourage you to go beyond front lighting and seek out unconventional light angles. Even a much-photographed bird, such as the Roseate Spoonbill, takes on a unique appearance when seen in a new light (figure 13.9). Backlighting and side lighting produce magically beautiful images that are guaranteed to stand out from the crowd.

On clear days, the best conditions for these light angles occur during the hour or so just after sunrise and just before sunset when the sun is low in the sky. But once the sun rises too high in the sky, the effect is far less dramatic and instead becomes simply harsh. Back and side lighting can also be achieved when the sun is weakened, for instance, by light cloud or haze, although the impact will be less dramatic.

After taking a number of conventionally illuminated images of Forster's Terns one afternoon, shortly before

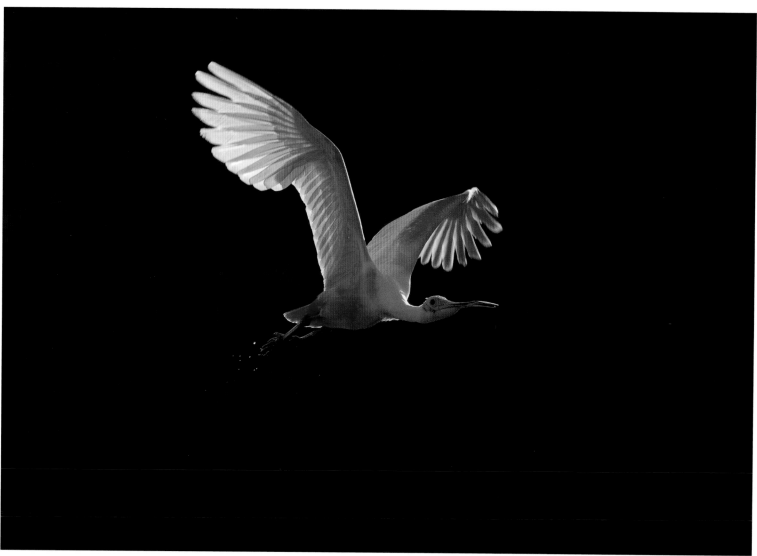

Figure 13.9: Back lighting from the late afternoon sun illuminates a Roseate Spoonbill's wings as it flies past deeply shaded mangroves.

Canon EOS 7D with 400mm f/5.6L USM lens, handheld, 1/2000 sec., f/8.0, ISO 1000. Tampa Bay, Florida.

Figure 13.10: Forster's Tern illuminated by low side light in late afternoon.
Canon EOS 7D Mark II with EF 100–400 mm IS II lens (at 400mm), handheld, 1/1600 sec.,
f/6.3, ISO 400. Bolsa Chica Ecological Reserve, California.

Figure 13.11: Amid dark surroundings, a Black Oystercatcher calls at last light.
Canon EOS 7D with 500mm f/4L IS USM lens, 1.4× teleconverter, Gitzo tripod, 1/640 sec., f/5.6,
ISO 800. Monterey, California.

sunset, I noticed the dramatically side-lit one in figure 13.10. Images with extremes of contrast such as this present an exposure challenge. To obtain the correct exposure and keep detail in the white areas, I metered some brightly lit vegetation just outside the frame and recomposed the image so that dark water formed the background.

In the Spotlight

At its lowest point in the sky, the sun can have the effect of spotlighting the subject—a situation that is intensified when the surroundings are very dark. Such conditions are well worth keeping an eye out for, even when you think the day's light is just about over. In figure 13.11, for instance, the setting sun's last rays illuminate a Black Oystercatcher among deeply shaded rocks. Overall dark-toned, moody images such as this are sometimes called "low-key" images. We'll explore the opposite—high-key images—shortly.

Interesting Bokeh

Shooting toward the sun can produce bright out-of-focus circular highlights in the background. These artifacts are formed by the sun reflecting off objects, such as dewdrops on grass. (This is different from lens flare, which may also occur when shooting toward the sun. See chapter 5.) Some photographers may find these highlights distracting, and the first impulse is to exclude them from the frame. Others think outside the box and view them as an interesting effect.

This introduces the concept of bokeh, a term of Japanese origin that refers to the aesthetic quality of out-of-focus parts of an image. Although many bird photographers prefer the smooth bokeh that results from clean, evenly colored backgrounds, don't overlook the creative potential of blurred shapes or highlights in the background or foreground that produce a more interesting bokeh and might be used as compositional elements. The circular highlights behind the Red-winged Blackbird in figure 13.12 immediately caught my eye, and so I included them in the composition.

Long focal length lenses used wide open give the strongest bokeh effects, but the shape and blurriness of background objects also depend on the lens design and the distance between photographer, subject, and background. Experiment with bokeh, and let your creativity flourish.

Figure 13.12: Backlit Red-winged Blackbird in cattail marsh. I deliberately composed this image to include the interesting background highlights, formed by the sun reflecting off debris on the water's surface.
Canon EOS 7D Mark II with EF 500mm f/4/L IS II lens, Gitzo tripod, 1/2000 sec., f/5.6, ISO 1000. (Note: Distraction cloned out.) Ithaca, New York.

Figure 13.13: A preening Reddish Egret and its reflection form a stunning high-key composition.
Canon EOS 1Ds Mark II with 500mm f/4L IS USM lens, Canon Speedlight 580 EXII, Gitzo tripod, 1/1250 sec., f/8, ISO 400. Estero Lagoon, Fort Myers, Florida.

Figure 13.14: Common Redpoll male perched on milkweed stem. I carefully positioned the perch at a distance from the snow in order to form a completely out-of-focus background.
Canon EOS 1Ds Mark II with 500mm f/4L IS USM lens, Gitzo tripod. 1/800 sec., f/5.6, ISO 400. Freeville, New York.

High-Key Approach

A highly dramatic way to portray birds is to isolate them against clean, light- or white-toned surroundings. The resulting minimalist composition focuses attention on the bird's shape and form alone. Combine that with a photogenic pose and the result can be surreal. The Reddish Egret in figure 13.13 paused briefly to preen, allowing me barely enough time to frame it and its reflection before it resumed chasing fish in its famously crazy way.

Images dominated by light tones, such as this one and the California Quail in 13.3, are termed high-key. High-key lighting conditions occur only with particular weather conditions or environments: mist and fog, white sand, snow-covered surroundings, or the bright gray or white skies produced by high overcast conditions (as was the case here). Be sure to expose well to the right to keep the light tones light (review chapter 6 if necessary).

The perfect conditions for a high-key image occurred one snowy winter's day when many Common Redpolls were visiting my backyard feeders. I envisioned a redpoll portrayed with stark simplicity against a clean, white background (figure 13.14). Once there was enough snow around to create the background, I placed some dry milkweed seedpods next to the feeder and captured the shot from a blind nearby. The image is still one of my favorites.

Natural Patterns

Human minds are exquisitely tuned to notice and react to interesting patterns in the natural world. Incorporating patterns in compositions—whether birds en masse or close-up feather designs—should definitely be part of your creative repertoire.

One strategy is to fill the frame with a flock of birds to form a pattern, whether intentionally blurred or all tack sharp. For the all-over design of Red-winged Blackbirds in figure 13.15, I used a long focal length lens and a slow shutter speed to capture them en masse flying past golden autumn foliage. The image works well because all the birds are moving in the same direction. However, flocks in which the birds are positioned haphazardly often look chaotic.

Environmental patterns can be beautiful in their own right. Add birds—even taking up a very small part of the frame—and you have the recipe for a compelling shot. Atop a windy cliff on Alaska's Pribilof Islands I was fascinated by swirling patterns of kelp and wind-whipped sea foam on the water's surface far below. Seabirds often flew low across these ever-changing designs. For figure 13.16, I zoomed my 100–400mm lens to a short focal length to capture two Tufted Puffins against the natural design.

Figure 13.15: Red-winged Blackbird flock in autumn. Canon EOS 1D Mark III with 500mm f/4L IS USM lens, Gitzo tripod, 1/50 sec., f/11.0, ISO 100. Bosque Del Apache National Wildlife Refuge, New Mexico.

Figure 13.16: Tufted Puffins and ocean pattern. Canon EOS 7D Mark II with EF 100–400 mm IS II lens (at 148mm), handheld, 1/1600 sec., f/6.3, ISO 1250. St. Paul, Pribilof Islands, Alaska.

Figure 13.17: The sun is not yet on these Greater Sandhill Cranes but has illuminated the distant mountains, reflected in the water.
Canon EOS 7D Mark II with EF 500mm f/4/L IS II lens, 1.4× III teleconverter, Gitzo tripod, 1/800 sec., f/5.6, ISO 1000. Bosque Del Apache National Wildlife Refuge, New Mexico.

Figure 13.18: Hooded Merganser female with reflected reeds forming a bold pattern.
Canon EOS 7D with 500mm f/4L IS USM lens, 1.4× teleconverter, beanbag over vehicle window, 1/160 sec., f/11, ISO 800. (Note: I lightened the darkest lines during postprocessing.) Viera Wetlands, Florida.

Break the Rules!

Creativity often starts with questioning convention. Consider color. One principle of color theory is that colors that humans view as "warm" (reds, yellows, and so on) appear to advance in a composition, whereas "cool" colors (blues and greens) recede. That explains why the typical backgrounds made up of blue sky or green vegetation allow birds to stand out so well. What happens when you try the opposite—cool-toned bird against warm-toned background? In figure 13.17, for instance, the morning sun has not yet cleared the trees close behind me so the Sandhill Cranes are still in shade, indicated by the bluish color cast on their plumage. Distant mountains are in sunlight, though, forming the gorgeous salmon-colored reflection in the water. The effect is magical!

Composition is another area where creative results can come from straying beyond your comfort zone. In figure 13.18, a bold pattern surrounds a female Hooded Merganser defying all the conventional wisdom of separating the bird from the background. Yet the composition is eye-catching and the fact that the viewer may need to work a little harder than normal to appreciate the bird is part of what makes the image interesting! Trust your own impressions when making images such as this. Own your artistic vision and create something that pleases you!

Creative Editing

So far we've covered various in-camera methods to create artistic images, but the process of image editing opens up a whole universe of creative potential. You can achieve some interesting effects using Adobe Photoshop or whatever software you already use to optimize your RAW images (see chapter 14). The ghost-like Mute Swans in figure 13.19 illustrate a very simple creative edit. While playing with the various sliders in Adobe Camera Raw, I moved Clarity to the far left (–100), which greatly softened the birds' outlines. I intensified colors by setting Vibrance +47 and Saturation +20, and I lightened the entire image.

The Filter and Blur Galleries in Photoshop offer an assortment of special effects to get you started, but far more can be achieved using various special effects software packages available for purchase, for instance the Topaz Photography Collection. An extensive exploration of creative image editing is beyond the scope of this book. Indeed entire books on the topic already exist. (See the Resources section.) In particular, I recommend eBooks by nature photographer Denise Ippolito, whose creative editing methods produce stunning works of art.

Take Risks!

Digital technology has brought technical excellence within reach of all photographers and has given us tremendous freedom to go beyond the ordinary and venture into a realm where bird images are created and appreciated as much for their soul and artistry as for their natural history content. Now, it's your turn to express your creativity and have fun while doing so.

The image of Sandhill Cranes in figure 13.20 was taken after sunset when the light level was too low for conventional techniques. I took that as my cue to play! The dream-like effect is due to a long exposure time during which I deliberately shook the camera vertically. During postprocessing in Adobe Camera Raw, I moved the Color Temperature slider to the left to add blue tones and increased the Vibrance value

Figure 13.19: Creative edit of a pair of Mute Swans. Canon EOS 7D Mark II with 500mm f/4L IS lens, 1.4× tele-converter, Gitzo tripod, 1/640 sec., f/11.0, ISO 1250. Barrie, Ontario, Canada.

to intensify the overall color. Voila! A piece of art!

Develop your creative vision to your heart's content. Move outside of your comfort zone, take risks, experiment, and by all means enjoy yourself. As photographer Dewitt Jones once said, "It's not trespassing to go beyond your own boundaries."

Figure 13.20: Abstract interpretation of Sandhill Cranes at roost. I used a slow shutter speed combined with deliberate vertical camera shake to create the dream-like effect.

Canon EOS 7D Mark II with EF 100–400 mm IS II lens (at 400mm), Gitzo tripod, ½ sec., f/5.6, ISO 400. Platte River, Kearney, Nebraska.

Chapter 14

BASIC IMAGE EDITING

The topic of image editing, or "postprocessing," is broad (and sometimes confusing) enough in scope to be the subject of numerous books and online resources. Here, I will only touch on the very basics and, while I share my own workflow for organizing and editing images, mine is only one of many possible procedures. I usually do minimal image processing, as I'd rather be out shooting than sitting at a computer!

Image-Editing Software

The two software programs that photographers most commonly use to develop, or "optimize," images are Adobe Photoshop and Adobe Lightroom. I use Photoshop, which offers an extensive and powerful range of image-processing tools and design functions. It includes the RAW conversion plug-in Adobe Camera RAW (ACR) and comes with a separate file browser program called Adobe Bridge. It was originally developed decades ago as a graphic design program that was quickly adopted by photographers.

Lightroom, developed many years later, is a powerful all-in-one image-processing and file-management program targeted expressly toward photographers. Lightroom's Develop module contains the same optimization tools as in ACR plus a limited number of other Photoshop-like functions. But the program's greatest strength lies in efficient file browsing and organization.

Given Lightroom's obvious advantages, why do I still restrict myself to using Photoshop? Blame inertia! I've used Photoshop for many years and have methods to optimize my images that I'm comfortable with, including some of the more creative tools in Photoshop that are absent from Lightroom.

I want you to learn directly from the masters of image processing, and so I'll direct your attention to a few excellent sources of information:

- Two books recently published by Rocky Nook (the publisher of this book): *The Enthusiast's Guide to Lightroom* (2017) and *The Enthusiast's Guide to Photoshop* (2018) both by Rafael "RC" Concepcion.
- *Photoshop for Photographers* bundle of video courses online by Adobe Photoshop master educator Tim Grey at www.greylearning.com.

The RAW Advantage

Before we get going, I'll put in another plug for shooting in RAW mode. RAW capture provides the maximum amount of digital information captured by the camera's sensor and gives you the most control over how your images will ultimately appear. You can interpret and manipulate that information in various ways repeatedly during postprocessing. Preset camera parameters—such as white balance, contrast, and exposure—are not permanent in a RAW file, whereas in JPEG mode, those settings are irreversibly applied at the moment of capture. Trying to fix errors in a JPEG file usually degrades the image. The downside is that RAW files must be converted to another format such as TIFF or PSD for use, but it is through the wide-reaching control you have during the conversion process that the power of RAW becomes obvious.

Workflow

When you're processing numerous images, it's vital to be organized and proceed in a systematic way.

My workflow includes the following steps:

1. Download images into a new folder on the computer. For this example I'll call my folder New Pix.
2. In Bridge, open New Pix, select all images, and then add contact and copyright information. (Tip: Create a metadata template to do this efficiently.)
3. Make a backup copy of the entire New Pix folder on an external hard drive (my RAW Archive).
4. Still in Bridge, select and open an image (or a batch of images). This automatically opens the ACR dialog box (figure 14.1).
5. Within the ACR dialog box, examine the image(s) for sharpness at 100% magnification via the Zoom tool. Star those that warrant keeping by reason of being sharply focused and/or showing something interesting or special. Delete any that are completely out of focus.

6. Within the ACR basic adjustments window, check the image and its histogram. Adjust color and tone, if necessary, using the following sliders: White Balance (Temperature affects blue and yellow tones, Tint affects green and magenta tones), Exposure, Highlights, Shadows, and Vibrance. (I only occasionally use the other sliders.) These adjustments can be made either to a single image or to an entire batch.

7. Click Open Image(s) to open the selected image(s) in Photoshop. Save each as a TIFF file in the same New Pix folder. My filenames include the original file number as well as brief subject description, such as AmOystercatcherFlight_8633.

8. In Photoshop, straighten and/or crop each image as necessary, clean up the image by removing dust spots, flaws, or distracting elements.

9. Apply targeted adjustments and tweak color balance as needed.

10. Add caption and keywords. At this point the image is in its final form.

11. Save the image in my Image Collection archive, the working collection from which I pull images for clients. It resides on a dedicated internal hard drive on my desktop computer and is hierarchically organized into folders and subfolders, for instance *Birds: North America>Birds of Prey>Mississippi Kite*.

Figure 14.1: The ACR dialog box. In this example, I am evaluating a batch of seven images as shown in the leftmost panel. The image at the top is rated with a star to signify I consider it worth optimizing and converting into usable form. The histogram for the selected image is in the upper right, and below that is a set of movable sliders to adjust various parameters. To work more efficiently, you may select all the images and then apply the same optimization adjustments to each.

12. After converting all the worthwhile images in the New Pix folder, make another backup copy of this entire folder to a second external hard drive (my Edited Archive). Yes, I make multiple backups of my files!

13. Delete the New Pix folder from the computer.

14. For output—for instance for publication, to make prints, or to post online—I apply noise reduction as necessary (usually only to the image background), resize the image, and save it as a separate output file. Depending on the intended use, I may sharpen the image.

A Word about Sharpening

Images being prepared for output often benefit from a small amount of judicious sharpening, but it is a process in which less can be more. The secret is subtlety. Heavy-handed sharpening makes a subject look unnatural, yet it's a pitfall that many photographers fall into when learning image processing. Signs that you've taken it too far are details with a too crisp, almost grainy quality and/or a faint, white halo around the edge of the subject. View images at 100% magnification to make sure you don't over-do sharpening, especially when preparing images for web use.

I use Unsharp Mask found in Photoshop's Filter menu (*Filter>Sharpen>Unsharp Mask*). It works by enhancing contrast along the edges of the subject. The Unsharp Mask dialog box contains three adjustable parameters to fine-tune the sharpening effect: Amount, Radius, and Threshold. Each combination of picture and intended use will require its own set of sharpening values, but as a very general rule of thumb, for a high-resolution output file such as I might use for an 11" × 14" print, I would use the values Amount 100, Radius 1, and Threshold 4. I rarely sharpen web-size images.

Photoshop Tips and Tricks

I prefer to leave the content of my images as close to the original capture as possible, and so, the workflow I've outlined above is all I do for most of my images. But by now you've doubtless discovered that you often can't control field conditions nor can you avoid making occasional mistakes. It's inevitable that some of your shots will have minor flaws. Next, I'll show you a few Photoshop methods to remedy them. First, though, familiarize yourself with the various tools within Photoshop's Tool Palette, especially the following:

- Selection tools (Marquee, Lasso, Magic Wand)
- Cloning tools (Healing Brush, Spot Healing Brush, Clone Stamp)
- Eraser tool
- Dodge and Burn tools
- Crop tool

You may want to learn about using Layers, Adjustment Layers, and Layer Masks, too.

Fixing Exposure Errors

If you still need to be convinced to shoot in RAW mode, consider the overexposed Mute Swans shown in figure 14.2. Notice the burned out white areas on the swans, also revealed by the peak abutting the histogram's rightmost edge. One of RAW capture's greatest benefits is the ability to correct exposure errors such as this without losing image quality. This is achieved during the process of RAW conversion using the adjustment sliders in the ACR dialog box. Figure 14.3 shows how I recovered the feather detail using the Exposure and Highlights sliders (see figure 1.14 in chapter 1 for the finished image, including equipment details and camera settings). Had the image been captured as a JPEG, I could have darkened the image during editing, but those white areas would simply have become flat gray with no feather detail.

Figure 14.2: The Adobe Camera RAW dialog box containing the original unadjusted capture of a Mute Swan pair. As the image and the histogram reveal, the birds' wings and back are overexposed and show no detail in the feathering.

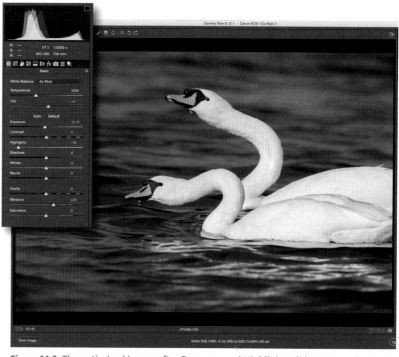

Figure 14.3: The optimized image after Exposure and Highlights sliders were adjusted to recover detail in the birds' white feathers on the wings and back.

Removing Distractions

To clone or not to clone? That is indeed the question! Before I spend time removing distracting elements, I decide whether or not the final image will be worth the effort. Maybe the shot has redeeming qualities such as a bird displaying interesting behavior, I think it is marketable, or maybe I simply like it for some aesthetic reason. I rarely, if ever,

make huge changes in a shot. Also, it's important to keep in mind that removing (other than by cropping) or adding elements disqualifies an image for most photo contests. It's best to be honest about what you have done to an image.

The image of an American Oystercatcher in figure 14.4 has some obvious distracting elements. I used several Photoshop tools to clean up the shot. I removed the out-of-focus bird in the

distance and the shadow in the foreground by first selecting them and a small part of their surroundings using the Lasso tool and then deleting the contents of the selection using *Delete>Content-Aware Fill* (see next section). I used the Healing Brush to remove the pole at the top of the frame. I disguised the tire tracks by picking a color from the sand and painting over the tracks using the Brush tool

Figure 14.4: The original capture of a flying American Oystercatcher has several background and foreground distractions. Because it is an otherwise appealing image showing great action and a pleasing wing position, I decided it was worth keeping and, therefore, removed the flaws.

Figure 14.5: The optimized image of an American Oystercatcher, distractions removed and the image cropped so the subject fills more of the frame.

Canon EOS 7D Mark II with EF 100–400 mm IS II lens (at 400mm), handheld, 1/2000 sec., f/8.0, ISO 500. Nickerson Beach, Long Island, New York.

at reduced opacity. Finally, I used the Crop tool to produce the final image in figure 14.5.

The types of distractions I sometimes remove include stray twigs in the frame and food fragments or bright highlights on a bird's bill. I designate files that have had anything but minor content alteration by appending the letter "R" (short for "retouched") to the filename and briefly describe the alterations in the caption. Standard optimization adjustments such as exposure, contrast, saturation, white balance, and cropping are not considered content alteration.

Improving Composition by Adding Space

Like me, you probably sometimes capture an interesting, sharp shot that is poorly framed. The culprit usually is a fast moving or flying bird! Cropping can help, but if the subject is close to an edge and facing out of the frame, as is the flying Acorn Woodpecker in figure 14.6, a different solution is needed. To improve the composition, add space to the image, which in Photoshop parlance translates to extending the canvas.

Choose *Image>Canvas Size*, pick an anchor point and extension color, and then type in the new dimensions. For figure 14.6 I added white space on the right of the frame. Next, I selected the white area, and hit Delete. In the resulting drop-down Fill menu, I chose Content-Aware, which filled the new space with blue sky. Finally, I cropped away empty space on the left of the frame for the final composition in figure 14.7.

Content-Aware Fill is also a powerful method to remove distractions from an image, but because it works by sampling the surroundings to come up

Figure 14.6: A poorly framed image of an Acorn Woodpecker in flight carrying an acorn. The Canvas Size dialog box shows I am ready to extend the image canvas to the right.

Figure 14.7: The same image after the canvas was extended on the right of the frame to improve composition.

Canon EOS 7D with EF 400mm f/5.6L USM lens, hand-held, 1/2000 sec., f/6.3, ISO 500. Mt. Diablo State Park, Walnut Creek, California.

with the content of the fill, it gives the best results when the area around the unwanted object is smooth and evenly toned. Avoid using it to remove objects surrounded by a lot of detail, or where there is pronounced contrast, tonality, or patterns, because doing so can introduce odd-looking artifacts.

How do you add space to a highly detailed image such as the two Arctic Terns flying over buttercups at the beginning of this chapter? The original capture had one bird too near the frame's left edge. I solved the problem by examining other frames in the same sequence of images to find a matching area—a narrow strip of habitat—to serve as fill. I copied and pasted it into the canvas extension that I'd created on the left of the frame, then used the Eraser and Healing Brush tools to carefully blend the new material with the existing content.

Figure 14.8: Three Great Crested Flycatcher soon-to-fledge nestlings look out of their nest hole entrance. One is afflicted with red-eye. The bird's pupil is selected and the Hue/Saturation dropdown menu is open in preparation for desaturating the red color.

Red-Eye Repair

Using flash sometimes produces ugly eye-shine called "red-eye" or "steel-eye." Although it's best solved by readjusting the flash position (see chapter 2), it can also be dealt with during post-processing. The Photoshop screenshot in figure 14.8 shows an image of Great Crested Flycatcher nestlings, of which the upper-right bird is afflicted with red-eye.

Following are the steps I use to remedy this type of problem:

1. In Photoshop, select the bird's entire pupil using the Lasso or Magic Wand tool.
2. Choose *Image>Adjustments>Hue/Saturation*. Move the Saturation slider to left to reduce saturation of the red tones (they will turn gray).
3. With pupil still selected, choose *Image>Adjustments>Brightness/Contrast*. Move Brightness slider to left and Contrast slider to right to darken pupil.
4. For steel-eye (silvery appearance of pupil), skip step 2, as only step 3 is needed.

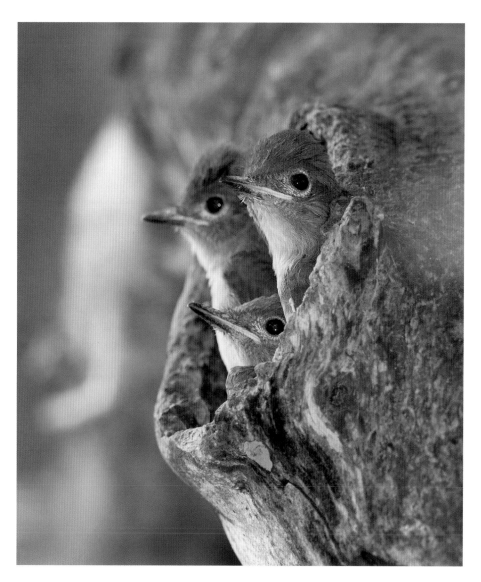

Figure 14.9: The red-eye of the upper-right nestling has been remedied.
Canon EOS 5D Mark III with EF 500mm f/4/L IS II lens, 1.4× III teleconverter, Gitzo tripod, Canon Speedlight 580 EXII, Better Beamer flash extender, 1/2000 sec., f/5.6, ISO 400. Central New York.

Figure 14.9 shows the final image.

Alternatively, you can use Photoshop's Red Eye Removal tool, but I prefer the above process because it retains the eye's dimensionality and natural appearance.

Red-eye repair is an example of a problem that calls for a targeted adjustment: changing a particular part of an image but not the entire shot. Targeted adjustments can be achieved in several ways. Here, you learned one simple way: using a selection tool to select the target area and then applying an adjustment. More flexible methods entail Layers, Adjustment Layers, and Layer Masks. These powerful functions let you go back to an earlier step of the process and change the extent or amount of adjustment if necessary. I encourage you to explore these Photoshop techniques for yourself. You'll likely use them frequently as your image-processing skills evolve.

Figure 14.10: Northern Gannet carrying nest material. Original, unprocessed capture.
Canon EOS 7D Mark II with EF 100–400 mm IS II lens (at 160mm), handheld, 1/1600 sec., f/5.6, ISO 640. Cape St. Mary's Ecological Reserve, Newfoundland.

Figure 14.11: Screenshot showing two layers: the original, low-contrast capture on top of a background layer that was processed to be darker and with higher contrast. The upper layer has been carefully erased away to reveal only the darkened main subject underneath. The final image (figure 12.11) combined the two layers into one. (Below)

Targeted Adjustments

Targeted adjustments were used to optimize the image of a Northern Gannet on a foggy morning (see figure 12.11). Figure 14.10 shows the original image converted from the RAW file with no adjustments. My goal was to retain the foggy appearance of the background birds while enhancing the main subject so that it stood out better from the background. The final image was a combination of two separate RAW conversions layered one on top of the other.

Refer to figure 14.11 as you follow through my workflow:
1. I made one conversion from the low-contrast, original capture with no adjustments (we'll call it image #1).
2. I made a second, darker and higher-contrast conversion processed using the following slider settings in ACR: Highlights −17, Blacks −54, Vibrance +63, and Saturation +6 (image #2).
3. Image #2 (the processed file) served as the background layer.
4. I selected and copied image #1 and pasted it on top of image #2 to form a new layer (figure 14.11).
5. Using the Eraser tool with a very small brush size, I carefully erased away the flying bird in the upper layer to reveal the darkened layer underneath.
6. I lowered the opacity of the upper layer slightly.

7. Finally, I flattened the image (i.e., combined the two layers into one) and saved it.

I've described a mere handful of the vast range of Photoshop tools and techniques available. Now it's up to you to explore them for yourself. But before I end this chapter, let's get creative!

Escape from Reality

If your goal is to render images as true to life as possible, Photoshop gives you the tools to do that. But it also gives you the power to push the boundaries of reality, if you so desire. Here is an example of how I changed a blah shot into something dramatic and unique with just a few simple steps in Photoshop.

First, the back story: By the time I finally got around to photographing the consistently present flock of White Pelicans in figure 14.12, on the last evening of my trip to Utah's Bear River Migratory Bird Refuge, the light was dull and flat under an overcast sky. But I captured a few images anyway. Not surprisingly, they were nothing special.

Revisiting the shots months later, I decided to play with them in Photoshop, processing beyond what I would normally do, moving away from reality and toward art. I chose one of the more interesting frames that included two pelicans stretching up with open

Figure 14.12: White Pelican flock. The original unprocessed capture taken in flat lighting under an overcast sky.
Canon EOS 7D Mark II with EF 500mm f/4/L IS II lens, 1.4× III teleconverter, Gitzo tripod, 1/500 sec., f/11, ISO 800. Bear River Migratory Bird Refuge, Utah.

Figure 14.13: In this processed version of figure 14.12, the color, saturation, and contrast have been intensified to create a dramatic, hyper-realistic version of the drab original.

Figure 14.14: The image has been processed one step further away from reality by the addition of the Plastic Wrap filter in Photoshop. (Left)

bills. Figure 14.12 shows the original unprocessed capture, and figures 14.13 and 14.14 show the results of my experimentation.

The following is what I did to produce figure 14.13:

1. In ACR, I moved the Temperature slider toward blue and the Tint slider toward magenta; I substantially increased Vibrance and Saturation; and then I opened the image in Photoshop.
2. In Photoshop, I chose *Image>Adjustments>Levels*. I then pulled the ends of both the Input sliders inward, substantially increasing the contrast.
3. Finally, I used the Burn tool with a large brush size to further darken the background.

This made the originally drab image considerably more dramatic and interesting. It would have been fine to stop at this point, but I was in a playful mood. I went one step further from reality by choosing *Filter>FilterGallery>Artistic>Plastic Wrap* to produce figure 14.14. I love it!

They're *your* images. Play!

Chapter 15

BIRD PHOTOGRAPHY HOTSPOTS

Certain special places have characteristics that make them magnets for birds: abundant food, safe habitat for nesting or roosting, or location on a migratory pathway for instance. Add accessibility to humans, and you have the recipe for a bird photography hotspot. In this chapter, I'll share some of my favorite North American destinations—each famous for bird species diversity and/or abundance, site accessibility, and subject approachability. Plus, I'll offer photography tips based on my own experiences.

General Tips

Plan to spend several days at the hotspot. That way you can learn what birds are present and notice their activity patterns. You'll have time to explore and may notice opportunities you might not have considered at first. What's more, the longer you stay, the better your chances will be for good weather at least some of the time.

Being prepared saves time and effort when you're visiting an unfamiliar place, so get as much information about the destination as you can ahead of your visit. Keep in mind that conditions can change from year to year. Nature is never static. Furthermore, wildlife refuges are managed habitats: Be sure to find out current conditions before you make travel plans. Talk to other photographers who've been to the location—use those social media contacts! Search the Internet for example photos to see what might be accomplished, what the scenery is like, what weather conditions to expect, and so on. Most of these hotspots have their own websites with downloadable maps or brochures. Hours vary from site to site and in some cases (for instance, state parks) fees may apply.

Courtesy in the Field

These sites are well visited by photographers and non-photographers alike. There's an art to working around other bird photographers in the field, and it involves courtesy. Give people space. If someone is actively shooting, don't assume you have the right to join them. She or he may have spent considerable time and effort to gain the trust of the subject, and your sudden arrival may spoil the moment. Instead, catch the other photographer's eye and indicate that you'd like to approach. Advance slowly and quietly. If the other person is low to the ground, you should approach that way too...nothing scares a bird more than a looming human being!

Courtesy toward others and respecting personal space extends to the birds, too, of course. Review techniques for approaching birds in chapter 4. Keep in mind that you are entering the birds' world. Obey all signs and barriers that are in place to protect wildlife. Breaking the rules not only disturbs the birds, it also reflects poorly on bird photographers in general and may result in access being restricted or even denied to all of us.

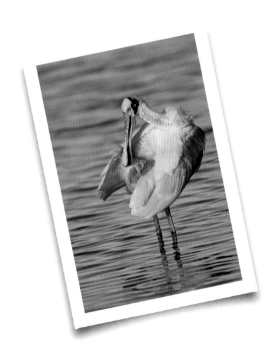

Wonderful locations for bird photography are abundant in North America.

Bolsa Chica Ecological Reserve, California

Located just south of Long Beach, Bolsa Chica is a bird photographers' paradise. Every season offers something to photograph: close-up portraits, birds in flight and action, as well as opportunities to practice creative techniques. In winter, pelicans, egrets, grebes, gulls, and cormorants engage in feeding frenzies, while flocks of shorebirds speed past. Wintering ducks abound—the dike trails along the channel offer good vantage points to capture them in flight. Herons and raptors are around all year long.

In spring and summer, pairs of Forster's Terns perch on railings at the bridge, and courting Elegant Terns gather in noisy groups on sandbars at low tide (figure 15.1) and perform swooping display flights overhead. Black Skimmers ply the waters nearby. All these species nest in protected colonies closed to the public. At high tide, the tide gate between Bolsa Chica's inner and outer bays offers great opportunities to capture terns diving for fish, especially during July when they are feeding young. The mesa has Anna's and Allen's Hummingbirds, and nesting Great Horned Owls.

Located amid the suburbs of southern California, Bolsa Chica has many human visitors throughout the year. Since the birds are used to people, they often allow close approach—hang out on the wooden bridge over the inner lagoon, and you'll discover just how close (figure 15.2)!

When to go: Any time of year but winter, spring, and summer have most activity.

What to expect: Even if you don't own a super telephoto, you can get great shots at Bolsa Chica with intermediate length lens—either prime or zoom. I often explore the trails there carrying just a 100–400mm zoom.

Food and lodging: Hotels and eateries in Sunset Beach, Huntington Beach, and Long Beach.

Tips: The endangered Ridgway's Rail regularly nests at Bolsa Chica. Watch and listen for it in saltmarsh vegetation, especially near the bridge.

Nearby photo ops: San Joaquin Wildlife Sanctuary, Irvine (call to check water levels before visiting). Many good sites in the San Diego area (about 90 miles south).

Website: www.wildlife.ca.gov/Lands/Places-to-Visit/Bolsa-Chica-ER

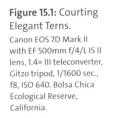

Figure 15.1: Courting Elegant Terns.
Canon EOS 7D Mark II with EF 500mm f/4/L IS II lens, 1.4× III teleconverter, Gitzo tripod, 1/1600 sec., f8, ISO 640. Bolsa Chica Ecological Reserve, California.

Figure 15.2: A friendly Brown Pelican perches on the bridge over the inner lagoon.
Canon EOS 1Ds Mark II with 28–105mm lens at 28mm, handheld, 1/1000 sec., f/8, ISO 800. Bolsa Chica
Ecological Reserve, California.

Bosque Del Apache National Wildlife Refuge, New Mexico

Perhaps North America's best-known bird photo destination, Bosque Del Apache is famous for vast blizzards of Snow Geese and tens of thousands of overwintering Sandhill Cranes (figures 15.3 and 15.4) in a setting with a picturesque mountain backdrop. Northern Pintails, Ross's Geese, and other waterfowl can also be present in large numbers, as well as Greater Roadrunners, Gambel's Quail, Bald Eagles, and others.

In autumn, golden cottonwoods provide beautiful surroundings for the cranes, whose numbers peak in late November and December. Much desired are shots of Snow Geese "blasting off" en masse at sunrise, covering the colorful dawn sky. In past years, these occurred within the refuge at the aptly named Flight Deck, but recently, the largest pre-sunrise Snow Goose gatherings occur at the Crane Pool along the refuge access road, where cranes roost overnight, (figure 15.3). Arrive before dawn, join the other photographers lined up elbow-to-elbow on the dike along the pool, and pick either a wide-angle lens for the big picture or a telephoto to show the goose flock close-up. After the geese leave, the cranes take off in more leisurely groups. Both species head into the refuge interior to feed on corn that is grown by the refuge as winter food for the cranes. Drive the Farm Loop road to a recently cut cornfield to continue photographing them, or explore the Marsh Loop for a different selection of subjects. Toward sunset, head back to the Crane Pool to capture silhouettes as the cranes fly back to roost. Bosque Del Apache can be crowded at times, but few places offer such consistent opportunities for creative imagery.

When to go: November through February. Visit during a full moon for especially evocative shots. The popular Festival of the Cranes in mid-November offers photo workshops and fieldtrips.

What to expect: In fall, daytime temperatures can be mild but expect bitter cold on early autumn mornings and all day during winter. Like other wildlife refuges, Bosque is managed: Refuge staff drains and floods various ponds seasonally, so birds occur in different places from year to year. Cornfield locations also vary year to year.

Food and lodging: Cafes in San Antonio just outside the refuge, hotels and more food options in Socorro, about 11 miles north.

Tips: Bring a headlamp to make camera settings in the dark while waiting for sunrise goose blastoffs, wear warm clothes including hat and gloves, bring heat packs to keep your fingers nimble.

Website: www.fws.gov/refuge/Bosque_del_Apache

Figure 15.3:
Four Greater Sandhill Cranes silhouetted against water colored by the reflection of the sunset sky.
Canon EOS 7D Mark II with EF 500mm f/4/L IS II lens, Gitzo tripod, 1/500 sec., f/5.0, ISO 1600. Bosque Del Apache National Wildlife Refuge, New Mexico.

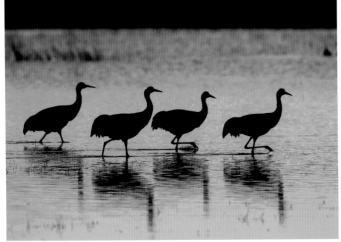

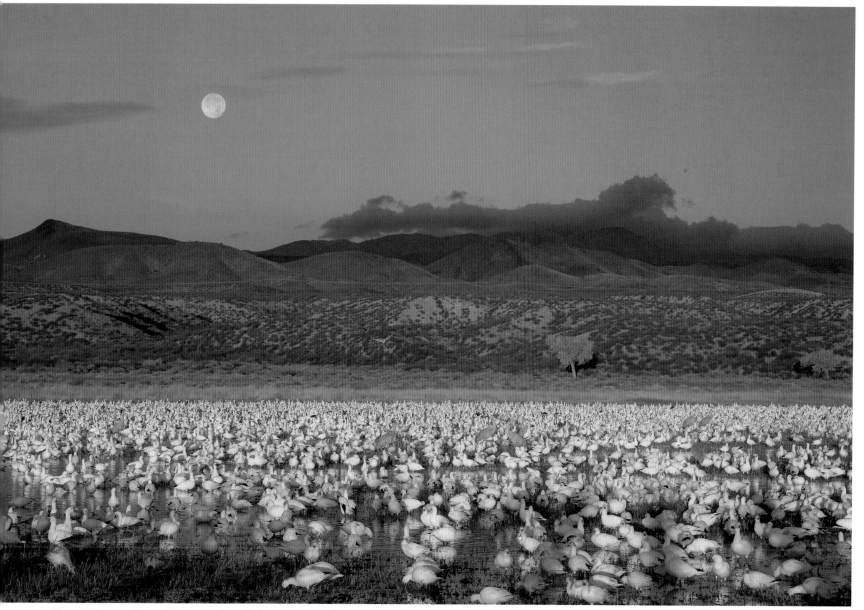

Figure 15.4: Snow Geese at Bosque Del Apache's Crane Pool with a setting full moon at sunrise in December.

Canon EOS 5D Mark III with EF24–105mm f/4L IS USM lens at 99mm, Gitzo tripod, 1/125 sec., f/16, ISO 400.

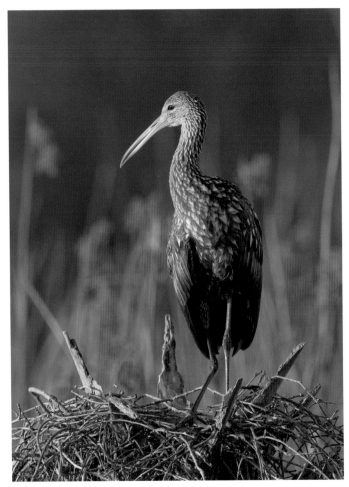

Figure 15.5: Viera Wetlands is one of the best spots to photograph the normally elusive Limpkin.

Canon EOS 7D with 500mm f/4L IS USM lens, 1.4× converter, Gitzo tripod, 1/640 sec., f/5.6, ISO 500.

Ritch Grissom Memorial Wetlands (Viera Wetlands), Florida

Commonly known as Viera Wetlands, this man-made bird oasis is actually part of Brevard County's water treatment system. A nearly three-mile network of unpaved berm roads, open to walking, biking or vehicular traffic, lead visitors around four large water treatment impoundments and a central lake, offering up-close looks at a wide variety of water birds, waders, and raptors. Most are used to seeing people and can be easily approached within range of intermediate or even short focal length lenses.

It is one of the best spots to photograph Limpkins (figure 15.5) and Florida Sandhill Cranes, both year-round residents that nest there. Other resident birds include Crested Caracara, Red-shouldered Hawk, Red-bellied Woodpecker, Anhinga, White Ibis, Great Blue Heron (figure 15.6), Green Heron, and many other wading birds. Bald Eagle and American Bittern are sometimes seen. Hooded Mergansers, Blue-winged Teal, and other waterfowl are present in winter. Also in winter, large Tree Swallow flocks sometimes feed on wax myrtle berries in the shrubbery along the reserve's western side. Any time of year watch for Limpkins feasting on apple snails.

When to go: For peak diversity, visit in December through April. In March, nesting is underway for Great Blue Herons and Anhingas, and Sandhill Crane families are on parade. In May, Limpkin chicks make their debut.

What to expect: Roads can be busy on weekends but there is plenty of parking. Roads become very slippery in wet weather and may be closed to vehicles. Beware of alligators sunning themselves along the impoundment banks.

Food and lodging: Hotels and eateries in Viera, Melbourne (20 miles south), and Titusville (30 miles north).

Tips: Great opportunities for silhouettes of birds and scenery at sunrise from the berm road along the reserve's western side.

Nearby photo ops: Cruickshank Reserve in nearby Rockledge is one of the best spots to photograph endangered Florida Scrub-jays.

Website: www.brevardfl.gov/Natural-Resources/EnvironmentalResources/VieraWetlands

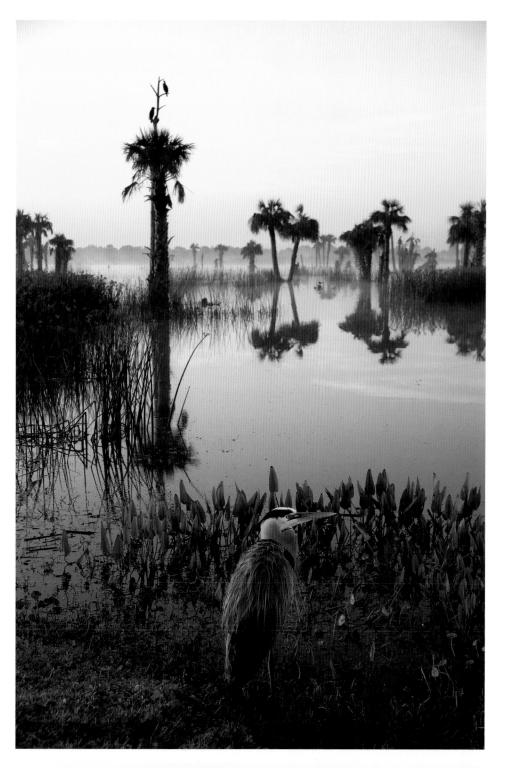

Figure 15.6: A Great Blue Heron poses at sunrise
Canon EOS 1Ds Mark II with 28–105mm lens at 53mm, handheld, 1/160 sec., f/8, ISO 500. Viera Wetlands, Florida.

Fort De Soto Park, Pinellas County, Florida

Located just south of St. Petersburg is Fort De Soto Park.

The North Beach area usually offers the best photo opportunities. Near the snack bar, the beach and lagoon attracts resting flocks of Black Skimmers, Laughing Gulls, and terns. On March mornings, I've photographed Sandwich and Royal Terns strutting their elegant courtship displays. Brown Pelicans dive for fish off shore, White Ibis and Willets probe the surf line for food. Various other shorebirds also occur, especially in winter.

At the North Beach lagoon you can often find a Reddish Egret performing its crazy dances across the water's surface as it chases fish this way and that (figure 15.7). (Tip: don't frame too tightly or you may clip wing tips!)

Farther north is my favorite spot to photograph American Oystercatchers foraging for shellfish along the shore or courting on the beach. A protected area of the beach and dunes provides nesting habitat for Wilson's and Snowy Plovers, American Oystercatchers, Black Skimmers, and Least Terns. Do not enter the protected area—there are plenty of good opportunities outside the barrier fence.

For mobility, I most often roam the beach with handheld camera and an intermediate telephoto lens, but a longer lens (on a tripod or ground pod) can be useful, too.

There are large expanses of sandy beaches and shallow tidal lagoons where numerous bird species can be photographed, some at close range (figure 15.8).

When to go: You'll find something to photograph at any time of year, but winter through spring is best. My favorite month is March, when many species are in peak breeding plumage and courtship behavior begins.

What to expect: This popular park gets busy, especially on weekends. To avoid having subjects flushed by beachgoers, get there first thing in the morning, avoid the middle of the day, and return in late afternoon when visitor numbers thin out.

Food and lodging: The park has a snack bar. Hotels and eateries are found in nearby St. Petersburg.

Tips: Park entry fee charged. For something different, photograph the famous Sunshine Skyway Bridge at sunrise from the eastern end of the park. (If you're lucky, there will be a flock of birds to include in the frame too!)

Nearby photo ops: Alafia Bank Sanctuary (off-shore Roseate Spoonbill colony in Tampa Bay, charter boat trip), Honeymoon Island (nesting Osprey).

Website: www.pinellascounty.org/park/05_Ft_DeSoto.htm

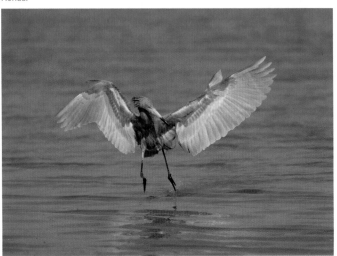

Figure 15.7: Reddish Egret chases fish. Canon EOS 7D Mark II with 400mm f/5.6L USM lens, handheld, 1/2000 sec., f/8, ISO 400. Fort De Soto Park, Florida.

Figure 15.8: Terns, gulls, and skimmers are cooperative subjects at
Fort De Soto Park, near St. Petersburg, Florida.

Figure 15.9: Roseate Spoonbill preens its tail feathers.
Canon EOS 7D Mark II with 500mm f/4L IS lens, 1.4× teleconverter, Gitzo tripod, 1/1600 sec., f/5.6, ISO 400. Merritt Island National Wildlife Refuge, Florida.

Merritt Island National Wildlife Refuge, Titusville, Florida

One of Florida's most popular bird photography locations, Merritt Island National Wildlife Refuge, is adjacent to the Kennedy Space Center on Florida's Space Coast. The seven-mile Black Point Wildlife Drive leads visitors around shallow saltwater marshes and freshwater impoundments, and through scrublands and pine flatwoods. The refuge is famous for large numbers of wading birds, shorebirds, and waterfowl. Colorful Roseate Spoonbills (figure 15.9) sometimes join in feeding frenzies, which develop suddenly when scores of waders, such as Great and Snowy Egrets, Little Blue Herons, and White Ibis join flocks of White Pelicans to feast on schools of fish (figure 15.10).

Bald Eagles, Red-shouldered Hawks, and other raptors are often seen. Don't miss the dense flocks of American Coots in winter. Duck photography can be good; some of my favorite Blue-winged Teal images are from Merritt Island.

Whether shooting from your vehicle or on foot, your longest lens will be useful, although shorter focal lengths are handy, too, for flight shots, birds in scenery, or when you want to show the full extent of those feeding frenzies!

When to go: Best times are October through April. Waterfowl most abundant from November through February.

What to expect: The wildlife drive is narrow in parts. If you stop to photograph, pull off to the side to avoid blocking traffic.

Food and lodging: Hotels and eateries in Titusville.

Tips: Entry fee required. Early morning is best for peak bird activity. Windy days may be less productive.

Nearby photo ops: Cruickshank Reserve in Rockledge (32 miles south) is one of the best locations to photograph endangered Florida Scrub-jays.

Website: www.fws.gov/refuge/Merritt_Island

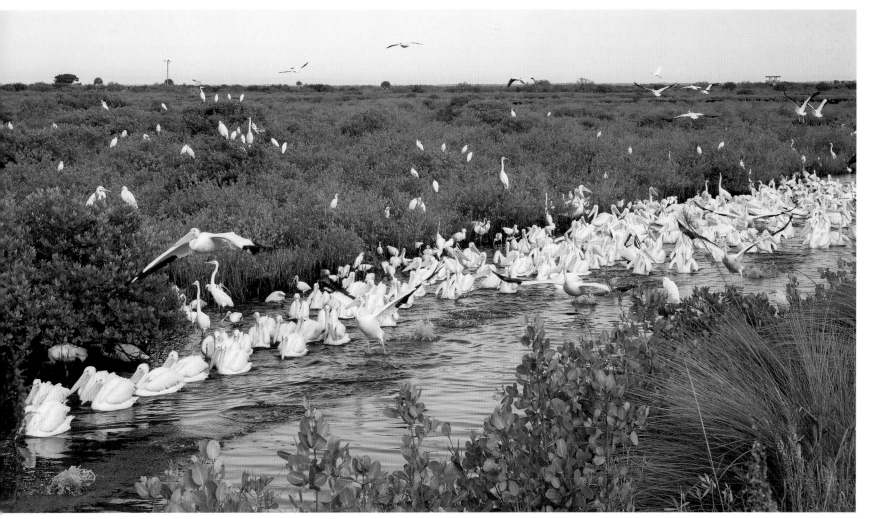

Figure 15.10: A feeding frenzy of White Pelicans, Great and Snowy Egrets, White Ibis, and Roseate Spoonbills.

Canon EOS 5D Mark III with 28–105 mm f/3.5–4.5 USM lens (at 70mm), handheld, 1/500 sec., f/11, ISO 640. Merritt Island National Wildlife Refuge, Florida.

Figure 15.11: Pyrrhuloxia male perches on a prickly pear cactus.
Canon EOS 1D Mark III with 500mm f/4L IS USM lens, 1.4× teleconverter, Gitzo tripod, 1/1000 sec., f/5.6, ISO 640. Rio Grande Valley, Texas.

Rio Grande Valley Photography Ranches, South Texas

The lower Rio Grande region is famous for a number of privately owned ranches that have been repurposed for wildlife photography, offering unparalleled opportunities for high-quality images of birds and other animals in native habitats.

These ranches are excellent for Texas specialties such as Green Jays and Audubon's Orioles, as well as Pyrrhuloxia (figure 15.11), Curve-billed Thrashers and other resident songbirds, Greater Roadrunners, Crested Caracaras, Harris's Hawks, Northern Bobwhites, and various mammals and reptiles. May and June bring a wide array of migrant songbirds, such as Painted Buntings and various warblers, for which you'll need your longest telephoto lens.

Photographers pay a daily fee (typically $100–$200 per day) for access to professionally designed, permanent photo blinds located at water holes and feeding stations (figure 15.12). Blinds accommodate several people and some are constructed below ground to allow shooting at ground or water level. Ranches may suggest, or in some cases require, the services of one of their expert guides who are experienced photographers themselves, and who know the local wildlife and how to arrange successful setups.

When to go: Any time from late winter through June is good (I visited in March). May and June are peak months for migrating songbirds. Avoid July through September when it can be extremely hot (plus birds are molting).

What to expect: Be prepared to sit for several hours in a multi-person blind. Check whether the guide's fee is included or must be paid separately.

Food and lodging: Hotels and eateries in McAllen and Edinburg. Certain ranches offer on-site lodging and meals.

Tips: For the best variety of species, setups, and surroundings, plan on visiting several ranches in the region, spending a few days at each.

Most popular ranches include:
Santa Clara Ranch (www.santaclara-ranch.com)
Martin Refuge (www.martinrefuge.com)
Laguna Seca Ranch (www.laguna-secaranch.com)

Figure 15.12: One of several waterholes has attracted numerous Northern Cardinals in mid-March. Santa Clara Ranch, Texas.

Bear River Migratory Bird Refuge, Utah

Set against a dramatic backdrop formed by the Wasatch Mountains, Bear River Migratory Bird Refuge encompasses the delta through which the Bear River enters Utah's Great Salt Lake. A 12-mile auto tour, open sunrise to sunset, takes visitors past freshwater lakes, marshes, and mud flats that are home to numerous waterbirds. My mid-May visit coincided with pairs of American Avocets and Black-necked Stilts courting, mating, and building nests; and displaying Yellow-headed Blackbirds and flocks of American White Pelicans feeding. Numerous Western and Clark's Grebes nest on the refuge, and although the young are not typically seen until July, I was thrilled to spend several days photographing a pair with chicks in May—an early brood likely due to the preceding mild winter (figure 15.13). Other photogenic species include Cinnamon Teal, White-faced Ibis, and Black-crowned Night Heron. Even a small Yellow-headed Blackbird against this stunning landscape makes for a lovely image (figure 15.14). Don't miss the Cliff Swallows nesting under the eaves of the restrooms by the auto tour entrance!

When to go: Early spring or fall for migrating waterfowl and shorebirds. Spring and summer for nesting waterbirds. October–December for Tundra Swans. Winter for raptors.

What to expect: You'll need your longest lens here. There are many good photo opportunities from a vehicle, but it is fine to exit the vehicle for a lower shooting angle (certain species may be skittish). Check for current water level conditions before you plan your trip. Pools often freeze over in winter. Check for road closings in bad weather.

Food and lodging: Hotels and eateries in Brigham City nearby or Salt Lake City (60 miles south).

Tips: Signing up for a field trip at the Great Salt Lake Bird Festival, held annually in May, is a great way to be introduced to the birds of the refuge and elsewhere in the region.

Nearby photo ops: Antelope Island State Park and causeway (Chukars, Burrowing Owls). Farmington Bay Wildlife Management Area (wintering waterfowl and raptors, but restricted access spring/summer).

Website: www.fws.gov/refuge/bear_river_migratory_bird_refuge

Figure 15.13: Western Grebe parent and chick.
Canon EOS 7D Mark II with EF 500mm f/4/L IS II lens, 1.4× III teleconverter, Gitzo tripod, 1/2000 sec., f/7.1, ISO 400. Bear River Migratory Bird Refuge, Utah.

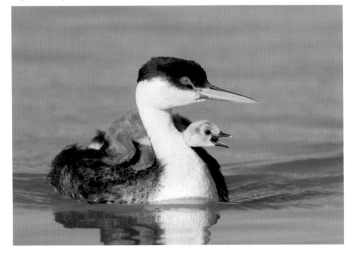

Figure 15.14: Yellow-headed Blackbird in marsh vegetation.
Canon EOS 5D Mark III with 28–105 mm f/3.5–4.5 USM lens (at 96mm), Gitzo tripod, 1/400 sec., f/9, ISO 500. Bear River Migratory Bird Refuge, Utah. (Right)

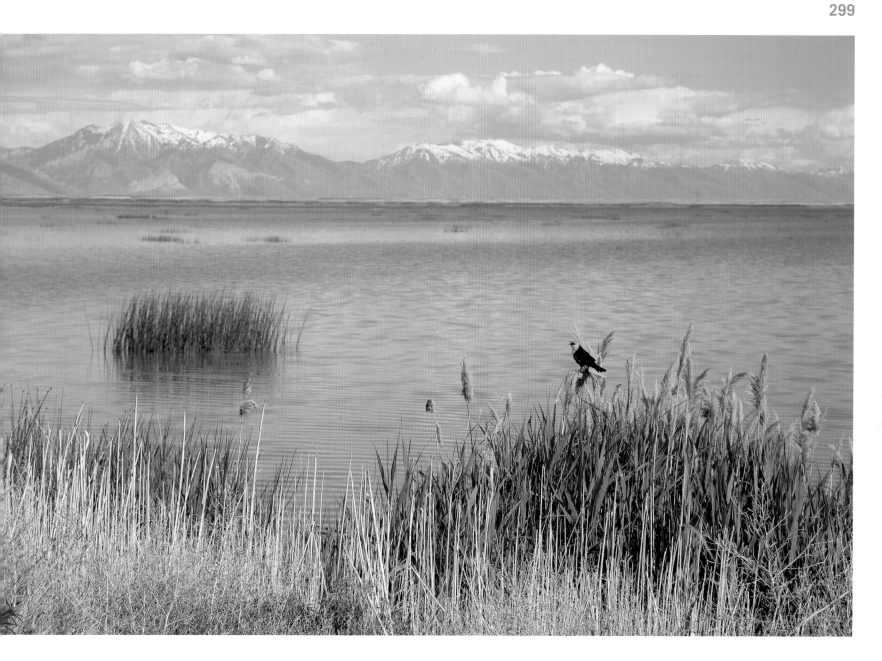

Figure 15.15: Northern Gannet pair performs bill-fencing display.
Canon EOS 7D Mark II with EF 500mm f/4/L IS II lens, 1.4× III teleconverter, Gitzo tripod, 1/1250 sec., f/8, ISO 400. Cape St. Mary's Ecological Reserve, Newfoundland.

Cape St. Mary's Ecological Reserve, Newfoundland

At the southern tip of Newfoundland's Avalon Peninsula, Cape St. Mary's Ecological Reserve bills itself as North America's most accessible seabird colony. A dramatic sea stack packed with nesting Northern Gannets, aptly-named "Bird Rock" (figure 15.16), is separated from a viewing area by a deep chasm a mere 50 feet wide. As many as twenty-five thousand gannets nest here each year, offering a close-up view into their family life, from courtship and nest building to feeding their young. Amid the nonstop action, watch for photogenic behaviors such as the bill fencing display performed by a pair at their nest site (figure 15.15). To capture gannets and other species in flight, watch for predictable flight paths, but be aware that they may change depending on wind direction. If you can tear your eyes away from the gannets, Black-legged Kittiwakes, Common and Thick-billed Murres, Black Guillemots, and Razorbills nest on nearby rock ledges. Any length lens is useful here, from wide angle to super telephoto.

When to go: May through October. In May–June gannets court and build nests, by July chicks are being fed, and the young birds fledge in early fall.

What to expect: The half-mile trail from the visitor center to the colony is uneven in parts and may be strenuous to some people. Expect fog much of the time (one estimate is 200 days of fog per year!). Use great caution at cliff edges. There are no safety barriers, and it's a 100-foot drop onto the rocks below!

Food and lodging: Hotels and grocery store in St Brides, more restaurant options in Placentia.

Tips: Don't let the often-foggy conditions dampen your enthusiasm. Be creative: The fog can lend images a mood of mystery!

Nearby photo ops: Witless Bay Ecological Reserve (2+ hours north, boat excursions for Atlantic Puffins, Common Murres, and whales).

Website: www.newfoundlandlabrador.com/top-destinations/cape-st-marys

Figure 15.16: A small section of the huge breeding colony of Northern Gannets.
Canon EOS 5D Mark III with EF24–105mm f/4L IS USM lens at 67mm, Gitzo tripod, 1/1600 sec., f/11,
ISO 640. Cape St. Mary's Ecological Reserve, Newfoundland.

Figure 15.17: Crested Auklet pair.
Canon EOS 7D Mark II with 500mm f/4L IS lens, 1.4× teleconverter, Gitzo tripod, 1/500 sec., f/7.1, ISO 640. St. Paul, Pribilof Islands, Alaska.

St. Paul, Pribilof Islands, Alaska

A seabird paradise for any bird photographer, St. Paul is the largest and most accessible of Alaska's Pribilof Islands, located in the Bering Sea north of the Aleutian archipelago. Its towering cliffs provide nesting sites for vast numbers of Horned and Tufted Puffins; Crested, Parakeet, and Least Auklets; Red-faced Cormorants; Common and Thick-billed Murres; Northern Fulmars; and Black-legged and Red-legged Kittiwakes. Cliff-top paths overlook rocky ledges where birds perch (figures 15.17 and 15.18). Wide views of the ocean provide endless opportunities for photographing birds in flight. With care, birds may be approached closely, often within intermediate telephoto range. While I was glad to have my 500mm plus 1.4X teleconverter on a recent trip, my most-used lens was a 100–400mm zoom.

Windy days can be great for birds in flight as they swoop along cliff edges propelled upward by strong updrafts, but be sure to protect gear from the ever-present salt spray. There are many opportunities to be creative: For instance, for an unusual perspective, point your lens downward from cliff tops to capture birds flying directly below you.

Whether you go alone or join an organized photo tour, travel is arranged through St. Paul Island Tour, which offers package deals priced by length of stay. Package price includes round-trip flight from the mainland, lodging, meals, ground transportation on the island, and guiding service. Guides know best spots for photography and are very helpful.

When to go: June through August. July has peak species diversity. Late July to mid-August is peak time for puffins carrying fish to feed their young. Crested Auklets may be harder to find then. They and other auklets finish nesting and disperse from the breeding colonies earlier than puffins.

What to expect: Bad weather is the norm. Be prepared for fog, wind, cool temperatures, and sometimes rain, so dress accordingly.

Food and lodging: Included in St. Paul Island Tour package deals.

Tips: Stay several days to improve your chances of good weather. Transport from the mainland is by small plane with limited overhead luggage space. Visitors' checked-in bags may occasionally be delayed, so carry onto the plane anything (personal and photographic) that you might need for a couple of days if the rest of your gear is delayed.

Website: https://stpaulislandtour.com

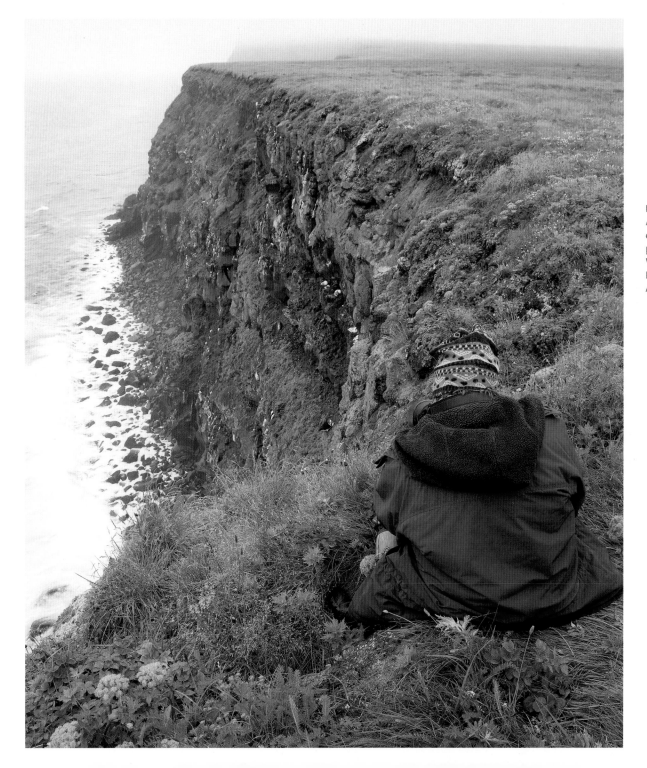

Figure 15.18:
A photographer communes with the puffins at the Ridge Wall rookery. St. Paul, Pribilof Islands, Alaska.

Nickerson Beach Park, Long Island, New York

Nickerson Beach Park, on Long Island's southern shore, is a popular spot to photograph large numbers of nesting Black Skimmers, Least and Common Terns, and American Oystercatchers, as well as a few endangered Piping Plovers. Some of these birds can be approached quite closely with caution. Two large roped-off areas house the skimmer and tern colonies among dune vegetation. A few nests may be right next to the rope barriers within range of a 400mm lens, but in general, longer focal lengths are preferable. Oystercatchers and plovers may nest on the open beach, their nests protected by wire cages.

Figure 15.19: American Oystercatcher family. Canon EOS 7D Mark II with EF100–400mm f/4.5–5.6L IS II USM lens at 400mm, Gitzo tripod, 1/1000 sec., f/8.0, ISO 800. Nickerson Beach, New York.

Late May to early June sees the first oystercatcher chicks and by mid-June the families are easy to find (figure 15.19). Plover clutches hatch by mid-June after which the families may wander widely. At this time, terns are still on eggs (watch for males bringing fish for their nesting mates), but skimmers are still courting. Tern chicks hatch and can be photographed being fed at the nest in late June and July, followed by skimmer chicks in August.

Lying on the sand for a low perspective gives a more intimate view of the subject. Many species are quite tolerant, allowing humans to get fairly close (figure 15.20). Wear long sleeves for comfort, and use a ground pod to keep sand out of your gear. On sunny days, arrive before sunrise to find a subject in optimal light, then return and stay until after sunset.

When to go: May–September for nesting seabirds. December–February explore Nickerson and nearby Jones Beach to find Snowy Owls that often spend the winter there.

What to expect: Common Terns are extremely aggressive, attacking you with sharp bills and slimy droppings if you get too close to their nests! Wear a hat (and maybe a raincoat too) for protection, stay well back, and keep still and low. If you dislike photographing banded birds, be aware that some of the oystercatchers and plovers have colored leg bands.

Food and lodging: Hotels and eateries in nearby Long Beach, Oceanside, Rockville Centre, and elsewhere.

Tips: At least during peak summer months, plan on arriving before 9am or after 5pm to avoid a hefty parking/entry fee. Check the pond next to the main parking lot for Black Skimmers bathing and skimming, especially early morning.

Website: www.nassaucountyny.gov/2802/Nickerson-Beach-Park

Figure 15.20: Black Skimmers and Black Oystercatchers make tolerant subjects for bird photographers. Nickerson Beach, New York. (Right)

Figure 15.21: Black-bellied Whistling Ducks.
Canon EOS 7D Mark II with 500mm f/4L IS lens, Gitzo tripod, 1/200 sec., f/16, ISO 400. Circle B Bar Reserve, Florida.

Other Good Bird Photography Locations

(Asterisks indicate I have visited the location.)

Platte River Valley, Nebraska *: As many as half a million Greater and Lesser Sandhill Cranes migrate through the Platte River Valley each spring (see this chapter's opening image). The Rowe Sanctuary in Kearney and the Crane Trust in Grand Island offer morning and evening sessions in photo blinds at crane roosts. Overnight blinds are available. Late February through early April. Book well ahead—spots fill up quickly.

Barnegat Lighthouse State Park, New Jersey *: Probably North America's best spot for wintering Harlequin Ducks, along with scoters and other sea ducks, that can be photographed from a rock jetty. Also present can be Common Loons, Red-breasted Mergansers, Purple Sandpipers, and Brant. Rocks are dangerously slippery when wet; wear cleated footwear. October–April. Check website for winter hours.

Magee Marsh, Ohio: Find migrating warblers and other songbirds at close range from the boardwalk at this famous spring migration location on the southern shore of Lake Erie. Species diversity and numbers are weather dependent and vary widely day to day.

Plan to spend several days here in May, especially the second and third weeks of the month. Boardwalk can be extremely crowded.

High Island, Texas: Houston Audubon sanctuary offers two photo opportunities. For spring migrants, book a seat in the Boy Scout Woods photo blind. Or reserve a spot on the Smith Oaks Rookery photography platform overlooking nesting Roseate Spoonbills and other waders. Both locations are best in late March to early May. Reservations and prepayment required. Book early for the best options.

Circle B Bar Reserve, Lakeland, Florida *: Part of Polk County Environmental Lands Program, this former cattle ranch has a system of walking trails that lead visitors around several wetlands and to a lake overlook. Birds that can be photographed here include Purple Gallinules, Red-shouldered Hawks, Black-bellied Whistling Ducks (figure 15.21), Red-bellied Woodpeckers, Barred and Great Horned Owls, and nesting Florida Sandhill Cranes. Check website for hours.

Green Cay Wetlands (Boynton Beach) and Wakodahatchee Wetlands *(Delray Beach) Florida: Two man-made wetlands are home to a wealth of water birds (including the coveted Purple Gallinule and Least Bittern) easily photographed from boardwalks. Year-round opportunities.

Machias Seal Island, Maine/New Brunswick *: A rocky island where Atlantic Puffins and Razorbills can be photographed at close range from wooden blinds. Only a few tour operators are available for the one-and-a-half hour boat rides to visit the island, so reserve your spot well in advance. Book multiple trips in case bad weather should cause a cancellation. Late June through early August.

Your Local Hotspot Anywhere!

Take advantage of the wealth of birdlife in your local area—nature reserves, urban/suburban parks, beaches, campgrounds, fishing areas at lakes, and ponds. Explore refuges in the USFWS National Wildlife Refuge System. If you're a birder, you already know where to find birds in your own region and in which season. If not, join a bird club and go on field trips.

These special places bring us face to face with nature's many moods—often breathtakingly beautiful, sometimes vulnerable, occasionally brutal, but always fascinating. Don't forget to sometimes switch off your "photographer" mentality and simply be there in the moment, with all your senses aware—sight, sound, even smell! Just as meaningful as the photographs we take away with us, the memories of the experience itself are a major part of what makes nature photography so rewarding. Enjoy!

Figure 15.22: Red-breasted Sapsucker.
Canon EOS 1D Mark III with 500mm f/4L IS USM lens, 1.4× teleconverter, Gitzo tripod, 1/500 sec., f/5.6, ISO 400. Aspen campground, Lee Vining, California.

Chapter 16

WHAT'S NEXT?

By now you have a growing collection of beautiful images of birds.
What do you plan to do with them?

Figure 16.1: This image of a Common Loon and chick has been a popular subject for décor prints.

Canon EOS 1Ds Mark II with 500mm f/4L IS USM lens, 2× teleconverter, Gitzo tripod, 1/800 sec., f/8.0, ISO 250. Onaway, Michigan.

For some, the experience of being surrounded by nature combined with the challenge and thrill of bird photography are their own rewards. Most photographers want to go further by sharing their work, either with family and friends or with a far wider audience. Whether the reason you share images is to achieve recognition and acclaim, make money, educate and inspire the public, give back to nature by supporting a worthy cause, or all of the above, the ways to put your images to good use are as varied as are photographers themselves. This chapter offers a few suggestions.

Displaying and Sharing Your Work

Online Sharing

The numerous ways to share your work online hardly need an introduction. You can set up a personal website and/or blog, or display your work on free photo sharing sites such as Flickr. You can join online nature photography forums such as NatureScapes.net and BirdPhotographers.net to display images, receive admiration and feedback, and engage in discussions. And, of course, you can enjoy watching your images accumulate "likes" on social media sites such as Instagram and Facebook.

Prints and Notecards

One time-honored way to display and share your images is to print them for wall décor or as greeting cards (figure 16.1). I produce standard-size paper prints and cards on my Epson inkjet printer. For large-size reproductions and special media, I order prints from companies online. I have had consistently high-quality products and good service from MPix (www.mpix.com). Other photographer friends use Nations Photo Lab (www.nationsphotolab.com), and there are numerous other reputable printing companies. I purchase frames and mats from Frame Destination

Figure 16.2: A display of frame-free, foam board standout prints. Photo courtesy of Midge Marchaterre.

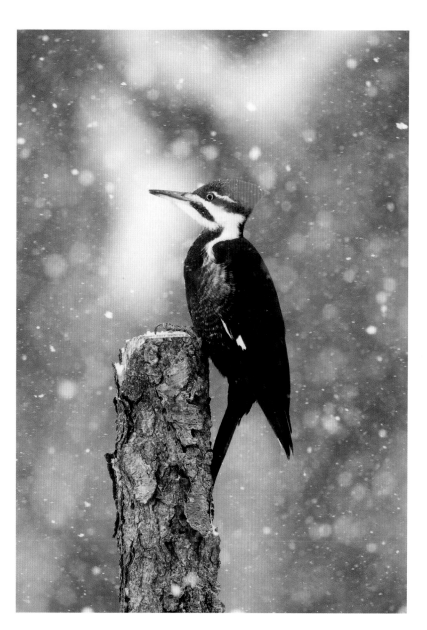

Figure 16.3: Pileated Woodpecker in a snowstorm. After this image appeared on a magazine back cover, I received several requests for prints.

Canon EOS 1Ds Mark II with 500mm f/4L IS USM lens, 1.4× teleconverter, Gitzo tripod, 1/800 sec., f/7.1, ISO 640. Freeville, New York.

(www.framedestination.com). Use your imagination with framing: I have one friend who displays her bird images beautifully in old picture frames that she collects and refurbishes.

The classic matted and framed paper print has been joined by a variety of non-traditional printing and mounting media. Images can now be reproduced directly onto canvas, metal, acrylic, and glass. Paper prints can be mounted on thick foam board with a finished edging to create what are termed "standouts." These special media options have a clean, contemporary look, and, since they do not require frames, they are ready to hang (figure 16.2), which can be an effective selling point.

My strategy is to produce prints only on request when people contact me to purchase a specific image they've seen published in a magazine (such as the

Figure 16.4: A shipment of notecards ready to go a retailer. You'll recognize some of the images from this book!

Pileated Woodpecker in figure 16.3) or in one of my presentations. Other photographers enjoy selling framed prints at art fairs and bird festivals, but I have never found that to be profitable. You can also sell online through such sites as fineartamerica.com or from your own website. Loons, eagles, owls, penguins, puffins, and colorful backyard birds are popular and saleable subjects. And let's not forget fluffy chicks!

In order for people to see your prints, you need somewhere to hang them.

Many places will gladly display your framed prints on their walls: coffee shops and restaurants, doctor's waiting rooms, hospitals, libraries, gift shops, bank and corporation foyers, art galleries, and the list goes on. Add a price tag and your business card so that potential buyers can contact you.

In certain cases I will donate framed prints, for example, to a raffle or auction to raise funds for a good cause. And I always give prints as thank-you gifts to the many generous people who

have helped me obtain images over the years by sharing location information, offering leads to potential photo ops, or granting me access to private property. People always love a photo of "their" bird!

Somewhat surprisingly, in this age of instant messaging and animated e-greeting cards, I still have good success selling notecards. I print them on pre-scored card stock from Red River Paper (www.redriverpaper.com) from whom I also purchase envelopes and clear display bags or boxes. (They also provide free templates to help you design your cards, as well as downloadable inkjet printer profiles for accurate color reproduction.) I sell the cards wholesale to birding supply stores (figure 16.4) as well as directly to the public. Whenever I give a presentation, I bring along a selection of individually sleeved cards and make them available for purchase, and they have proven to be very popular. Boxed card sets also make great gifts.

Calendars and Photo Books

What could be more wonderful than a wall calendar or coffee table book filled with your own bird images? Calendars make great gifts for family and friends, can be used as fundraisers for a conservation organization, or can be sold for profit. Several online, on-demand printing companies offer customized

calendars that you can either design directly online or on your desktop computer after downloading their free software. I personally have not made calendars this way, but photographer friends who have done so have had good success using Create Photo Calendars (www.createphotocalendars.com) and Smart Press (www.smartpress.com). You can sell the printed calendars directly to your customers or, in the case of the first example, leave it to the company to fulfill orders through their online shop.

A quality photo book is an elegant way to showcase a portfolio of work. There are many options to create one, but I recommend Blurb (www.blurb. com) for their professional quality, for both printed and eBooks. You can design your book online or offline using Blurb's free software, and then upload the finished product to order your book. You can order copies and sell your book yourself, or you can sell it through their online bookstore.

Presentations

If you are comfortable speaking to a crowd, one of the best ways to use your images is to give a presentation (figure 16.5). (I still think of them as slide shows!) Your goal might be to educate and inspire others about birds, to promote a worthy cause, to take people on a journey through a travelogue, or

Figure 16.5: Members of a bird club enjoy a presentation. Photo courtesy of Midge Marchaterre.

simply to showcase your work. My presentations have included all those genres. I like to combine education and entertainment, interspersing bird natural history and photo tips with personal stories and insights, and of course, lots of great bird photos. Create your presentation using a software program such as Microsoft PowerPoint, Apple Keynote, or FotoMagico.

Know who your audience will be and choose a topic that is likely to match their level of interest and prior knowledge. One of my popular presentations, called *Beyond Bird Feeders*, is on the topic of bird-friendly gardening to create backyard habitat (figures 16.6 and 16.7). I have given this presentation to

Figure 16.6: Title slide for my presentation Beyond Bird Feeders, developed in Apple Keynote.

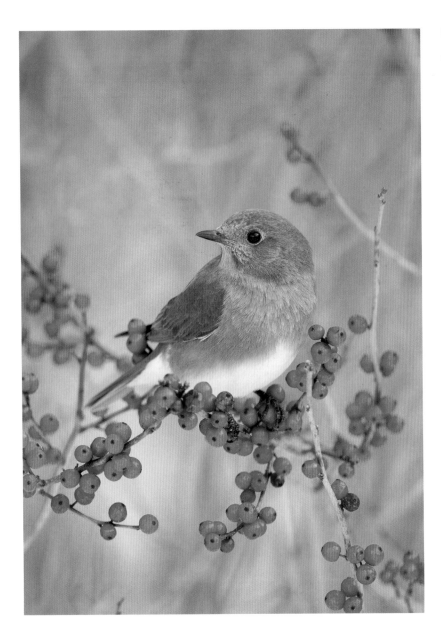

Figure 16.7: Eastern Bluebird male on winterberry holly in winter. One of the images from my educational presentation about bird-friendly gardening. Canon EOS 7D with 500mm f/4L IS USM lens, 1.4× teleconverter, Gitzo tripod, 1/320 sec., f/5.6, ISO 640. Freeville, New York.

gardening clubs as well as to birding organizations.

Practice your show in front of a few friends first and ask for feedback, then practice again until you are completely comfortable with the material. Preparation is the secret to a smooth delivery. Start small at first, presenting to a local camera or bird club, and then graduate to larger groups and organizations, if you wish.

TIPS FOR A SUCCESSFUL PRESENTATION

- **Lead-up to the event:** Practice! The more you practice the smoother your delivery will be.

- **Begin strong:** Engage the audience at the outset with a compelling image, a bold or surprising statement, or a funny personal story.

- **Organization:** Have a well-organized narration that includes storytelling as well as providing information.

- **Keep it interesting:** Show a variety of image styles besides standard bird portraits such as behavior and action, birds in habitat, close-ups (head shots, feather details), and birds amid landscapes for a sense of place.

- **Slide transitions:** Experiment with the software's transition styles between slides. For an interesting effect, include a montage of images within a single slide, in which the components dissolve in and out at different times.

- **Pace:** Vary the pace. Include slow sections where you dwell on a particular image and fast sections with quick transitions between images and sequences.

- **Time:** Keep your presentation to 45–50 minutes, which, in my experience, translates to about 100 slides. Leave the audience wanting more instead of feeling overwhelmed by too much.

- **Delivery:** Speak to the audience, not to your notes. Look around the room at intervals while you speak. Decide whether you will answer questions during the talk or only at the end, and tell the audience this when you begin.

- **End strong:** End with a powerful image and strong closing statement.

- **Thanks:** Thank the audience and the event's host(s).

Photo Contests

If you enjoy the thrill of competing, consider submitting your best work to a nature photography contest. The prestige that comes from winning a top prize is enormous (figure 16.8). At the national and international levels, the standards are extraordinarily high, as is the competition due to the sheer number of entries. Birds are popular subjects, with several contests devoted to them alone. Even in general contests, the bird category tends to receive the most entries. Fortunately, in addition to their very top prizes, several of the following contests display their Top 100 and Top 250 entries online. Being awarded this status is considered a significant achievement.

Some of the best-known contests are Audubon Photography Awards, Nature's Best (several contests annually), Share the View, National Wildlife Photo Contest, The Nature Conservancy Photo Contest, North American Nature Photography Association Showcase, Outdoor Photographer Nature's Colors Contest, Festival de l'Oiseau and—the pinnacle of nature photo contests—the Wildlife Photographer of the Year. Local and regional publications and organizations often run contests that can be equally rewarding to enter. Plus, the number of entries will be lower so you have a better probability of success. To increase your chances, follow the tips on the next page.

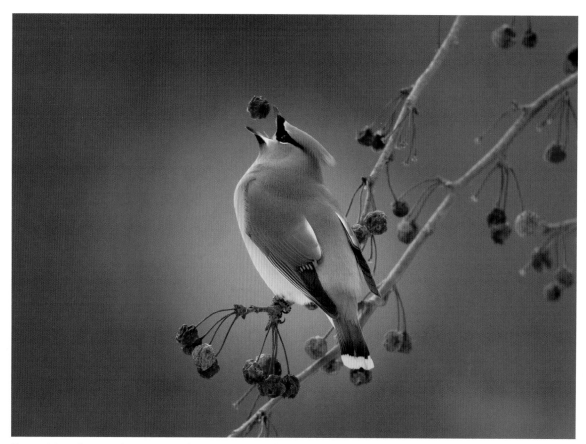

Figure 16.8: Cedar Waxwing eating a crabapple. This image (which also appeared in chapter 8) won Grand Prize in the 2017 Share the View International Nature Photography Competition.
Canon EOS 7D with 500mm f/4L IS USM lens, 1.4× teleconverter, Gitzo tripod, 1/1250 sec., f/5.6, ISO 800. Ithaca, New York.

TIPS FOR ENTERING PHOTO CONTESTS

- Read the rules carefully, in particular regarding what rights to the entries the organizers require. Depending on the reason the contest is being held, some organizers want unlimited rights to all submitted images, whether prizewinners or not. Be aware of what you might be giving away.

- Examine the winning images from previous years. Do the styles vary or are they similar from year to year? How do your images compare to them in content and technical quality?

- Submit your very best and most unique work. Images should be technically perfect but at the same time they should portray the subject in a way that's different from the usual. Judges get jaded after having to look at many images. Surprise them with something photographed differently. Try a bird shown small in a stunning landscape, a beautifully composed feather detail or a subject captured from a unique angle, for instance. And it doesn't have to be a rare or exotic species—a common bird shown in a fresh way is just as likely to get the judges' attention.

- Pay attention to the technical requirements: Don't oversaturate or over-sharpen entries. Adhere to the required dimensions.

- Pay attention to the ethical rules regarding captive or baited subjects. The same goes for what is permissible regarding cloning out elements from, or adding elements to, the original frame. Most top contests prohibit both of these and, regarding the latter, require finalists to submit the RAW files to be sure the rules have been followed.

- Don't leave uploading your submission to the last minute! Many people do, leading to a traffic jam at the contest website, so you risk missing the deadline.

Giving Back to Nature

Perhaps the noblest role our photos can serve is to give back to nature. Nature photographers have the collective opportunity and, in my opinion, the responsibility to harness the power of their work in support of conservation. High-quality images can greatly enhance the success of efforts that advocate for and protect the very birds we love to photograph.

As a photographer, your level of involvement in conservation work can be as deep as you wish. Examples of ways to help include donating photos for education and fund-raising, volunteering your time and skills to conservation organizations, giving presentations to bring attention to conservation issues or to raise funds, or taking the journalistic approach by photographing conservation stories and writing magazine articles.

Regarding donations, I frequently get requests for free use of my photos. Usually, I base my decision on whether or not I have had previous dealings with the requester, and I like to help those who've helped me. But I also "think global, act local," and so, I grant free use of certain images to a land trust that protects natural places in my region. A few examples will illustrate other ways I've been involved in giving back to nature.

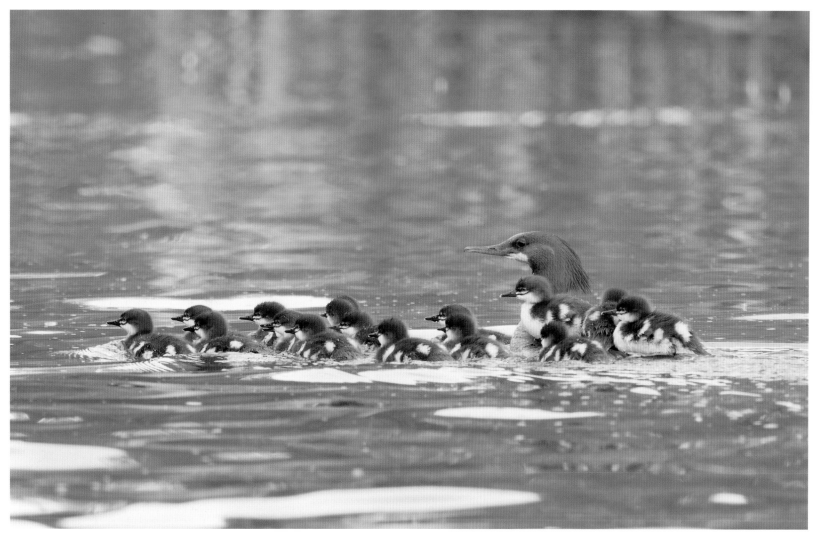

Figure 16.9: Common Merganser female with ducklings.
Canon EOS 7D Mark II with EF 500mm f/4/L IS II lens, 1.4× III teleconverter, Gitzo tripod, 1/800 sec., f/5.6, ISO 640.
Lansing, New York.

Figure 16.10: Interpretive sign at the entrance to a protected natural area. Lansing, New York.

and the local community's increased appreciation and protection.

Wildlife Refuges

Wildlife refuges in the National Wildlife Refuge system are among my favorite places to do bird photography. When planning a visit, I may contact refuge staff ahead of time for information and advice about timing my trip or where to find particular subjects. For certain projects, I sometimes request special access. In exchange, I offer to donate photos that the refuge can use for their educational programs or interpretive signage (sometimes that forms part of the requirement for special access anyway).

In preparation for a visit to Montana's Bowdoin National Wildlife Refuge with the goal of photographing Eared Grebes, I emailed the refuge for information. The refuge biologist and other staff were very accommodating, even phoning me to give advice. In thanks for their help, I offered a selection of images. Imagine my delight when they chose one for the cover of their new brochure (figure 16.11)!

Conservation Organizations

I recently worked with a local conservation group to raise awareness and support for a newly protected reserve in the community. The organization invited me to put on an exhibition of photos at a local library with the theme of birds that could be spotted at the reserve.

The project was a winning situation all round. After a summer spent photographing at the reserve, I had obtained many new images, such as the Common Merganser family in figure 16.9, which I could use for other projects as well as include in the exhibition. I also donated some of these images for use in the organization's interpretive signage (figure 16.10). The show opened to great acclaim, and several of the prints even sold at the opening event! The organization gained more supporters for their conservation efforts, and the birds benefited from subsequent habitat restoration

Figure 16.11: An Eared Grebe with two chicks. The image appeared on the refuge's brochure cover.
Canon EOS 7D Mark II with EF 500mm f/4/L IS II lens, 2× III teleconverter, Skimmer Ground Pod, 1/2000 sec., f/8.0, ISO 500. Bowdoin National Wildlife Refuge, Montana.

Giving More than Photos: Black Tern Project

Besides donating photos, you may be able to contribute other skills in exchange for photographing at a wildlife refuge or nature reserve. One example could be monitoring bird activity while you are in the field, as I once did during a self-assigned project to photograph threatened Black Terns nesting in upstate New York. I requested permission from the state's Department of Environmental Conservation to access a restricted wildlife management area. In return, I was asked to gather data about the tern population, something I was glad to do.

During that summer, I paddled into the huge marsh several times a week. In addition to pursuing photography, I determined the location of the main Black Tern colony, estimated the number of tern pairs present, and counted and

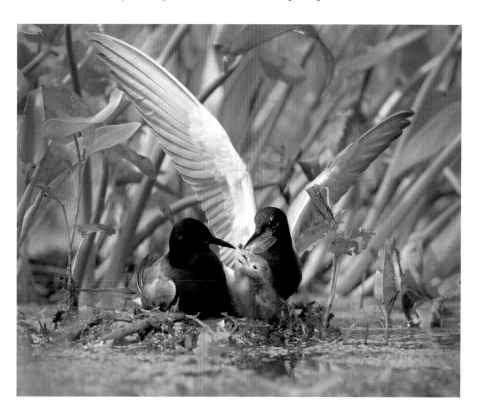

Figure 16.12:
Black Terns; one adult feeding its chick at nest.
Canon EOS 1Ds Mark II with 500mm f/4L IS USM lens, 1.4× teleconverter, Gitzo tripod, Kwik Camo blind, 1/640 sec., f/5.6, ISO 400. Perch River Wildlife Management Area, New York.

mapped nests and eggs. One advantage of my efforts was keeping track of the dates eggs were laid. That information let me calculate when to return to photograph newly hatched chicks at the nest (figure 16.12). Later, I published an article in *Bird Watching* magazine about Black Tern life history and the decline of the species in the northeastern USA, and I also gave several presentations on the topic.

This brings up the question of how to get published. The short answer is: Write!

Be a Writer (or Team Up with One)

Outstanding bird photographs are so ubiquitous these days that it is quite difficult to get your work published in traditional media and harder still to get paid for it. A few birding magazines publish a selection of readers' images (unpaid) but if you have higher ambitions, one thing that can help is the ability to write well while also enjoying the process. Pick a topic you know about and for which you have a good selection of images for illustration, and pitch the idea to a magazine as a photo-text package. For nature articles you'll need to have a solid grasp of natural history and an appreciation for scientific accuracy. Alternatively, the topic could be a personal birding experience that impacted

Figure 16.13: Opening spread for an article about Alaska's Pribilof Islands in *Wild Planet Photo Magazine*, January 2016 issue. Image courtesy of *Wild Planet*.

your life, a bird photography trip to a bucket-list location, or a how-to bird photography piece.

When looking for a home for your article, a good place to start is with small regional wildlife magazines, such as those published by state and regional wildlife and game departments. Some online venues may be more open to queries than the traditional media (although again, unpaid). Photography forums such as naturescapes.net and the North American Nature Photography Association blog are often looking for articles to publish, and e-magazines such as *Wild Planet Photo Magazine* (figure 16.13) feature many portfolios and written pieces from readers. (Note that for all these examples you must be

a subscriber or member.) And, of course, you could always publish your own blog.

If your sights are set toward national-level magazines, the bar is far higher. Your pitch is more likely to succeed if the photographs demonstrate a journalistic approach to the topic. Consider teaming up with a science writer or a biologist who specializes in some aspect of bird biology or conservation that would make a compelling photo story.

Figure 16.14: Western Tanager male. Canon EOS 1D Mark III with 500mm f/4L IS USM lens, 1.4× teleconverter, Gitzo tripod, 1/800 sec., f/5.6, ISO 400. Mono Lake Basin, California. (Right)

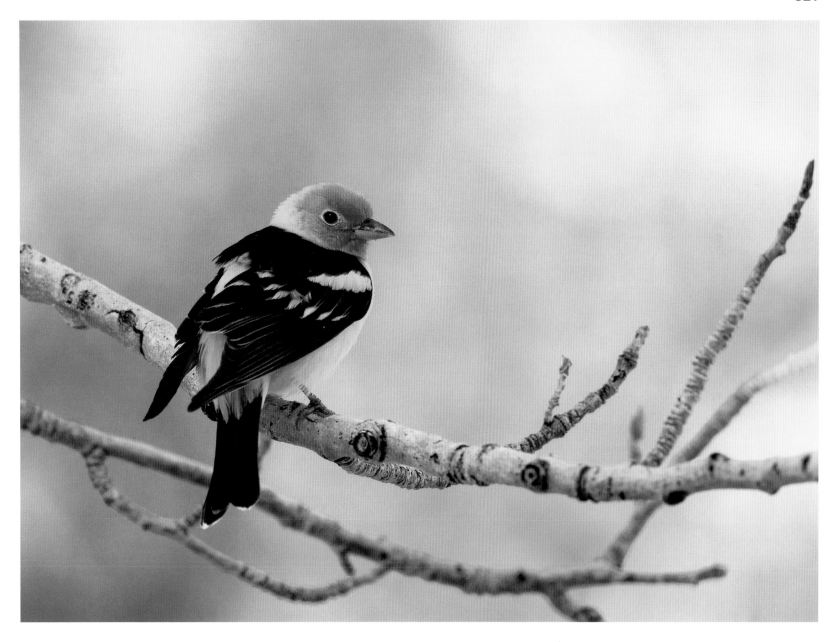

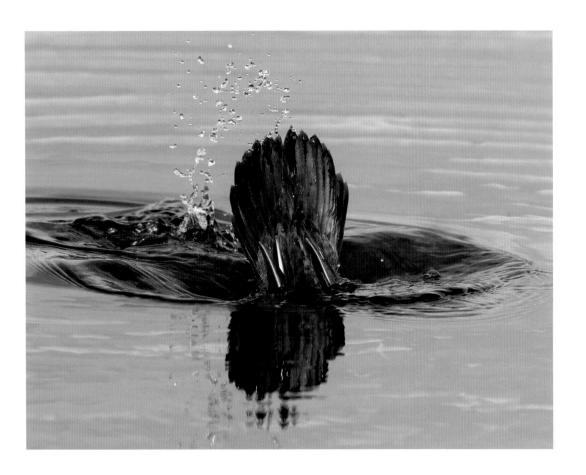

AFTERWORD

Going Forward with Your Bird Photography

A beautiful bird portrait can be a piece of art that captures our hearts. An action shot can leave us with a sense of awe at the drama of the natural world. Portrayed in its environment, an image of a bird can be a powerful force for conservation of an ever more vulnerable Earth. Captured in an imaginative way, a photo can surprise us and even make us chuckle. Whatever goals you envision for your work, strive to strengthen your technical skills, develop your artistic vision, and tell stories with your images, always with the well-being of the birds as first priority. Take risks, be creative, be persistent, and, above all, have fun!

Marie Read
December 2018

ACKNOWLEDGMENTS

Many kind and generous people have helped me during the preparation of this book.

First and foremost, my deepest gratitude goes to wildlife photographer Mike Milicia who acted as technical editor. His knowledge, expertise, teaching skill, and attention to detail have made the technical material in this book far more accurate and comprehensible than I ever could have achieved alone.

I'm grateful to the following friends and colleagues—many fine photographers among them—who each took the time to read parts of the text and whose suggestions greatly improved the material: Christine Bogdanowicz, Doug Brown, Keith Carver, Christopher Ciccone, Bobby Harrison, Laura Kammermeier, Mia McPherson, Erv Nichols, Sandra Noll, Liz Pearson, Diane Porter, Jim Roetzel, Donna Schulman, Steve Smith, and Diana Whiting. Thanks also to Jane Freeburg for giving me the courage to pursue and follow through with this daunting project.

Thanks to the talented staff at Rocky Nook, especially my editor Joan Dixon for the fine editing and guidance, to Petra Strauch for the beautiful book design and layout, and to the rest of the Rocky Nook team for handling the details of printing and production of the final printed volume you now hold in your hands.

And finally, I would be lost without my husband Peter Wrege—dedicated field biologist, problem-solver, skilled handyman, brutal editor, and gourmet cook. My deepest thanks for his enduring support and practical help over the years. Without him, this wonderful career would never have happened.

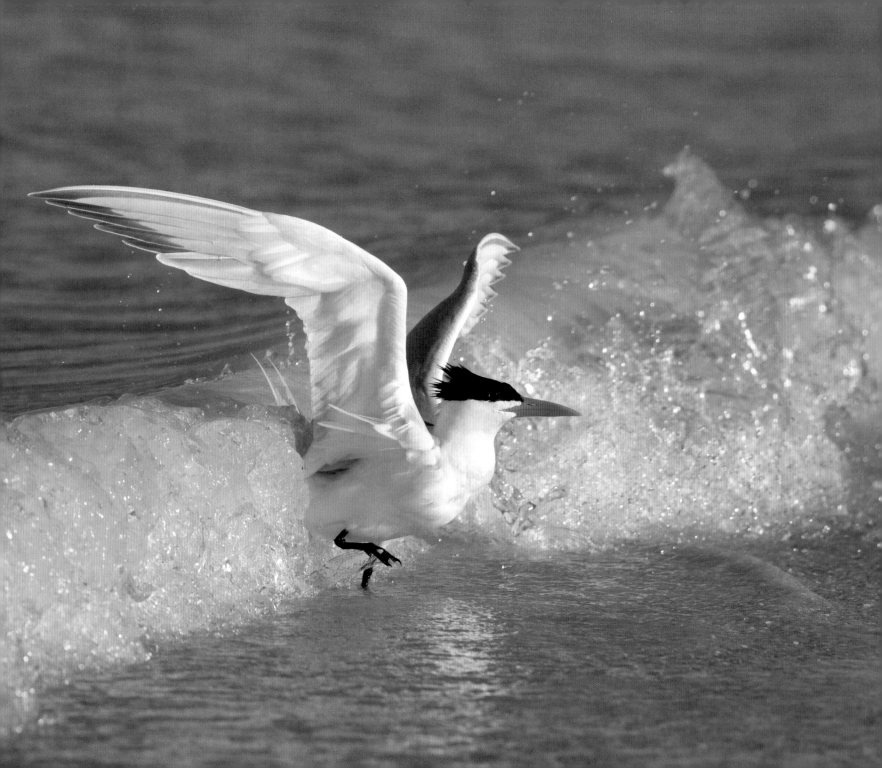

APPENDICES

CAPTIONS FOR CHAPTER-OPENING AND COVER IMAGES

Front cover: Roseate Spoonbill landing. Canon EOS 1D Mark III with 400mm f/5.6L USM lens, handheld. 1/4000 sec., f/5.6, ISO 400. Orlando, Florida.

Chapter 1: Horned Puffins. Canon EOS 7D Mark II with EF 100–400 mm IS II lens (at 349 mm), handheld, 1/2000 sec., f/5.6, ISO 800. St. Paul, Pribilof Islands, Alaska.

Chapter 2: Yellow-headed Blackbird male courtship antics. Canon EOS 1D Mark III with 500mm f/4L IS USM lens, 1.4× teleconverter, Gitzo tripod, 1/2500 sec., f/5.6, ISO 400. Mono Lake Basin, California.

Chapter 3: Tricolored Heron foraging over the surface of a pond. Canon EOS 7D Mark II with EF 100–400 mm IS II lens (at 321mm), handheld, 1/2500 sec., f/5.6, ISO 640. Viera Wetlands, Florida.

Chapter 4: American Oystercatcher closeup. Canon EOS 7D II camera with 400mm f/5.6L USM lens, handheld, 1/1000 sec., f/5.6, ISO 500. Fort De Soto Park, Florida.

Chapter 5: Eared Grebe with two chicks riding on its back. Canon EOS 7D Mark II with EF 500mm f/4/L IS II lens, 1.4× III teleconverter, Skimmer Ground Pod, 1/1600 sec., f/5.6, ISO 640. Bowdoin National Wildlife Refuge, Montana.

Chapter 6: Northern Gannet displaying. Canon EOS 7D Mark II with EF 100–400 mm IS II lens (at 400mm), handheld, 1/2000 sec., f/5.6, ISO 400. Cape Saint Mary's Ecological Reserve, Newfoundland, Canada.

Chapter 7: Two Common Redpolls in the author's backyard. Canon EOS 1Ds Mark II with 500mm f/4L IS USM lens, 1.4× teleconverter, Gitzo tripod, photo blind, 1/250 sec., f/5.6, ISO 500. Freeville, New York.

Chapter 8: A Pinyon Jay takes flight with its throat packed with pine nuts. Canon EOS 1D Mark III with 500mm f/4L IS USM lens, 1.4× teleconverter, Gitzo tripod, 1/1600 sec., f/5.6, ISO 400. Mono Lake Basin, California.

Chapter 9: Indigo Bunting male perches in flowering eastern redbud in the author's backyard. Nikon F5 with Nikkor 500mm AF-S f/4 lens, 1.4× teleconverter, Gitzo tripod, photo blind, Fuji Velvia film, camera settings not recorded. Freeville, New York.

Chapter 10: Tufted Puffin prepares to land. Canon EOS 7D Mark II with Canon EF 100–400 mm IS II lens (at 234mm), handheld, 1/1600 sec., f/5.6, ISO 1600. St. Paul, Pribilof Islands, Alaska.

Chapter 11: Black Oystercatcher foraging on a mussel bed. Canon EOS 1Ds Mark II with 500mm f/4L IS USM lens, 1.4× teleconverter, Gitzo tripod, 1/500 sec., f/5.6, ISO 800. Santa Cruz, California.

Chapter 12: Snow Bunting flock in flight with falling snow. Canon EOS 1D Mark III with 400mm f/5.6L USM lens, handheld, 1/1250 sec., f/8.0, ISO 1000. Freeville, New York.

Chapter 13: Red-faced Cormorant and ocean pattern. Canon EOS 7D Mark II with EF 100–400 mm IS II lens (at 135mm), Gitzo tripod, 1/2000 sec., f/8, ISO 500. St. Paul, Pribilof Islands, Alaska.

Chapter 14: Two Arctic Terns fly over a field of buttercups. Canon EOS 7D Mark II with EF 500mm f/4/L IS II lens, beanbag over vehicle window, 1/1600 sec., f/5.6, ISO 640. (Space added at left edge.) Keflavik, Iceland.

Chapter 15: Migrating Sandhill Cranes on the Platte River in March, photographed from overnight blind. Canon EOS 7D Mark II with EF100–400mm f/4.5–5.6L IS II USM lens at 400mm, Gitzo tripod, 1/640 sec., f/5.6, ISO 640. Rowe Sanctuary, Kearney, Nebraska.

Chapter 16: Black Tern adult broods chick at nest. Canon EOS 1Ds Mark II with 500mm f/4L IS USM lens, 1.4× teleconverter, Gitzo tripod, Phoenix Poke Boat, Kwik Camo blind, 1/640 sec., f/5.6, ISO 400. Perch River Wildlife Management Area, New York.

Afterword: Hooded Merganser male takes his leave. Canon EOS 7D Mark II with 500mm f/4L IS lens, beanbag over vehicle window, 1/2000 sec., f/5.6, ISO 400. Viera Wetlands, Florida.

Appendices: Royal Tern chased by a wave. Canon EOS 7D with EF 400mm f/5.6L USM lens, handheld, 1/2500 sec., f/5.6, ISO 400. Fort De Soto Park Florida.

RESOURCES

Bird Natural History Resources

All About Birds
Cornell Lab of Ornithology's online
guide to birds and birdwatching (free)
https://www.allaboutbirds.org

Bird Academy at The Cornell Lab of
Ornithology
Online courses (free and paid) about
birds
https://academy.allaboutbirds.org

Birds of North America Online
Comprehensive life histories of North
American birds (subscription)
https://birdsna.org

eBird – Online database of bird observa-
tions from North America and world-
wide managed by the Cornell Lab of
Ornithology
https://ebird.org

**Books, eBooks, Online Photo
Instruction**

A Guide to Creative Blurs
eBook by Denise Ippolito
www.deniseippolitocom.contentshelf.
com/shop

*Bringing Nature Home: How You Can
Sustain Wildlife with Native Plants,
2nd Edition*
by Doug Tallamy
Timber Press, 2009

*Cornell Lab of Ornithology Handbook of
Bird Biology, 3rd Edition* edited
by Irby J. Lovette and John W. Fitzpatrick
Wiley-Blackwell, 2016

The Creative Art of Photography
eBook by Denise Ippolito
wwwdeniseippolitocom.contentshelf.
com/shop

The Enthusiast's Guide to Lightroom
by Rafael "RC" Concepcion, Rocky Nook,
2017

The Enthusiast's Guide to Photoshop
by Rafael "RC" Concepcion, Rocky Nook,
2018

*Into the Nest: Intimate Views of the
Courting, Parenting, and Family Lives of
Familiar Birds*
by Laura Erickson and Marie Read,
Storey Publishing, 2015

*Natural Gardening for Birds: Create a
Bird-Friendly Habitat in Your Backyard,
2nd Edition*
by Julie Zickefoose.
Skyhorse publishing, 2016

Outdoor Flash Photography
by John Gerlach and Barbara Eddy
Routledge, 2017

Photoshop for Photographers
Bundle of video courses
by Adobe Photoshop master educator
Tim Grey
www.greylearning.com

Nature Photography Forums

NatureScapes.net

BirdPhotographers.net

Photo Blinds, Boats, and Feeders

Duncraft
Bird feeders and accessories
www.duncraft.com

Phoenix Poke Boats, Inc.
https://pokeboat.com

Tragopan Photography Blinds
https://photographyblinds.com

Photo Equipment and Accessories

Adorama Camera, Inc.
www.adorama.com

B&H Photo & Video
www.bhphotovideo.com

BLACKRAPID
Specialized camera straps and slings
www.blackrapid.com

Hunt's Photo & Video
www.huntsphotoandvideo.com

Kirk Enterprises
Window mounts, lens plates, etc.
https://kirkphoto.com

LensCoat
Weatherproof lens and camera covers,
tripod cushioning, photo blinds, etc.
https://lenscoat.com

NatureScapes.net Store
Large selection of gear for nature
photographers
https://store.naturescapes.net

Outdoor Photo Gear
Kwik Camo photo blind, Apex beanbag,
etc.
www.outdoorphotogear.com

Really Right Stuff LLC
Tripods and heads, lens plates and
brackets, etc.
www.reallyrightstuff.com

Photo Equipment Reviews

DPReview
www.dpreview.com

The Digital Picture
www.the-digital-picture.com

Fred Miranda
Equipment reviews, forum discussions,
etc.
www.fredmiranda.com

Printed Products and Supplies

Blurb
Online service for creating and printing
photo books, eBooks
www.blurb.com

Create Photo Calendars
Customized calendars and other
products
www.createphotocalendars.com

Frame Destination
Standard and custom frames and
supplies
www.framedestination.com

Mpix
Prints and other photo products
www.mpix.com

Nations Photo Lab
Prints and other photo products
www.nationsphotolab.com

Red River Paper
Notecard stock, envelopes, display bags,
and boxes
www.redriverpaper.com

SmartPress
Customized calendars and other
products
www.smartpress.com

INDEX

BIRDS FEATURED IN THE BOOK

Don't close the book on us yet!

Interested in learning more on the art and craft of photography? Looking for tips and tricks to share with friends? For updates on new titles, access to free downloads, blog posts, our eBook store, and so much more visit

rookynook.com/information/newsletter